KAZIMIR MALEVICH
AND THE ART OF GEOMETRY

I believe that you can reach the point where there is no difference between developing the habit of pretending to believe and developing the habit of believing

Umberto Eco, *Foucault's Pendulum* (London 1989), p.467

KAZIMIR MALEVICH
AND THE ART OF GEOMETRY

John Milner

Yale University Press
New Haven and London 1996

To Henry Milner
Diver, designer, photographer

Designed by Miranda Harrison.

Set in Bembo by Best-set Typesetter Ltd., Hong Kong.
Printed in Spain.

Library of Congress Cataloging-in-Publication Data

Milner, John.
Kazimir Malevich and the art of geometry/John Milner.
p. cm.
Includes biographical references and index.
ISBN 0-300-06417-9 (cloth)
1. Malevich, Kazimir Severinovich, 1878–1935 – Criticism and interpretation.
2. Suprematism in art. I. Malevich, Kazimir Severinovich, 1878–1935. II. Title.

ND699.M285M56 1996
759.7 – dc20

95-40662
CIP

Plates 9, 15, 17, 18, 40, 41, 44, 45, 48, 49, 50, 62, 78
and 169: © ADAGP, Paris and DACS, London 1996. Plates 20
and 154: © Succession Picasso/DACS 1996. Plate 81:
© Succession H. Matisse/DACS 1996.

Contents

Acknowledgments

This study is the result of a Leverhulme Fellowship held in 1993–94, for which I am deeply grateful. I am also grateful to the University of Newcastle-upon-Tyne which granted leave of absence for the period of the Fellowship.

Malevich appears in many ways to be a cardinal figure in the art of the first half of the twentieth century. Without seeing his work in the original it is impossible to estimate the sometimes rough directness and the strident impact of his canvases. In this the Stedelijk Museum in Amsterdam has played a remarkable role in the preservation and display of an extraordinary wealth of works by Malevich. Museum scholars are sometimes hidden in the details of bibliographic acknowledgments, so this is the place to acknowledge a debt of admiration to Joop Joosten's work with the material at the Stedelijk Museum. My many academic debts to the writings of scholars I hope to have recorded in the footnotes and bibliography, but any student of Malevich must acknowledge in particular the monumental efforts and achievements of Troels Andersen. Without his translations of Malevich's writings, and without his exhibition work, no worthwhile investigation of Malevich can proceed far. The study of Malevich has attracted the attentions of remarkable scholars internationally. It is not my aim to contradict the scholars listed in the bibliography of this book but to add to their already considerable insights.

Personally I wish to thank John Golding, Christopher Green, Norbert Lynton and Peter Vergo, who have encouraged me perhaps more than they realized. A special debt of gratitude is due to Robin Milner-Gulland at Sussex University and to Anthony Parton at the University of Newcastle-upon Tyne for their inspired, vigorous and even bizarre exchanges on the subject over a period of years. It was a great pleasure to advise on the reconstruction of Melnikov's lost Soviet Pavilion which was undertaken wholly by my son Henry Milner, a designer. I am immeasurably indebted to my wife Lesley Milner, to whom once more my deepest thanks. Without her help this book would not have been written.

Many individuals and museums have been helpful in providing photographic material and information. I am particularly grateful in this respect to Mr and Mrs N.D. Lobanov-Rostovsky in London. Their collection is a spectacular archive of Russian stage design. Varvara Rodchenko and Alexander Lavrentiev in Moscow sent archival photographs, as did M. Herman Berninger of Zurich. The art historian MaryAnne Stevens at the Royal Academy and the archeologist Professor Pavel Dolukhanov in Newcastle helped me to establish contacts which at first seemed impossible. I am also very grateful to Nina and Graham Williams for their invaluable assistance with photographic material.

Among museum collections I am particularly grateful to Mr V.A. Rodionov, Director General of the Tretyakov Gallery in Moscow, to Mr Timofei Aleksandrov at the Russian Museum in St Petersburg, to Mrs Veronika Akopdzhanova at the Literary Museum in Moscow, and to Mrs L.I. Ilina at the Art Gallery in Astrakhan. In addition I should thank Mr Osvaldas Daugelis at the M.K. Čiurlionis Museum in Kaunas and Dr Roswitha Neu-Koch of the Rheinisches Bildarchiv at Cologne.

Among photographers I acknowledge the work of Martien Coppens and Peter Cox at Eindhoven and Jörg P. Anders in Berlin. Henry Milner drew all the diagrams.

Looking at a painting by Malevich, I was struck with the conviction that the proportions of his canvas were in the ratio known as the Golden Section, that is approximately 8:13. This proved to be correct, although it by no means applied to all of his paintings. Yet it did reveal to me an evident fact: it showed me that as so much Russian art of the decade 1915–25 is more or less geometric in its forms, then concepts and systems of proportion could constitute an essential organizing feature. It became clear that Russian artists working in this way imbued their geometry with a meaning, particularly after the Russian Revolution in 1917. It was as if they were assembling a vocabulary of revolutionary forms even though their origin lay in the pre-Revolutionary wartime Russia of 1915. Malevich at once emerged as a primary originator of what was later to be developed by many painters, designers and architects in Russia and abroad.

As I began to examine this geometry more closely two more facts became evident. First, I found that surprisingly little attempt has been made to examine the use of geometry as a kind of subject matter capable of carrying a meaning in the way other images can convey meaning. Second, I recognized that the long history of mathematics in art is a tradition and convention relevant to the study of Malevich and his followers. The period 1915–25 had about it, despite warfare and partly because of the Revolution, a sense of an imminent Renaissance set in a century of optimistic faith in scientific progress, increased travel and burgeoning global awareness. Not surprisingly, mathematics and geometry had a major role in this twentieth-century Renaissance just as they had in the Rome of Vitruvius or in fifteenth- and sixteenth-century Italy.

For a long time the nature of this mathematics remained obscure to me, not least because contemporary theories of the fourth dimension were both popular and obscure. New developments in mathematics, including non-Euclidean mathematics, were frequently cited by Russian Futurist artists and poets but were hardly visible in their works beyond mentions of the square root of minus one, which seemed to be used more as a talisman than as a concept in mathematics.

A second insight opened up the subject when progress seemed impossible, and again it concerned a simple but pervasively influential cardinal fact long neglected, not least in my own considerations of the subject. Aware from the start that the proportions of canvases were significant, I examined without apparent progress long lists of the dimensions of paintings by Malevich, Tatlin, Rodchenko, Popova and others. These measurements were not always accurately given by museums and they resulted in unfathomable columns of metric measurements. It was Dmitri Sarabianov's book on Popova that provided the spark necessary to illuminate what lay before me. Sarabianov lists a painting by Popova that she inscribed on the back '3/4 *arsh*', meaning 'three-quarters *arshin*'. Popova was using the old, and now archaic, Russian and Turkish measure, the *arshin*, which was particularly used for measuring materials, including canvas. One *arshin* is made up of sixteen *vershok* or *vershki*. I am grateful to my colleague at the University of Newcastle-upon-Tyne, the historian David Saunders, who with his wide knowledge of Russian history and culture was able to locate the use of the *arshin* in stories by Chekhov and who was also able to guide me to an accurate definition of the *arshin* as equivalent to 71.12 cm. Applying this

to the sizes of the canvases used by Malevich and his contemporaries reduces mountains of apparently meaningless decimal measurements to whole numbers. The reason why this was so important was that it revealed the underlying modular units manipulated by Malevich and others to form the basic scale of their proportional and perspectival systems: it provided a way to examine their use of geometry in what Malevich called 'New Systems in Art'. It was, in a word, one of the essential missing tools necessary for the investigation.

In this text *arshin* and *vershok* are translated back into centimetres correct to two decimal places. Malevich was not so accurate: this is an effect of the conversion process.

Malevich created the most celebrated geometric painting of the twentieth century. It was painted on a square canvas and featured a black square centrally placed within a white area extending to the edges of the canvas. He called it *Quadrilateral* and it has since become known as *The Black Square*. He exhibited the painting in December 1915 along with many other canvases painted with geometrical shapes (Plate 192).

Yet Malevich was concerned with geometry from the early days of his painting career. Long before it became his subject matter he repeatedly adopted the square as a format for his paintings. In 1907, for example, he executed a whole series of tempera paintings, including a self-portrait, using square card. The possibility of cutting the card indicates that he deliberately chose to make his boards square or to keep them square. A small gouache self-portrait of *c.*1909 again employs this shape, and it recurs many times later in paintings on canvas where the square is not a standard shape although it can be readily constructed. Malevich deliberately chose to use a format in which neither the vertical nor the horizontal direction dominates. As it has no tendency either to the landscape or to the portrait conventions, it can be seen as a form held in balance between the two. It is for this reason a dynamic format for the painter to adopt, as it appears to expand equally in all directions from its centre. The *Self-Portrait* (Plate 1), painted in about 1909, illustrates this strong central focus as well as the powerful rhythms radiating outwards in all directions.

Throughout his career Malevich paid particular attention to the properties of the square. He attributed much of his development as an artist to his study of its qualities. In doing this he was the heir to a tradition that stretched back in time to the ancient Greek philosopher and mathematician Pythagoras, for whom number had a divine significance. Pythagoras taught that the divine harmony of the universe was expressed and revealed in number, which also formed the basis of music and geometry. One example of this was the Golden Section which divided a line so that the relation of the parts was the same as the ratio of the larger part to the whole line: all of the relationships are in the same proportion in this way. Harmonious proportions based upon the square, the circle, the triangle and their interactions had practical applications permitting the idea of harmonious proportions to spread rapidly into architecture, as the Roman architectural writer Vitruvius made clear. Attempts to relate the proportions of the human body to geometric and architectural proportions made geometry into a depiction of a divine order in human form so that humanity reflected the harmony of the deity. The German Albrecht Dürer and the Italian Leonardo da Vinci were familiar with imagery of this kind, as their drawings reveal. Traditions of alchemy also adopted and propagated comparable ideas whereby the geometry of the square, the circle and the triangle was taken to illustrate the perfected harmony between the male principle or sun (Sol), the female principle or moon (Luna) and God. All of these systems of thought, and others related to them, attributed particular meanings to geometry and proportion. Descriptions of ideal states, for example, stressed geometric architectural forms to indicate the simple, disciplined and harmonious order of society. Campanella's *City of the Sun* of 1602, for example, was organized and described in precisely this way.

Malevich knew and used these traditions, but he learnt of them within the context of a particular time. He was born in February 1878 to parents of Polish descent who named him after the Polish king and saint, Kazimir. His Polish background may have been important to him as he continued on occasion to use *Malewicz*, the Polish spelling of his name, in later years. During his youth a movement away from realism in art was spreading throughout France, Germany, Russia and elsewhere. This Symbolist movement, which asserted the power of the imagination, of feeling and aspiration, encouraged a re-examination of a wide range of mystical beliefs. This can be seen in the ideals of the Rosicrucian Salon and in the paintings made by Paul Gauguin in Brittany and Tahiti. It can also be seen in the mystical teachings of the Theosophical Society whose writers had a profound effect upon the art of their day. Theosophists re-examined the teachings of ancient mystics including Pythagoras and Orpheus, both of whom were concerned with the power of harmony expressed in proportion, geometry and music.

As a young man Kazimir Malevich found the means to travel to Moscow and St Petersburg, just at the time when Symbolism was at its height there. He encountered in Moscow the canvases of Gauguin and at the same time grew to know the Theosophical theories of Peter Ouspensky, who was examining new ideas of an apparently imminent 'fourth dimension'. It was here that proportion, geometry and new perspectives began to preoccupy Malevich. His recurrent use of the square format for his paintings was simply one sign of this.

The eight-year interval between Malevich's Symbolist *Self-Portrait* of 1907 (Plate 10) and his *Black Square* of 1915 (Plate 193) was a period of intense learning and experiment which transformed a concern for the proportions of canvases, figures and perspectives into the powerful generator of a new vision of the world.

The early work of Malevich was executed when the wealthy merchants Shchukin and Morozov were building great collections of French art in Moscow. Soon the works of Gauguin in particular were readily available for young artists to study; indeed, Shchukin had a whole wall of paintings by Gauguin and there is much evidence to show their impact upon young Russian painters. Excitement at Matisse, Picasso and Cubism followed. By January 1909, when the French painter, art theorist and writer Maurice Denis visited Moscow, the importance of Gauguin was well established in Russia. The painters Mikhail Larionov, Natalya Goncharova, Kazimir Malevich and many others responded to his decoratively expressive and mystical images. Denis had known Gauguin personally and also his follower, the painter Paul Sérusier, who did so much in France to revive the study of number as it was understood by nineteenth-century admirers of Pythagoras. Sérusier, Denis and later Matisse were all convinced of the power of harmony and proportion. Matisse's *Notes of a Painter*, published in France in 1908, discussed harmony at length and his essay appeared almost at once in Russian translation. By the time Henri Matisse himself travelled to Russia in 1911, the impact of French art in Russia was at its height. Malevich formed part of that eagerly receptive audience who visited the French exhibitions and the French collections of Shchukin and Morozov. Malevich's pre-war work suggests that it may have been easier to study some aspects of adventurous French art in Moscow than it was in Paris.

The Symbolist

In Moscow in 1892 Pavel Tretyakov donated his collection of Russian art to the city and was appointed its curator. There is no clearer sign of the increased importance attached to distinctly Russian art, including ikon painting. This was to prove instrumental in the growing debate concerning the separate identity of Russian art and culture which, since the days of Peter the Great, had paid homage to the arts of Western Europe.[1]

At precisely the same time the Shchukin family of Moscow merchants was beginning to develop *their* collection into one of the most important, innovative and up-to-date assemblages of Impressionist and Post-Impressionist art anywhere. In 1892 Petr Shchukin began to build his museum. The following year Ivan Shchukin[2] settled in Paris using the pseudonym Jean Brochet. He lived in the Avenue Wagram where his elegant apartments were visited by many Russians, including Merezhkovsky, one of the founders of the Russian Symbolist movement, as well as French painters and writers such as Degas, Renoir, Rodin, Redon, the Symbolist critic and novelist J.K. Huysmans and the dealer Durand-Ruel. He was also a friend of the Spanish painter Zuloaga, whose enthusiasm for El Greco he shared.[3] Although Ivan Shchukin sold most of his paintings in 1900, his activities indicate the close link between recent French art and the great merchant family of Moscow. It was a connection that Sergei Shchukin was to exploit to the full with profound consequences for Russian art. The exhibition of French art that opened at the Hermitage Museum in St Petersburg but moved to Moscow in December 1896 can only have confirmed these interests.[4] It included work by Corot, Courbet, Millet, Monet, Renoir and many others. The simple fact that Paris, especially since the International Exhibition of 1889, was considered the capital of art had attracted many Russian artists including Serov and Korovin to travel there. But in the collection that Sergei Shchukin was to amass and subsequently make accessible to painters, the latest Parisian art came to Moscow, provoking heated debate.

Sergei Shchukin's palatial house on Great Znamensky Street in Moscow was to house a spectacular collection. In 1897 he had ordered a Burne-Jones tapestry[5] but in the same year he began to buy paintings by Monet. He added works by Sisley and Pissarro the next year, and in 1899 Monet's *Haystacks at Giverny*.[6] He then responded to Symbolist tastes, acquiring a study by Puvis de Chavannes for his *Poor Fisherman*[7] as well as work by Gaston La Touche,[8] which he purchased at the International Exhibition held in Paris in 1900. By 1903 Sergei Shchukin had begun to buy the works by Gauguin which were to fill his dining room, hanging one against another like ikons in the ikonostasis of a Russian Orthodox church. With his fellow merchant millionaire Morozov he became a passionate and competitive purchaser of the paintings of Gauguin, who had, after all, died only that very year, far from both France and Russia. Shchukin was not alone in his interest in Gauguin. Apart from Morozov, the painter Borisov-Musatov, who studied at the Atelier Cormon in Paris in the 1890s, was an enthusiast for Gauguin, as well as Denis, Ranson, Bernard and Vuillard, all painters linked closely to the school of Pont Aven. Soon, and partly as a result of Shchukin's collection, his enthusiasm for Gauguin was shared by many other Russian painters, including the young Pavel Kuznetsov, Mikhail Larionov and

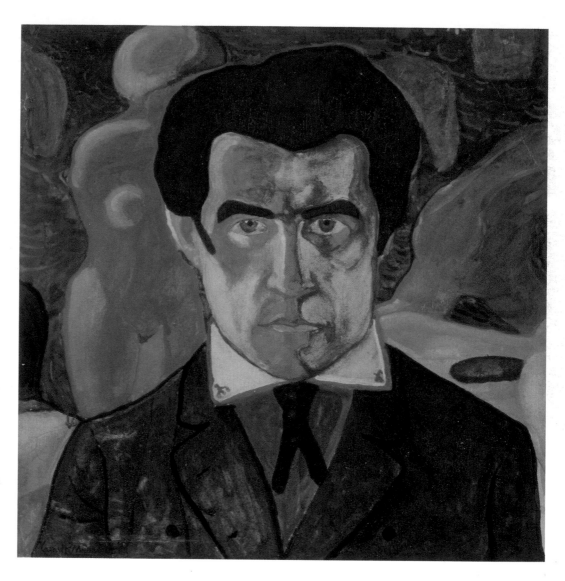

1. Kazimir Malevich *Self-Portrait*, *c.*1909. Gouache on paper. 6 × 6 *vershok*. 26.67 × 26.67 cm (given as 27 × 26.8 cm). Tretyakov Gallery, Moscow: Gift of George Costakis 1977.

Natalya Goncharova. Without this background their development, and even that of Malevich (Plate 1), is unintelligible.

In addition, there were periodicals – especially *Mir iskusstva* (The World of Art), a lavish, decorative and sophisticated international magazine of the arts founded in 1898, to which Diaghilev, the future dynamo of the *Ballets Russes*, Bakst, Benois and other artists contributed discussions of art in Paris and Munich as well as Russia. Diaghilev's International Art Exhibition in 1899 in St Petersburg included Degas, Gustave Moreau and Whistler.

The painter, designer and art historian Alexandre Benois began to take a special interest in the painting and ideas of Maurice Denis, and Benois himself was to paint in Brittany. By the turn of the century Petr Shchukin owned Denis's *Figures in a Spring Landscape (The Sacred Grove)*, which later joined Sergei Shchukin's collection. It was perhaps Maurice Denis more than any other single figure who was to make the links between French Post-Impressionism and art in Moscow absolutely vital. Denis, who knew Gauguin's work intimately, who painted at Pont Aven in Brittany (Plate 2), who discussed religious art, mysticism, number and proportion with Sérusier, who visited the monastery at Beuron,

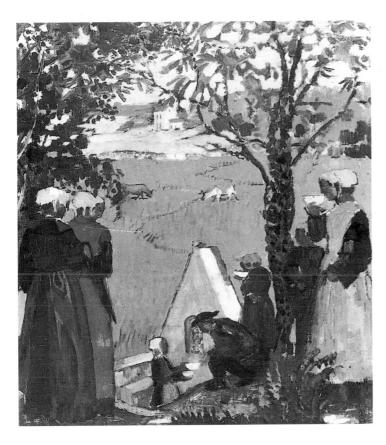

and who was a Nabi and visitor to Ranson's apartment, The Temple, in Montparnasse, was to make a link that changed Russian art.

Alexandre Benois wrote about Denis in *Mir iskusstva*, no. 7, in 1901, illustrating his *Mother* and *Mother and Child*,[9] whilst Denis himself was writing about Sérusier's work which was displayed at that time in the Salon National in Paris: 'At last, M. Sérusier has arrived back with us from Germany where the erudite monks have taught him the sacred measurements — the mathematical formulae of traditional composition — and have preached the example of those marvellous artists steeped in impeccable geometries who were the Egyptians'.[10] At the moment when Sergei Shchukin began to collect works by Gauguin, Sérusier was building his studio at Châteauneuf du Faou in Brittany and decorating it with zodiacal signs and geometric forms. Already in Russia this kind of mysticism was well known. In 1901 Bakst illustrated an article entitled *The Stars* by Vasili Rozanov. He depicted ancient astronomers consulting the stars and their calculations (Plate 3). Bakst framed this scene with an Egyptian sculpture at the left and a Greek sculpture at the right hidden among the oak leaves, which Schuré linked to the Druidic rites of earliest times. Indeed, interest in astrology was as evident in France as in Russia. Paul Flambart, for example, published *Influence astral: Essai d'astrologie experimentale* in 1901, and *Langage astral* in 1902.[11] Mystical journals flourished too in which alchemy, astrology, divination and ancient cults were regularly discussed and promoted. The writings of Charles Howard Hinton on the fourth dimension appealed perhaps to a similar market convinced of another world adjacent to that of conventional perception.[12] There were numerous Russian-French connections in these interests quite apart from the founder of the Theosophical Society, Mme Blavatsky. Valery Bryusov, for example,

2, above left. Maurice Denis *Sacred Spring in Guidel*, 1905. Oil on canvas. 39 × 34.5 cm. Hermitage Museum, St Petersburg. Formerly in the collection of I.A. Morozov.

3, above right. Leon Bakst Illustration for the article 'The Stars' by Vasili Rozanov, 1901. *World of Art*, 1901, no. 7.

visited Paris in 1903, and on 27 March that year he lectured on 'The Keys of the Mysteries' at the Historical Museum in Moscow. This atmosphere of mysticism and exotica both in France and in Russia made the reception to Symbolist art from Rosicrucianism to that of Redon or Gauguin highly sympathetic. Beyond this, the mathematical mysticism of Sérusier, Verkade and even Denis was spreading: Sérusier went so far as to date his letters to Denis in zodiacal horoscope form: ♀ 12 ♋ 3 (Friday 12 July 1903),[13] and Denis visited Verkade at the Beuron monastery where Sérusier had studied proportional systems.[14]

The periodical *Mir iskusstva* introduced Gauguin to the Russian public in 1904, and links between French and Russian arts continued to develop, particularly through the international nature of the Symbolist movement. One such link was embodied in the French poet and journalist René Ghil, who became a correspondent for the Russian Symbolist journal *Vesy* (Libra).[15] *Vesy* discussed Redon and translated Baudelaire and the Belgian Symbolist playwright Maeterlinck into Russian, and it was in *Vesy* that Valery Bryusov published his 'Keys to the Mysteries' in which he describes 'rays of hope . . . brief moments of ecstasy, of supersensitive intuition, which allow other interpretations of the phenomena of our world, penetrating deeper beyond their outer shell to their very core. The fundamental task of art really consists in engraving these brief moments of insight, of inspiration.'[16] In 1905 Bryusov published an article on the Symbolist Odilon Redon in the journal *Vesy*, comprising excerpts from an article by Emile Bernard published in 1904 in *L'Occident*.[17] In 1905 Denis was writing on the sacred mathematics of the Beuron monastery's painters by providing an introduction to Sérusier's translation of *The Beuron Aesthetic* written by its founder, the monk Peter Lenz.[18]

By 1906 the Russian collector Shchukin was systematically buying paintings by Gauguin, whose retrospective memorial exhibition he saw at the Salon d'Automne in Paris that year. Larionov and Kuznetsov also saw the exhibition, as well as the Fauve paintings at the Salon d'Automne. They had travelled to Paris to assist Diaghilev in installing the exhibition 'Two Hundred Years of Russian Art', also at the Salon d'Automne in the Grand Palais. Cézanne was displayed in force there. These exhibitions opened on 6 October 1906. Franco-Russian artistic connections were substantial and immediate. Larionov's month in Paris seeing paintings by Gauguin, Cézanne, Matisse, the Fauves, the Nabis and Symbolists transformed his art.[19] Here he was able to make direct comparisons with Russian art. Multiple personal contacts were established. Benois, for example, met Maurice Denis, who at the start of the year had visited the aging Cézanne at Aix en Provence, himself communicating his search for 'the cylinder and the sphere' in his perception and his art.[20] The year 1906 also marked Sergei Shchukin's first visit to the studio of Matisse, where he bought the still life *Dishes on a Table*.[21] The merchant Mikhail Morozov had also bought work by Gauguin, *Canoe* (*Te Vaa*) of 1896, and *Landscape with Two Goats* (*Tarari Maruru*) of 1897, and Ivan Morozov not only bought Maurice Denis's *Sacred Spring at Guidel* (Plate 2) of 1905, but he actually visited Denis at St Germain-en-Laye, near Paris, where he reserved Denis's *Bacchus and Ariadne* (1906–7, now in the Hermitage Museum, St Petersburg) and commissioned a matching *Polyphemus* (1907, also in the Hermitage Museum). Most important, however, was his commissioning of a major mural series from Denis, *The Story of Psyche*, comprising five large canvases for his home in Moscow.[22]

At this point the fusion of ideas between French and Russian art was sealed. The mathematical, mystical and cosmological interests of French artists were evident in Moscow. It changed Russian painting. The growth of these ideas can now be considered in the framework of art in Russia.

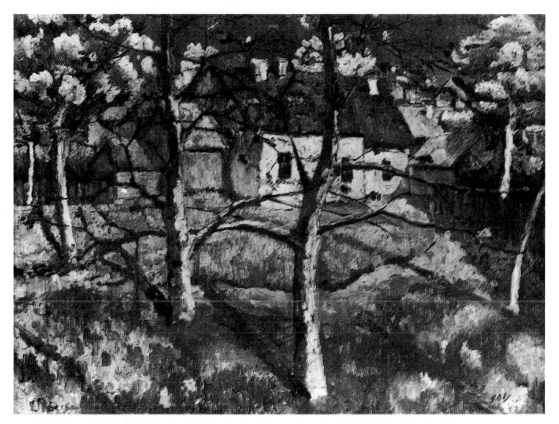

4. Kazimir Malevich *Apple Tree in Blossom*, 1904. Oil on canvas. 12 × 16 *vershok*. 53.34 × 71.12 cm (given as 55 × 70 cm). Russian Museum, St Petersburg.

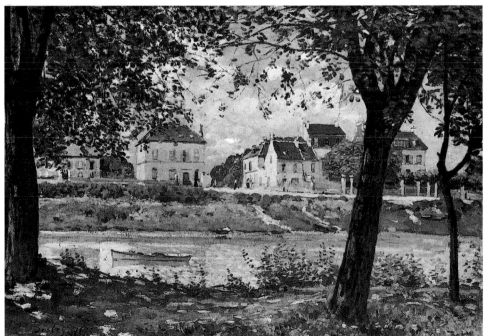

5. Alfred Sisley *Villeneuve-la-Garenne*, 1872. Oil on canvas. 59 × 80 cm. Hermitage Museum, St Petersburg. Formerly in the collection of P.I. Shchukin and subsequently in the collection of S.I. Shchukin.

An early painting by Malevich (Plate 4) shows a spring landscape with houses lit up by strong sunlight. (Malevich seems to have worked outside before 1904.) Its theme sounds like Van Gogh but its technique is a coarse, but decisive, development of Impressionism. In fact, *Apple Trees in Blossom*, of 1904, seems to echo in its pictorial structure the view of Villeneuve-la-Garenne (Plate 5), painted by Sisley in 1872 and which Petr Shchukin

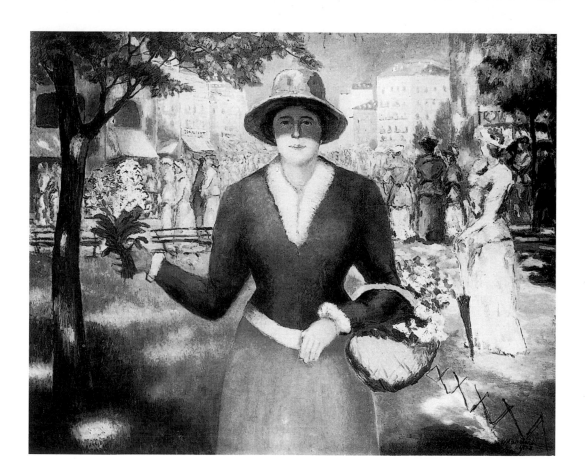

6. Kazimir Malevich
Flowergirl, *c.*1903. Oil
on canvas. 80 × 100 cm.
Russian Museum, St
Petersburg.

acquired from Durand-Ruel in 1898. Both show brightly lit houses seen through a screen
of trees with foliage above and with long shadows across the grass. There are similarities
too in the roofs and angles of the paintings, and they are of a similar size. Kazimir
Malevich was twenty-six years old by 1904 but not really a cosmopolitan figure. He
appears to have attended agricultural college before moving with his family to Kursk in
1896. Details of his early life are difficult to confirm, however, and his paintings are
notoriously unreliably dated.[23] That Malevich responded to Impressionism is beyond
doubt, though, and if this painting does relate to the work that belonged to Petr
Shchukin, it indicates how important such collections were for practising young artists in
Moscow. If the even more gauche *Flowergirl* (Plate 6) dates from this time too, then
clearly Impressionism of a sort was a style to which the young Malevich aspired. He was
able to visit the Morozov and Shchukin collections after his arrival in Moscow in 1904
and the impact of the French example is decisively evident in Malevich's paintings. In the
case of *Flowergirl* the source of inspiration might perhaps be Pissarro's *Place du Théâtre
Français* of 1898, which Petr Shchukin bought from Durand-Ruel the same year, for it
incorporates tall city buildings in the background rather as Malevich was to do some five
or six years later. The elegantly dressed figures strolling through the park recall Renoir's
handling of this theme, although Malevich is unable or unwilling to adopt the sensual
sophistication of Renoir. Finally, the awkward and dominant central figure of *Flowergirl*
seems prefigured in Manet's *Bar at the Folies Bergère*. But what appears to be an awkward
homage to Impressionism is deceptive: the pose is stiffly flat with an arm held out
sideways in a way that precludes any credible reading in depth. The flatness is unlikely to
be incompetence; it is, furthermore, a flatness advocated by Denis and Sérusier and also
exemplified in the work of Gauguin. In Gauguin's *Day of the God* a comparable but

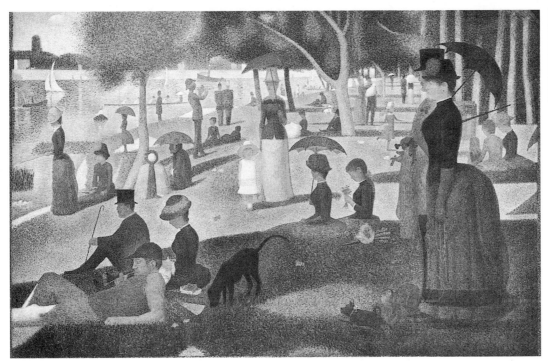

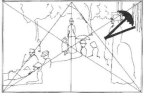

8, above. Diagram of Plate 7, indicating major structural lines and proportions in the composition.

7, left. Georges Seurat *Un Dimanche après-midi à l'Ile de la Grande Jatte*, 1884–86. Oil on canvas. 205 × 308 cm. Art Institute of Chicago: The Helen Birch Bartlett Memorial Collection. Photograph © 1994, Art Institute of Chicago. All rights reserved.

symmetrical pose is adopted by the Moon Goddess. But the painting by Malevich has nothing of the exoticism of Gauguin. It is possible, but unlikely, that the painting by Malevich is a late work, a version of an early work or a reworking of an early work. The technique adopted to paint the distant apartment blocks closely resembles the technique of late works featuring buildings.

Both paintings exemplify qualities characteristic of Malevich. They are crudely direct and vigorously experimental exercises in an adopted style or technique. Their presentation of the image is frontal and they appear to use canvas sizes of simple proportions. *Apple Trees in Blossom* (Plate 4) is roughly 3:4 in proportion; *Flowergirl* (Plate 6) is in the ratio 4:5. It is possible that Malevich is seriously and consciously considering the proportions of his canvases in a way compatible with the approach of Seurat, Sérusier or another source. The forced symmetry of *Flowergirl* divides the canvas equally down the centre and further increases the viewer's awareness of the flat surface rhythms and their proportions in a manner that resembles the compositional strategies of Paul Gauguin. The journal *Mir iskusstva* had recently discussed Gauguin in Russian, but even if the great collectors were only just beginning to turn to Gauguin's painting, artists such as Borisov-Musatov had already been impressed by his example. Borisov-Musatov died only two years after Gauguin but the influence of both Gauguin and the Nabis painters was evident at the memorial exhibition of his work installed by the *Mir iskusstva* in 1906.[24] By that time Diaghilev's Russian exhibition was on display in Paris, Larionov and Kuznetsov were absorbing the whole range of art in Paris at first hand, and Sergei Shchukin was buying several Gauguin paintings each year.[25] A more problematic comparison can be made with Seurat's *Grande Jatte* (Plate 7) of 1884–6 which has a central female figure and a glimpse of contemporary life absent from Gauguin's paintings. At the left of his canvas Seurat introduced two figures whose compositional role is similar to that of the two strolling women in Malevich's *Flowergirl*. Seurat's enormous canvas was a *tour de force* of mathematical subdivision and construction with the parasol at right acting like compasses or dividers to highlight the role of measurement throughout (Plate 8).

French links were especially valued and encouraged by the new periodical *Zolotoe runo*

(The Golden Fleece), founded, edited and published bilingually in French and Russian by the millionaire N.P. Ryabushinsky from 1906 to 1909. This was a periodical which consciously pursued beauty.[26]

From 25 March 1907 Malevich was exhibiting with the Moscow Association of Artists, his first known listing as an exhibitor. The exhibition also included Larionov, Goncharova, David Burlyuk, Aleksandr Shevchenko, Aleksei Morgunov, Yakulov and Kandinsky. This was an alignment of talents that was soon to prove formidable in the development of Russian art. It was because of this exhibition that Malevich met Larionov and Goncharova who were to be a decisive influence upon the direction of his aims and painting.

This exhibition was followed in April 1907 by the opening of the exhibition of the Blue Rose, financed by Nikolai Ryabushinsky and held under the auspices of *Zolotoe runo*. In some ways a Symbolist exhibition, it featured Pavel Kuznetsov who had accompanied Diaghilev and Larionov to Paris a few months earlier, as well as Sapunov, Saryan and others who brought together a sense of rich colour and handling that united Symbolist aims with an approach to the painterliness of Matisse. *Zolotoe runo* dedicated a whole issue to the exhibition in which the critic Makovsky acknowledged their debt to Maurice Denis and Borisov-Musatov. Larionov became co-editor of the art section of the periodical in January 1908.[27]

In the same month the Golden Fleece Salon opened in Moscow and included a large contingent of French paintings by Bonnard, Cézanne, Gauguin, Redon, Signac, Van Gogh and Vuillard as well as Braque, Derain, Gleizes, Le Fauconnier, Metzinger, Matisse and Van Dongen.[28] Every opportunity existed for an immediate and thorough study of recent French art. It could scarcely have been more up-to-date and it was complemented by the purchases of Ivan Morozov (Monet, Cézanne, Derain, Signac) and of Sergei

9, below left. Mikhail Larionov *Rain* (detail), 1907–8. Oil on canvas. 85 × 85 cm. Musée national d'art moderne, Paris.

10, below right. Kazimir Malevich *Self-Portrait*, 1907. Tempera on card. Inscribed on the reverse in Russian 'Study for a fresco painting'. 1 × 1 *arshin* (16 × 16 *vershok*). 71.12 × 71.12 cm (given as 69.3 × 70 cm). Russian Museum, St Petersburg.

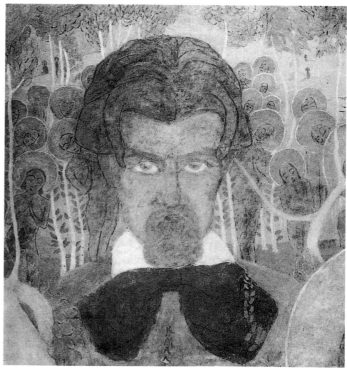

Shchukin (Gauguin and Vuillard). In 1907 alone Ivan Morozov bought three canvases by Gauguin from Vollard including his *Sacred Spring (Nave Nave Moe)* of 1894.[29] There was also his commission from Maurice Denis, who in 1907 was recounting Sérusier's definition of Synthetism: '"Synthesis", said Sérusier, "consists in containing all possible forms within the small number of forms which we are capable of conceiving: straight lines, several angles, arcs of circles and ellipses. Outside of these we become lost in an ocean of varieties." Here is doubtlessly a mathematical conception of art, not lacking in grandeur.'[30]

In the light of this channel of communication it is perhaps appropriate to begin to consider further the mathematical content of new Russian painting. Larionov's painting *Rain* (Plate 9), which Parton credibly dates to 1907–8, is a good example, for it is a substantial painting that is *square*, a rare enough shape for a canvas and not among the traditional proportions for landscape, seascape or portrait, so it must have been deliberately chosen. It is a study in intervals and rhythm formed by the straight vertical lines that divide up the canvas like a screen of water down the glass of a window as a viewer looks out onto a garden. Were it a representation of the four elements, this would clearly represent water. Larionov has chosen a regular geometric shape for a canvas divided by intervals of straight lines. This suggests a clear communication of some of the sacred measurements that so interested Sérusier and Denis. Only a little smaller is a whole suite of Symbolist paintings by Malevich, including a self-portrait (Plate 10), which also use the square format. This is the series painted in tempera on card.[31]

Malevich has now thrown aside any sign of the contemporary life of the streets and fields of the kind that attracted the Impressionists. His painting has already lost the Impressionist freshness of touch that gave a sense of air and space. Instead Malevich, now some twenty-nine years of age, dominates an otherworldly landscape of trees, decoratively and flatly painted. Angels or saints fill the whole band of space in the middle distance; their hands are folded in prayer and their overlapping halos form a rhythmic pattern. This aspect of the painting, so suggestive of Paradise or Heaven, uses something of the patterned rhythm of art nouveau, abundantly available to Malevich through Russian and foreign periodicals, buildings and decorations. Here the artist is caught up in Paradise and not as an incidental figure, for the angels all face the viewer as he does himself. Malevich presents himself, perhaps wryly, as the artistic aesthete with an exaggerated floppy bow to his smock, plentiful hair and a fashionable beard: he is transported to Paradise in his studio clothes. The frontality and symmetry of this self-portrait recalls the tradition that stretches all the way back to Dürer's *Self-Portrait* of 1500, painted at the age of twenty-seven. But Dürer's background was blank and that of Malevich is not. As if to leave the viewer in no doubt of his profession he has signed the painting in a unique way. Beneath the bow, hand-written vertically, are the Russian letters МАЛ (mal). These first three letters of his name suggest also a secondary meaning, as МАЛЯР (malyar) signifies a painter.[32]

At bottom right Malevich includes a fragment of a haloed figure as if to position himself within the throng of angels. This mixing of observed self-portrait and otherworldly religious vision is what characterized Gauguin's work in Brittany. Gauguin's *Self-Portrait with Yellow Christ* is one example among several.[33] Malevich suggests that the painter operates as a visionary mystic employing symbols. His angels or saints occupy a sacred forest directly comparable to those woods and landscapes depicted by Sérusier and Denis (Plate 2) in the Bois d'Amour at Pont Aven in Brittany. The theme is confirmed by other paintings in the series, particularly the painting which Petrova has tentatively entitled *Prayer* (Plate 11). The pose of the single angelic or saintly figure suggests the theme of melancholia depicted much as Sérusier or Gauguin would have done it (Plate 12). The figure is set within a stylized landscape of trees and hills in which the growing

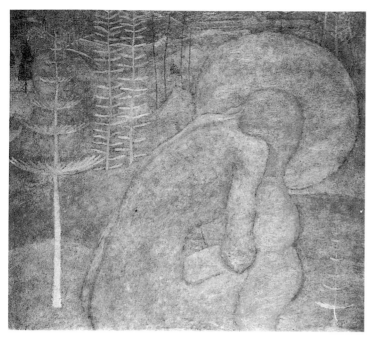

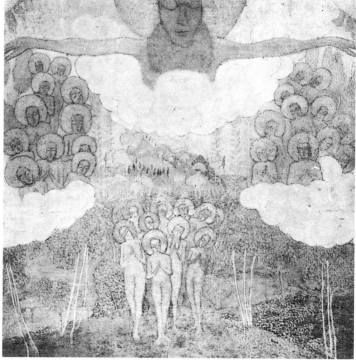

11, above. Kazimir Malevich *Prayer* or *Melancholia*, 1907. Tempera on card. 16 × 17 *vershok*. 71.12 × 75.57 cm (given as 70 × 74.8 cm). Russian Museum, St Petersburg.

12, above right. Paul Gauguin *Human Misery*, 1898–99. Woodcut printed in black on japan paper. Numbered in graphite *16*. 19.4 × 29.5 cm. Art Institute of Chicago: Gift of Frank B. Hubachek © (1947.436). Photograph © 1994, Art Institute of Chicago. All rights reserved.

13, right. Kazimir Malevich *The Triumph of the Heavens*, 1907. Tempera on card. 1 × 1 *arshin* (16 × 16 *vershok*). 71.12 × 71.12 cm (given as 72.5 × 70 cm). Russian Museum, St Petersburg.

plants mark out the mathematical rhythms and relationships often associated with the iconography of melancholia. Here is a painting perhaps conceived as expressive of a state of the soul. The Russian merchant collectors owned several such paintings including Gauguin's *Café at Arles* (with Morozov from 1908), Denis's *Sacred Grove* (with Petr Shchukin from 1900) and Puvis de Chavannes's *Poor Fisherman* (with Sergei Shchukin from 1900).

Other paintings by Malevich in this series are much the same size and share the golden, close-toned colour of these works. They have been described as studies for fresco paintings and this may have emphasized the decorative tendencies that permeate this overwhelmingly luxurious and rapturously golden paradise. If they were for a single

scheme of decoration it is unlikely that the self-portrait could have been included in a church interior. It is more likely to have been an experimental approach to a potential project of this kind executed close to the lavish sense of beauty and the religious exoticism of the Blue Rose painters or the artists of the *Zolotoe runo* (The Golden Fleece).

Symmetry characterizes some of the panels, particularly the *Self-Portrait* (Plate 10) and *The Triumph of the Heavens* (Plate 13), in which the gold and green landscape is dominated by the giant figure in the yellow cloud, an image of Christ in majesty invoking, with some originality, the triumph of the Crucifixion. Whilst it is possible to speculate upon the arrangement of polyptychs or sequences of paintings, this is difficult not least because of the nature of the imagery, which does not follow Christian traditions of iconography closely or consistently. Instead Malevich depicts a paradise and in *The Triumph of the Heavens* some of the figures inhabiting the cloud at the right appear to be closer to Buddhist than to Christian imagery – precisely the blending of religions proposed by the Theosophists Blavatsky and Schuré and precisely the kind of imagery adopted by Ranson, Redon and other Nabis painters. Indeed, the small painting, *The Shroud of Christ* (Plate 14), is unlike anything in Christian art. The image of growth, recurrent in the so-called fresco studies, has here resulted in magnificently decorative and wholly artificial plants that tower like an exotic lotus above Christ's body, dominating with their colour and symmetry the whole painting. The shroud likewise is a florid and jewel-like mass of glowing colour against which the figure appears slight and weightless. There is a hint of Gauguin's otherworldly Tahitian paradise but here the emphasis is everywhere upon flowering effusion and growth, a visionary image of plentitude and vitality which spills from every point except for the stillness of the black halo. There are likewise two black suns, perhaps in sympathetic eclipse, but the sky itself is an unnatural and shimmering mass of scales.

The square format and near symmetry of some of the fresco studies (Plates 10, 11 and 13) brings forward the possibility of mathematical proportions being in play here. The square and circle are essential to any close study of the pictorial possibilities of the Golden

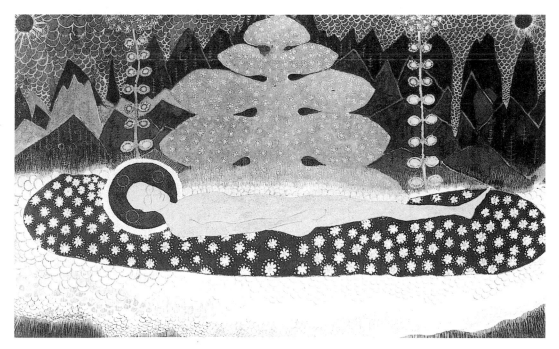

14. Kazimir Malevich *The Shroud of Christ*, 1908. Gouache on card. Signed and dated lower left. 23.4 × 34.3 cm. Tretyakov Gallery, Moscow: Gift of George Costakis 1977.

Section and its diagonal is the square root of 2 (or $\sqrt{2}$) promoted by Sérusier. Any such system of proportions would be much simplified by an underlying grid of squares. As these works are on card they were probably cut to size deliberately: this avoids the issue of standard canvas sizes. What is most significant here is their size, with edges given variously as 69.3, 70, 74.8, 72.5 and 71.5 centimetres. These are all close to 71.12 cm, which in Russia was a significant measurement. Malevich has deliberately cut these pieces of card to the old Russian measure of one *arshin*, the standard measure now obsolete but formerly widely in use in Russia and Turkey, particularly as a measure of materials, including canvas. The *arshin* was to play a vital role in Malevich's development, and the role of mathematics, arithmetic and geometry in Russian art cannot be understood at all without reference to the *arshin*.

For example, the fact that one *arshin* is divided into 16 *vershok* greatly encouraged the subdivision of a canvas or board into 2, 4, 8 and finally 16 squares, each one *vershok* wide. This kept all calculations, as far as possible, in whole numbers and minimized the need for complicated arithmetic. The subsequent adoption of the metric system has wholly obscured this phenomenon by reducing the sizes of all Russian artworks to unremarkable decimal figures that obscure the grander simplicity of their proportions. With some hesitation it is possible to propose that this series on card was painted one *arshin* square in each case. This represents 71.12×71.12 cm. Damage, framing, the vicissitudes of history or plain inaccuracy may cause limited variations of size as given by museums and owners. But in order for proportion to be studied, the scale is also given in this book in *arshin* and *vershok* with measurements in centimetres adjusted accordingly. An analysis of this series in part explains the symmetry of *The Triumph of the Heavens* (Plate 13) in which the diagonals and divisions into quarters and eighths provide all of the main axes as well as the central focus on the green mountain citadel of Paradise that Malevich has painted. Such mathematical relationships, as Sérusier and Denis knew in detail, were an organizing force that promoted generative rhythms resulting in harmony. As in music, in the visual arts harmony was to be understood not as a soporific lack of dynamism but as a proportional system that could generate an infinite number of relationships. The numerical sequence known as the Fibonacci series (see Appendix 1) is one such system. Used in art or design it will ensure that each part relates proportionally to the whole design as well as to its other constituent parts. At any point growth can emerge and harmonious relationships develop. For the painter, sculptor or architect this has long been used as an invaluable approximation to the Golden Section or Divine Proportion, as Sérusier and also Schuré knew, for it too relates the circle to the square and provides a vast array of geometrical relations with ease and clarity. The eye can perceive these relations instinctively, or consciously once they are indicated. Seurat's painting is full of them. Once Malevich's canvases, and those of many contemporaries, are translated into *arshin* and *vershok* their own generative harmonies and sense of proportion appear. This no more explains them away than the octave's existence explains away music, but it clarifies understanding of the paintings and the philosophy behind them. It becomes possible to consider the meaning of this mathematics and geometry in the art of Malevich and his contemporaries.

When Malevich exhibited *Studies for a Fresco Painting* (Plates 11 and 13) at the Moscow Association of Artists in 1908, his world must have seemed close in its themes and appearance to the lavish symbolism and otherworldly decorativeness of the Blue Rose group associated with The Golden Fleece Salon. Malevich must also have shared their enthusiasm for French art and for the Nabis in particular, and their art was rapidly becoming more accessible in Moscow in 1908.

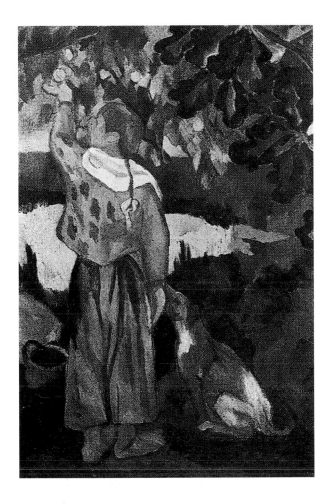

15. Natalya Goncharova *Fruit Harvest*, 1909. Central panel of a triptych. Oil on canvas. 104 × 69 cm. Tretyakov Gallery, Moscow.

Ryabushinsky financed further exhibitions of the Golden Fleece Salon in 1908 and 1909. These were increasingly thorough homages to recent French art. The Salon, which opened at the Khludov Gallery in Rozhdestvenki Street, Moscow, on 5 April 1908, included 197 French works. In the same exhibition as Larionov, Goncharova and Kuznetsov hung works by Pissarro, Degas, Cézanne, Redon, Bonnard, Vuillard, Maillol, Signac, Rodin and Bourdelle. In addition, there were paintings by Matisse, Derain, Marquet, Van Dongen, Rouault, Le Fauconnier and Metzinger.[34] Ryabushinsky had asked the French art critic and theorist Alexandre Mercereau to choose the French works, whilst Maurice Denis and Auguste Rodin were made co-editors of *Zolotoe runo*'s special issue nos. 7–9 (July–September) which illustrated 94 French works of art.[35] The following issue less extensively discussed the Russian painters exhibiting.

Particularly important purchases by Ivan Morozov at this time included the spectacular pair of Van Gogh's *Night Café* and Gauguin's closely related *Café at Arles*, both of 1888, as well as other paintings by Gauguin (*Flowers of France*, 1891 and *At the Foot of the Mountain*, 1892) and paintings by Renoir, Bonnard and Vlaminck. In 1908 Sergei Shchukin bought Van Gogh's *Dr Rey* and Cézanne's *Self-Portrait* as well as Gauguin's *Vairumati Tei Oa* of 1892 and *What, Are You Jealous?* (1892). He was in fact so well stocked with paintings by Gauguin that his celebrated 'ikonostasis' or wall of Gauguins, as already mentioned, now dominated his dining room. It was apparently an overwhelming sight to his many visitors and a distinctly Russian way to hang them. Just how potent the impact was may be seen by making a comparison of Goncharova's triptych *Fruit*

Harvest (Plate 15) of 1908 with Gauguin's *Rupe Rupe*, which dominated the centre of Shchukin's 'ikonostasis' of Gauguins.

Shchukin was an adventurous and extraordinary collector who met Matisse in Paris when they both visited Picasso together.[36] Significantly the *Zolotoe runo* periodical, on the one hand, published extracts from Gauguin's Tahitian notebook *Noa-Noa* in 1909 together with illustrations of his reliefs and ceramics, but on the other hand it illustrated, in issue no. 6, 1909, sixteen paintings by Matisse, including *Harmony in Red* of 1908–9, together with a translation of Matisse's essay *Notes of a Painter* only recently published in France. Both the *Notes* and the title of *Harmony in Red* stress the central role of *harmony* for Matisse.[37] Sérusier and Denis used the term in the same sense. In addition, Matisse had worked with Signac and through him had learnt of the theories, ideas, techniques and paintings of Seurat. Matisse was perfectly placed to understand all of this and his impact in Russia was to be decisive. In the Golden Fleece exhibition of 11 January to 15 February 1909 Russian painters were again exhibiting alongside Denis, Sérusier, Bonnard, Vuillard, Roussel as well as Signac, Cross, Van Rysselberghe and works by Van Gogh, Gauguin and Cézanne. Again, Fauve painters complemented this with Matisse, Derain, Van Dongen, Braque, Marquet and Vlaminck.[38] Russian contributors such as Larionov, Goncharova, Fonvizen and Kuznetsov could not have found a more informative survey in Paris.

At about this time Malevich, well aware of these happenings, made another square *Self-Portrait* (Plate 1), in gouache and quite small at 6 *vershok* (26.67 cm).[39] In view of the Post-Impressionist and Fauve work dominating the *Zolotoe runo* exhibitions and periodical, this *Self-Portrait* might credibly date from 1909–10. There are several elements of the earlier self-portrait (Plate 10) repeated here, which are those Gauguin-like elements, namely the motif of a self-portrait against a painting as in Gauguin's *Self-Portrait with Yellow Christ*. As before, the head and shoulders of the painter dominate the square canvas so that the portrait is substantially symmetrical. But Malevich has removed his beard, reduced his bow to a kind of unobtrusive necktie and, instead of angels or saints behind him, he has bathers. By revising this self-portrait theme Malevich has revealed a shift of allegiance from the otherworldly mysticism of 1907 to the more direct but still idyllic world of the bathers as depicted by Renoir, Cézanne, Bernard and, mostly recently, Matisse. By extending the background painting off the edges of his portrait, Malevich suggests a world of ambiguous reality with perhaps an image of the mental life that preoccupied his creative thoughts in 1909–10. Morozov had a Cézanne *Bathers* by 1910, although by then Sergei Shchukin also had Matisse's recent *Nymph and Satyr*. With more or less precision this is the derivation of Malevich's background scene: it is a sign of artistic allegiance. The mathematics of the square image are again used directly and simply. Divided 6 × 6 *vershok* it precisely fixes, for example, the facial features from chin to eyebrows and from cheek to cheek; in fact the whole face and head fits within the central vertical third of the painting. Diagonals drawn from top corners to bottom centre follow the lines of shirt collars and coat lapels. The frontality adopted by Malevich makes the head and shoulders symmetrical, stressing the T-shape cross made by eyebrows, nose and mouth. It also means that no middle distance exists and that the background canvas falls like a backdrop without any explanation of the distance from head to background painting. This in turn pushes the head forward to make a powerful painting. As its square format is neither vertical nor horizontal, it retains the full energy of its diagonals, which link, for example, the bather upper right and the shoulder low left: the effect is powerful or explosive and its flatness suggests ikons as much as French painting in this dynamic immediacy. If it is like an ikon then it must in essence have a sacred purpose. Gauguin

was not ashamed to adopt the role of Jesus in his paintings, although Malevich clearly prefers to appear an urbane and sophisticated figure where Gauguin wished to appear a savage.

Maurice Denis, who was by now teaching alongside Paul Sérusier at the Académie Ranson in Paris, enthusiastically endorsed geometric systems of proportion in art. 'Without doubt,' wrote Denis in May 1909 'born of architecture, sculpture has conserved for a long time, specifically up to the classical epoque, the sense of geometrical proportions, of expression by measurements, which are oriental and symbolic in origin.'[40] According to Denis, Puvis de Chavannes and Redon 'imitated the Creator who has created everything according to measure, number and weight and who is himself the absolute order.'[41]

By the time this appeared in print, Denis had visited Russia to supervise the installation of his murals commissioned by Ivan Morozov. He became Morozov's friend and adviser. Denis travelled to Moscow in January 1909 and found that 'Everything is white here, silent, little traffic in the streets.'[42] He was impressed by sleigh rides and ikons in the Kremlin cathedrals where, in the Uspensky (Assumption) Cathedral 'the iconostasis is of unbelievable richness . . . There is so much grandeur here.'[43] He was impressed also by Morozov's triumph in acquiring Van Gogh's and Gauguin's versions of the *Café at Arles*. Although Denis listed the names of Russian artists in his *Journal* after seeing their work at the Tretyakov Gallery, little seems to have impressed him except by reference to French example. Vrubel he considered 'a kind of Gustave Moreau influenced by Böcklin', Serov was 'a pupil of Besnard'. At the Golden Fleece exhibition Denis found Milioti an 'imitation of Ranson',[44] and when he visited St Petersburg, where he was received by Diaghilev and Benois, he saw paintings by Venetsianov that he considered to be 'a singular mixture of Léopold Robert, Courbet and Degas'.[45]

Denis was, however, impressed by Sergei Shchukin's collection in his house on Znamenka Lane in Moscow: 'In the Dining Room . . . a large Burne-Jones tapestry and two rows of Gauguin in Tahiti, shouting yellows, oriental carpets and an old Matisse, and two Cézannes . . . a Matisse room and one for Van Gogh'.[46] There were in fact sixteen Gauguins in the dining room, to which Shchukin was to add Matisse's *Harmony in Red* of 1908–9. Shchukin was now adventurously buying paintings by Matisse and Picasso. It was in 1909 that he commissioned the great canvases *Dance* and *Music* direct from Matisse.[47]

The impact of all of this on Russian artists was enormous. Denis's article 'De Gauguin et de Van Gogh au Classicisme', published in May 1909 in Paris, appeared almost simultaneously in *Zolotoe runo* in Russia where it was studied by Larionov.[48] Also published were illustrations of Gauguin's wood carvings and the translation of Charles Morice's article on Gauguin's sculpture.[49] Larionov's work appeared meanwhile in the periodical *Vesy* (Libra).[50]

Paris addressed itself to the world. There was a 'depth of movement' (*Mouvement profondeur*) between Paris and Moscow in particular. These words, inscribed by Robert Delaunay on one of his images of the Eiffel Tower painted in 1909, sum up something of the dynamism of that relationship.[51] Now that the *Ballets Russes* had opened in Paris (in May and June 1909) it was a two-way dialogue. Malevich, drawn ineluctably into the circle of Larionov and Goncharova, shared their enthusiasm. Mystical themes embedded in the life of the peasantry, and painted with decorative and powerful colour reflecting primitive local carving and painting, were aspects as evident in the Breton paintings of Gauguin as in the paintings soon to emerge from Larionov, Goncharova and Malevich. All of this became part of a new world view requiring its own response to circumstance

16. Alchemical illustration from Johann Daniel Mylius's *Philosophia reformata*, Frankfort 1622.

and opportunity. Ultimately it demanded a rigorous examination of the plethora of styles now presented to Russian artists. To develop something authentic demanded a reconciliation of Russian and Western concerns. One field in which this occurred was in the mystical interpretation of mathematics.

Five years previous to these events, in 1904, the outbreak of the Russo-Japanese war led to the sinking of the Russian fleet at the battle of Tsushima in 1905. The poet, Velimir Khlebnikov, a friend of Larionov, was making his first visit to Moscow. So impressed was he by the naval disaster that he determined to discover 'the mathematical laws of history'.[52] This was perhaps not a new idea. Recent Theosophical writings by Blavatsky, Schuré and others had suggested that some great and divine plan exists through and beyond history, partially realized by the prophets of different ages and through reincarnation. In the fashionably mystical worlds of *fin-de-siècle* France and Russia such theories held the attention of many. Even materialists seemed to believe in development and evolution. At the opposite extreme Rosicrucians embraced a wide range of occult lore in which divination, astrology and alchemy played a part (Plate 16). The modern city was often compared to Babel and talk of decadence became as fashionable as belief in progress. Mediums were much in demand.

One medium who was also an artist was the Bohemian painter and printmaker František Kupka, who was already making visionary prints about the mysteries of the universe by 1900.[53] His imagery of the Egyptian sphinx (Plate 17) and astrology recalls Schuré and Péladan. It evokes a world beyond the passage of time but somehow *containing* time. Kupka was in Paris and in contact with the painter Jacques Villon in 1903 when he began work on illustrations for Reclus's six-volume book *L'Homme et la terre*.[54] One of Kupka's designs, the *Divisions and Rhythms of History* (Plate 18), precisely illustrated the theme preoccupying the Russian poet Khlebnikov. Khlebnikov had, however, trained as a mathematician at the University of Kazan, where he also began to take an interest in non-Euclidean mathematics through a study of the Russian mathematician Lobachevsky. It should also be remembered that the long-running discussion of the fourth dimension frequently involved theories of time.[55] For example, a certain D.C. Hinton's *The Fourth Dimension*, published in 1904 in New York, discussed Pythagoras and the theorem named after him at some length, explaining how *shearing* could undermine the familiar Euclidean form of the theorem to make the sheared square on the hypotenuse equal the difference of the squares on the other two sides. But Hinton also discussed Lobachevsky and the possible geometry of the fourth dimension. To evoke an idea of the fourth dimension, he reverts to the idea of a point, line and plane each involving the relation of space to a higher space. (H.G. Wells had touched upon this in *The Time Machine* in 1895.) He concluded that 'the higher cube passing through three-dimensional space will appear a cube', for this is the cross-section of a four-dimensional cube just as a square plane is the cross-section of a three-dimensional cube. The perceived world, suggests Hinton, is no more than our limited three-dimensional view of higher space: we see only cross-sections of the higher world as if they were shadows or shapes upon a screen. This implies that the past and future in some way exist with a shape that can be studied and discerned. It brings Khlebnikov and Hinton onto common ground in their interests in the relation of time, space and dimensions and also in their mutual interest in Lobachevsky and other non-Euclidean mathematicians. This common mathematical ground was in a sense the search for an appropriate cosmology.

There followed in Russia the abortive political uprisings and repressions of the 1905 Revolution and a growing sense of anxiety about the future, the possible form of which

seemed too precarious and difficult to predict with any confidence. The book *Cosmic Consciousness* by Maurice Bucke, published in 1905, investigated comparable ideas and had certainly been seen by Khlebnikov by 1919, and may in fact have become known to him soon after its publication.[56] Furthermore, in Paris Apollinaire and artists of his acquaintance were also considering questions of cosmology. Apollinaire described René Arcos, a writer of the Abbaye de Creteil circle, as 'a cosmogonic who perceives the movement of the spheres and who floats in ecstasy among the nebulae'.[57] The painter Gleizes was associated with this group as well, which also published Jules Romains's 'Vie unanime' in Barzun's *La Terrestre Tragédie* in 1907.[58] Likewise, Apollinaire, perhaps following Schuré's discussion of Orpheus or simply the Symbolists' (or Gustave Moreau's) Orphic imagery, was writing *Le Bestiaire ou Marchande de quatre saisons* in 1907, published as the *Cortège d'Orphée* in 1910. Apollinaire, like Schuré, discussed Orpheus and Hermes Trismegistus.[59] He was soon to apply the terms Orphic and Hermetic Cubism to the work of painters he knew: this signified the painterly followers of Orpheus and of Hermes. The mystical system was to be an element in Cubism and complemented by the Section d'Or (Golden Section) group which formed around Duchamp and others. In both France and Russia Schuré continued to be influential. There were, as we have seen, many links by 1909. These were extended vastly in the years before the war when Paris was at its most daring and international, and when contacts with Russia were most numerous. The painter Alexandra Exter became part of this exchange, as did Robert and Sonia Delaunay,[60] whilst Denis and Sérusier were teaching at the Académie Ranson, which had been founded in Montparnasse in 1908. As Denis recalled, Sérusier 'used the laws of mathematical construction before the pioneering cubists. Sérusier spoke of angles and numerical relationships to one of his pupils who soon transposed natural forms geometrically and harmoniously to become one of the most delicate champions of French cubism. That was Roger de La Fresnaye.'[61] Here Sérusier kept in play, right through the high period of Cubism, the two palettes (warm and cold), the theories of harmony and mathematics, and behind it all the spiritualism and mysticism that Gauguin and Schuré had sparked off in him in the later 1880s.

17, above left. František Kupka *Quam ad causam sumus* (or *The Way of Silence*), 1900. Etching with aquatint. 34.7 × 34.8 cm. Národní Galerie, Prague.

18, above right. František Kupka *Divisions and Rhythms of History*, c.1905. Illustration for Elisée Reclus's *L'Homme et la terre*, Paris, 1905–8. Chinese ink heightened with white gouache. 31 × 38.6 cm. Národní Galerie, Prague.

19. Mikalojus K. Č iurlionis
*Sonata No. 6 (Sonata of the
Stars): Andante*, 1908.
Tempera on paper. 73.5 ×
62.5 cm. Mikalojus K.
Č iurlionis State Art
Museum, Kaunas.

In Russia, and internationally, the somewhat distinct theories of Theosophical evolution and the debated theories of the fourth dimension were brought together by the Theosophist and mystic Peter Ouspensky, whose book *The Fourth Dimension*, published in St Petersburg in 1909, revealed a clear debt to the writings of both Hinton and Schuré. His influence was to develop enormously and internationally in the next four years. His vision of a world beyond appearances was perhaps depicted by the Lithuanian composer and painter Mikalojus Čiurlionis, whose *Sonata of the Stars: Andante* (Plate 19) of 1908 has evocations of ancient Egypt, of angels, of planetary growth and the flow of time against a glimpse of eternity in the immovable fixed stars. His painting could scarcely be closer to the mysticism exemplified by Blavatsky, Schuré and Ouspensky. His imagery was close to the otherworldly mysticism of Malevich's *Shroud of Christ* of 1908. Here was geometry, mysticism, proportion and the flow of time linking ancient Egypt with the mathematics of the universe and the mathematics of the canvas.[62]

Bathers and Peasants

The bathers glimpsed in Malevich's *Self-Portrait* (Plate 1) emerged into prominence in 1910–11. Iconographically, the theme of bathers remains mysterious. In Cézanne's case, bathers inhabit a luminous landscape, a version of the south of France, steeped in hard and brilliant light. As this encompasses the anonymous bathers they appear to be part of the landscape as well as a miraculous extrusion from it. Cézanne's compositional vigour locks bathers and landscape into a single pictorial structure: they belong together. The merchant and collector Ivan Morozov bought one of Cézanne's paintings of bathers in 1910, and so Cézanne's theme was from that time available in Russia for close inspection.

After Cézanne's death in 1906, his work was increasingly seen in Paris where it excited Picasso and Matisse (among others) enough for them to adopt the bathers theme. It was these examples which by their force and energy impressed Malevich and his contemporaries. Picasso's monumental painting *The Dryad* (Plate 20), for example, lurches forward from a timeless forest, the human figure reordered, partly perhaps with an eye to African carvings. *The Dryad* overturned conventional canons of beauty in many ways but not least by its proportions. Since at least 1906 Picasso had been studying new rhythmic proportions for the figure.[1] Artists in an earlier age sometimes used Adam and Eve for this purpose on the assumption that, as God made them perfect, they provided a good subject to embody harmonious relations and ideal form. Picasso's *dryad* is, however, large, overtly forceful and crude as she emerges from an earthy forest glade. She has none of the poise, for example, of the figure in Dürer's *Eve*.[2] Like the bathers of Cézanne she is part of her landscape, but she has lost the blue shimmer of Cézanne to become a monumental and primeval force of an altogether earthier nature.

The case with Matisse in Russia is more complex and altogether closer to the territory already established by Gauguin, Sérusier and Denis. Sergei Shchukin commissioned Matisse for the two 13-foot panels of *Dance* and *Music*, and in October 1911 Matisse travelled to St Petersburg and then on to Moscow to inspect their installation. Whilst there he supervised the hanging of twenty-one of his paintings in a 'Matisse room'. These included still lifes but also the *Game of Bowls* of 1908 and the arcadian scene, already so like a bathers theme, of the *Nymph and Satyr* of 1909. The Dionysian energy of *Dance*, of 1909–10, had been badly received in Paris. Yet Matisse's reduction of the landscape and figures into the most economical and dynamic relationship evoked that wild and sensual past adumbrated in Matisse's own *Joie de vivre* and was as elemental in its way as Picasso's *Dryad*, also in Shchukin's collection.[3] Larionov was just one of the painters and admirers that Matisse met in Moscow.[4] If Matisse's themes in *Dance* and *Music* are considered in relation to the Theosophist Schuré's discussion of the ancient cults of Dionysus and of Orpheus, this highlights their elemental quality, which lifts them from the here and now into a formalized, schematic and almost diagrammatic landscape. This fusion of ideas and techniques was, if anything, gaining in power and not fading. In Moscow the paintings of Cézanne, Picasso and Matisse provided images of an archetypal world of mankind within nature, part of nature and in harmony with nature. In addition, Matisse knew of Seurat's harmonic and expressive proportions, lines and directions

20. Pablo Picasso *Dryad*, 1908. Oil on canvas. 185 × 108 cm. Hermitage Museum, St Petersburg (formerly S.I. Shchukin Collection).

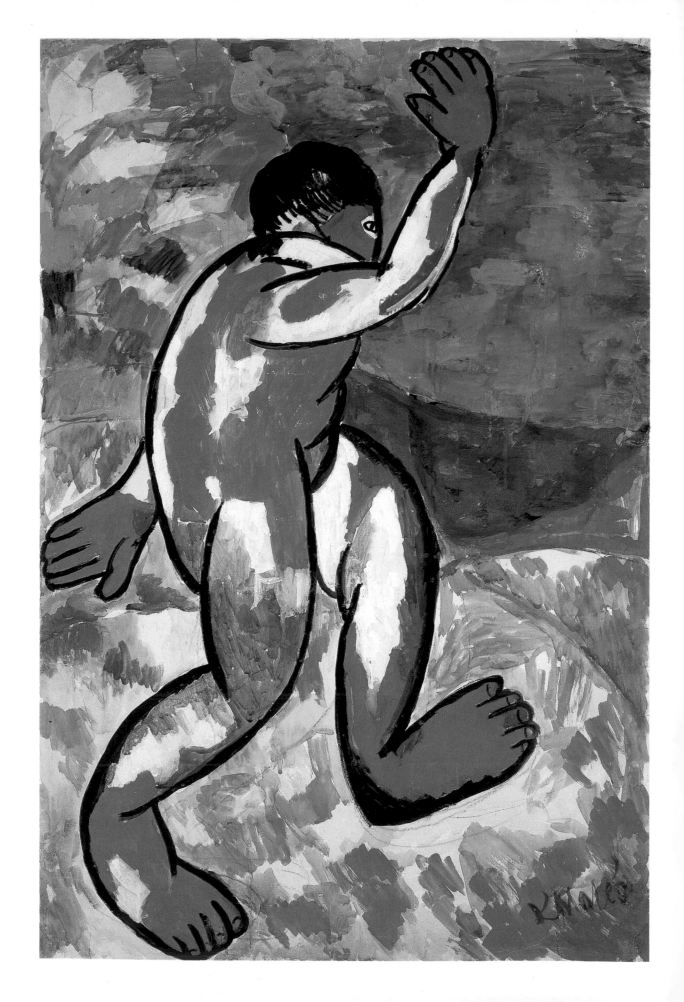

through his close contact with Signac, whose book *D'Eugène Delacroix au Néo-Impressionisme* was published in Russian in 1912.[5] Matisse, aware of the Russian home of these paintings, can only have been made more aware of Russian dance and music by the performances of the *Ballets Russes* in Paris, including productions of the exotic *Schéhérazade* (June 1910, Rimsky-Korsakov, decor by Bakst), *Les Orientales* also in the 1910 season (decor by Korovin and Bakst), and Stravinsky's *Firebird* (June 1910, decor by Aleksandr Golovin). What was perhaps both overwhelming and deceptive about Matisse's two mural-scale paintings for Shchukin was his apparent directness of execution and the simplicity that he achieved, but as his numerous studies reveal this was only achieved by forethought and efficient editing of his compositions.

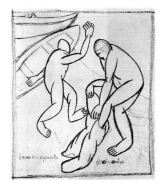

22. Kazimir Malevich *Bathers*, 1910–11. Pencil on paper. Inscribed lower left, 'running to bathe', and lower right, 'dressing'. 20.4 × 15.8 cm. Russian Museum, St Petersburg (acquired 1928).

21, opposite page. Kazimir Malevich *Bather*, 1911. Gouache on paper. 24 × 16 *vershok* (1½ × 1 arshin). 106.68 × 71.12 cm (given as 105 × 69 cm). Stedelijk Museum, Amsterdam.

Malevich's response was immediately evident. He was closest to Matisse in *Bather* (Plate 21) of 1911; its subject, simplification and dynamic energy, new to Malevich, make 1911 a credible date. At the First Moscow Salon, held that year, he included several series of paintings including the mystical square paintings of his *Yellow Series*, multifigure paintings of his *White Series* and bathers in the *Red Series*. The painting of a running bather is executed with great immediacy in gouache on paper. A pencil drawing (Plate 22) reveals a more elaborate composition with rowing boats, which suggests that Malevich either then reduced his composition to the single bather or that the large gouache is a study for a larger composition. The drawing has in fact more signs of contemporary life about it, particularly the rowing boats, which were subjects previously adopted by Monet and Renoir. By contrast, the large gouache shows a beach scene edited ruthlessly to leave just a few elements built up from curves, rather like the landscape in Matisse's *Dance*. In addition, Malevich gives his bather a wild aspect. The naked figure rushes to the ocean with complete abandon, leaving behind all trace of clothing and with it contemporary life and civilization. Man, land and water meet here in an elemental encounter. Malevich has constructed his figure with curves that directly recall those used by Matisse to giving circling, continuous rhythm to the bodies of his wildly dancing figures in *Dance*, yet Malevich uses cruder curves and a less co-ordinated movement down along the shore to the water. In the drawing the poise of the other bather is achieved only with extreme and awkward proportions which, for example, result in the nearer, raised leg becoming much smaller than the more distant standing leg. The wholly flat and flipper-like hands of his bathers Malevich has perhaps developed from Picasso's *Dryad*, whose wild inelegance these figures to some degree share. The drawing by Malevich is crossed by a thin, clear horizontal line below the half-way point, and also a thin vertical line at left where it almost touches the bather's hand. These suggest editing of the image and they correspond closely to the position of the figure in relation to the edges of the painting in the large gouache. Although the gouache is freely brushed in, preliminary drawing is visible so that proportions and position were obviously worked out in advance. There are also indications of an underlying grid of squares which can be detected passing horizontally through the instep of the foot lower left and through the thighs. Vertical lines pass up from the point of the toe lower left up through the thigh to touch the back of the head. A second vertical line passes through the foot and hand to the right of centre. The vertical lines mark off thirds across the gouache which can be further subdivided into sixths of the width. The horizontals fit the same proportions to mark out a grid of 9 × 6 squares, in the ratio 3:2 with an overall size of 1½ × 1 *arshin*.

Gauguin had set an important and provocative precedent for the redesign of the human figure, but his figures were exotic bathers, the anonymous inhabitants of a far-off and ideal world. The bathers of Cézanne and Matisse, the *Dryad* of Picasso, all share

something of this remote and idyllic quality which Malevich here adopts in his own sequence of bathers, stressing their timeless qualities and providing a vague, ideal setting for his reconstruction of the figure. The Universal Exhibition in Paris in 1889 had shown Gauguin artifacts from many cultures, so that even when he was working in Tahiti Gauguin employed poses, proportions and forms of figures from ancient Egypt and from Buddhist friezes to construct figures for his Tahitian themes. Such eclectic archaism was a feature of Picasso's painting from 1906. Despite its historicism, it provided the means for a new examination of the image of the figure: both Matisse and Picasso in fact cited poses from Ingres even when they were radically reapportioning the figure. But its exotic borrowings could also be understood in the more esoteric terms promoted by mystics including Blavatsky, Schuré, Péladan and, more recently, by the critic Alexandre Mercereau, whose writings on Matisse were published in Russia. He became a founder member of the International Society for Psychical Research in 1911,[6] but he was also a member of the Puteaux group of Cubist artists gathering in Paris in 1911. Associated with this group were Roger de La Fresnaye, who had studied Sérusier's mathematical, and perhaps also his mystical, theories at first hand, the painters Gleizes and Metzinger, associates of the Abbaye de Creteil, and Robert and Sonia Delaunay. As Sonia Delaunay was Russian, she provided an invaluable link between Russian and French artists in Paris in this period. The brothers Jacques Villon, Marcel Duchamp and Raymond Duchamp-Villon were central to the Puteaux group. Duchamp's *Paradise* of 1911 includes Adam and Eve; the theme was also tackled in the same year by his associate, Francis Picabia. The Puteaux group discussed Seurat, Leonardo's *Treatise on Painting*,[7] the philosophy of Bergson and non-Euclidean geometry.[8] When they became active as an exhibiting group, they adopted the significant title of 'La Section d'Or' or the Golden Section, the Divine Proportion. Alexandra Exter and Alexander Archipenko were among their exhibitors.[9] As the poet and critic Apollinaire noted, this was a 'new salon whose name is borrowed from antiquity's Measure of Beauty'.[10]

The mysticism that characterized the Puteaux group and Section d'Or painters has been underestimated. Geometry for these thinkers is related to a revision of Renaissance systems of proportion and perspective so that these concepts can be redesigned for their own time. The internationalism of great exhibitions, museums, publishing and travel meant that customs and cultural artifacts that differed widely in time and space were now frequently compared and considered side by side. Kupka, for example, included Indian religions, telepathy, alchemy, astrology and spiritualism among his interests as he sought 'a correspondence between the general activity of the universe and the psychic and cerebral activity of man'.[11] Robert Delaunay similarly sought a harmony between the cosmos and the individual, paraphrasing Leonardo da Vinci in this context: 'our soul exists in a state of harmony, and harmony is only engendered by the simultaneity with which the measure and proportions of light arrive through our eyes to our soul.'[12]

André Salmon, a critic associated with the Puteaux group, wrote about Picasso's 'metaphysical acrobats, ballerinas like maids of Diana, enchanting clowns and Trismegisturian harlequins'.[13] 'Those,' he wrote, 'who see in the work of Picasso the marks of the occult, of the symbol or of the mystic are in great danger of never understanding it.' He explains: 'By these means he wished to give us a total representation of man and of things. Such is the accomplishment of the barbarian image makers.'[14] For Salmon, Picasso was 'an alchemist prince',[15] perhaps because he shared with alchemists the aim of a complete world view, an image relating man to the cosmos of the kind illustrated in the alchemical literature of the past – for example, in the book by the seventeenth-century Rosicrucian, Robert Fludd, whose beautifully illustrated *Utriusque cosmi majoris et*

minoris historia (The History of Both the Greater and Lesser Cosmos) seems to have been known to the writer and traveller Blaise Cendrars.[16] Cendrars was in turn a close associate of both the Delaunays and Chagall at this time and he was in Russia from April to November 1911. The fusion of a geometrical system of harmony or proportion and perspective, with a mystical attempt to derive from this an overall image of man's place in the universe, was precisely the task of the alchemist who took his clue from Pythagoras in the identification of number with the elements of divine creation. Interest in such modes of thought was encouraged by the comparative studies and related mysticism of the Theosophical Society, which by 1911–12 was vigorous in Russia and highly active internationally. At this time Peter Ouspensky was among its most successful, popular and lively writers. His studies included, for example, tarot cards, which he asserted originated in an Egyptian source in the library of Alexandria and which he called 'a philosophical machine . . . a philosophical abacus'.[17] He related and compared the mystical systems of alchemy, magic, astrology and the cabala, and he related the tarot card pack to the modern pack of cards. Ouspensky held the Theosophical belief in a mystical tradition surviving from Hermes Trismegistus via Pythagoras to the present. He published his most significant and influential book in St Petersburg in 1911: this was *Tertium Organum: A Key to the Mysteries of the Universe*, which attempts to incorporate recent mathematical speculation concerning non-Euclidean geometry and also the fourth dimension into the Theosophical system of thought.[18] This robust and highly readable text outlines an image of man's place in the universe. It seeks to define the framework within which time and space find their being: it leads Ouspensky to argue that the future can influence the past. Like Hinton, whose work he discusses, Ouspensky imagines time as a development of space in a higher dimension: from this position it becomes feasible that in a higher dimension future time is already in some way in existence. Kandinsky's text *Concerning the Spiritual in Art* discusses comparable concerns,[19] whilst in the writings of Larionov's friend, the poet Velimir Khlebnikov, there are recurrent signs of a comparable search for the mathematical laws of history. He wrote to his sister, the painter Vera Khlebnikova, in 1911, for example, saying: 'I am working on numbers. They keep fascinating me all over again.'[20] Such mystical and cosmic concerns are even reflected in the ballet *Petrushka* by Stravinsky and Benois, performed by Diaghilev's *Ballets Russes* in Paris in June 1911, in the scene where the puppet Petrushka is in his room with the night sky for walls.

On 4 December 1911 the Union of Youth exhibition opened in St Petersburg. Titles of works exhibited by David Burlyuk in particular reveal the archaism of Theosophical thinking. Exhibit no. 9, for example, was *Portrait of a Student (Turkish Style)*, while exhibit no. 10 was produced using 'the Assyrian Method'. The fourth dimension was not mentioned, but Burlyuk did introduce four viewpoints permitting the painting to be viewed from four sides: this was no. 7, *Moments of the Decomposition of Surfaces and Elements of Wind and Evening Introduced in a Marine Landscape (Odessa), Represented from Four Points of View*. The composer-painter Mikhail Matyushin exhibited landscapes but also tree branches presented as figurative sculptures.[21] The catalogue also lists six titled works and six 'sketches' by Malevich. What characterized the titled works was a focus on peasant themes and rural life in *The Harvest*,[22] *Peasant Funeral*, *Woodcutter*, *In the Field* and *The Carpenter*. Here is a shift from the theme of the bather, which was in essence potentially remote and idyllic. Malevich now set his figures in a distinctly Russian peasant context whilst confidently pursuing the reorganization of the figure along primitive lines. Gauguin's love of the primitive in Brittany and later in Tahiti again provides the immediate precedent, and examples of this were abundantly accessible in Moscow.

23. Kazimir Malevich *The Harvest*, 1910–11. Pen on paper. 9.2 × 14 cm. Russian Museum, St Petersburg.

The Harvest (Plate 23) and the missing *Peasant Funeral* are large multifigure compositions and reflect the example of Natalya Goncharova, whose exhibits included *Grape Gathering* and *Woodcutters*.[23] Malevich's theme has more antecedents: the peasant gathering in the harvest was a characteristic motif in Breton paintings by Gauguin, Sérusier, Denis, Bernard and their circle. Malevich flattened out his figures rhythmically in a shallow space, but so had Pont-Aven painters before him.

The lost *Peasant Funeral* was a second attempt at a major figure composition, for which several studies exist. In this large and imposing painting, tall peasant figures, stretching from the top of the canvas to the bottom, progress from left to right. There are at least twelve full-size figures and two children in the procession. At far right two peasants hold wooden beams that presumably support the coffin, which is out of sight. What dominates the painting is the procession itself. In its solemnity, its theme and even in its shallow frieze-like composition this painting recalls Courbet's *Burial at Ornans*, now in the Musée d'Orsay, Paris. The vertical repetition of figures forms a dirge-like rhythm across the canvas. If Malevich's theme represents a genre-scene, that is if it simply illustrates peasant customs and life style, then it is reminiscent of the painter Venetsianov, of Courbet and of paintings by the Wanderers: it is essentially reportage. But if its theme is death or superstition, then this perhaps shows a different attitude and an interest in the religious life of the peasantry within the Russian countryside. This would be a strategy closer to Gauguin, to Sérusier and to Denis. They were willing to focus upon religious imagery and to use religious iconography whilst adopting the visual devices of the region itself. Gauguin's *Yellow Christ* is an example of this. Gauguin showed the Crucifixion in a Breton setting, but he also adopted the unusual proportions of the crucifix which hung locally in the church at nearby Trémalo in Brittany. Malevich is clearly adopting this second strategy (Plate 28). His figures are locked into their own culture and the way that Malevich has proportioned the bodies and drawn the heads is a stylization taken from folk art and, perhaps, from ikons. The gouache studies of single heads (Plate 24) show Malevich maximizing the intensity of facial expression by giving the face a mask-like simplicity dominated by large almond-shaped eyes. The two surviving studies show a development of the direct painting technique of Malevich from softer modelling to the

establishment of separate planes with clear, hard edges and firm drawing. The larger of these studies (Plate 24) is square and the smaller gouache study is almost square. The large canvas itself is a double square, the diagonal of which is closely identified with the Golden Section.

A drawing exists (Plate 25) that suggests that Malevich may have been considering a frieze or triptych fairly closely based upon Courbet's composition. The drawing depicts the scene of a burial with a gravedigger right of centre and a mass of mourners visible behind the grave and facing the viewer. At right one peasant woman is clearly drawn in greater detail. She represents a new ideal figure in her proportions and the viewpoint

24. Kazimir Malevich *Study of a Peasant*, 1911. Gouache on card. 6 × 7 *vershok*. 26.67 × 31.12 cm (given as 26.7 × 32 cm). Centre Georges Pompidou, Paris (formerly Kandinsky Collection).

25. Kazimir Malevich *Burial*, c.1911. Crayon on paper. 18.5 × 28 cm. Private collection.

25

26. Kazimir Malevich *Peasant Women in Church*, 1911–12. Pencil on paper. 21.9 × 18.4 cm. Russian Museum, St Petersburg (acquired from the L. Zheverzheev Collection 1928).

27. Kazimir Malevich *Peasant Women in Church*, 1911. Oil on canvas. On the verso is painted *The Woodcutter* (Plate 56). 6 × 6 *vershok*. 75 × 97.5 cm. Stedelijk Museum, Amsterdam (acquired from Hugo Häring 1958).

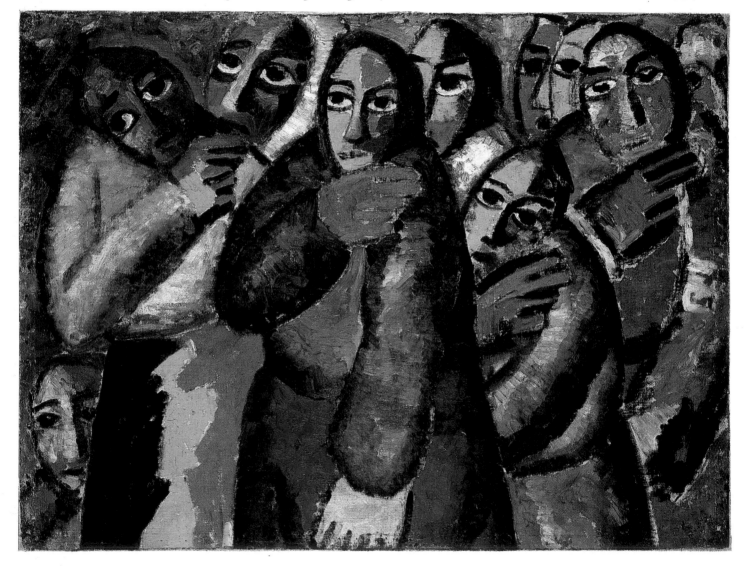

from which she is depicted, rather in the manner of the profile and front views of figures in Seurat's *Poseuses* or in Picasso's *Dutch Girls* of 1906. Clearly this drawing recalls Courbet's enormous composition, but by contrast Malevich's protagonists perform their duties against a background of devout figures. The ambience is closer to Gauguin in Pont-Aven: Malevich is a less dispassionate observer than Courbet, for whom the theme of burial seemed to be no more than one of life's mundane activities. The frontal figures sketched in by Malevich in this drawing recall his own paintings of saints in Paradise. For Malevich, as for Gauguin and, of course, for Theosophists, the theme of death has mystical and religious meanings. Malevich's drawing indicates that the onlookers attending the burial have a hand across their chest as a sign of respect or as an indication of crossing themselves during the service. This is made more explicit in another drawing (Plate 26) perhaps related to the figures at the right of the project to paint the burial theme. Here every woman crosses herself. Precisely this gesture dominates a canvas study (Plate 27) which reproduces the top half of the composition defined in this drawing. Such piety set within scenes of peasant life and landscape was precisely the theme of Gauguin's *Vision after the Sermon* to which Malevich referred in the composition of a contemporary drawing (Plate 28). But as the study makes clear in the stylized heads that Malevich crowds together top right (Plate 26), Picasso remains an immediate inspiration for the new proportions of the figure.

Here we see Malevich ambitiously exploring the theme of death, devotion and belief. He is confidently determined to develop a new vision of the peasant figure based upon Russian sources of folk art and ikon painting. Gauguin, Picasso and, most immediately, Goncharova all encouraged these developments, which reveal Malevich as a painter of tenacity and strength.

A drawing of the head of a praying woman (Plate 29) shows a high degree of refinement in this process. This whole subject generated ideas for Malevich. It enabled him to tackle major themes, complex compositions and to redesign the human figure with reference to the ideals of both the East and the West. Each subject was capable of further development. In plate 29, for example, Malevich was close to a format derived from Russian ikons that depict the head of Christ or the Virgin Mary. The squarish

28, below left. Kazimir Malevich *Golgotha*, *c.*1911–12. Crayon on paper. 22 × 21 cm. Collection Ludwig, Cologne.

29, below right. Kazimir Malevich *Woman in Prayer*, 1911–12. Pencil on paper. 18.6 × 14.2 cm. Russian Museum, St Petersburg (acquired from the I. Zheverzheev Collection 1928).

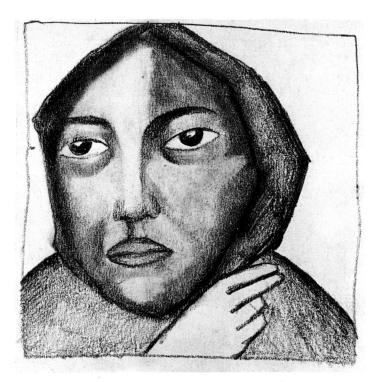

format, the devotional aspect and the stylization of the head produce an intense and otherworldly image. The forceful directness, which he once employed to depict his own face, has now been employed in an impersonal way.

Another drawing of burial, *At the Cemetery* (Plate 30), approaches the theme differently, for this is the burial of a child whose small coffin lies between its parents beside the grave. The father has dug the grave in the cemetery, the gate of which is visible among the distant trees. The mother kneels in prayer. Four crosses are visible, three marking graves and one on the gateway. Possibly this burial has a personal significance for Malevich in some way. As the crosses in this graveyard scene do not bear the extra footpiece characteristic of the Russian Orthodox crucifix, this may be a Polish or Catholic cemetery, which might support a personal interpretation of the theme.[24] This may be important as the spade, prayer, gravedigger, cross and black rectangle are all themes that recur in later work by Malevich. The black rectangle of the grave may be important too as a tomb or threshold.

Other works exhibited by Malevich in 1911 concern labour in the fields at harvest time, the woodcutter and the carpenter, and a portrait of Malevich's friend, the painter Ivan Klyun, known, as the title of no. 36 at the Union of Youth exhibition indicates, as *Portrait of Ivan Vasilievich Klyunkov*. All of these themes dominate Malevich's thought over the next two years when he was collaborating closely with the composer Matyushin and the painter Klyun.[25] The woodcutter and the harvest are themes associated with the cycle of the farming year in peasant life. They are associated with the imagery of the calendar because of this, so that a harvest provides an image of fecundity and of the plenitude of

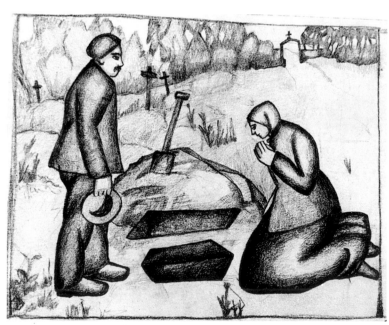

30, above. Kazimir Malevich *At the Cemetery*, 1911. Pencil on paper. 15.2 × 17.7 cm. Russian Museum, St Petersburg (acquired from the L. Zheverzheev Collection 1928).

31, right. Kazimir Malevich *The Gardener*, 1911. Gouache on paper. 20 × 16 *vershok* (1¼ × 1 *arshin*). 88.9 × 71.12 cm (given as 91 × 70 cm). Stedelijk Museum, Amsterdam.

32. Kazimir Malevich
On the Boulevard, 1911.
Gouache on paper. 16 × 16
vershok (1 × 1 *arshin*). 71.12
× 71.12 cm (given as 72 ×
71 cm). Stedelijk Museum,
Amsterdam.

the earth. The painters of Pont-Aven used the theme repeatedly with just this meaning. Goncharova and Malevich simply followed suit.

The works designated as *Sketches* (*Eskizy*, *Esquisses*) in December 1911 may have included works on paper which Malevich executed with all the decisive calligraphic flair seen in his *Bather* (Plate 21). This series illustrates a series of city scenes of work and leisure. Only one of them, *The Gardener* (Plate 31) with his spade, incidentally recalls the *Burial* (Plate 25) and *At the Cemetery* (Plate 30). The figures have red limbs and crude physiognomies. These scenes of urban work contrast with the rural peasant themes. Like *Bather*, they display the Fauve qualities of strong colour and immediacy of application. In *The Gardener* (Plate 31) and *On the Boulevard* (Plate 32), a smaller figure is inserted top left busily and actively working while the larger foreground figure pauses or relaxes. As the painting of the plants and bushes indicates, the Fauvism of these works on paper is mediated by the example of recent work by Larionov who, after all, had known Fauve work since 1905 and who had recently met Matisse in Moscow.

The Gardener is one *arshin* (or 16 *vershok*) wide; *On the Boulevard* is one *arshin* square. Related works in the series follow precisely these proportions, including the *Man with a*

29

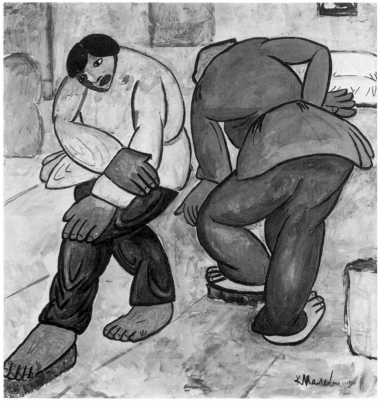

33, above left. Kazimir Malevich *Man with a Sack*, 1911. Gouache on paper. 20 × 16 *vershok* (1¼ × 1 *arshin*). Ratio 5:4. 88.9 × 71.12 cm (given as 88 × 71 cm). Stedelijk Museum, Amsterdam.

34, above right. Kazimir Malevich *Floor Polishers*, 1911–12. Gouache on paper. 16 × 16 *vershok* (1 × 1 *arshin*). 71.12 × 71.12 cm (given as 71.7 × 71 cm). Stedelijk Museum, Amsterdam. Shown at the Donkey's Tail Exhibition, Moscow, March 1912, catalogued as no. 164, and also shown in Berlin in 1927. This illustrates a traditional Russian technique for polishing a floor. Here the location appears to be an art gallery.

Sack (Plate 33), which is one *arshin* wide, and *Floor Polishers* (Plate 34), which is one *arshin* square. This last work shows a new mathematical complexity, as the two figures, like inelegant versions of Degas dancers, reverse their positions along the diagonals of the *arshin* grid while they polish the floor of an art gallery in a traditional Russian manner. *The Gardener* and *On the Boulevard* might make a pair to *Man with a Sack* and *Floor Polishers*, except that the latter two show a new interest in dynamic movement where the first two are static.

The theme of movement is sustained elsewhere. A drawing survives, for example, for a canvas of *Two Men with a Handcart*, again a dynamic theme of work with a wheel at the heart of the composition. There is also a larger and more monumental work on paper depicting a washerwoman (Plate 35), another theme reminiscent of Degas. This study is half as big again (1½ *arshin*) but is almost square. Malevich has boldly defied convention in his flattened picture space that distorts the ellipse of the tub into a sharp-ended almond shape. The tub's legs are also wilfully crude and the woman's feet are large. Yet Malevich did reconsider his composition in these works on paper: here a bucket that features in a drawing (Plate 36) is painted out in the gouache (Plate 35).

Whether the washerwoman theme derives from Degas or from an alchemical source (Plate 37) is impossible to determine. There is little sign of the water or washing in either the drawing or the gouache. Were it not for the title by Malevich it would not be clear that this in fact shows a washerwoman at work. The recurrent square format of many of these works is perhaps significant in itself; here is a gouache whose strength relies heavily upon its geometry. For Malevich, the square-format canvas had already been in use for several years. Here the inner proportions deriving from the square become evident as a feature of the imagery.

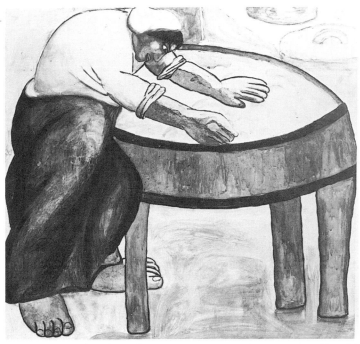

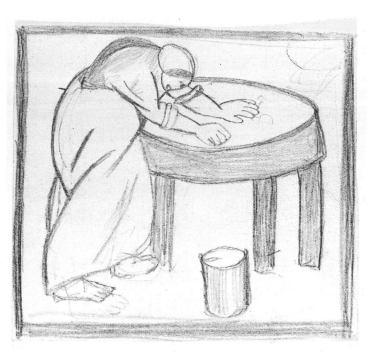

35. Kazimir Malevich *Washerwoman*, 1911. Gouache on paper. 22 × 24 *vershok*. 97.79 × 106.68 cm (given as 98 × 105 cm). Private collection, Basel. Shown at the Donkey's Tail Exhibition, Moscow 1912, catalogued as no. 160.

36. Kazimir Malevich *Washerwoman*, *c*.1911. Pencil on paper. 9 × 10 cm. Collection Ludwig, Cologne.

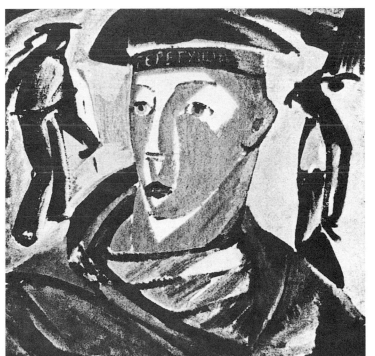

37. B. Schwan *Alchemical illustration*. This depicts alchemical whitening by means of the image of washerwomen at work. The illustration is from Johann Daniel Mylius's *Philosophia reformata*, Frankfort 1622.

38. Vladimir Tatlin *Sailor*, 1911–12. Oil on canvas. 16 × 16 *vershok* (1 × 1 *arshin*). 71.12 × 71.12 cm (given as 71.5 × 71.15 cm). Russian Museum, St Petersburg.

December 1911 saw Tatlin adopt the same geometric priorities in a work of equal anonymity but of greater elegance and sophistication (Plate 38). The square canvas had come of age by 1911. It focused attention on the inner rhythms because neither the horizontal nor vertical proportion dominated the painting. It made these paintings an art

39. Works by Malevich on display at the Donkey's Tail Exhibition, Moscow, 24 March–21 April 1912. Works visible include, at left *Gathering Corn*, *Argentine Polka* (second from left, upper row), *Peasant Funeral*, flanked by the two studies. Below may be seen *Washerwoman*, *Floorpolishers*, *Man with a Sack*, *Men with a Handcart* and *The Gardener*. Photograph © Puni-Archive, Herman Berninger, Zurich.

of the compass and ruler; it made their proportions depend upon the relation of the circle and the square. These ratios and geometric relationships were promoted by the artists Sérusier and Verkade, who referred back via ancient precedents and myths to Hermes Trismegistus and to Pythagoras. Theosophists and other mystics sought to understand this geometry as a revelation of spiritual enlightenment. We approach the image of the man within the circle and the square so familiar to the generation of Leonardo da Vinci.

In *Sailor* (Plate 38) Tatlin found an equivalent for the peasant themes used by Malevich. From this moment forward, December 1911, the mathematical element provides an implicit meaning that complements the recognizable, readable image and in itself becomes a carrier of meaning. It is only the realization of the significance of the *arshin* measure which makes the interrelation of all these works visible. Tatlin's *Sailor* is one *arshin* square and is constructed from circular arcs.

The perspective and proportional systems developing here make an art that is constructed consciously on a geometrical basis, as was the older perspective with its single vanishing point. It is not a mirror to nature but an articulate means of construction, which in turn proposes a world view applicable to architecture as well as to painting.[26]

From 24 March to 21 April 1912 many works by Malevich were exhibited in Moscow at the Donkey's Tail exhibition (Plate 39). There were portraits and new works to complement those shown recently in St Petersburg. The second Knave of Diamonds exhibition had opened in Moscow on 25 January 1912 with recent work from Germany (Kirchner, Marc, Macke) and from France (Matisse, Picasso, Robert Delaunay, Gleizes, Derain, Léger). At a debate organized at the Polytechnic Museum on 12 February 1912 Goncharova denounced the Knave of Diamonds exhibition and announced the formation of the Donkey's Tail group.[27] Maksimilian Voloshin had spoken at the debate on Cézanne, Van Gogh and Gauguin as precursors of Cubism,[28] and it was part of Goncharova's stance that Russian artists were too preoccupied with the example of Western art. She sought to reverse the dominance of Western cultural conventions which had entered Russian art at the time of Peter the Great, a domination exemplified by the

exhibition 'One Hundred Years of French Painting' held in St Petersburg in 1912 to mark the centenary of Napoleon's retreat from Moscow. This exhibition ranged from David to Derain and was organized by *Apollon* magazine.[29] The critic S. Makovsky discussed French art from the I.A. Morozov Collection in *Apollon* nos. 3–4 in 1912.[30] In Moscow the opening of the Alexander III Museum of Fine Arts (now the State Pushkin Museum) in 1912 can only further have stressed the Russian fixation with Western European art.[31]

It is nevertheless ironic that Goncharova should protest at westernizing trends in Russian art and demand a distinctly Russian and Eastern or Asian cultural identity. Like Larionov she was extremely well informed on the subject of French art and she frequently responded brilliantly to its example when painting her own canvases. Even the title of the Donkey's Tail probably contains a reference to the works once exhibited at the juryless Salon des Indépendants in Paris but actually executed by Boronali, a Montmartre donkey with a brush attached to its tail.

Larionov organized the Donkey's Tail exhibition for March–April 1912 in Moscow. There Malevich exhibited all of his recent work alongside paintings by Larionov, Goncharova, Chagall, Tatlin, Rozanova, Filonov, Morgunov, Shevchenko and others.[32] All of these artists embraced a deliberately primitive approach (neo-primitivism) which again oddly reflected contemporary events in Paris where Delaunay, Picasso and others were paying homage to the achievements of the naive painter Henri 'Le Douanier' Rousseau. Shchukin was swift to respond to this initiative and in 1912 he acquired Rousseau's *Bridge at Sèvres* (1908), but Russian artists, thanks to the Futurist poet and painter Zdanevich, were soon to find an equivalent in the Georgian signboard painter Niko Pirosmanashvili. Shchukin and Morozov were simultaneously buying important paintings by Cézanne, Bonnard, Matisse and Picasso. The influence of the West was not to be easily discarded: it was much in evidence at the Donkey's Tail exhibition of 1912. The publication in Russian of Signac's *From Delacroix to Neo-Impressionism. With Introductory Texts on the Laws of Colour from Charles Blanc's 'Grammaire des Arts du Dessin'*[33] can only have increased its impact, particularly in relation to Delaunay and Kandinsky, who appeared together in the *Blue Rider Almanac* published in Munich in May 1912.[34] As Larionov, Goncharova and Malevich seem to have exhibited at the second Blue Rider exhibition (of works on paper) in Munich, Malevich cannot have been unaware or unaffected by Kandinsky and Delaunay even though the Donkey's Tail group wished to turn their attention to the cultures of the East.[35]

Delaunay wrote to Kandinsky in 1912 admiring his use of colour and explaining that he wished to achieve 'movement of colour'.[36] Delaunay's own monumental *The City of Paris* was exhibited at the Salon des Indépendants in Paris in 1912. Its theme of the Three Graces seen against a backdrop of the River Seine and the city of Paris linked ancient times with the modern city. The Graces were idealized figures present in the shattered and prismatic forms of Delaunay's city. Both Delaunay and Kandinsky justified their adventurous explorations by reference to an occult, spiritual view of the world. Kandinsky's 'Über die Formfrage' (On the Question of Form) published in 1912 asserted, for example, that 'the world resounds. It is a cosmos of spiritually acting beings. So dead matter is living spirit.'[37] Whilst in Russia Peter Ouspensky was at his most popular and still dispensing mystical/mathematical theories in 1912 in the wake of his book *Tertium Organum*. He published an essay entitled *Superman* in 1912. Simultaneously, Malevich's poet friend Khlebnikov was progressing with his own numerical studies. His *Teacher and Pupil* (1912) discussed numbers alongside word roots and even predicted the fall of a state in 1917. His character of the teacher comments 'Wasn't the number 365 considered

sacred in ancient Babylon?' and he asserts that 'At intervals of 413 years, waves of unification crest among nations'.[38]

Larionov's Venus paintings (Plate 40, for example) of 1912 perhaps suggest an awareness of iconography through time, reaching back to Manet and beyond to Titian, similar to Khlebnikov's development of the idea of words' extension through time, but this does not suggest independence of the West. However, Larionov's *Seasons*, painted in 1912–13, did concern the cyclic concepts of time characteristic of the agricultural year, just as certain paintings by Goncharova and Malevich did. Larionov's simplified great female figures (Plate 41) personify the seasons by their poses, their attributes and their activities.[39] Despite all Larionov's Westernized knowledge and sophistication these works achieved a new and direct neo-primitive image highly compatible with the aims of Malevich in paintings shown at the Donkey's Tail exhibition in 1912. Again, the round of the seasons and their labours mark out a cyclic image of time, like the images of a Book of Hours or of a *lubok* calendar (Plate 42), where the scyther is associated with July/August; in the zodiac the scyther is Leo, where the reaper is August/September (Virgo), the thresher is September/October (Libra), the vintage is October/November (Scorpio) and so on. Geometry in this framework was likely to be cyclic, clock-like and temporal in its implication.

Malevich exhibited paintings of this kind at the Donkey's Tail exhibition which ran from 24 March to 21 April 1912. He contrasted urban themes such as *The Gardener* (Plate 31) and *Floor Polishers* (Plate 34) with peasant themes once more. The new paintings were a thematic extension of *The Harvest* (Plate 23) and the imposing *Peasant Funeral*, the most ambitious works exhibited at the Union of Youth exhibition held in St Petersburg from December 1911. Several themes recur, so that *Peasant Women in Church* (Plate 27), for example, appears among new work but derives from the *Peasant Funeral*. In addition, there were two paintings re-examining the theme of gathering or cutting the corn but now executed using a new technique in which sharp contrasts of light and shade model his forms in a way that suggests cylindrical or conical shapes in high relief.

In preferring these subjects Malevich identified with the rural peasantry and therefore with the land. In some ways this obviously reflected the example of Gauguin and his followers, but the themes of the harvest and the woodcutter bring with them other sources of inspiration. These images, defined as the labours of the months and associated

40, below left. Mikhail Larionov *Kapsatskaya Venus (Squaddie's Venus)*, 1912. Oil on canvas. 99.5 × 129.5 cm. State Art Museum, Nizhny-Novgorod.

41, below right. Mikhail Larionov *Autumn*, 1912–13. Oil on canvas. 136.5 × 113 cm. Reproduced by Eganbyuri in 1913. Photograph: Musée national d'art moderne, Centre Georges Pompidou, Paris. The pose of the large figure is like that used by Malevich in his *Flowergirl* and earlier by Gauguin in *The Day of the God (Mahana No Atua)* of 1894.

with zodiacal signs in Western Europe since the Middle Ages, had resurfaced in mid-nineteenth century France in the paintings of Millet and his admirer Van Gogh. In Russia Goncharova and Malevich adopted these themes even whilst protesting against Western European cultural domination. To a degree Larionov followed suit with his spectacular *Seasons* series, but otherwise he found his equivalent of these subjects in his experience of army life, just as Tatlin turned to the imagery of sailors.[40]

Larionov was a founder of the Knave of Diamonds exhibition society. Its title has been interpreted as a reference to prisoners' uniforms stamped with diamond shapes. It is also possible that it refers to the French critic Paul Mantz's description of Manet's *Fifer* as being as flat as the Knave of Diamonds. Cardplayers are also a theme used several times by Cézanne, and by Chardin before him. But cards can also be used to tell fortunes. The Russian painter Venetsianov, for example, used this theme,[41] and an early painting by Larionov shows a scene with cardplayers. In terms of fortune-telling, however, the modern pack of cards is the descendant of the tarot pack, which can be seen as a kind of cosmological diagram. The pack contained an element of chance and a strict mathematical structure in its four suits of thirteen cards in two colours. A game of cards can be seen as a kind of battle, like chess (which interested Marcel Duchamp), or it can be used to attempt fortune-telling. Khlebnikov had just these interests and in 1912 he began to collaborate on Russian 'Futurist' books including *A Game in Hell*, written with Kruchenykh and lithographed and illustrated by Goncharova, and *World Backwards*, which included illustrations by Larionov and Tatlin.[42] In the former the devil plays cards with sinners, and in the second time runs in reverse so that the protagonists grow younger.[43]

It is unlikely that Larionov, Goncharova and Malevich abandoned all the principles that they had originally brought to the Knave of Diamonds group. The Donkey's Tail group was perhaps in part reasserting values originally embedded at the Knave of Diamonds. Some of these were undoubtedly geometrical and mathematical interests, which corresponded to new ideas of time and space and the development of new systems of art.

The Knave of Diamonds' own insignia (Plate 43) is a good example. It fits precisely into a hexagon within a circle. This is a well-known proportion that occurs in the Parthenon portico and elsewhere. The iconography of the card game, its *lubok*-like image and its proportions all refer to ancient themes. These themes of time and space were to develop dramatically in 1913.

Rural Futurist

By 1913 Cubism was at its height in Paris; the significance of mathematics in this has perhaps been underestimated. In their celebrated book *Du Cubisme*, which saw two Russian translations in 1913, the Cubist painters Albert Gleizes and Jean Metzinger were at pains to indicate the importance of geometry: 'If we wished to offer the space of painters to geometry we should have to refer it to the non-Euclidean scientist; we should have to study, at some length, certain theorems of Riemann's.' On the other hand, they felt anxious to dissociate themselves from 'the facilities of a fantastic occultism; if we condemn the exclusive use of customary symbols it is not because we wish to replace them by cabalistic signs'.[1]

Yet Apollinaire asserted that 'the new artists are searching for an ideal beauty that will . . . be . . . an expression of the universe'.[2] It was Apollinaire who introduced the terms Hermetic and Orphic Cubism with their mystical connotations relating back to Hermes and Orpheus, as Schuré had described them. In March 1913 Apollinaire asserted that 'The reign of Orpheus is beginning'[3] and saw 'Orphism' manifesting itself for the first time at the Salon des Indépendants in Paris in 1913, where, among other works, Apollinaire singled out Chagall's *Adam and Eve* for praise.[4] Chagall was to work closely with Delaunay in 1913 and was much affected by Delaunay's ideas. By March 1913 Chagall was exhibiting at the Target exhibition in Moscow along with Larionov, Goncharova, Malevich and others.[5] Larionov certainly knew of Orphism. Launching his own new style, 'Rayism' (*Luchizm*) in 1913 (Plate 44), he described it as a synthesis of Cubism, Futurism and Orphism, compromising his new independence thoroughly in the process while simultaneously calling for a 'striving towards the East'.[6] The Georgian painter Yakulov also visited Robert and Sonia Delaunay at Louveciennes in 1913. There is no doubt that their ideas were known in Russia or that Robert Delaunay at least sought to revivify painting by reference to ancient mysticism and a belief in proportions as the basis of harmony.[7] For Delaunay these issues were inseparable. 'Art,' wrote Robert Delaunay in 1913, 'is the voice that Light makes us hear and that Hermes Trismegistus spoke of in his Pimander.'[8] He also discussed 'harmony' as sensibility 'ordered by the creator' for the fullest expression of the subject: 'the subject is harmonic proportion and that proportion is composed of diverse members simultaneously in action.[9] The "subject" is eternal in the artwork and must appear to the initiate in all its order, in all its science.'[10] One of the most succinctly edited and powerful expressions of this 'science of proportions' was his *Disk*, painted about 1912, in itself a target-like format and perhaps part of the inspiration for Larionov's exhibition title. In Theosophical writings by Blavatsky, the quartering of the circle suggested a linking of Earth and Heaven, marking out the four cardinal compass points, the four elements and four seasons. This necessarily refers to the action of sun and moon and the cyclic renewal of the seasons in the calendar. This is precisely the theme exemplified at the Target exhibition in Larionov's own *Seasons* series (Plate 41). Larionov's acknowledgment of Orphism was perhaps evident in his paintings as well as in his *Rayist Manifesto* in 1913.[11] To insert the image of humanity into these elements or rhythms is to develop a cosmological image of mankind's place in the

universe. This is implicit in Larionov's *Seasons*, but it was made much more explicit by Chagall, whose contemporary *Homage to Apollinaire* (Plate 45) combines a format derived from Delaunay with the Creation myth from Genesis. His solution to this difficult iconography is close to the imagery of alchemy. It incidentally illustrates rather clearly the fusion of such thinking in France and Russia.

Chagall's painting is roughly square and its size suggests that it was intended to be a major work at roughly two metres across, substantially larger than Delaunay's *Disk*.[12] Chagall has placed a rough circle within this square and he has drawn in divisions of both circle and square into four sectors which are further subdivided by the square's diagonals. This quartering recalls that of Delaunay directly, and a reference to the four elements of earth, air, fire and water is concealed in the names inscribed around the pierced heart motif, lower left: Apollin*aire* suggests *air* (air), Cañu*do* suggests *eau* (water); *Cendrars* suggests *cendres* (cinders, fire), and *Walden* (forest) suggests earth – indeed, Chagall has positioned these friends' and patrons' names in a square format. The pierced heart is a sign of love and this relates to the main theme. Here Adam and Eve split apart from their original unity as described in the Book of Genesis. The *one* becomes *two*. Eve holds the apple to show that we are looking at a representation of the creation of Eve and the Fall from grace. Behind Adam/Eve the great disk counts out the passage of time, as we see from fragments of the clock-face 9, 10, 11 visible upper left. Adam and Eve are caught within time like the hands of a clock, for with the Fall came work, death and the beginning of human history. Chagall's painting is a monumental image of the origins of human history as related in the book of Genesis. The circular clock-face, like Delaunay's disk which it so resembles, marks the cycle of time with the clouds and birds lower left, and the arcs of circles upper left indicate that this is a clock in the sky measuring solar and lunar movements, precisely the themes adopted by Delaunay in 1913.

However, Chagall also gives an indication of a further reading. His Adam and Eve are still one creature – they share for example one set of legs: in this form they are

44, above left. Mikhail Larionov *Portrait of a Fool*, originally titled *Blue Rayism*, 1912. Oil on canvas. 14 × 16 *vershok* (1 *arshin* wide). 62.23 × 71.12 cm (given as 64.8 × 71.15 cm).

45, above right. Marc Chagall *Homage to Apollinaire, Walden, Cendrars, Cañudo*, 1912. Oil with gold and silver powder on canvas. 200 × 189.5 cm. Stedelijk Van Abbemuseum, Eindhoven.

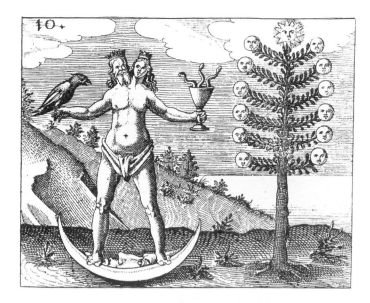

46, above left. B. Schwan *Alchemical illustration.* The mystic fusion of Sol and Luna, of the sun and moon, of gold and silver, of male and female. The illustration is from Johann Daniel Mylius's *Philosophia reformata*, Frankfort 1622.

47, above right. B. Schwan *Alchemical illustration.* The Heavenly Marriage of Sol and Luna. The geometrical design signifies the squaring of the circle. The illustration is from Johann Daniel Mylius's *Philosophia reformata*, Frankfort 1622.

48, right. Marc Chagall *Study II for Homage to Apollinaire*, 1911. Pencil on paper. Inscribed 'Paris'. 13 × 12 cm. Musée national d'art moderne, Paris.

49, far right. Marc Chagall *Study I for Homage to Apollinaire*, dated 1911. Pencil on paper. Inscribed in Russian 'Vreme' (time). 33 × 26 cm. Musée national d'art moderne, Paris.

androgynous. The two-headed male-female is a recurrent image in alchemy but exceedingly rare elsewhere. Its adoption here, and in other works by Chagall, suggests an alchemical source such as the *Philosophia reformata* of 1622 (Plates 46 and 47) with illustrations by Mylius. Here Sol (Sun) and Luna (Moon) separate, recombine and decay through the several stages of alchemical purification. As gold and silver they represent the highest goals of purification and the unity of mankind and god. Chagall has even used gold and silver powder on his painting. These forces reunited in alchemy restore the harmony of the universe and the balance of the four elements into the quintessence of the philosopher's stone. The alchemist achieves this in part by a study of divine proportions represented as the relation of triangle, circle and square. The perfect forms of Sol and Luna, of male and female principles within this, represent mankind in harmony with the universe and the reversal of the Fall of Adam and Eve.[13] Chagall's painting illustrates almost all of these features, revealing a little more of the roots of his imagery and the response of at least one Russian artist to Delaunay's Orphism.[14]

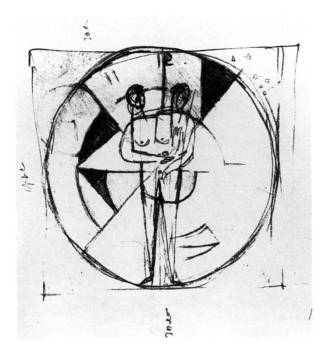

50. Marc Chagall *Study for Homage to Apollinaire*, 1911. Pencil on paper. Inscribed top and bottom in Russian 'zolot(oy)' (gold). 16.1 × 19.6 cm. Musée national d'art moderne, Paris.

Drawings for *Homage to Apollinaire* show the primeval pair co-joined in the garden of Eden or against geometric schemes.[15] One of these, inscribed 'Paris' (Plate 48), is close to the finished format although a further half-circle at right suggests partial eclipse. Interestingly another drawing (Plate 49) by Chagall, dated 1911, places Adam/Eve against a spiral. Lettering against the feet clearly says ВРЕМЯ (time) and may also say ПРОСТРАНСТВО (space). A third drawing (Plate 50) is inscribed *zolot*, a fragment of the word 'gold'.

The Russian Orthodox liturgy stresses the story of Adam and Eve and also the role of Jesus as the new Adam. Chagall was Jewish, and may have taken the theme directly from Genesis, but he may also have been inspired by Christian ikons. However, the primal Adam was also discussed by Peter Ouspensky in his book *Tertium Organum* of 1911 (the date inscribed on several of Chagall's drawings for this painting):

Mankind is also a living being. It is the Great Man, the Adam Kadmon of the Kabalists. Adam Kadmon is a being alive in man, including himself in the minds of all men. H.P. Blavatsky speaks about this in her voluminous book *The Secret Doctrine*. 'It is not the Adam of dust (of Genesis, Chapter II) who is thus made in the divine image, but the Divine Androgyne (of Chapter I) or Adam Kadmon.' Adam Kadmon is humanity or the human race – Homo Sapiens – a being with the body of an animal and the face of a superhuman.[16]

In exhibiting at the Target exhibition in Moscow in the Spring of 1913,[17] Malevich was again associating deliberately with the eastward looking group of Larionov, Goncharova,[18] Le-Dantyu, Zdanevich, Chagall and so on. Amongst the titles listed by Malevich is one that pays lip-service to the new allegiance: no. 97 was entitled *Peasant Women in the Field (New Russian Style)*. Unfortunately, Chagall's works, catalogue nos. 125–27, were not listed with titles, so that direct comparisons are not possible at this crucial moment. It is well known, however, that the exhibition deliberately promoted neo-primitivism and included paintings by the untaught Georgian shop-sign painter Pirosmanashvili, as well as a large number of children's drawings.

51. Kazimir Malevich
Peasant Woman with Buckets and Child, 1912. Oil on canvas. 16 × 16 *vershok* (1 *arshin* square). 71.12 × 71.12 cm (given as 73 × 73 m). Stedelijk Museum, Amsterdam. Shown at the Donkey's Tail Exhibition, Moscow 1912.

Several works which Malevich showed at the Donkey's Tail in 1912 reveal this tendency. *Peasant Woman with Buckets and Child*, 1912 (Plate 51), is again one *arshin* square and is constructed from arcs like those of the *Washerwoman* (Plate 35). The almond shape of intersecting circular arcs dominates the painting and is also used in the overall form and features of the heads of the peasant woman and child. The image is as fully flattened as possible and there are sequences of rhyming shapes from woman to child as in a peasant embroidery. With the new calendar and seasonal themes in mind, this might represent Aquarius the water-carrier in the signs of the zodiac. The theme was similarly employed in 1912 by Chagall, who associated the water-carrier with the moon. Malevich, however, hung the painting at the exhibition (Plate 39) of 1912 between *Peasant Women in Church* and his recent *Harvest*, as if they were pendentives to his monumental *Reaper*, also visible in the exhibition photograph. All of this tells of peasant work, devoutness and strength, situating peasant life and death among the rhythms of seasonal work on the farm. *Harvest* is again close to one *arshin* square. Perhaps in response to Cubism, Malevich has now strengthened his use of light and shade to emphasize tubular forms not wholly unlike those of Léger. Malevich had also exhibited at the Donkey's Tail a full-length *Woodcutter*.

If there is a link with Léger this might illustrate it, for Léger's *Nudes in the Forest* contains a whole series of axemen. Léger was teaching at the Russian Academy of Wassilieff in Paris and had displayed five works in the Knave of Diamonds exhibition in January 1912 (catalogue nos. 117–21). Malevich perhaps emulated Léger's tubular and conical stylization of the figure for a while. In his *Woodcutter* Malevich found a subject capable of filling Cézanne's analytical desire to see the sphere, cylinder and cone, but his technique was surely mediated by Cubism by 1912. On the other hand, Millet, Van Gogh and even Gauguin in Tahiti used the theme of the man with the axe. For Malevich it was clearly part of a series, which its proportions as well as its theme and date help to identify. The painting is one *arshin* wide.

The key to this new series is perhaps the *Head of a Peasant* (Plate 52), also exhibited at the Donkey's Tail. This lost work is square but a little larger than usual at 18 *vershok* ($1\frac{1}{8}$ *arshin*). It follows in the sequence of square images of heads that included the two early self-portraits by Malevich. The ikon-like unreality of the painting takes it away from the function of holding a mirror to nature. This painting is powerful not least because it has been severely edited down to the essentials of its image and composition. A closely related drawing helps to explain the background detail. The drawing, which Malevich inscribed with the Russian word for 'orthodox' (Plate 53), placed the head and shoulder against a village dominated by the cylindrical towers and onion domes of a church. In this context the long beard perhaps suggests the Old Believers or the time before Tsar Peter introduced so much that was Western into Russia. There is nothing to fix a specific historical period for the setting of Malevich's figure. As before, Malevich has placed the head against a backdrop to identify its mental and physical context. The head itself is resolved with great precision and is closely similar to the drawing – note, for example, the rising

52, below left. Kazimir Malevich *Head of a Peasant*, 1912. Oil on canvas. 18 × 18 *vershok*. 80.01 × 80.01 cm (given as 80 × 80 cm). Whereabouts unknown (lost in Berlin). Shown at the Donkey's Tail Exhibition, Moscow 1912, as *Portrait of Ivan Vasilievich Klyunkov* and illustrated in the periodical *Ogonyok*, no. 1, 1913.

53, below right. Kazimir Malevich *The Orthodox*, 1912. Pencil on paper. Inscribed in Russian 'pravoslavnyy' (orthodox). 13.7 × 8.7 cm (sheet size 14.9 × 11.2 cm). Whereabouts unknown.

edge of beard on the cheek at left. But whereas the eyes of the believer turn slightly aside in the drawing, in the square painting they assume a hypnotic frontal focus: he is intended perhaps as a new kind of ikon. Light here strikes Malevich's surfaces from several directions: to this degree and in its strictly frontal pose *Head of a Peasant* resembles Picasso's dramatic *Portrait of Ambroise Vollard*, acquired by Ivan Morozov in 1913.

Despite the fact that they were exhibited a few at a time, these paintings comprise a coherent series beginning with *Head of a Peasant* (Plate 52) of 1912. Reappraisal of the theme of the head, painted like an ikon in a square format, seems to demarcate every new phase of Malevich's development as a painter. It suggests that he characteristically and repeatedly re-examined familiar themes in terms of his latest technique or newest discovery. When *Head of a Peasant* was illustrated in the periodical *Ogonyok* in 1913, it was described as *Portrait of Ivan Vasilievich Klyunkov*.[19] According to the art historian Larisa Zhadova, this was an erroneous identification.[20] Whatever the detailed complexities of identifying specific canvases in particular exhibitions, it is clear that this portrait very closely resembles later portraits of Malevich's friend Ivan Klyunkov (who subsequently shortened his name to Klyun). It is as if Malevich established what he considered to be the new face of his time and then elaborated upon the theme in two ways: first, by providing genre-like scenes for the protagonist and related figures; and, second, by further refining and developing the image of the face itself to the point where it initiates a new series of related paintings. Malevich then reinterpreted his peasant themes in the light of these new techniques.

This *Head of a Peasant* (Plate 52) appears slightly modified in a drawing (Plate 54) in the Wilhelm Hack Museum at Ludwigshafen. The hair hangs down in a convex shape and the shoulders are curved in a single arc almost coincident with the line of the beard. It has a completeness and simplicity of form – as if it were a drawing of a wood carving. This sculptural aspect was a characteristic of Picasso's reorganization of the figure and was dramatically evident in his powerful *Peasant Woman* and *Dryad*, both of which were available in Moscow for Malevich to study. However, Malevich made the fall of light in the painting *Head of a Peasant* so dramatically inconsistent that the firmly modelled forms appeared locked into the high relief elements of the background church buildings. The painting also shows a dark shoulder at left and a higher light shoulder at right, both indicated by straight lines. These are not features of the Ludwigshafen drawing but they do appear as features of a lost full-length painting of a peasant with an axe.

Peasant with an Axe (see Plate 55) may also be a portrait of Ivan Vasilievich Klyunkov: it is certainly closely related to *Head of a Peasant* (Plate 52). The peasant's head has similar mask-like features seen in a symmetrical front view and extended down into a rendering of the whole seated figure. Light is again employed inconsistently throughout, in a manner derived from Cubism, so as to construct cylindrical or conical shapes with an appearance of metallic sheen. The light provides firm chiaroscuro and modelling at every point but its diverse directions preclude a suggestion of deep space. For this reason the rather cubic forms of the background, perhaps depicting wood cut into planks and blocks, press forward against the image of the woodcutter. But they do not intersect with the figure, whose outline remains complete.

This is a monumental image stylistically reminiscent of slightly earlier Picasso and yet set distinctively in a rural and peasant setting. As Malevich explores this setting, illustrating life 'going on', his work moves a little closer to genre. This is an image of the male figure identified with his trade, a kind of protagonist of village life.

For Malevich, as for Larionov, Goncharova and even Chagall, painting in far-off Paris, the life of the village was a theme in which genre activities were given a wider symbolic

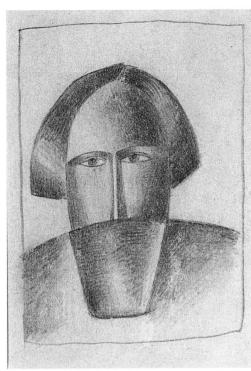

54, left. Kazimir Malevich *Untitled* (Head of a Peasant), 1911–12. Pencil on paper. 14.6 × 10.3 cm. Wilhelm Hack Museum, Ludwigshafen.

55, below. Kazimir Malevich's paintings exhibited at the Union of Youth exhibition in St Petersburg, 1913. Paintings visible in this installation include the following lost works. Centre, *Peasant with an Axe*, c.1912. Oil on canvas. Estimated size 24 × 16 *vershok* (1½ × 1 *arshin*). 106.68 × 71.12 cm. Left, *Peasants in the Street*, 1912–13. Oil on canvas. Estimated size 18 × 18 *vershok*. 80.01 × 80.01 cm. Photograph © Puni-Archive, Herman Berninger, Zurich.

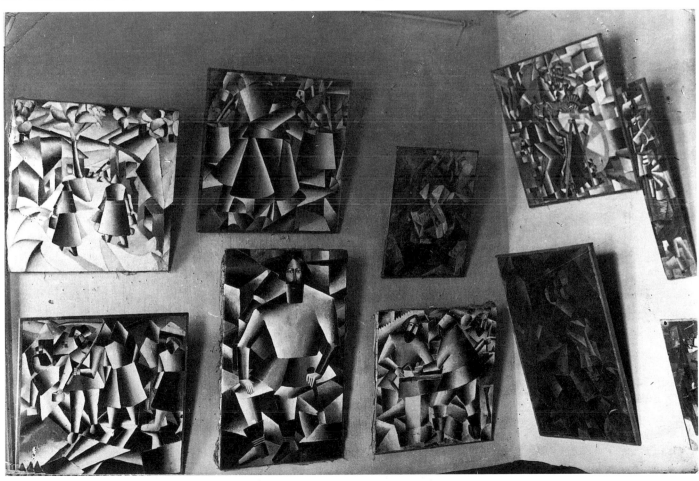

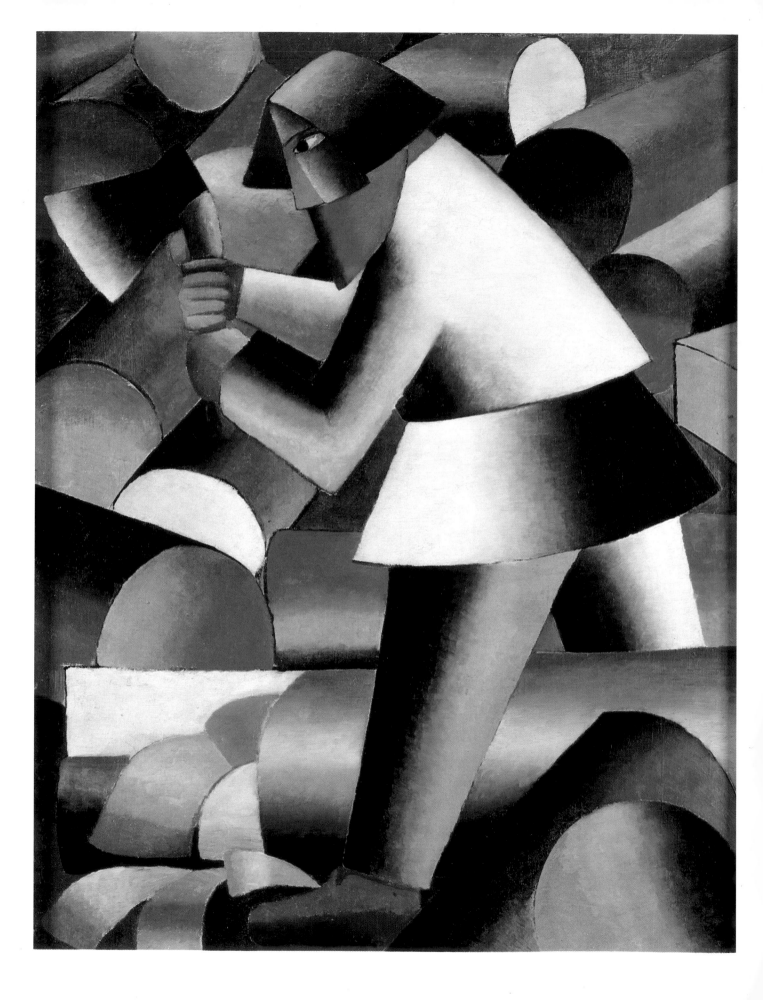

force. Legend, the passage of the seasons and village customs, mediated by Gauguin and Van Gogh, made the village and fields into an arena for images of a monumental significance as painted by Russian painters.

An important lost painting makes this clear. It is probably identifiable with *Peasants in the Street* (see Plate 55), which Malevich exhibited in November 1913.[21] The canvas, which appears to be square, incorporates at least five figures of male and female peasants. Three, at the right, walk into the painting. Farm buildings or village houses are visible top left. Dominating the whole scene is a peasant man carrying a scythe with its handle against his shoulder so that the blade passes above his head. This is clearly seen in a related drawing. The most extraordinary feature of the whole canvas is the daring depiction of the brilliant reflections of two women peasants visible at the base of the painting. This suggests watery ground, perhaps after a storm. It is noticeable that at lower right the reflection moves downwards to the right, whereas the other reflection of a peasant woman falls away to the left. At this point it becomes clear that the man with a scythe also has a shadow, which in his case passes diagonally upwards towards the upper left corner. Inconsistent Cubist light sources again model the figures into a crystalline relief effect, which Malevich could have studied, for example, in Picasso's *Factory at Horta* in Shchukin's collection, but nothing like these splayed reflections can be found there, even if the farm buildings do resemble Picasso's factory. By means of these reflections Malevich has sliced and spliced the space and perspective of his painting in a wholly new way. As the two diamond-shaped heads, upper right, reveal, he has simplified the form, too, so that his figures are more constructed than observed. And yet he still manages to show a genre scene of village life.

This robust element of genre encourages a mundane interpretation of imagery. In this reading, the man with the scythe is simply a peasant returning to the fields to work – an image in the repertoire of Courbet or Millet. But the image of a man with a scythe can have other meanings, signifying death (as the grim reaper), or the god Saturn (and hence Old Father Time). Given that Hinton, Ouspensky, Bragdon and Khlebnikov were so concerned with new concepts of time, it is as well to be alert to this possibility. Time, after all, was also a key element of Chagall's *Homage to Apollinaire* (Plate 45). Chagall and Malevich had recently shown works together at the Donkey's Tail exhibition. When the man with the scythe appears in Chagall's work, it is with precisely this blend of genre and experiment. Later in 1913 Malevich was to call this 'trans-sense realism' (*zaumnyy realizm*). Chagall's irrational *I and the Village* could justify such a description.[22]

The man with the scythe is associated with another iconographic system already approached by Gauguin, Van Gogh, Larionov, Goncharova and Malevich: he appears as one of the labours of the seasons. Practical images of farming and husbandry since medieval times, the labours of the seasons were also illustrations for the calendar and hence were associated with signs of the zodiac and months of the year.[23] This blending of practicality with an awareness of the changing seasons and stars is what Malevich illustrates in this series of paintings. The man with the scythe is associated with the labours of the month of June and the zodiacal sign of Cancer (the Crab). Malevich's four figures circle and pass like the seasons; this canvas is as much about time as it is about work. Only this rural theme allows such a duality of meaning.

At this point it is possible to reconsider the *Woodcutter* painting (Plate 56) displayed at the Donkey's Tail exhibition of 1912. The strict, hieratic profile is designed to explain the particular idealization of the human form. The chiaroscuro results in an image of sculptural strength. Cylindrical logs form a dense background into which the woodcutter is integrated, although each form remains distinct and there is no mixing of one surface with another.

56. Kazimir Malevich *The Woodcutter*, 1912. Oil on canvas. On the reverse is *Peasant Women at Church*, 1911 (Plate 27). 21 × 16 *vershok*. 93.34 × 71.12 cm (given as 94 × 71.5 cm). Stedelijk Museum, Amsterdam (acquired from Hugo Häring 1958). Shown at the Donkey's Tail Exhibition, Moscow 1912.

Seen as genre, the woodcutter is one of the main protagonists of village life as Van Gogh observed him (Plate 57) busily doing his job.[24] In calendar imagery he cuts off old growth ready for the new year in March or April: he is associated with Aries, the Ram (Plate 58), the first and most dynamic sign of the zodiac. The Theosophists Schuré and Ouspensky both discussed the imagery of the zodiac at length. Here is an image that brings all of these concerns together. In terms of geometry and proportion we find Malevich keeping to the standard width of one *arshin* and devising an elaborate conflict of straight and curved lines within his composition.

A pencil drawing of *The Woodcutter* (Plate 59) provides a variation on the composition. Lower right, for example, shows the diagonal form of a log which in the painting is overlaid by the circular cross-section of another log. The shavings produced by chopping show variations too. This suggests that the drawing was a preliminary study rather than a later record, as alterations readily achieved in the act of painting would be recorded in a later drawing. Both painting and drawing indicate a rectangular object halfway up the right edge above the corner of the woodman's clothing. This is presumably the workman's bench, which appears elsewhere. Even more clearly than the painting, Malevich's

57. Vincent van Gogh *Woodcutter (Le Bûcheron)*, 1885. Black crayon. 44 × 54.5 cm. Van Gogh Museum, Amsterdam.

58. *The Woodcutter*, associated with Aries. Bodleian Library, Oxford.

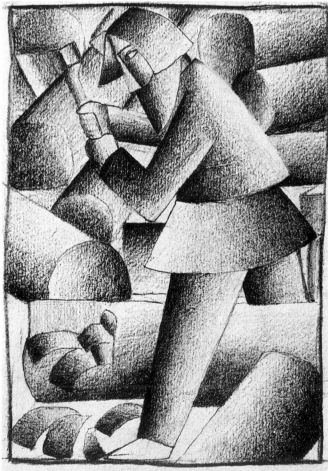

59. Kazimir Malevich *The Woodcutter*, 1912–13. Pencil on paper. 17.1 × 17.7 cm. Russian Museum, St Petersburg.

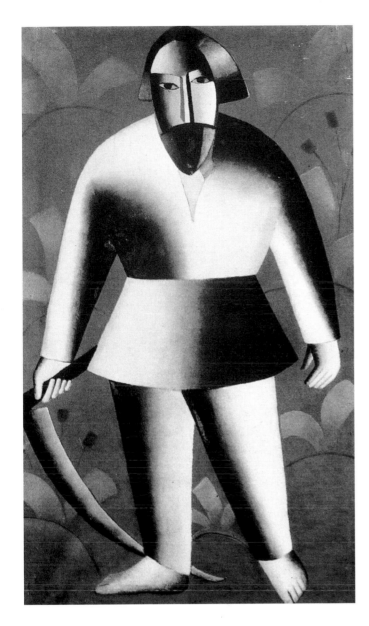

60. Kazimir Malevich *The Scyther (Mower)*, 1912. Oil on canvas. 25 × 15 *vershok*. 111.3 × 66.68 cm (given as 113.5 × 66.5 cm). State Art Museum, Nizhny Novgorod.

drawing reveals the linear structure underlying the composition: one sign of this is the coinciding, at top left, of the edge of the axe-blade and the edge of the log. This effectively locks together foreground and background objects, which were not touching in three-dimensional space. It is an ambiguity removed from the painting, but one that implies that the lines were put in place before the image was constructed.[25] A related painting of *The Carpenter's Shop* (visible at the right in Plate 55) shows the next stage of processing wood in the village, here built up into an ambitious composition of two figures, either side of the bench, working with a saw. In addition, a large two-handed saw hangs in the background, visible top left of the canvas. The genre aspect and the theme of village work are still strong here.

The image of the man with the scythe reappears in *The Scyther* (Plate 60) from the State Art Museum in Nizhny-Novgorod. This is presumably the painting catalogued as *The Mower*, no. 96 at the Target exhibition. Like the *Peasant with an Axe* (Plate 55), he appears

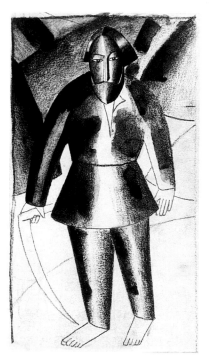

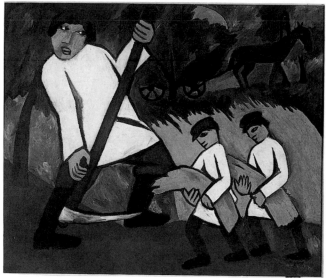

62. Natalya Goncharova *Haycutting*, 1911. Oil on canvas. 98 × 117.7 cm. Formerly Tomilina-Larionova Collection.

61, left. Kazimir Malevich *Mower ('Kosar')*, 1912. Pencil on paper with black watercolour. Dated 1912 on the reverse. 17.4 × 11.6 cm. Russian Museum, St Petersburg (acquired 1928).

as a protagonist in a pose that closely reflects, especially in the placing of the feet, one of the figures in *The Seasons* of Larionov. It is a light balletic pose in bare feet, certainly inappropriate to scything.[26] When Millet drew a Reaper handling the scythe, he was dressed for the heavy physical activity. *The Scyther* or *Mower* by Malevich is removed from the category of genre by this lack of footwear, which is evident also in a drawing (Plate 61). A further impractical feature is the shortness of the handle, which does not extend behind the figure in either the painting or the drawing. The drawing has a steep background of hay piled up into stooks. The painting has a vibrant red background of stylized plants with leaves closely resembling in shape the wood shavings visible in *The Woodcutter* (Plate 56). This imposing figure in front elevation complements *The Woodcutter's* side elevation to represent an image of the new man emerging, his head and shoulders a refinement of the image first resolved in *Head of a Peasant* (Plate 52). The theme itself has numerous French precedents, including works by Millet and Seurat. Goncharova (Plate 62), like Malevich, responded to French precedents but asserted a firmer, more strident rhythm by adopting the flat stylizations of folk decorations

As a calendar image, the mower or scyther corresponds to the labour of the seasons for the month of June and the zodiacal sign of Cancer (Plate 63). The stylized red cornfield has its precedents in paintings of the buckwheat harvest by Emile Bernard and Gauguin.[27] Here it has a theatrical air and a flat, decorative background (Plate 64).

Female workers also appear in this series by Malevich and the reaping woman is a theme rehearsed several times. In the canvas at the B.M. Kustodiev Art Gallery at Astrakhan (Plate 65) she is seen bent over to cut corn with her sickle. She is depicted in strict profile and almost fills the square canvas. As a labour of the seasons she represents July; her activity is associated with fierce heat and the zodiacal sign of Leo (Plate 66). A version of the painting was exhibited at the Donkey's Tail in 1912. Both Millet and Van Gogh provide precedents for the use of the theme and the pose of the woman recurs in Malevich's work in other contexts. A drawing (Plate 67) of women outside a log-built

63. The sign of the zodiac Cancer and scything, the labour of the month for June/July. Bodleian Library, Oxford.

64, right. Kazimir Malevich *Rye Harvest* (sketch), 1911. Pencil on paper. 19 × 23 cm. Collection Ludwig, Cologne.

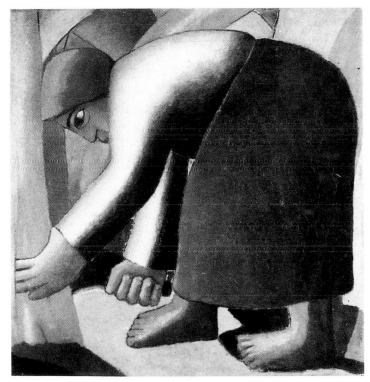

65. Kazimir Malevich *Reaping Woman*, 1912. Oil on canvas. 60 × 68 cm. B.M. Kustodiev Art Museum, Astrakhan.

66, above. The sign of the zodiac Leo and harvesting with a sickle, the labour of the month for July/August. Bodleian Library, Oxford.

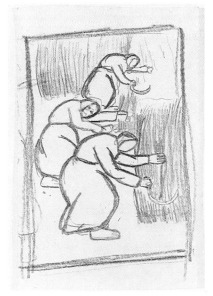

67, left. Kazimir Malevich *Study for Rye Harvest*, 1911. Pencil on paper. 14 × 8.5 cm. Collection Ludwig, Cologne.

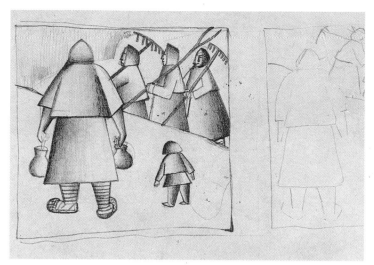

68. Kazimir Malevich *In the Fields*, 1912. Pencil on paper. 16.6 × 17.7 cm. Russian Museum, St Petersburg (acquired 1928).

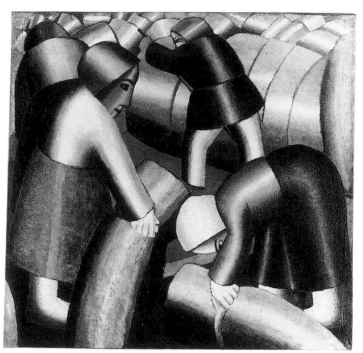

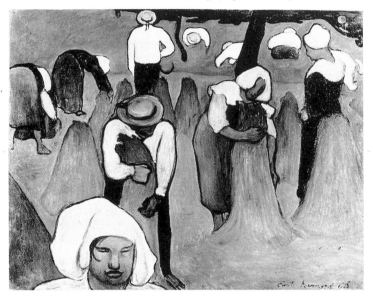

71. The sign of the zodiac Virgo and threshing, the labour of the month for August/September. Bodleian Library, Oxford.

70, above. Emile Bernard *Buckwheat Harvest (Le Blé noir)*, 1888. 72 × 92 cm. Collection Josefowitz.

house or beside piled logs illustrates the pose but without so clear a purpose. Elsewhere it appears (Plate 68), and particularly in the painting *Taking in the Rye* of 1912 (Plate 69) which is, as so often, one *arshin* square in size. Here the theme is identical with Emile Bernard's *Blé noir* or *Buckwheat Harvest* (Plate 70) of 1888, although Malevich's figures are tubular and doll-like. This painting is distinct from the stylization of much of this series and may belong to the sequence preceding it which included the *Peasant Woman with Buckets and Child* (Plate 51). On the other hand, it is the result of the same tight geometry evident in other works of 1912, using curves developed from a golden section of the square canvas. This subdivision in fact isolates the bending woman in precisely the way she appears in the reaping woman theme. In its geometric tension this is comparable with Tatlin's *Sailor* (Plate 38): Malevich in fact uses arcs of the same radius.

The labour of the seasons associated with August September and the zodiacal sign of Virgo is threshing the harvest (Plate 71). Whilst no painting by Malevich on this theme

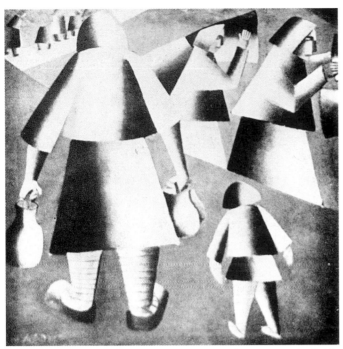

72. Kazimir Malevich *In the Fields*, *c*.1912. Oil on canvas. Probably 16 × 16 *vershok* (1 *arshin* square). 71.12 × 71.12 cm. Whereabouts unknown.

69, opposite page, above right. Kazimir Malevich *Taking in the Rye*, 1912. Oil on canvas. 16 × 16 *vershok* (1 *arshin* square). 71.12 × 71.12 cm (given as 72 × 74.5 cm). Stedelijk Museum, Amsterdam.

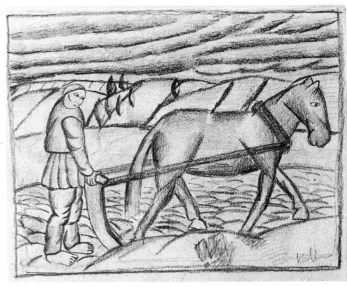

73. Kazimir Malevich *Ploughing*, 1911–12. Pencil on paper. 19.2 × 21.9 cm. Russian Museum, St Petersburg (acquired 1928).

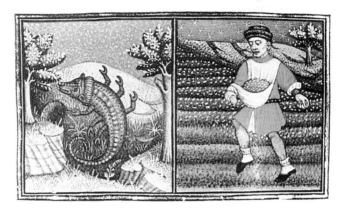

74, above. The sign of the zodiac Scorpio and sowing, the labour of the month for October/November. Bodleian Library, Oxford.

is known, a pencil drawing survives. There may have been a related painting by Malevich or he may have decided instead to adopt the related theme of taking in the harvest. The lost painting *In the Fields* (Plate 72) uses this theme and may represent, therefore, the seasonal labour for August. Again a scene of peasant women working is depicted upon a square canvas: here women carry sheaves of corn in a procession which moves off to the right. Other figures are visible in the distance, shown top left, but the foreground is dominated by the back of a woman carrying pitchers of water. She is accompanied by a small child. Malevich had incorporated front and side elevations of male peasants in this sequence as well as a side view of the female. Here he gives us the female back elevation and two profiles. A second related drawing exists in which the women go off with rakes and forks to collect the harvest, whereas in the painting they are bringing it in. The lost painting is likely to be one *arshin* square.

Malevich may also have depicted the vintage or gathering of grapes, the labour for September/October, associated with the zodiacal sign Libra.[28] A painting on this theme by Van Gogh was readily visible in Moscow, and it also appeared as an image of *Autumn* in Larionov's *Seasons* (Plate 41). Malevich may have preferred the theme of ploughing (Plate 73). The *Sower*, indicative of October/November and the sign Scorpio (Plate 74), also

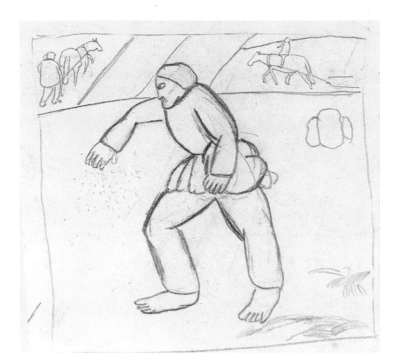

76. M. Merian *Alchemical illustration*. This depicts the alchemical sower returning his gold to the earth. Illustration from Michael Maier's *Atalans fugiens (emblema VI)*, Frankfort 1617.

75, above. Kazimir Malevich *Sower*, 1911–12. Pencil on paper. 12.3 × 12 cm. Collection Ludwig, Cologne.

77. Kazimir Malevich *Morning after the Storm*, 1912–13. Oil on canvas. 18 × 18 *vershok*. 80.01 × 80.01 cm (given as 80 × 79.9 cm). Solomon R. Guggenheim Museum, New York.

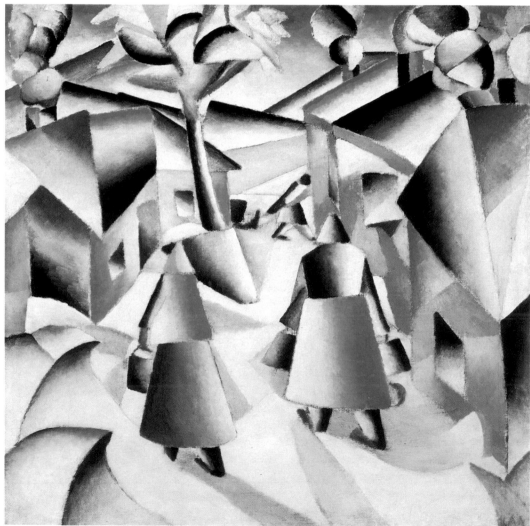

seems to be missing from Malevich's works, although a drawing (Plate 75) suggests that a canvas existed. This image, used by Millet and subsequently borrowed by Van Gogh, also has an alchemical meaning: it shows the philosopher sowing his gold (or wisdom) in the earth (Plate 76). Indeed, the whole zodiac has an alchemical interpretation.

However, it is possible that *Morning after the Storm* (Plate 77), a canvas exhibited at the Target show in April 1913 (catalogue no. 90), and at the Union of Youth show in 1913 as *Morning after the Storm: Transe-Sense Realism 1912*, and also in Paris at the Salon des Indépendants of 1 March–30 April 1914 as catalogue no. 2156: *Matin, après l'orage*, was perhaps an image of the zodiacal sign of Aquarius, since it depicts women carrying water. But Malevich tends to depict the labour and not the sign. Perhaps instead this is simply an image of winter with its snowy streets and distant figure pulling a sledge.[29] Yet this is a square painting on a familiar scale and it is perhaps a part of the sequence. In its rear view of the women it resembles the woman and child of *In the Fields*. In its theme of carrying buckets it harks back to *Peasant Woman with Buckets and Child* of earlier in 1912. Here, however, the development of his handling of planes is evident. The earlier sombre earthiness and flattened forms have given way to an effect of metallic scintillation.

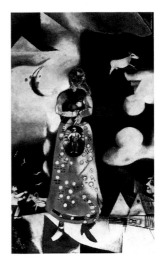

78. Marc Chagall *Pregnant Woman (Pregnant Shapes)*, 1912. Oil on canvas. 195 × 115 cm. Stedelijk Museum, Amsterdam.

As both Malevich and Chagall exhibited with the Donkey's Tail it is useful to compare contemporary paintings by these two painters. Both painted Russian village life and its labours. Chagall's *Pregnant Woman* (Plate 78), for example, is a canvas of 1912–13 in which the ploughman is seen at work followed by birds. Wooden houses are seen to the right against the low horizon. Geometric shapes and a goat leap through the sky. The goat may signify the zodiacal sign of Capricorn. The moon is present too, so that we observe the cyclic passage of sun and moon through the sky. Zodiacal time is related to human activity. The painting's dominant figure points to the child within the womb, the seed of the new year gestating in winter. Most extraordinary is the head: this is half-female (at left) and half-male (bearded profile at right). This is an alchemical image of the hermaphrodite, the combination of Sol (sun) and Luna (moon), of gold and silver, who produce the philosopher's son in the hermetic coalition. It is an image of rebirth through the cyclic time of the sun, moon and seasons. It is comparable with alchemical imagery of the year's eternal renewal.[30] This provides a fruitful framework within which to consider the work of Malevich in 1912–13.

The whole series by Malevich has coherence both formally and thematically. The genre aspect is compatible with new ideas in the handling of space or in the representation of time. If its harvesting themes are still redolent of Bernard, Gauguin and Van Gogh, its forms are closer to Picasso, Braque and Léger. Whilst its techniques in this way seem more French than Russian, its image of peasant life is, like that of Chagall, an image of life in Eastern Europe. Parisian Cubism also had commentators who spoke frequently in the grandest cosmological terms, and the French Cubist painters Gleizes and Metzinger saw their book *Du Cubisme* appear in two Russian translations in 1913.[31] As one of these was edited by Malevich's friend, the composer Mikhail Matyushin, Malevich certainly had access to the book and its ideas. Apollinaire, in his own book *Les Peintres Cubistes* of 1913, declared of Metzinger that 'each of his paintings contains a judgment of the universe, and his whole work is like the sky at night, when, cleared of clouds, it trembles with lovely lights.'[32] Apollinaire considered that 'the new painters do not propose, any more than their predecessors, to be geometers. But it may be said that geometry is to the plastic arts what grammar is to the art of the writer.'[33]

At the Target exhibition in Spring 1913, Malevich gave ample indication of his use of mathematics to provide a structural grammar for his paintings. But his work was also, like that ascribed to Metzinger, 'a judgement of the Universe.' This was a feature of all the

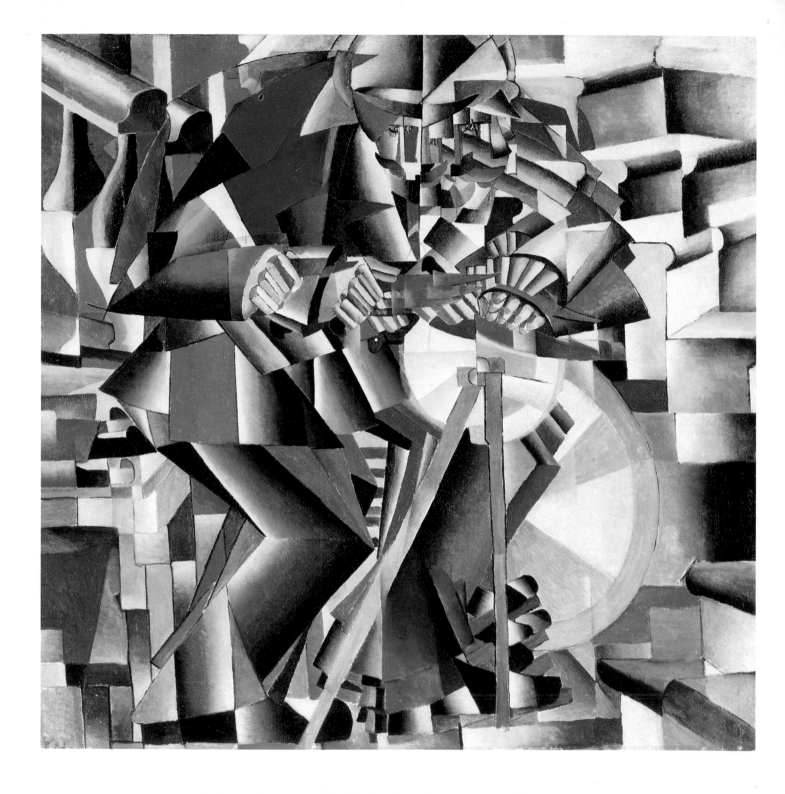

paintings that Malevich displayed at the Target exhibition – *Morning after the Storm* (catalogue entry no. 90) and *Village Street* (no. 91), *Portrait of Ivan Klyunkov* (no. 92), *Peasant Woman with Buckets* (no. 93), *The Mower* (no. 96) and *Peasant Women in the Field (New Russian Style)* (no. 97). Only one work is unidentifiable from its title: *Dynamic Decomposition* (no. 96). But if it resembled other paintings on display it was concerned with the spectrum of movement, from the rotation of the seasons to the movement of the labouring figure. In addition to these works, one other painting, on a large square canvas,

80. Diagram of the compositional structure of Plate 79.

79, opposite page. Kazimir Malevich *The Knifegrinder: Principle of Scintillation,* 1912–13. Oil on canvas. 18 × 18 *vershok.* 80.01 × 80.01 cm (given as 79.7 × 79.7 cm). Yale University Art Gallery, New Haven: Gift of the Société Anonyme.

was listed in the catalogue of the Target exhibition and it took movement as its focal theme. Catalogued as no. 95: *The Knifegrinder: Principle of Scintillation* (Plate 79), it was shown in St Petersburg in November 1913 at the Union of Youth exhibition. It was dated 1912 and described as 'trans-sense realism' (*zaumnyy realizm*).[34] *The Knifegrinder* is 18 *vershok* or $1\frac{1}{8}$ *arshin* square, its larger size indicating its importance. It marks the beginning of a new series in the work of Malevich and is a direct acknowledgment perhaps of the inspiration provided by three Parisian examplars in Matisse, Delaunay and Duchamp.

The Knifegrinder is not a scene of rural peasant life. The workman sharpens his knives at the foot of a flight of steps, visible upper and lower right, and a balustrade is also visible. These are the steps of a substantial building, not a peasant hut. The arc of steps curves around the knifegrinder, whose rhythmic movements Malevich has indicated by the repetition of the foot upon the pedal, the repetition of fingers and hands and the duplication of the nose and other facial features. The grinding machine provides the pivot of the composition (Plate 80). Its vertical and diagonal struts indicate a golden section subdivision of the square canvas. The upright strut follows the golden section to the focal point where the wheel spins. The flywheel provides a larger arc lower right of centre.

The rhythm of rotation appears to spread out like ripples from the centre of the machine animating the flight of steps as they impinge upon the man. Matisse's *Dance* had featured a wild circling rhythm that spread throughout the painting, and this major canvas was certainly available for viewing in Moscow. There were no straight lines, however, in that composition, but a related painting by Matisse, the *Nasturtiums and 'Dance'* of 1912 (Plate 81) was soon acquired by Sergei Shchukin. Enough of the dance is visible to retain its circular movement, but in the foreground a sculptor's modelling stand supports a vase of nasturtiums. This extends the rhythm of the dancers since the tip of the vase connects with the dancers' touching fingers. As a result arms, vase and stand splay out around this

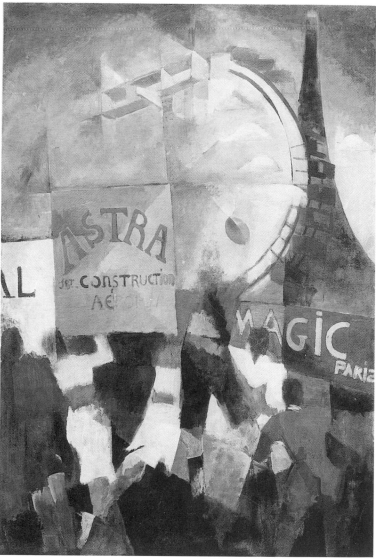

81, above left. Henri Matisse *Nasturtiums with 'Dance'*, 1912. Oil on canvas. 190.5 × 114.5cm. Hermitage Museum, St Petersburg. Formerly in the Sergei Shchukin Collection.

82, above right. Robert Delaunay *The Cardiff Team (Third State)*, 1912–13. Oil on canvas. 196.5 × 130 cm. Stedelijk Van Abbemuseum, Eindhoven.

point. The modelling illustrates the same compositional function as the struts of the machine painted by Malevich.

But the circular rotation of the grinding machine is more geometrically precise than anything in the fluid movement of Matisse's *Dance*. It recalls the clock-face circle of Chagall's *Homage to Apollinaire* (Plate 45) and, beyond that, the disk motifs of Robert and Sonia Delaunay, for here again, hidden beneath the scintillation of fragmented forms, the underlying motif of the circle within the square is visible. Yet Malevich is depicting a whirling machine driven by the power of human limbs. Whilst this is not an automobile or an aeroplane it does give an impression of glittering and mechanical movement. This mechanical element was alien to Matisse although Delaunay admired the giant Ferris Wheel in Paris and painted the aeroplane of Blériot in his *Cardiff Team* of 1913 (Plate 82) of which he said that 'the whole painting is an ensemble of rhythms'.[35] This painting was exhibited at the Salon des Indépendants in 1913 in Paris. By winter 1913 Robert Delaunay was working on his *Sun and Moon (Soleil-Lune)* series of paintings.

Fast movement and machinery were admired by the Italian Futurists and it is certainly likely that Malevich knew some of their work by 1913. But French artists too depicted mechanical devices and movements. In 1913 Apollinaire had written in *Les Peintres Cubistes* of Marc Chagall, Marcel Duchamp and Francis Picabia as Orphic Cubists. We have noted Larionov's interest in Orphism as expressed in his recent manifesto and there is no reason to assume that Malevich was ignorant of Marcel Duchamp's *Nude Descending a Staircase* of 1912. The flights of stairs in Duchamp's painting and *The Knifegrinder* of Malevich play a similar role in pacing out the regular rhythm against which the figures' own movements are set. As the art historian Patricia Railing has noted, a small related lithograph, perhaps produced later by Malevich, is inscribed 'Futurism: Movement of a man on a staircase'.[36] This may reflect later awareness of Duchamp's painting, which brought him notoriety in New York in 1913, but it is possible that Malevich knew of it through any number of sources by 1913. One further indication, of a wholly different kind, derives from the provenance of *The Knifegrinder* (Plate 79) which came to Yale University Art Gallery as a gift from the Société Anonyme, the organization for which Katherine Dreier and Marcel Duchamp were buyers. Duchamp must have been intrigued to see a Russian interpretation of a theme of his own and one in which mechanical devices and also mathematics played their part.[37]

Like so many of the recent paintings by Malevich, *The Knifegrinder*'s subject concerned the act or equipment of cutting. Here it is a knife, elsewhere is found the axe, the scythe, the sickle and the saw. Soon, in 1913–14 the scissors, sabre and bayonet were to join the list of cutting devices. This may refer to collage, apparently unused so far by Malevich, or it may relate to his geometry in some way, to the sectioning of a line or the cutting of a form. Until *The Knifegrinder* Malevich painted figures with unbroken silhouettes and unbroken planes. Splicing images was a new development in *The Knifegrinder* where, in the Italian Futurist manner, several fragments of repeated images were to be linked, slotting into their surroundings and intersecting.

By May 1913, Malevich was impatient to progress beyond his scenes of peasant life as a letter to Mikhail Matyushin indicates: 'all the time harvesters, sheaves, peasant faces do not allow me to paint . . . I wish to fly ahead into those times when the earth and the moon will serve man as energy, movement.'[38] Robert Delaunay wrote in broadly similar terms the following month in a letter sent to August Macke from Louveciennes: 'It is there [in the simultaneous contrast of colours] that the spirit can evolve, by comparing the antagonisms, the struggles, the movement from which is born the decisive moment, when man becomes aware of himself on earth.'[39]

In October 1913 Sonia Delaunay and Blaise Cendrars released their decorated scroll poem *La Prose du Transsibérien de la petite Jéhanne de France*. It was published by Editions des Hommes Nouveaux in Paris, but Sonia Delaunay also prepared a design for a poster for Smirnov's lecture on simultaneity delivered at the Stray Dog Cabaret in St Petersburg in 1913. One way or another Orphism was readily available to Malevich by 1913. His paintings and his comments both suggest a compatibility of techniques and ideas. Furthermore, in the Russian *Apollon* magazine the critic Sillart discussed the Parisian exhibition of the Futurist sculpture of Umberto Boccioni, describing his work in terms equally applicable in Russia. He discussed the figure 'as a centre of plastic movements in space'[40] but he detected only the rhythms of the machine.[41] Writing about Boccioni's *Development of a Bottle in Space*, he concluded that such sculptures 'can interest a mathematician or a physicist, but I cannot see how there is any kind of sculptural significance in them'.[42]

The Knifegrinder seems to be unique in Malevich's work, although other paintings that dramatically splinter forms in this way may have been lost. Its 'scintillation', to use

Malevich's term, creates a light effect by the intersection of many small planes, an effect also used by the Italian Futurist painter Gino Severini. *The Knifegrinder* is a composite homage to contemporary themes. Despite its size, dynamic energy and resolution, this composition is perhaps primarily a response to the ideas of others. But it is in itself a remarkably resolved painting in which every detail is efficiently related to the whole and made to play its part.[43] One reason for this is its mathematical underpinning. Straight lines radiate from the focal point and by their directions link the stairs with the circular movement of the knifegrinder's wheel. This makes for a dynamic harmony because it relates all of these rhythms together and links them to the triangle of the struts in the grinding machine. This is a right-angled triangle with 27° and 63° as the other angles. These angles, all multiples of 9°, are repeated elsewhere. We are witnessing not simply the format of the circle in the square with a secondary focal point marking the golden section vertically and horizontally but also a recurrent use of the angles of 27° and 63° in particular – it occurs, for example, in the angle of the banister to the vertical edge top left (its complement being 27° to complete the right-angle). The number 9 also features in the *vershok* grid as the canvas is 18 *vershok* square and can readily be divided into a grid of 9 × 9 squares.

Two other paintings of 1912–13 share this emphasis on multiples of the 9-degree angle. The first, *Head of a Peasant Woman*, is the same width (18 *vershok*, or 80.01 cm), but there are important differences. In this painting features are not repeated in a cinematographic way and they do not therefore need to insect or appear transparent as an effect of movement. *Head of a Peasant Woman* is a firmly static composition, with its subject centrally placed and frontally viewed like earlier heads by Malevich. Yet Malevich has been radical in his construction of the head in its kerchief. The face is not easily recognized as it so firmly resists conventions. In addition, Malevich has built up the image from conical and cylindrical curves vigorously modelled in a manner that scarcely reflects the forms of facial features. In part at least this is organized geometrically. The top angles of the head are 36° and 45° with a right-angled triangle inserted along the vertical which bisects both the brow and the canvas. Other angles include 45, 72 and 81°, all once again multiples of 9°. In this respect *Head of a Peasant Woman* seems to be related to the far more dynamic *Knifegrinder*.[44] The image is perhaps one of a distinct series in which Malevich readdressed the themes of his recent paintings of peasants. It also appears in two lithographic variants and should be considered in the context of other lithographic images, some of which may once have had a direct relation to canvases now lost. That some of these rework older themes is an example of Malevich's characteristic recycling of subjects as his enthusiastic response to Cubism and Futurism affected his techniques and compositions. It also suggests that this handful of themes is of special importance to Malevich over and above their genre interest.

The second, *Peasant Woman with Buckets* of 1912–13 (Plate 83), is evidently a composite work developed from a whole sequence of earlier paintings. It has the back elevation of *Peasant Women in the Field* and it has the watercarrier theme revived from the smaller *Peasant Woman with Buckets and Child*. The image of balanced buckets suspended from a bar across the shoulders is familiar from older Russian art, from *lubok* prints and from Grabar's Impressionist painting *March Snow* of 1904.[45]

Malevich's canvas (18 *vershok* square) should be compared with *The Knifegrinder* and *Head of a Peasant Woman*, which are the same width. They could form a kind of triptych with square canvases either side of the *Head of a Peasant Woman*. Even if we acknowledge the substantial shift of theme from male to female, urban to rural and mechanical to non-mechanical there remain similarities, for *Peasant Woman with Buckets* has, like *The*

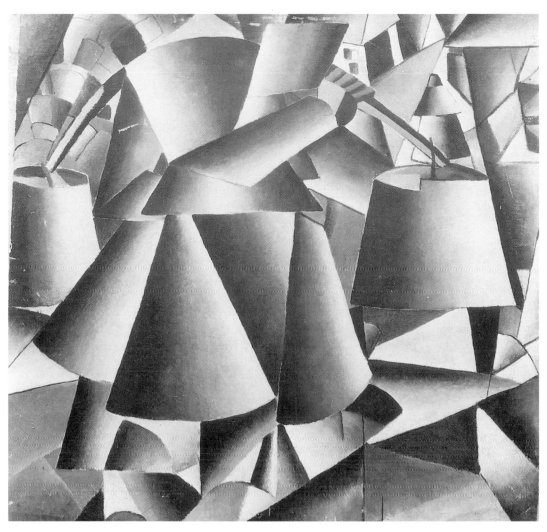

83, above. Kazimir Malevich *Peasant Woman with Buckets*, 1912–13. Oil on canvas. 18 × 18 *vershok*. 80.01 × 80.01 cm (given as 80.3 × 80.3 cm). Museum of Modern Art, New York.

84. Diagram of the compositional structure of Plate 83.

Knifegrinder, a specific focal point around which curved planes diverge (Plate 84). This point at the left of the waist is on the major diagonal of the square from top left. Angles associated with this point are multiples of 9°: 45°, 63°, 99°, 18°, 90°. Elsewhere 27°, 36° and 72° occur. Thematically, perhaps the most recent forerunner of this painting was the *Morning after the Storm* (Plate 77) which featured a back view of women carrying buckets. In fact, these two paintings were hung together at the Union of Youth exhibition in 1913. Malevich provides in both paintings a distant view of the village street where a further figure is visible. There is some breaking up of the figure in the later painting but no transparency in the planes. The hand holding the wooden support for the buckets attaches to an arm connecting with the waist. This is a monumental and powerful painting employing straight and curved lines to establish curved surfaces, but this does not lead to effects of transparency of the kind used by Duchamp or Boccioni to depict movements. There is scarcely any sense of psychological contact with this figure: she has little or no personal identity and is a construction of geometric forms which are related to the canvas edge as much as to the image. These geometric forms, which are subject to the effects of light and shade, describe curved surfaces awkwardly interlocked. In turn those surfaces are set in a shallow picture space which, like a backdrop, lies immediately behind the figure, permitting little sense of recession into any deeper space. This square painting was illustrated in the periodical *Ogonyok* in 1913 where it was dated 1912.[47] Malevich was dedicated to geometry by this point. *Peasant Woman with Buckets* perhaps marks the point where Malevich began to make the mathematical basis of his work a primary consideration. Compared with other paintings exhibited at Target this painting is rigid with angles and has nothing of the easier and perhaps more arbitrarily determined space of the *The Scyther* (Plate 60) or related works. Consequently, the square format was subjected by Malevich to a rigorous investigation into its internal proportions and relationships. These he explored by using proportions based on the *arshin* measurement. 'Light enters my study from above,' wrote Malevich to Matyushin on 3 July 1913, '. . . the sun somehow manages to pass its rays into my little window and light up a whole square *arshin* of the painting.'[48]

85. Kazimir Malevich *Peasant Woman with Buckets* (Study), 1912. Pencil on brown cardboard. 9.4 × 10.5 cm. Wilhelm Hack Museum, Ludwigshafen.

86. Diagram of the compositional structure of Plate 85.

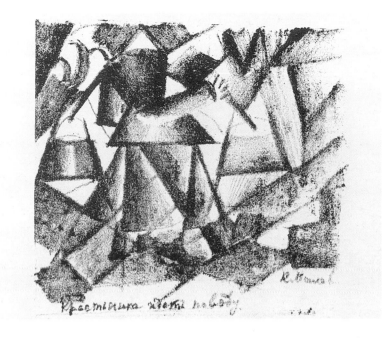

87. Kazimir Malevich *Peasant Woman with Buckets*, 1912–13. Lithograph on white paper. Published in A. Kruchenykh's book *Vozropshchem (Lets Grumble)*, St Petersburg 1913. Inscribed in the stone, 'The peasant woman goes for water'. Signed lower right. 9.7 × 10.5 cm (paper 17.4 × 11 cm). British Library, London.

Two drawings and one lithograph are closely related to this painting. The drawing (Plate 85) in the Wilhelm Hack Museum at Ludwigshafen is perhaps the first of the sequence, for here the space is airy and light without the dense interlocking of forms that characterizes the painting. The back view of the woman is easy to recognize and there is an element of anatomical detail. The line of the thighs, for example, is visible within the skirt. This helps to explain the downward-pointing cone visible in the equivalent area of the painting. Similarly, both feet are clear in the drawing, whereas they are fully locked into the mass of planes that dominate the lower edge of the painting. The position of the arms is also visible in the drawing and we can see that the arms are both bent at the elbow. In the painting this is less clear as the dense assemblage of conical forms makes it less easy to recognize imagery. The head, even though it is reduced to a triangle in the drawing, is clearly positioned and is recognizable as the woman's head. This triangle, in a more compressed form, is visible in yellow, top left of centre, in the painting. The drawing has suggestions of buildings and trees indicated by angles and arcs (Plate 86). Finally, in the drawing the *pose* of the peasant woman is convincing and straightforward: it appears to be both lively and relaxed as she walks along. By contrast, the painting is tight, dense with curved planes and seems almost too big for the square canvas. There is an air of explosive heavy movement. Despite the heavy shading of planes the woman in the painting seems locked into the geometry of her surroundings.

Turning to the lithograph (Plate 87), we are at once much closer to the denser geometry of the painting. The skirt, for example, is now a tight zigzag of four cone surfaces as in the canvas. More effort is required to discern the bent arms of the upper torso. The landscape is here more obviously geometry than landscape. Across the lower part of the print lines criss-cross to suggest the perspective of a floor surface and this now obscures the feet. The head's triangle, now white, is recognizable, but a plane to the right of it echoes its shape and looks just as solid. In the drawing this was softer and evidently a background motif. In fact, a severe geometry is at work in both the lithograph and drawing. Truncated cones inform each part, whether bucket or torso, just as in the painting. All of the major angles are multiples of 9° (i.e. 108, 72, 54, 63, 45, 27). Isolating

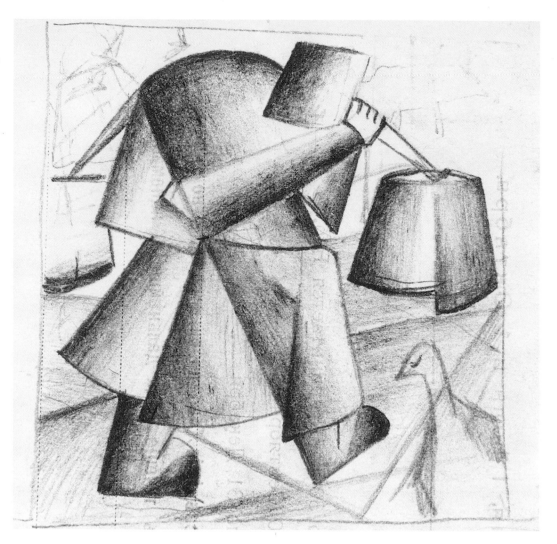

88, above. Kazimir Malevich
Peasant Woman with Buckets,
1912–13. Pencil on paper. 10.5 ×
10.7 cm. Russian Museum,
St Petersburg (acquired 1928).

89. Diagram of the compositional
structure of Plate 88.

62

90. Mikhail Matyushin, Kazimir Malevich and Aleksei Kruchenykh at Uusikirkko, Finland, in July 1913. Kruchenykh holds a prototype version of *Troe*, although here the lettering and large comma are different from the published version.

these angles makes the underlying structure clearer, but Malevich is constructing his figure deliberately to fit a geometric scheme. Perspective and proportion, which can quite credibly record observation, have an equally active role in constructing the rhythms and spaces of paintings themselves. This allows Malevich to permit new concepts of space and time.

Surprisingly, the influence of the Pont-Aven painters, Sérusier and Gauguin, is still visible. A drawing (Plate 88) in the Russian Museum in St Petersburg shows a remarkable variation on the other drawing and the lithograph. The pose is the same and there are traces of the background huts and trees as well as the line of the path. But three other features are noticeable. First, in the foreground lower right is a goose that is essentially a Pont-Aven goose: this brings back the genre element, although this is lost again in the painting. Second, the head has either vanished or become the rhomboid shape next to the hand. Finally, the elbows are no longer as intelligible as they were in the other drawing and lithograph. Yet this image closely resembles the painting too. It may follow from this that two positions of the peasant woman's walking movement are superimposed.

There is again a focal point coinciding with that in the painting and there is a firm geometric structure in what seems at first a slight drawing on poor paper. In fact, it is a carefully resolved (Plate 89) drawing that Malevich may have made whilst working on the canvas. All of the major angles within its square perimeter are multiples of 9°: 9, 27, 36, 45, 54, 72, 81, 90, 99.

The lithograph of the *Peasant Woman with Buckets* (Plate 87) was published in the book *Vozropshchem (Let's Grumble)*, a Russian Futurist work by the poet A. Kruchenykh, one of many collaborative publications produced by Kruchenykh, Khlebnikov and others in 1913–14. Kruchenykh was the husband of the painter Olga Rozanova, who shared many of Kruchenykh's interests and who was a fellow illustrator of *Vozropshchem*. In fact, there is a continuity in Malevich's illustrative work in 1913: two sets emerge and one of these relates to the peasant theme. On 18–19 July 1913, for example, Malevich, Kruchenykh and Matyushin visited Uusikirkko in Finland to establish the First All-Russian Congress of Bards of the Future (Plate 90). One result of this encounter was the opera *Victory over the Sun* to which we shall return. Another result of this collaboration was the Russian Futurist book *Troe* (The Three)[49] and this had on its cover (Plate 91) an image of a standing peasant woman formalized in a similar way to the *Peasant Woman with Buckets*.

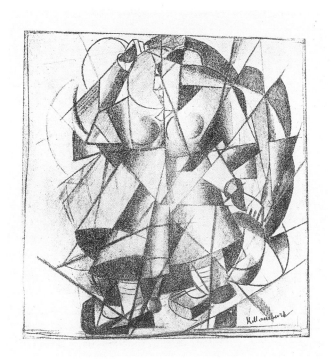

The skirt in particular is close in shape. Here Malevich has even constructed his lettering with the same shapes as if they were a modern cuneiform. This woman is now so completely resolved as an image that she can be edited down no further. She is the Russian Futurist peasant woman. Nothing in Italian Futurism was comparable because peasant imagery was, on the whole, at odds with the mechanistic dynamics of the Italian Futurists. Yet Malevich in *The Knifegrinder* celebrated the movement of machinery – albeit simple machinery. Malevich in his Russian Futurist book illustrations seemed willing to maintain the peasant imagery alongside more mechanistic themes.

All of the lithographs of the peasant themes repeat earlier motifs as if to sum up major achievements and important images for Malevich. *Prayer* (Plate 92) takes its theme from the funeral sequence but it is further developed in the lithograph published in the Russian Futurist book *Explodity* in June 1913. A woman kneels facing to the right, as the patterned shoes lower left make clear. The largest plane corresponds to her skirt and the curve of her back is visible at left. But the image then becomes difficult to read as a result of the triangular plane which opens out into the surrounding space upper left. The woman's kerchief can be seen as the uppermost triangle with her face below it where her hand touches her brow in the sign of the cross.

Undoubtedly an element of genre survives and it remains possible to recognize the theme adopted in the previous series. But apart from an impression of religious devotion Malevich tells us little about his figure.[50] He has balanced geometry and imagery so that neither predominates. His techniques range from a mundane record of the shoes to the open triangular shape which cannot be interpreted as a depiction at all. One main diagonal line cuts the figure, other conical and cylindrical forms are then built outwards from this axis. The mathematical aspect visible in *Peasant Woman with Buckets* is equally in evidence here. Her angles are multiples of 9° (54, 81, 72, 99).

The solitary peasant woman was the theme of five more lithographs published in 1913. In Kruchenykh and Khlebnikov's book *Slovo kak takovoe* (The Word as Such), published in October 1913, the *Reaper* (Plate 93) reappears on the cover complete with her sickle, but her image is crossed by a dense network of intersecting lines. Within this, the broad mass of the torso may be glimpsed and fingers appear at the top of the image just as shoes, like those of the woman in *Prayer* (Plate 92), appear lower down. Larionov's technique of Rayism had produced networks of intersecting rays of light, but Malevich has a different version of this: he has shaded the areas that his lines create so as to give them an appearance of opaque solidity. A related image (Plate 94), already published in *Troe* in September 1913, depicts precisely the same theme and pose. This is most evident in the feet which are obviously versions of the same motif. The *Woman Reaping* published in *Troe* (Plate 94) has feet, legs and skirts which are easily recognized as the woman moves forward and to the left. The profile of her face appears top centre and there are indications of her breasts. Referring back to the *Reaper* in *Slovo kak takovoe* (Plate 93) those features become evident there too. But *Woman Reaping* in *Troe* (Plate 94) is a rounder assemblage of planes built out from an explosive arrangement of lines, so that the overall effect is of a shape approaching a circle within an approximate square. This is full of a bustle and movement reminiscent of *The Knifegrinder*. *Woman Reaping* and geometry, the peasant and dynamism, are being brought together into a new synthesis.

In three remaining peasant images Malevich adopted the static full-frontal portrait format. Two were female and the other male and all three were versions of images developed in paintings. The two images of women derive from the oil painting *Head of a Peasant Woman* (Plate 95) and were published in Russian Futurist books in 1913. One (Plate 96) was pasted onto the cover of *Porosyata* (Piglets) by V. Zina and A. Kruchenykh,

91, opposite page, left. Kazimir Malevich Cover for *Troe*, 1913. Lithograph, published September 1913. 19.8 × 18.3 cm.

92, opposite page, right. Kazimir Malevich *Prayer*, 1913. Lithograph. Published in A. Kruchenykh's book *Explodity* in 1913. Inscribed in the stone 'Molitva' (prayer) and signed lower right. 17.6 × 11.8 cm.

93, opposite page left. Kazimir Malevich Cover illustration for *Slovo kak takovoe (The Word as Such)* by A. Kruchenykh and V. Khlebnikov, 1913. Lithograph. Published in Moscow, October 1913. 14.5 × 9.5 cm. British Library, London.

94, opposite page right. Kazimir Malevich *Woman Reaping*, 1913. Letterpress. Published in *Troe*, September 1913. 13.8 × 13 cm.

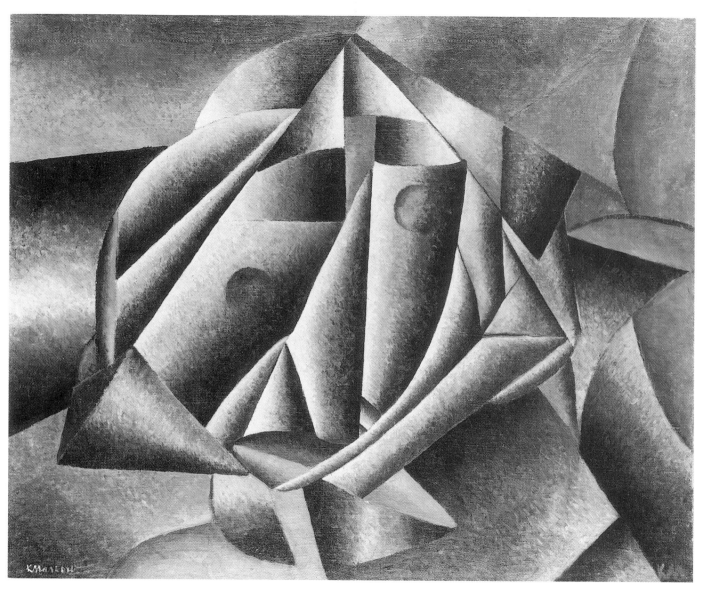

95, above. Kazimir Malevich *Head of a Peasant Woman*, 1912–13. Oil on canvas. 80 × 95 cm. Stedelijk Museum, Amsterdam (acquired from Hugo Häring 1958).

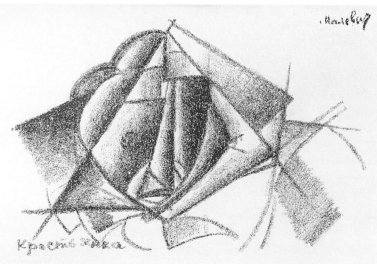

96. Kazimir Malevich *Head of a Peasant Woman*, 1913. Lithograph. Published on the cover of *Porosyata (Piglets)* by V. Zina and A. Kruchenykh in 1913. Inscribed in the stone, 'krestyanka' (peasant woman). 9.6 × 14 cm.

published in August 1913. As a lithographic drawing it is not as thoroughly resolved as the canvas, but Malevich established a structure of lines in which certain straight lines in particular play a decisive role. This lithograph is inscribed *krestyanka* (peasant woman) lower left. A straight diagonal rises sharply from this point to demarcate the edge of the kerchief and to pass beyond to establish a rectangular plane by means of a perpendicular line to the right. From such lines other planes are established and given solidity by means of shading. The woman's head has no neck: it is sunk deeply into enormously wide shoulders, as if she has been folded outwards and forwards around the central vertical axis. All of these features are visible but less obvious in the painting where some of the angles are changed.

The second lithograph (Plate 97) on this theme was published in *Troe*: its more meticulously finished presentation corresponds directly to the painting. The strong diagonal establishes a transparent plane with the line near centre top. The result is to stress a large part of an upright equilateral triangle framing the face but cut off lower right. The width of the figure still suggests a fold around the central vertical axis. This implies more than one viewpoint is adopted, a device being used by the Parisian Cubist Juan Gris at this time. Here Malevich's lithograph makes clear, at the right of his image, a *side* view of the woman's shoulder, neck and kerchief. This is a reading that is possible in the painting too, but the monochromatic lithograph, being simpler, makes the structure more plainly visible. In the sequence of lithographs this image is the most sculptural. Planes intersect in the underlying drawing, but each section is then firmly moulded by chiaroscuro to indicate a substantial form. Other works in the sequence are less fully resolved so that the crossing lines are dominant: the effect in this case is of a crystalline transparency. The segments become monumental, for they appear locked together with no intervening space.

The last lithographic image of a peasant published by Malevich in 1913 is inscribed *Portrait of a Builder Completed* (Plate 107). It is a graphic version of the painting *Portrait of Ivan Klyun* (Plate 105). The painting is a sophisticated and innovative work in which

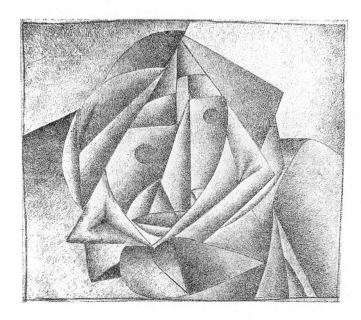

97. Kazimir Malevich *Head of a Peasant Woman*, 1913. Lithograph. Published in *Troe*, 1913. 11.4 × 13cm.

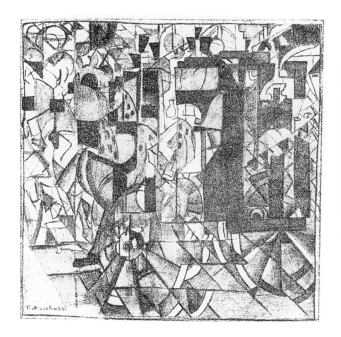

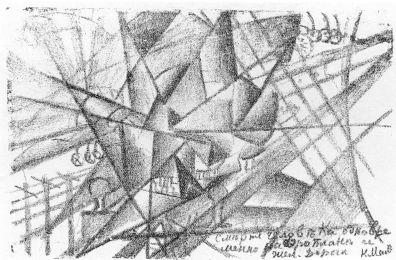

99, above. Kazimir Malevich *The Simultaneous Death of a Man in an Aeroplane and on the Railway*, 1913. Lithograph. Published in A. Kruchenykh's book *Explodity* in 1913. Inscribed with the title, and signed lower right in the stone. 9 × 14 cm.

98, above. Kazimir Malevich *Horse Driven Coach in Motion*, 1913. Letterpress. Published in *Troe*, 1913. 11 × 9.8 cm.

Malevich once again used the frontal image of the human head to devise and demonstrate wholly new techniques. The lithographic version chronologically rounds off the present graphic sequence, but as it is more of a new beginning than a conclusion it is best considered later, alongside a related drawing and the painting.

Other graphic works of 1913 show Malevich using urban subjects. He seems to have made little attempt to publish the prints depicting similar subjects together. Range and contrast seem more important. *Troe*, for example, included a crystalline drawing (Plate 98) of a horse and carriage in a city street. Crossing diagonals splice together several viewpoints in an atmospheric effect in which the many small planes recall those of *The Knifegrinder*. Like that painting this image is square and it may relate to a lost canvas. It is also possible that Malevich is literally illustrating a point made by Ouspensky in his book *Tertium Organum* which had been published the previous year. Ouspensky was discussing the different appearance of the world to different creatures: 'Why does a dog bark so furiously at a passing carriage? We do not quite understand it. We do not see how a passing carriage turns, twists and grimaces in the eyes of a dog. It is full of life – the wheels, the roof, the mudguards, the seat, the passengers – all this is moving, turning.'[51] The possibility that Malevich was illustrating the ideas of Ouspensky needs to be discussed. Malevich knew of these ideas, just as he knew of Cubism and the book *Du Cubisme*, because his friend Matyushin was citing both in 1913 and they were both together in Finland. Very soon they were collaborating on an opera.

Two remaining lithographs are important here and both were published in the book *Explodity*. The first lithograph, inscribed by Malevich with the title *The Simultaneous Death of a Man in an Aeroplane and on the Railway* (Plate 99), is a mass of exploding lines in which the nexus or kernel of sections so formed has been shaded in to suggest solidity where it is least expected.

Malevich later expressed the idea of the aeroplane 'hatching' from the train like a mechanical butterfly from a mechanical caterpillar. More than once he said that mechanical travel was not a matter of convenience, but represented an irresistible growth in mankind's spatial perceptions and control. Hinton also argued this way. Both men sought

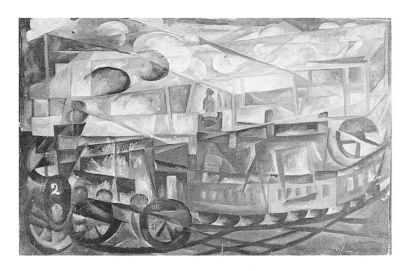

100. Natalya Goncharova *Aeroplane over Train*, 1913. Oil on canvas. 55 × 83.5 cm. Kazan Art Museum.

to extend the faculties of perception. In this case, for example, Malevich has his collision occur between a train which is limited to the two-dimensional world of railway tracks, and the aeroplane whose natural environment is three-dimensional space. The lithograph also shows telegraph poles crossed by wires lower left. The front of the train may be seen to the right of this. A similar keyhole shape is transferred to centre bottom of the print. Above this a sequence of pyramidal forms bursts outwards like an explosion. Finally, wheel-like forms appear centre left and top right. The whole image is crossed by sharply converging lines and, at right, steep additional diagonals.

It is not easy to reconcile this image with the title that Malevich has inscribed upon it. He has again employed crossing lines to produce angular shapes that he has then shaded as if they were solid forms lying side by side. The railway engine, however, is clearer and is associated with the telegraph poles that recede along the swiftly converging diagonal lines to the right. This feature comprises a conventional perspective system receding towards a vanishing point associated with the train. Roughly parallel diagonal lines mark out the different progress of the aeroplane seen centre left as a cylindrical shape within the rays of its propeller and wing. It is not immediately obvious that the aeroplane proceeded from lower right to upper left.[52]

The airplane was an image celebrated by Robert Delaunay. Powered flight was undertaken in earnest by 1913: the daring and dangerous achievements of pilots were widely reported. But what he might have made into an enthusiastic celebration of the inventions of a new age, Malevich handled rather differently. By relating the train and aeroplane images together Malevich reveals a direct inspiration from Goncharova who tackled precisely the same theme (Plate 100). In addition, the linear structure used by Malevich recalls the Rayist works that Larionov first exhibited at the 1913 Target exhibition. The theme itself also had Russian Futurist associations, as the poet Kamensky was a pilot until a serious crash suggested a safer career. The pilot experienced new perceptions and new perspectives. This made the pilot a new protagonist for Malevich and a pioneer of changing perceptions of humanity. Just as the train hatched to become a plane, so mankind was evolving new forms. Russian Futurists even observed this phenomenon in the continuing development of language through countless years of growth: all words have a dimension in time. Khlebnikov, whose publications Malevich was illustrating in 1913, was perhaps the most brilliantly original exponent of this idea. The compendium *A Trap for Judges II*, published in February 1913, for example, declares

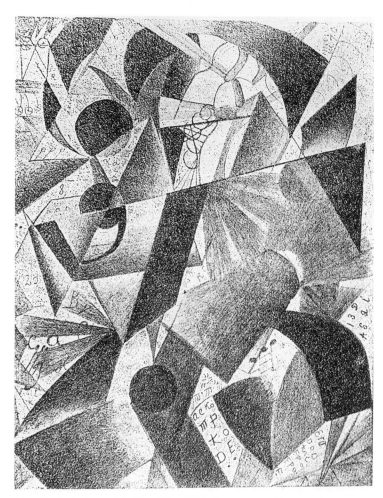

101. Kazimir Malevich *The Pilot*, 1913. Letterpress. 13 × 10.2 cm.

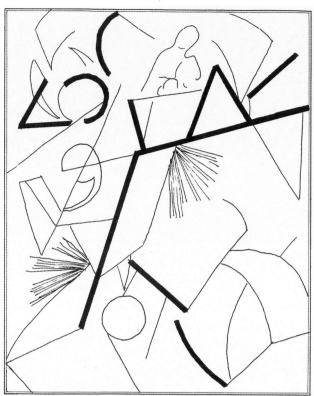

102. Diagram of the compositional structure of Plate 101.

Detail of cover illustration for *Troe* (see Plate 91).

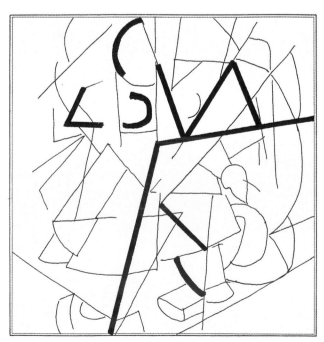

103. Diagram of the compositional structure of Plate 94.

70

in its manifesto: 'We characterise nouns not only by adjectives (as was chiefly done before us) but also by other parts of speech, as well as by individual letters and numbers . . . We think of vowels as space and time (the character of direction); consonants are colour and smell.'[53]

Figures and letters abound in several of Malevich's lithographs of 1913. The cover of *Troe* (Plate 91) with its letters made in a kind of cuneiform script is combined with the peasant woman image and also features a large reversed comma. Interestingly, a photograph (Plate 90) of Matyushin, Malevich and Kruchenykh taken at their convention in Finland in 1913 shows a variation on this cover with the comma the other way round. This represents, perhaps, a preliminary layout. Reversing the comma meant turning it through 180° – a movement in the third dimension – and a sign of the relation of symmetry to higher dimensions as described at length by Hinton and others.

Matyushin writing in *Troe* declared that: 'The days are not far when the conquered phantoms of three-dimensional space, of the illusory, drop-shaped time, and of the cowardly causality . . . will reveal before everybody what they have really been all the time – the annoying bars of a cage in which the human spirit is imprisoned.'[54] Repeatedly in these months Matyushin and his colleagues argued that a new perception of space and time was imminent and even already appearing. The future, made accessible by the new perception, would reveal the continuity of objects, materials and ideas through time. Older perception glimpsed only a cross-section of events. This was the theory advanced by Ouspensky in *Tertium Organum* in 1913.[55]

In *Troe* (Plate 91) the lettering of the title is given a strong character. The 'O', for instance, is split in a manner used in a painting (Plate 105) and print (Plate 107) of an eye in the *Portrait of Ivan Klyun*. A Russian word for the eye is *oko*. This may be some kind of rebus or cross-reference between poetry and image as Khlebnikov focused upon the word *oko* for a whole poem. The 'E' is drawn like the teeth of an irregular saw, which is again visible in the *Portrait of Ivan Klyun*. The characterization of individual letters was a preoccupation of Khlebnikov's. Malevich had illustrated *Slovo kak takovoe* (The Word as Such)[56] in 1913 but *Bukva kak takovaya* (The Letter as Such) was written the same year. There is a close interaction of the verbal and the visual at work here.

Malevich's 1913 lithograph of *The Pilot* (Plate 103) illustrates all of these elements in a dynamic mélange. Some forms resemble the print of the simultaneous plane/train crash, particularly the radiating shading that bursts right and downwards from near the centre and also lower left. These recall the 'propeller' motif but could equally suggest bursts of light, noise or movement. Centre top is the outline of a figure-like form that may be intended to indicate the pilot. There are pulleys top left suggesting a mechanism or the plane's wheels and elsewhere there are musical notes, lettering and numerals. The criss-crossing structure is, as usual in 1913, at least partly shaded in its sections. In some of these areas it incorporates a large comma (centre left) and two full-stops (or black disks). Malevich has also made the activity of calculation part of his image. The whole sheet evokes an appearance of crystalline transparency in which several kinds of reference, depiction and mark are visible. As a result there are at least three ways of reading the imagery in what is effectively an exercise in the perspectives of the newly perceived space. The apparently spontaneous profusion of crossing lines in Malevich's lithography of *The Pilot* (Plate 101) is meticulously controlled. For example, comparing the *Woman Reaping* (Plate 93), which was illustrated in *Troe* in 1913, with *The Pilot* reveals a largely identical infrastructure (Plates 102 and 103). It is possible, for example, to distinguish a pyramid shape behind and around the comma left of centre, and a comparable shape further to the right, suggesting Egyptian references close to Ouspensky's Theosophical interests. The

104. Kazimir Malevich *Arithmetic*, 1913. Lithograph. Published in A. Kruchenykh's book *Vozropshchem (Lets Grumble)*, St Petersburg 1913. Inscribed 'arithmetika', and signed lower right in the stone. 17.5 × 11.8 cm.

musical references recall Matyushin, who was by now working on the score of the opera *Victory over the Sun*. The opera featured flight through time, which this print may illustrate. More generally it suggests an image of the future scientist, described by Professor N.A. Oumoff at the Second Mendeleev Conference in December 1911 as the 'steersman of science', who 'should be constantly vigilant, notwithstanding the prosperity of his voyage; stars should constantly shine above him, by which he plots his course in the ocean of the unknown'. These words were recorded by Ouspensky in *Tertium Organum*.[57]

This sequence of lithographs, each inserted into Russian Futurist books published by Kruchenykh and Khlebnikov in 1913, makes arithmetical and geometrical calculations its dominant theme. The lithograph inscribed *arithmetika* (arithmetic) employs three contrasting but interwoven techniques (Plate 104); two of them are vigorously interlocked and balanced and one is incidental. First, the familiar structure of crossing lines with shaded sections produces a crystalline effect. Second, fragments of numerals, letters and other signs are slotted into this. These heavy graphic signs include, for instance, a section of the figure 4 below the centre of the print and a fragment of the figure 7 visible in the middle of the print; other signs are less intelligible. There is a Russian letter И (I) in the brackets across the centre (:7 И =) I which appears meaningless unless it is simply a general reference to arithmetic. The upper band of fragments is unrecognizable, while lower left is a straight line with toothed barbs resembling some kind of saw more than a numeral

or letter. The whole ensemble is perhaps an evocation of arithmetic, more for atmospheric effect than calculation: it is arithmetic as an image. Calculation is reserved for the underlying structure of the criss-cross grid.

Arithmetic, which like grammar was one of the liberal arts, has its own history as an image. It is associated with melancholia, as are the dividers and geometric solids that Dürer depicted. Dürer's print situated arithmetic and geometry as a development of human thought challenged and weighed down by the attempt to understand, measure and interpret the enormities of the cosmos. Dürer's print also contained references to alchemy conveyed through the image of the heated bowl. Malevich in turn indicates, top left in his print, a machine emitting steam (perhaps a samovar). Just as Dürer studied the proportion, perspective and mathematics appropriate to his age, so Malevich too is responding to the proportion, perspective and mathematics of his own time. In 1913 this involved ideas of the fourth dimension, a concept sustained by the writings of Theosophists and by sympathetic mathematicians. Time, space and geometry comprise for the artist the very substance of perspective. The tradition of single or double vanishing-point perspectives meant that a single time and space could be shown allowing spatial relations and proportions to be established and measured. By 1913 such simple perspectives seemed no longer adequate. The non-Euclidean geometry of Lobachevsky, Minkowski and others, and the theories of Theosophically inclined mathematicians like Claude Bragdon and of mathematically inclined Theosophists like Peter Ouspensky brought these simple systems into doubt. New perspectives were needed to depict plane flight or gravitationless space flight. The idea of time as a dimension also demanded a new perspectival system. In *Arithmetic* Malevich began to define these new perspectives.

Tertium Organum, the book first published by Ouspensky in St Petersburg in 1912, embraced many of these ideas. It discussed the fourth dimension, for instance, in relation to Mme Blavatsky's idea of perception: she stressed 'the superficial absurdity of assuming that space itself is measurable in any direction' and maintained that only matter could be measured within space.[58] 'Space,' Ouspensky said, 'is either a property of the world or a property of our cognition.'[59] When Ouspensky tried to illustrate this he wrote in terms of the relativity of movement, which any Futurist, Italian or Russian, would have recognized: 'every movement of our own is connected with the movement of everything around us. We know that this movement is illusory, but we *see* it as real. Objects turn round before us, run past us, outstrip one another. Houses, past which we drive slowly, turn about leisurely; if we drive fast, they turn quickly; trees suddenly spring up before us, run away and vanish.'[60] This suggests an idea of simultaneity familiar to Delaunay, Boccioni or Duchamp.

But Blavatsky and Ouspensky went further and accepted that time, both past and future, is a dimension upon which rhythmic intervals can be marked out as in space:

> Our planet, wrote Blavatsky, revolves once every year around the sun and at the same time turns once in every twenty-four hours upon its own axis, thus traversing minor circles within a larger one, so is the work of the smaller cyclic periods accomplished and recommenced, within the Great Saros. The revolution of the physical world, according to the ancient doctrine, is attended by a like revolution in the world of the intellect — the spiritual evolution of the world proceeding in cycles, like the physical one . . . Thus we see in history a regular alternation of ebb and flow in the tide of human progress.[61]

This is an argument that Blavatsky developed to incorporate astrology, reincarnation and other mystical concepts of cyclic rhythms in history. But this was precisely what fascinated

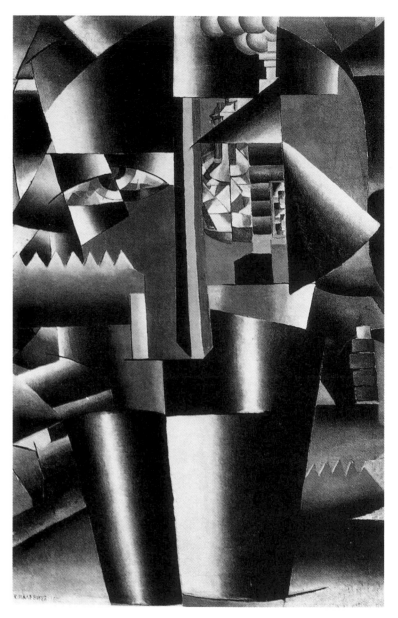

105. Kazimir Malevich
Portrait of Ivan Klyun, 1913.
Oil on canvas. Signed 'K.
Malevich 1911'. 25 × 16
vershok (1 *arshin* wide).
111.13 × 71.12 cm (given as
112 × 70 cm). Russian
Museum, St Petersburg.
Exhibited at the Salon des
Indépendants, Paris, March–
April 1914, and catalogued
as no. 2155.

the Futurist poet Khlebnikov and drove him to the study of number: 'Thus,' continued Blavatsky, 'all those great characters who tower like giants in the history of mankind, like Buddha-Siddartha, and Jesus, in the realm of the spiritual, and Alexander the Macedonian and Napoleon the Great in the realm of physical conquests, were but reflexed images of human types which had existed ten thousand years before . . . reproduced by the mysterious powers controlling the destinies of our world.'[62] According to Ouspensky 'in art we find the first experiments in a *language of the future*'.[63]

When Malevich exhibited with the Union of Youth in St Petersburg from 10 November 1913 to 10 January 1914, he categorized his works into two groups: transsense realism (*zaumnyy realizm*) and Cubo-Futurist Realism (*Kubo-Futuristicheskyy realizm*). The catalogue listed exhibit no. 65 under the heading of 'Trans-Sense Realism'. This painting was the *Portrait of Ivan Klyun* (Plate 105). A drawing (Plate 106) and a lithograph (Plate 107) also exist which are closely related to the painting.

It is characteristic of Malevich to commence a new series with a painting of a head and

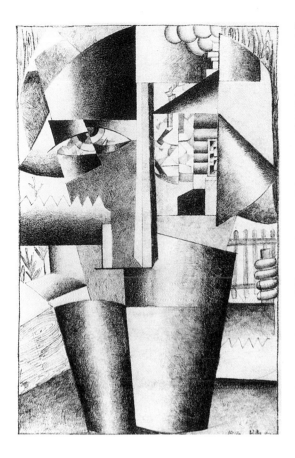

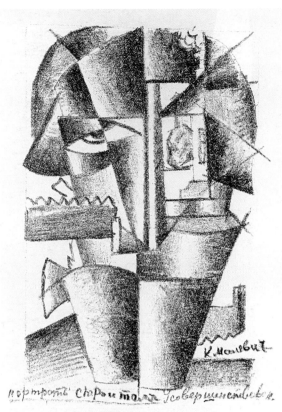

106, far left. Kazimir Malevich *Portrait of a Builder* (study), *c.*1913. Pencil on paper. Inscribed lower right '1911g.K.Mal' (year 1911, K.Mal). 49.6 × 33.4 cm. Tretyakov Gallery, Moscow (acquired 1929).

107, left. Kazimir Malevich *Portrait of a Builder Completed*, 1913. Lithograph. Tipped into the book *Porosyata (Piglets)*, published by V. Zina and A. Kruchenykh in 1913. Inscribed with the title in the stone. 17.5 × 11.2 cm. British Library, London.

shoulders seen frontally. *Portrait of Ivan Klyun* is such a painting – it is in fact closely related to the *Head of a Peasant* (Plate 52) and *The Orthodox* (Plate 53) of 1912, but much has changed in this year which saw Malevich collaborating with Matyushin, Kruchenykh and Khlebnikov. He also responded vigorously to Cubist and Futurist examples as *The Knifegrinder* (Plate 79) revealed. In addition, in 1913 the collector Morozov had acquired Picasso's *Portrait of Ambroise Vollard*, painted in 1910, which also comprised a full-frontal portrait and an impressive example of Cubist painting, which Malevich and others can scarcely have been expected wholly to ignore.

This bearded figure, painted several times by Malevich in 1912, is probably the painter Ivan Klyun in each instance. This portrait is a new version of *Head of a Peasant* (Plate 52). The hair, for example, lifts slightly at the left and this is carefully preserved in the later painting. The long nose, comprising three distinct tones, is the same. Similarly, the translucent and hypnotic eye is repeated, though transformed, in the later painting. Neither head has a visible mouth: this is hidden in a substantial beard in both paintings, and the shoulder at left meets the line of the beard at the same point and angle. But there are important innovations of content and style. The later painting is proportionately taller, being one *arshin* wide and just over $1\frac{1}{2}$ *arshin* tall. This means that there is little room for the familiar backdrop effect of explanatory detail. The church buildings of *Head of a Peasant* vanish and in their place three extraordinary motifs appear. Most obviously, Malevich has replaced one eye with a view of a wooden house and of a curious device beyond this. The house has its window split and partly obscured by a conical form derived from the hair of *Head of a Peasant*. There may be a visual pun here based on the idea of the eye as a window onto the soul, as Leonardo had described it. The other eye is split across two planes as the 'O' in the title *Troe* had been split. *Oko* is eye; *okno* is

window. This is exactly the kind of study of the sound, material and shape of Russian words and roots that Malevich's friend, the poet Khlebnikov, was so concerned with. As Khlebnikov and Malevich were collaborators on *Troe* and other books in 1913, such a correspondence of ideas would not be surprising. In France Duchamp made similar verbal points, titling a French window *Fresh Widow*, for example.

The second surprising image, not evident in *Head of a Peasant*, is the presence of the big two-handed saw. This is out of scale, out of place and, like the eye, it is split. The eye formed an analogy with the window based upon the verbal root and shape of the letter 'O' which is the same in the Russian and Latin alphabets. When we consider the saw, comparable explanations are possible. In *Troe*, the E (pronounced *ye*, as in *yet*, in Russian) was toothed like a primitive rake or saw. To eat, in Russian, is ЕСТЬ (*yest'*). Just as the window has replaced an eye, so the head that Malevich has painted has no mouth but it does have the teeth of a saw. This partly explains the positioning of the image of the saw. The Russian for saw is ПИЛА (*pila*), which is perhaps not relevant here, but to say that a saw is 'biting' is to use the verb КЛЮНУТЬ (*klyunut'*) which includes the name of Malevich's follower, the painter Ivan Klyun, of whom this is ostensibly the portrait.[64] It is possible that the images split by Malevich, the house, eye and saw, are linked by verbal relations. Malevich's contemporary involvement with the book *Slovo kak takovoe* (The Word as Such) is evidence of his awareness of verbal structures.[65] Beside the wooden house inside Klyun's eye is a mechanical device with a flared hood (like a skirt). Upper right of this is a funnel-like structure billowing steam or smoke. Both are again split images. The billowing clouds perhaps come from the house or from the mechanism and, in either case, suggest an analogy of house and samovar and a pairing of the words *dom* (house) and *dym* (smoke, steam).[66]

The billowing chimney occurs in other works. Most notably it features in the lithograph *Arithmetic* and this suggests a role of special importance. In *Arithmetic* (Plate 104) it appears as an outline drawing top left, with its roof-like form shaded in the painting. This combination of machine, mathematics and angular forms is in some way related to the *Portrait of Ivan Klyun*. The links may be either verbal or visual, or both.[67] Malevich sent the painting to the Salon des Indépendants in Paris (1 March–30 April 1914) where it was exhibit no. 2155. Despite the colossal size of the exhibition, Malevich may have felt an allegiance to the Orphism of Delaunay and Duchamp as he understood it. The Union of Youth exhibition held in St Petersburg included many works indicative of French liaisons. The painter Vera Shekhtel', for example, exhibited a work described in the catalogue as 'no. 155: *Orphist Painting*' (*Orfeisticheskaya Kartina*), whilst David Burlyuk displayed a 'pictorial bas-relief' of St George, executed in leather 'colours selected by chance (to be looked at from a distance of four arshin)'.[68] Malevich listed his *Portrait of Ivan Klyun* before his *Knifegrinder*. Klyun's own exhibits included a *Sawyer* (*Pil'shchik*), and it is evident that he used similar themes to those of Malevich.

The mysterious mechanism in Malevich's *Portrait of Ivan Klyun* (Plate 105) may relate to other mechanical objects that Malevich catalogued as 'Cubofuturist Realism'· at the Union of Youth exhibition in November 1913. These included no. 68 *Parafin Stove* (*Kerosinka*), no. 69 *Wall Clock* (*Stennye Chasy*), no. 70 *Lamp* (*Lampa*), and no. 71 *Samovar* (*Samovar*); together they form a sequence of four paintings of single objects.

In contrast to these mechanistic themes, Malevich's trans-sense realism (*zaumnyy realizm*) was dominated by rural and peasant themes. This remains true for the *Portrait of Ivan Klyun* and its related drawing and lithograph. The closely related lithograph (Plate 107), tipped into the Russian Futurist book *Porosyata* (Piglets), is inscribed 'portrait of a builder completed'. The small lithograph follows the painting, clarifying some of its linear

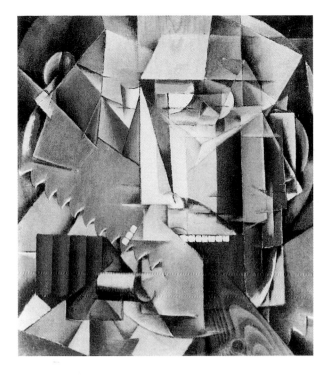

108. Ivan Klyun *Self-Portrait with a Saw*, 1914. Oil on canvas. 16 × 14 *vershok*. 71.12 × 62.23 cm (given as 71 × 62 cm). B.M. Kustodiev Art Gallery, Astrakhan.

structure, but its small size makes the image appear deceptively crude. Here again is the split eye motif, the house and mechanism beside it, and here too is the steaming chimney upper right and the split image of a saw. There is, however, one additional element: lower left an axe-blade appears. This image derives from earlier genre scenes in which the axe and saw appear. But these now form part of the composite image and are interlocked; they no longer function as an explanatory backdrop. These tools are needed to construct the wooden house, yet Malevich tells us that it is the builder, not the house, that is completed.

The drawing (Plate 106) of the theme shows other details absent from both the canvas and the lithograph. Peripheral panels have woodgrain indicated, a fence appears to the right and plants to the left. But in every other way it closely follows the painting. The proportions of all three are comparable and involve numerous angles that are multiples of 9°. The main image is locked firmly into these proportional rhythms.

Malevich's 'sitter', his friend Klyun who was also known as Klyunkov, made a self-portrait in 1914 (Plate 108), now in the B.M. Kustodiev Museum at Astrakhan, which is effectively a direct answer to Malevich's painting. The teeth of the saw appear at left and reappear in the right bottom corner beside the woodgrained area that they are presumably cutting. Klyun's image of the face is less easy to recognize than that of Malevich but it is similarly dominated by the pale-toned perpendicular of the nose. The line of the eyes (but no image of them) cuts through horizontally near the top of the nose area, but below it Klyun's teeth form lines of regular little squares, again split to right and left, like the teeth of the saw. Klyun tips his split images exactly in the manner used by Juan Gris in Paris. Klyun does not however include other features visible in Malevich's painting.

The images of eye and teeth evoke the senses of sight and taste. According to Ouspensky's book it is 'sensations' that 'are the basic unit of the perceiving apparatus'.[69] He goes on to argue that collected memories of sensations form into 'representations' and that memories of these form 'concepts' leading to words and speech. Citing Professor

Oumoff once more, Ouspensky repeated his description of discoveries which 'can only be incorporated in a new order, the free lines of which extend far beyond the limits not only of the old external world, but also beyond the fundamental forms of our thinking'.[70] It is tempting to see this construction of a new world with its own perspective in Malevich's *Portrait of Ivan Klyun* (Plate 105) where his friend and collaborator appears in the role of 'builder' or 'constructor'. Malevich takes a rural peasant image as an ikon of the new space.

At least two new directions in the paintings of Malevich began with the *Portrait of Ivan Klyun*: one was an exercise in the faceting of forms developed by Parisian Cubists – what Malevich called 'Cubo-Futurist realism' – and the other stressed irrational juxtapositions of images, which Malevich termed 'alogism' (*alogizm*). *Samovar* was among the paintings Malevich categorized as 'Cubo-Futurist.' The canvas (Plate 109) from the McCrory Corporation Collection and at least two related drawings exist. The top of the painting has both the chimney and skirt motif visible in the *Portrait of Ivan Klyun*. One of the drawings also includes the billows of steam. The drawing is possibly later than the painting as it simplifies its themes.

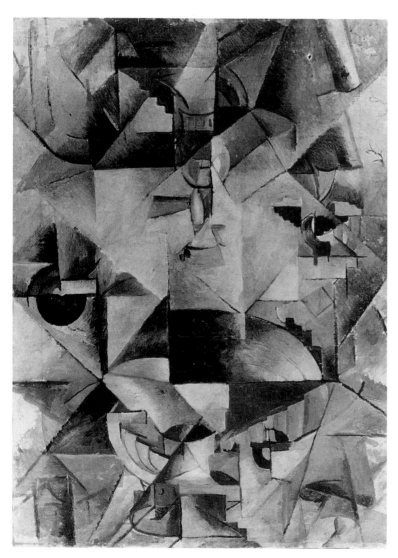

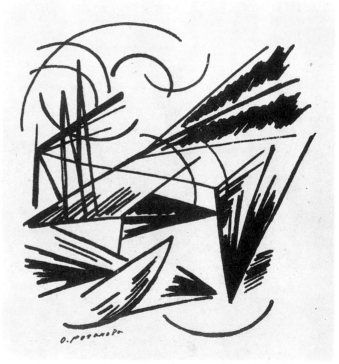

110, above. Olga Rozanova *Drawing*, 1913. Lithograph on yellow glazed paper. Published in the Union of Youth almanach, no. 3, March 1913, opposite p.22, St Petersburg. 24 × 24 cm.

109, left. Kazimir Malevich *Samovar*, *c*.1913. Oil on canvas. 18 × 14 *vershok*. 88.9 × 62.23 cm (given as 88.5 × 62.2 cm). The Museum of Modern Art, New York: The Riklis Collection of the McCrory Corporation (fractional gift). Photograph © 1995 The Museum of Modern Art, New York. The painting was shown this way up at the exhibition 'Tramway V', March 1915. It was also exhibited at the Salon des Indépendants in Paris in March–April 1914, catalogued as entry no. 2151.

Malevich assembled diverse glimpses of the samovar seen from several angles, although he still used the dominant cylindrical form to structure the drawing. Most of these features can be identified in the painting. The *Samovar* canvas was also exhibited at the Salon des Indépendants in Paris in 1914 (catalogue entry no. 2154), so Malevich may have seen this as his contribution to the international development of Cubist techniques. Its structure of intersecting diagonals and verticals is comparable with the techniques of Juan Gris, although its colour is more like that of certain paintings by Braque or Picasso. The shading of lines across the drawing are close in technique to those in *Arithmetic* (Plate 104). A second drawing combines different views and details by tilting one axis through another, as Gris does, but Malevich minimizes the structural lines preferring to press images or fragments directly one against the other.

In collaborating with Matyushin, Khlebnikov and Kruchenykh, Malevich found himself at the core of Russian Futurism. Given his equally close involvement with Larionov and Goncharova in 1913 he could not have been more centrally placed with regard to poets and painters in the Russian Futurist movement. Working with Kruchenykh also meant close contact with Kruchenykh's wife, the painter Olga Rozanova, who was a remarkable contributor to Russian Futurist publications. One of her illustrations for the Union of Youth almanac (Plate 110) reveals the extent to which she adopted the idea of a cube penetrating a plane. Hinton, Ouspensky and Bragdon had all used this idea to illustrate the immanence of higher dimensions. They imagined a three-dimensional cube making a variety of shapes as it passes through a two-dimensional plane. In this way they suggested that impressions of the familiar three-dimensional world might result from the passage of four-dimensional objects. Rozanova seemed to be close to illustrating this in 1913. Her dominant cubic form emerges from the white of the page shot about with dynamic crystalline shapes and angles. She used the very angles preferred by Malevich (27, 36, 45 and 81°). How this idea could be related to the visual evidence accessible to three-dimensional vision is reflected perhaps in the paintings not only of Olga Rozanova but also of Lyubov Popova in 1913. Popova was especially familiar with Cubist thought and practice, having studied painting with Metzinger and Le Fauconnier in Paris in 1913.

111, below left. Lyubov Popova *Woman + Air + Space (Seated Female Model)*, 1913–14. Oil on canvas. 24 × 20 *vershok* (1½ arshin high). 106.68 × 88.9 cm (given as 106 × 87 cm). Collection Ludwig, Cologne (ML 1292, neg. 161783).

112, below right. Diagram of the compositional structure of Plate 111.

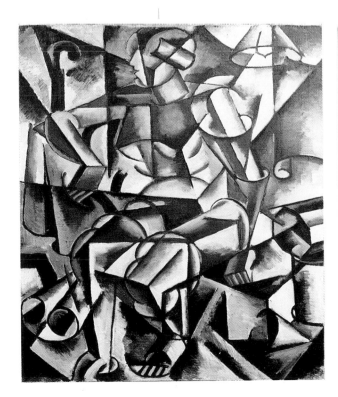

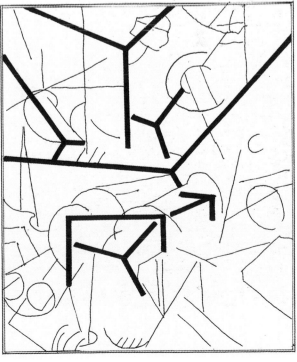

113. Vladimir Tatlin *Seated Nude*, 1913. Oil on canvas. 32 × 24 *vershok* (2 × 1½ *arshin*, ratio 4:3). 142.24 × 106.68 cm (given as 143 × 108 cm). Tretyakov Gallery, Moscow.

114. Diagram of the compositional structure of Plate 113.

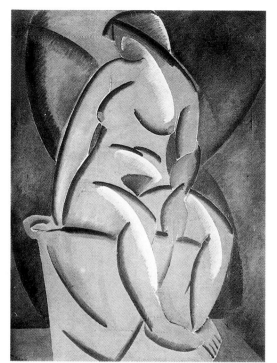

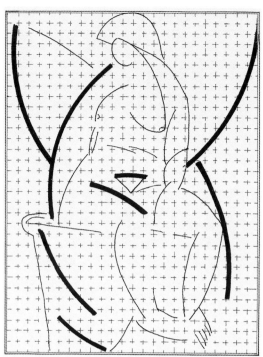

115. Albrecht Dürer *Nude Woman Constructed*, *c.*1500. Ink drawing from the Dresden Sketchbook (f.163r.). 29 × 18.8 cm. Sächsische Landesbibliothek, Dresden.

Italian Futurist ideas were also readily accessible in Paris at that time and clearly influenced the title, at least, of her *Woman + Air + Space (Seated Female Model)* of 1913 (Plate 111). In this painting a multitude of cubes intersect (Plate 112) and appear transparent in a crystalline effect. With the addition of spiral curves and a few cylindrical forms they construct the seated female nude. The cube, however, is essential to this, just as in Rozanova's drawing.[71] Some of Popova's cubes stand up straight as in the pelvis, hip and knee, but others tip and tilt as in the waist. She used the corner of the cube to project forms forward as in the lowered knee and the breast. She also used intersecting planes and diverse angles of light to construct a figure from geometric forms. Tatlin adopted the same technique in 1913 figure drawings where he experimented for a while with straight lines as well as curves. Malevich, Popova and Tatlin (Plates 113 and 114) were all three *constructing* figures on the basis of geometry in 1913. Individuality, likeness and character were all of secondary importance. These constructed figures had a different purpose: they were playing a role familiar in Renaissance studies of proportion where, as an example by Dürer illustrates (Plate 115), the figure and geometry were closely interlinked. This was, quite precisely, a search for harmony of proportions. It could be derived, at least in part, from analytical observation and measurements of the head and torso, but it was also synthetic and constructive, beginning with geometric relationships and concluding in the figure. Tatlin, like Dürer, constructed his nude (Plate 113) with circular arcs, achieving a surprising degree of realism. But the coherence of his figure lies in the relation of anatomy to geometry. It is the geometric rhythms of his canvas that construct the figurative image. Once these proportions are grasped, the painting becomes a mass of rhythmic beats, echoes and movements, based mostly on the 2-*arshin* height of the canvas and its 1½-*arshin* width (32 × 24 *vershok*; ratio 4:3). The crucial importance of the *arshin* measure is visible throughout these works. Without recognizing the *arshin* (and its division into 16 *vershok*), it is impossible to grasp the simplicity and grandeur of the mathematical ratios involved in works of this period.

116. Kazimir Malevich *Woman at a Tram Stop*, 1913. Oil on canvas. 20 × 20 *vershok* (1¼ × 1¼ *arshin*). 88.9 × 88.9 cm (given as 88 × 88 cm). Stedelijk Museum, Amsterdam. Shown at the 'Knave of Diamonds' exhibition, Moscow, January–February 1914, and catalogued as exhibit no. 57.

In preferring generalized construction to specific detail, and the approach of constructing with geometry, these painters relinquished the whole realist tradition. They moved beyond sensation by deleting or ignoring observed detail. They used their eyes to measure the geometric forms with which they constructed, not to record the incidental forms that happened to fall within their gaze. These were the building tools of the new perspectives and proportions, the sign and purpose of which was ultimately rhythm.

Ouspensky in 1912 described the issue by contrasting the phenomenon known to the senses (the sensation), with the noumenon, which is the hidden thing itself that excites the senses. 'Wishing to understand the noumenal world,' he wrote, 'we must seek a hidden meaning in everything.'[72] According to Ouspensky, only 'the soul of the artist'[73] can reveal this meaning: 'An artist must be a *clairvoyant*, he must see that which others do not see. And he must be a magician, must possess the gift of making others see what they do not see by themselves, but what he sees.'[74] In this context the apparently irrational juxtaposition of images heralded by the *Portrait of Ivan Klyun* deserves particular attention. Malevich used techniques derived from Cubism and Futurism to make a framework for memories, sensations, verbal play and paradoxical confrontations of image.

His painting *Woman at a Tram Stop* of 1913 (Plate 116), is crossed by lines like those

seen in *Arithmetic*: they are shaded to one side of the line, giving the suggestion of curved surfaces. However, these appear transparent when other planes, images and objects are visible through them. Here Malevich has chosen a square canvas, $1\frac{1}{4}$ *arshin* wide (20×20 *vershok*). The division of planes relating to an underlying grid within these fragmentary images appears in a way that recalls Cubist collage, where dislocations of space and discontinuities of scale are inevitable. But Malevich is not using collage. He is content instead to assemble planes and fragments as if they were collage elements. Here numerals signifying tram routes, a bottle from an advertisement and the image of a man in a hat are visible fragments of sensation. Yet there is no recognizable sign of the woman who, the title assures us, is at the tram stop. She does appear, however, in a drawing (Plate 117), which suggests that Malevich, like David Burlyuk, may have turned his canvas round as he worked on it, for in the drawing the image of the woman is at right angles to that of the man. Indications of railways, curtains[75] and a hand in the drawing suggest a collage of sensations comparable to Boccioni's railway triptych *The Farewells*.[76] In the painting, however, such incidental detail is minimized.

To put this another way, flat planes emerge here to play a dominant structural role in the composition, just as collage elements did for Cubists in Paris. Background areas such as that of the top left make the main dense assemblage appear to be a constructed object of some kind. Repeated motifs (boxes with numbers, three circular forms above) and reducing or telescopic elements (as in the concertina-like effects lower and centre right) all indicate arithmetical progressions. Malevich's urban theme of the tram stop is so fragmented that coherent narrative is impossible. The woman mentioned in the title is visible only in the drawing and we have no reason for her disappearance.

Similar difficulties characterize the *Portrait of a Lady Landowner* (Plate 118).[77] Textures

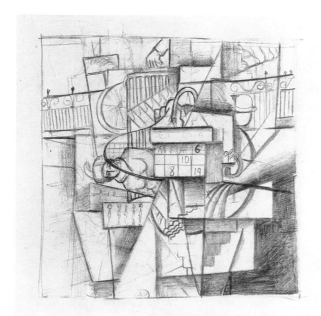

117, below. Kazimir Malevich *Woman at a Tram Stop*, 1913. Pencil on paper. 26.3 × 20 cm. Collection Ludwig, Cologne.

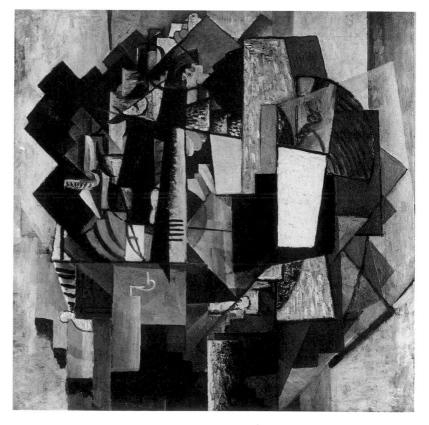

118, right. Kazimir Malevich *Portrait of a Lady Landowner*, 1913. Oil on canvas. Inscribed on the reverse 'Portrait of a Landlady/K. Malewicz/13 Desk and Room'. 18 × 18 *vershok*. 80.01 × 80.01 cm (given as 79.5 × 79.5 cm). Stedelijk Museum, Amsterdam. Shown at the 'Knave of Diamonds' exhibition, Moscow, January–February 1914, and catalogued as exhibit no. 59.

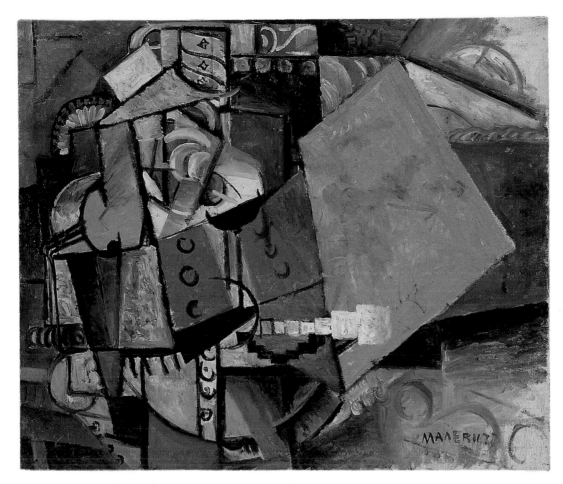

119. Kazimir Malevich
The Guardsman, 1913–14.
Oil on canvas. 13 × 15
vershok. 57.79 × 66.68 cm
(given as 57 × 66.5 cm).
Stedelijk Museum, Amster-
dam. Shown at the Knave
of Diamonds Exhibition,
Moscow, January–February
1914, and catalogued as
exhibit no. 60.

and fragments fill in the overlapping areas. Occasional motifs are familiar, especially catches, locks, hinges and fixings of one kind or another. But the assemblage of planes is itself presented as a kind of object that folds outwards like a book. Like the woman who vanished from the tram stop, the woman landowner is invisible. Her hair may conceivably appear in the concentric arcs upper right, but in such a profusion of planes the geometric elements seem most in evidence, especially the light surface that rises in two parts right of centre. This has angles (72, 81, 90, 99°) found elsewhere. It is perhaps the structure and angles of planes that begin to carry significance.

Malevich's small painting *The Guardsman* (Plate 119), exhibited at the Knave of Diamonds in Moscow from January 1914, shares many of these qualities. The diagonals of the canvas play an important role in the assemblage of detail in the left half of the canvas, but this is balanced against a trapezium in the right half. This geometric plane is painted flat but can be read as a more rectangular plane receding in perspective: image and geometry are balanced against each other. Arrows visible as underpainting in the large yellow plane indicate movement outwards and away from the assemblage of military detail at left. Such paintings are a mass of measurements, but whether these represent a perspective of one moment of time and space is doubtful.

A trio of paintings executed on panel in 1913 emphasize the sense of mystery that arises when forms that are so clear in shape and texture fail to construct an image for the eye to recognize. *Through Station* (Plate 120) uses an almost double-square proportion to

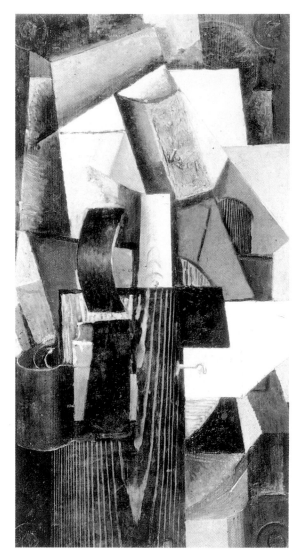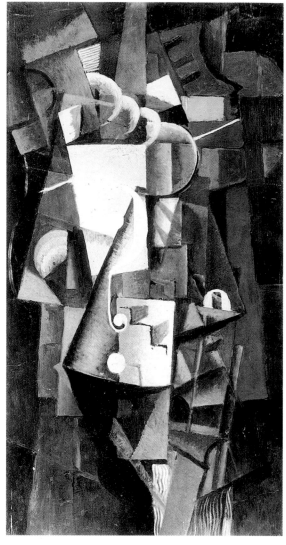

divide the board. A hinge motif is visible lower right which appears to be attached to the wood of the door. This is the actual wood upon which the painting is made and is not painted woodgrain. Above and around this, geometric shapes intersect and at least one is painted in thick impasto. A small hook or catch is visible below centre. The whole is perhaps an evocation of a train journey through time and space as it has a coherent atmospheric quality.[78]

The second panel, *Vanity Case* (Plate 121), similarly indicates progress and movement. Cog-like shapes top right, four transparent bubble shapes, a sequence of steps and, leading down, darker step-like forms – all these imply transformation, shift and change. Dominating this mysterious space is a pale geometric four-sided shape but foremost of all in this structure of overlapping planes is a question mark, as if to make mystery itself the subject, for there is no recognizable vanity case.[79]

The third panel, *Cow and Violin* (Plate 122), asserts the irrational juxtaposition of objects by overlapping five or so images. From the planes at the back, part of a conical plane emerges. A pale rectangle hovers parallel to the edges of the board and in front of this hangs the image of a violin (though its bridge and part of its strings are lower down).

Finally, in the foreground is a cow not in the least in scale with the violin. The cow and the violin were both images used by Chagall, but here different kinds of geometric forms are overlaid by the two incompatible images.

A later lithograph (Plate 123) carries an annotation describing this 'struggle through the confrontation of two forms – that of the cow and that of the violin in a cubist construction'.[80] Interpretation is bound to be speculative and tentative, but Malevich may have intended to confront the urban world of Picasso's Cubist *Violin*, acquired by Shchukin in 1912 and copied by Rozanova, with the familiar village and peasant themes used by the Russian artists exhibiting at the Target exhibition in 1913.[81] It may represent art (music) versus nature (animal) or it may arise from verbal comparisons, as in the *Portrait of Ivan Klyun*. The Russian for violin is *skripka*, the Russian for cattle is *skot*.[82] Anyone who, like Malevich, had collaborated with Khlebnikov would be aware of his search for the transformation of roots of words. It is also possible that Malevich, who indicated woodgraining in the drawn portrait of Ivan Klyun, had here recognized that it linked both peasant life and the musical instrument.

There may be some logical link or explanation about which Malevich has been

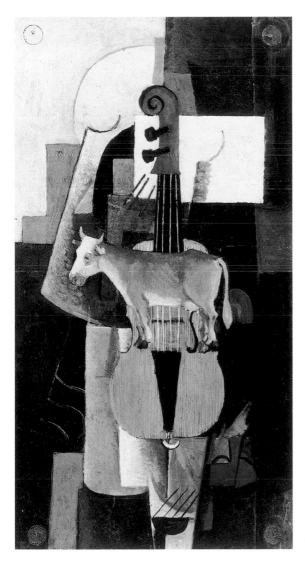

123. Kazimir Malevich *Cow and Violin*, 1919. Lithograph. Published in K. Malevich's *On New Systems in Art*, Vitebsk 1919. 13.2 × 8 cm.

122, left. Kazimir Malevich *Cow and Violin*, 1913. Oil on panel. 11 × 6 *vershok*. 48.9 × 26.67 cm (given as 48.8 × 25.8 cm). Russian Museum, St Petersburg.

reticent, but writing six years later he called such works alogical (without logic), perhaps deliberately not using the word *zaum* (trans-sense, or beyond mind) as this by then implied something else. According to Ouspensky the fourth dimension would inevitably appear illogical, and he listed characteristics of the four-dimensional world which coincide well with these paintings by Malevich: this suggests strongly that Malevich was following Ouspensky's arguments with deliberate care. Ouspensky argued that time exists spatially so that events 'must exist before and after their accomplishment and be, as it were, on the same plane'.[83] Cause and effect become simultaneous, and 'moments of different epochs, divided by long stretches of time, exist simultaneously and may be adjacent'. As near and far can meet, there is 'nothing measurable by our measures'. As his sixth point he asserts that 'that world is *outside logic*'.[84] Everything is also connected to everything else, according to Ouspensky, and all opposites are resolved.

The year 1913 had been an immensely prolific year for Malevich. Collaboration with Russian Futurist poets vastly extended his grasp of ideas and techniques. Yet over and above all the paintings and lithographs he was still to produce his single most important Russian Futurist collaborative venture. At the First All-Russian Congress of Bards of the Future held at Uusikirkko in Finland in July 1913, Malevich together with Kruchenykh and Matyushin had agreed to stage Kruchenykh's Russian Futurist opera *Victory over the Sun*. When the production opened for two nights in December 1913, Malevich emerged as a theatre designer unrivalled in Russian Futurist circles. Simultaneously he was exhibiting twelve 'Trans-Sense Realist' and also 'Cubo-Futurist Realist' paintings at the Union of Youth in St Petersburg. Each complemented the other, for ideas embedded in the paintings were explained in the opera. They developed side by side.

Victory over the Sun

Malevich posed for photographs with Matyushin and Kruchenykh in 1913 in St Petersburg as a sign of their close collaboration on the opera *Victory over the Sun*. The photographs (Plate 124) themselves incorporate Russian Futurist alogical effects. The commercial photographer's backdrop is inverted as if to suggest that Malevich is turning photographic realism on its head, just as Matyushin is turning music (here the piano) upside down too. The format recalls David Burlyuk's recent paintings designed to be seen from four sides. Furthermore, actual furniture is inverted in the foreground so that the Russian Futurists themselves are all situated within this illogical space.[1] The curtain visible in the backdrop also appears in a drawing of 1913.[2]

There can be little doubt that these witty spatial ambiguities reflect contemporary speculation about the fourth dimension. Matyushin owned copies of Hinton's books and he was writing about the fourth dimension during 1912–13 when the opera *Victory over the Sun* was being developed.[3] By the time Malevich attended the First All-Russian Congress of Futurist Bards at Uusikirkko in Finland on 18 and 19 July 1913, his painting exhibited an elaborate layering of spatial effects. As if to echo Ouspensky's assertion that the old measures were of little use in the fourth dimension, Malevich had recently made the act of calculation a subject for two of his lithographs of 1913 in *Arithmetic* (Plate 104) and *The Pilot* (Plate 101). More substantially, Malevich's *Portrait of Matyushin* (Plate 125), a 20-*vershok* square canvas of 1913, has a kind of ruler or at least a strip of squares foremost across the dense conglomeration of overlapping forms and fragments of images that comprise the painting. It may also suggest white piano keys. (Klyun's *Self-Portrait with a Saw* (Plate 108) used a similar device to indicate teeth.) Malevich's painting is a major tribute to Matyushin as a friend, colleague and collaborator on the opera. This painting, therefore, is the work of Malevich's that is most likely to employ Matyushin's spatial theories. A fragment of the composer's head is visible above centre, and his collar and tie appear left of centre along the bottom edge of the canvas. Elsewhere the meticulously painted keyhole of a lock is visible. The rest of the canvas is a dense compilation of intersecting planes with some indication of a focal point upper right. This cluster of fragments is then isolated within the overall canvas and appears as a kind of extraordinary object against a plain background. As usual, some angles are multiples of 9° (72, 81, 99). No images of cutting tools are visible, which is unusual in 1913. Clearly the canvas has a broad structure of major divisions as well as smaller, more detailed subdivisions. Matyushin, as a composer, would have been acutely aware of such structures within music.

As well as admiring Ouspensky's spatial and mathematical ideas, Matyushin and Malevich worked closely with the poet Velimir Khlebnikov. While Ouspensky was touring Egypt, India and Ceylon in 1913, Khlebnikov was making mathematical analyses of historical dates. His text *Two Individuals*, for example, subtracted 48 sequentially from 365 to leave 29 (one lunar orbit), providing what Khlebnikov called 'seven number heavens': 29, 77, 125, 173, 221, 317, 365 (a year).[4] It is important to bear this mysterious piece of mathematics in mind when looking at *The Pilot* and *Arithmetic*. In September

124. Matyushin, Kruchenykh and Malevich in St Petersburg, December 1913, posing before an inverted backdrop.

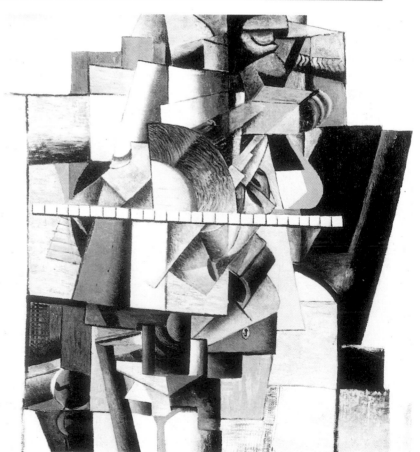

125. Kazimir Malevich *Portrait of Matyushin*, 1913. Oil on canvas. 20 × 20 *vershok* (1½ × 1½ *arshin*). 106.68 × 106.68 cm (given as 106.5 × 106.7 cm). Tretyakov Gallery, Moscow: Gift of George Costakis 1977. Shown at the Knave of Diamonds Exhibition, Moscow 1914, and catalogued as exhibit no. 56.

126 and 127. Diagrams of underlying structures in Malevich's *Arithmetic*, 1913 (Plate 104).

128. Poster advertising 'The World's First Four Productions of Futurist Theatre' at Luna Park Theatre, St Petersburg, 2–5 December 1913. The poster announces performances of Vladimir Mayakovsky's *A Tragedy* and *Victory over the Sun*.

1913, Khlebnikov wrote to Matyushin that he was 'busy with numbers, calculating from morning until night'.[5] Malevich was most familiar with Khlebnikov and his ideas in 1913, and his *Arithmetic* is as tightly crammed with calculations (in forms, images and process) as anything contemporary by Khlebnikov. The intersecting rays (9° angles of 18, 36, 45, 54, 63, 72, 81, 90, 99 and 108) that form a transparent and crystalline space (Plate 126) also incorporate square elements (Plate 127). There is an underlying mathematics to Malevich's print *Arithmetic* that connects him to Matyushin, Ouspensky and Khlebnikov. As *Arithmetic* also relates to the *Portrait of Ivan Klyun*, a whole nexus of interconnected works can be seen to be associated with the project for *Victory over the Sun*.

The original production of the opera was performed only twice. The poster (Plate 128) proclaimed that the performances, which took place at the Luna Park Theatre in St Petersburg, were the first productions of Futurist theatre in the world. Mayakovsky's *Vladimir Mayakovsky: A Tragedy* was performed on 2 and 4 December alternating with *Victory over the Sun* on 3 and 5 December in 1913. Filonov and Shkolnik designed Mayakovsky's play, but Malevich, perhaps with help from Kruchenykh's wife Rozanova, designed *Victory over the Sun*.[6]

A fragment of the score, an excerpt of the Prelude by Matyushin, was published in *Troe* in September 1913 with an explanatory note to indicate that square minims indicated the raising or lowering of a note by a quarter of a tone. A further excerpt with the same explanation appeared in the published libretto but little of the score appears to have survived. On the other hand, Kruchenykh's libretto has survived complete. In addition, there are numerous costume and stage designs by Malevich which permit an appraisal of the opera's importance, for Malevich at least. The fact that the opera was later revived at Vitebsk and also in a putative puppet version by Lissitzky points to an event of greater ambition that its brief initial two-night run might suggest.

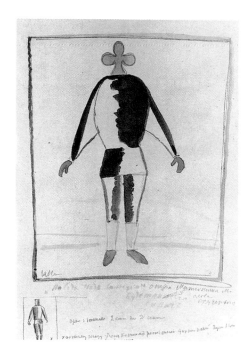 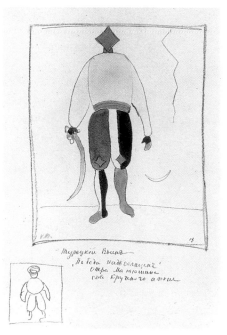 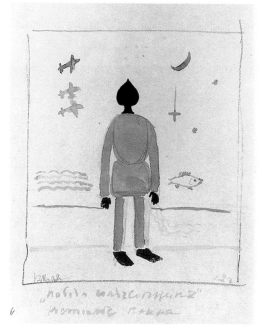

129, above. Kazimir Malevich *Futurist Strongman*, 1913. Watercolour and pencil. 54.4 × 36.2 cm. Russian Museum, St Petersburg (acquired from the artist's family 1936).

130, above middle. Kazimir Malevich *Turkish Warrior*, 1913. Watercolour and pencil. 54.3 × 36.4 cm. Russian Museum, St Petersburg (acquired from the artist's family 1936).

131, above right. Kazimir Malevich *Warrior*, 1913. Watercolour, Indian ink and pencil. 54.2 × 35.6 cm. Russian Museum, St Petersburg (acquired from the artist's family 1936).

Ostensibly the opera tells of the sun's capture and the actions of time-travellers. Superficially this could be understood as a celebration of the dawn of the new electro-mechanical age with its sources of energy and light independent of the natural rhythm of night and day. But if the theme is given its Russian context there are other implications to address. For artists and writers interested in new theories of time, the sun played a special role by marking out the year and its seasons, as depicted in the recent paintings of Goncharova and Malevich. As the calendar divisions and the hours of the clock were tied to the movement, or apparent movement, of the sun, to gain a 'victory over the sun' was to find a new concept of time which the sun did not dominate. The opera's time-traveller did not rely upon annual or diurnal solar rhythms. As in Ouspensky's vision of the fourth dimension, where the future could touch the past, the passage of time was a product of perception. In such a world the role of the sun was quite unexpectedly different.[7] 'Victory over the sun' meant a new perspective amidst the vast continuities of time and space. Yet Malevich, at least initially, included specific references to his own troubled time.

Some costume designs show standing figures with playing card symbols for heads – as if they were major protagonists in a game or confrontation. The *Futurist Strongman* (Plate 129) is designated the suit of clubs, but in red and not black. A *Turkish Warrior* (Plate 130) has the suit of diamonds at his head and knees while another *Warrior* (Plate 131) has spades. These references to warfare reflect the rising international tensions of 1913, and the mention of the Turkish warrior points the historical role of Turkey as an adversary of Russia, not least in the period leading to the outbreak of war which took place only eight months after the staging of *Victory over the Sun*. The Turk's sabre, the fish and the sword are all images that occur elsewhere. Any card game is a battle of the suits but Malevich goes further: he gives the suits a local and contemporary significance as if he were drafting Khlebnikov's analysis of history onto Ouspensky's analyses of the tarot with its ever-changing system of symbolic meanings. Turkey, for example, might signify the Eastern traditions of Islamic culture. The fish might indicate Christianity. In this way Russia's recurrent involvement with the decaying Ottoman Empire in pre-1914 Europe is pictured as a game in play.[8] The *Warrior* watercolour (Plate 131) also raises the

possibility of word games. A spade in cards is *pikovka*, but other words share the root *pik* (*piques* in French), hence *pik* (spike, pike, spear or lance), *piksha* is haddock, *piket* is picket and so on. There may even be a suggestion of *Pik*asso (Picasso). The crescent moon may indicate Islam and the sword and fish Christianity. The fish swimming in the sky suggests a symbolic function, but it may illustrate by analogy that aeroplanes swim through the air like fish.

These drawings seem to constitute a special series, although the Strongman of Plate 129 is accompanied by a small study of a figure that Malevich developed further into a seperate design for the *Futurist Strongman* (Plate 132). The 'clubs' costume, Malevich noted, is to be '3 *arshin* and 1 *vershok* high'. The cylindrical and metallic version was 3 *arshin* (Plate 132). This is the figure who opened and closed the opera.

Descriptions of the performance are vague. Mgrebov, for example, noted that: 'The curtain rose and the spectator faced a second curtain carrying three hieroglyphs indicating the author, composer and designer. The music struck up and the second curtain parted. A crier and a troubadour appeared . . . The prologue ended. Strange war-like cries rang out and the next curtain parted in its turn.'[9]

The prologue, written and spoken by Khlebnikov, is full of references to time-travel, reincarnation and magic. He speaks as the *Budetlyanin*, the Future-Dweller, the citizen of 'future-land'. Many of Khlebnikov's words remain untranslatable because they contain a wealth of pun and ambiguity based upon the manipulation of Russian roots, suffixes and prefixes. He announces to his audience, however, that figures will appear to lead them into a dream of the future. They will even see artists 'create a change in the look of nature',[10] a phrase which perhaps pays homage to Malevich.

Malevich made studies for each scene of the opera, but photographs of the performance (Plate 133) and some narrative accounts suggest a good deal of last-minute simplification.[11] The drawings for the sets are small and rough but on several of them Malevich has written '10 × 8' (Plate 134). The drawings are also characterized by an underlying structural device of a rectangle connected to the corners of the drawing by its points to form a kind of frame effect. If the central panel is drawn in the proportion 10 × 8, the 'frame' is a quarter of the whole width either side of the panel (Plate 135). The

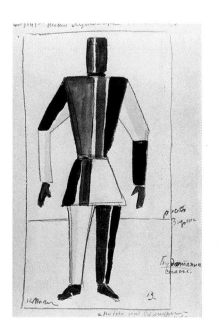

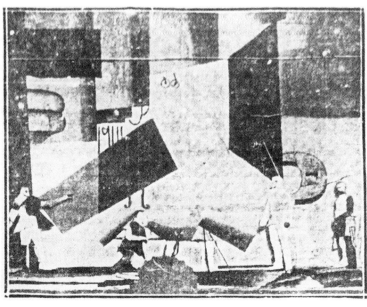

132, far left. Kazimir Malevich *Futurist Strongman*, 1913. Watercolour and pencil. Measurements at right indicate an intended costume height of 3 *arshin* (213 cm). 53.3 × 36.1 cm. Russian Museum, St Petersburg (acquired from the artist's family 1936).

133, left. Scene one of *Victory over the Sun*, 1913. Photograph of the performance published in the newspaper *Ranee Utro* (Early Morning), St Petersburg, 12 December 1913.

converging diagonals of the 'frame' motif then meet in a precise central vertical. The angles employed at the corners are 54 and 36°, recurrent angles for Malevich and characteristic of the so-called 'Egyptian triangle', which has sides three, four and five units in length.

Scene one of the opera (Plate 133) featured a black-and-white set in which two Futurist Strongmen (Plate 136) tear open the curtain declaring: 'All's well that begins well and will have no end.' They describe their antagonism to the 'sighs of prizes that amused the moldiness of rotten naiads'. In other words, academism is not for Futurists. The Second Futurist Strongman declares their aim to throw a dustsheet over the sun and to

136, below. Kazimir Malevich *Futurist Strongman*, 1913. Black chalk. 27 × 21 cm. Museum of Theatre and Musical Arts, St Petersburg. This example is from the silkscreen edition of 1973. Collection of Mr and Mrs N.D. Lobanov-Rostovsky, London.

137, below middle. Kazimir Malevich *Nero*, 1913. Black chalk. Inscribed 'Neron' (Nero). 27 × 21.5 cm. Museum of Theatre and Musical Arts, St Petersburg. This silkscreen edition, 1973. Collection of Mr and Mrs N.D. Lobanov-Rostovsky, London.

138, below right. Kazimir Malevich *The Traveller through the Centuries*, 1913. Black chalk on paper. Inscribed 'Black and white costume'. 27.2 × 21.3 cm. Museum of Theatre and Musical Arts, St Petersburg.

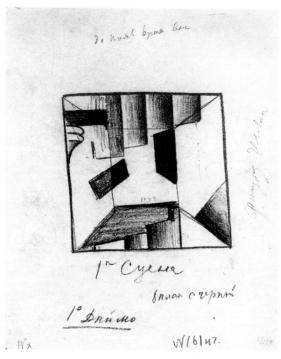

135. Diagram of the frame device in Malevich's set designs for *Victory over the Sun*.

134, left. Kazimir Malevich Design for scene one of *Victory over the Sun*, 1913. Black chalk. 21.3 × 27 cm. Museum of Theatre and Musical Arts, St Petersburg.

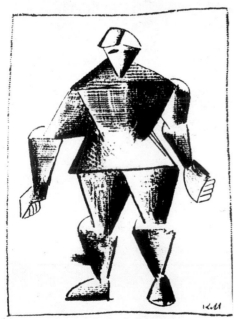

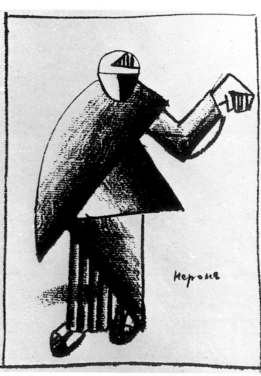

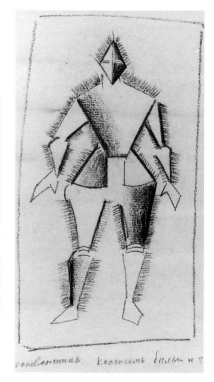

confine it to a boarded-up 'concrete house'.[12] Nero (Plate 137) and Caligula appear joined together into a single character and a figure like Hermes arrives, the Traveller through the Centuries (Plate 138) 'on airplane wheels'.[13] He is covered with pieces of paper on which are written: The Stone Age, The Middle Ages, and so on. Nero-Caligula's warning not to trust 'old measurements' is echoed by the Traveller's 'Do not trust former scales'. In this way new measurements, dimensions and time-travel are introduced almost at once, with the Traveller declaring: 'I will ride through all the centuries.'[14]

The Ill-Intentioned One (Plate 139) and The Squabbler (Plate 140) argue and fight. Some of the Squabbler's song uses wordplay lost in translation: for example 'lucost locust/ lance drink/drink lance' is meaningless in English but in Russian it is clearly a series of variations on similar words and their sounds: 'sarcha sarancha/*pik pit'/pit' pik*'.[15] As they squabble, 'A machine gun of the future country appears on stage and stops at a telegraph pole'.[16] This theme is perhaps illustrated in Malevich's lithograph *The Simultaneous Death of a Man in an Aeroplane and on the Railway* (Plate 99) of 1913 where the telegraph poles are visible lower left.[17]

Scene two featured an emphatically musical set with a cello-like curve and notes dominating the design (Plate 141). The drawing is inscribed 'green until the funeral' and also 'green and black'.[18] This suggests colour by stage lighting, an important aspect concerning the set and costume designs. Black areas would vanish on stage and white areas would be richly coloured by lighting. Costumes using several colours would appear

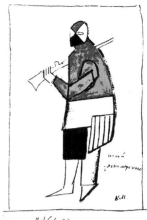

139. Kazimir Malevich *The Ill-Intentioned One*, 1913. Black chalk, ink and watercolour on paper. 27.3 × 21.3 cm. Museum of Theatre and Musical Arts, St Petersburg. This silkscreen edition, 1973. Collection of Mr and Mrs N.D. Lobanov-Rostovsky, London.

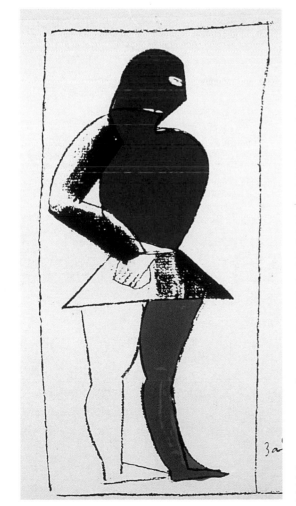

141. Kazimir Malevich Design for scene two of *Victory over the Sun*, 1913. Black chalk. 21.3 × 27 cm. Museum of Theatre and Musical Arts, St Petersburg.

140, left. Kazimir Malevich *Squabbler*, 1913. Black chalk and watercolour. 26.7 × 21 cm. Museum of Theatre and Musical Arts, St Petersburg. This silkscreen edition, 1973. Collection of Mr and Mrs N.D. Lobanov-Rostovsky, London.

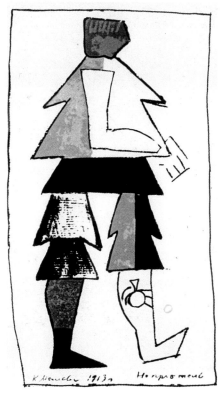

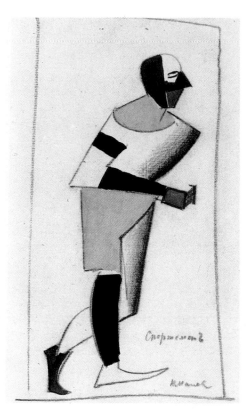

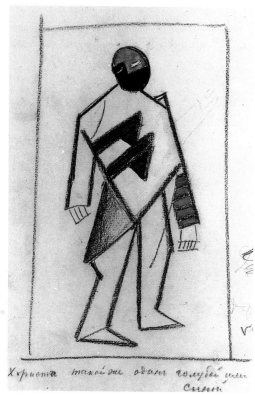

142, above. Kazimir Malevich *Enemy*, 1913. Black chalk and watercolour. 27.1 × 21.3 cm. Museum of Theatre and Musical Arts, St Petersburg. This silkscreen edition, 1973. Collection of Mr and Mrs N.D. Lobanov Rostovsky, London.

143, above middle. Kazimir Malevich *Sportsman*, 1913. Black chalk and watercolour. 27.2 × 21.2 cm. Museum of Theatre and Musical Arts, St Petersburg.

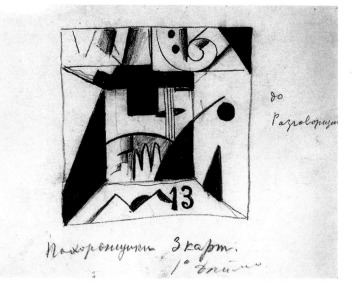

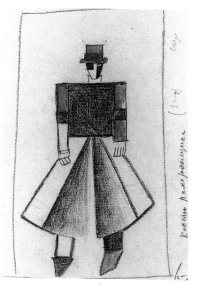

144, above right. Kazimir Malevich *Chorus Singer*, 1913. Black chalk and watercolour. 27.3 × 21.3 cm. Museum of Theatre and Musical Arts, St Petersburg.

to change dramatically with adjustments in the lighting so that figures might even appear fragmentary. As the Russian Futurist Benedekt Livshits expressed it: 'Pictorial stereometrics were first seeing the light within the confines of the stage.'[19] This set contains several points of contact with the libretto, which speaks of the 'little hooks of cranes' (upper right), 'steam and smoke' (upper right), 'steps' (lower centre) and the 'triumphal car' (wheel, left of centre). The notes and hooks recall the drawing for the *Portrait of the Matyushin* (Plate 125).

The action of scene two that unfolds before this green-illuminated design opens with Enemy Soldiers in Turkish costume (Plate 142), as well as Singers (Plate 144), Strongmen and Sportsmen (Plate 143). One of the Sportsmen sings of the end of the 'light of flowers' (*Net uzhe sveta tsvetov*) and proclaims the end of the seasons.[20] The First Strongman declares that 'The sun lies at our feet' (*Lezhit solntse v nogakh zavezannoe*). He then announces that 'the iron bird is flying' (*ptitsa letit zheleznaya*). The scene ends with news of an eclipse: 'The sun has hidden and darkness has fallen' (*skrylos' solntse/t'ma obstupila*). The hiding of the sun and the arrival of the aviator's 'iron bird' are simultaneous.[21]

In scene three (Plate 145),[22] the burial scene, 'black walls and floor' replace the green light of scene two. Against this the Pallbearers (*Pokhorozhniki*) appear in black and white with touches of blue and red-orange (Plate 146). The Pallbearers are firmly associated with the black square on their chests and hats. The black square appears again in the middle of the centre panel of the backdrop. As this scene signals the funeral of the sun, the black square marks its eclipse. Malevich was justified in claiming in later years that his *Black Square* dated from 1913 if we take it that he refers to the motif and to the idea that, as here, it represents the loss of light, the circle of nature succumbing to the square of humanity or humanity's escape from the sun's diurnal and annual rhythms into a new concept and new control of time.

Scene four (Plates 147 and 148) follows immediately and shows the defeated sun. Calculations are made on stage applying arithmetical procedures to the sun in some way. A figure is visible in a photograph (Plate 148) published on 12 December 1913 in which the letters ОЛНЦ (*olnts*) appear beneath a fragmentary calculation 'from 5 = 400'. ОЛНЦ (*olnts*) is from *sun* (СОЛНЦЕ, SOLNTsE) in Russian. These calculations are precisely like those of Khlebnikov at this time. Now the sun is captured there is no longer night and day: 'Know,' says the Many-and-the-One (Plate 149), 'that the earth does not turn.'[23]

Of all Malevich's studies for this opera the design for scene five is the most surprising. An irrational assemblage of chimneys, windows and stairs reveals the Future-Dweller's house in the Tenth Country, or Land of the Tenth Dimension (Plate 150). It is a masterly depiction of that new perspective of space turned inside out that is called for in the text.

145, opposite page, left. Kazimir Malevich Design for scene three of *Victory over the Sun*, 1913. Black chalk. 17.7 × 22.2 cm. Museum of Theatre and Musical Arts, St Petersburg.

146, opposite page, right. Kazimir Malevich *Pallbearer*, 1913. Black chalk and watercolour. 27 × 21.1 cm. Museum of Theatre and Musical Arts, St Petersburg.

147, below left. Kazimir Malevich Design for scene four of *Victory over the Sun*, 1913. Lithograph on the front cover of the libretto published in 1914. 9 × 10 cm.

148, below right. Scene four of *Victory over the Sun*, 1913. Photograph of the performance published in the newspaper *Ranee Utro* (Early Morning), St Petersburg, 12 December 1913.

After the nihilism of what went before, here is the new space glimpsed for the first time. It is here that the Alchemist's Universal (or New) Man reappears after the decay and darkness of the black square (Plate 151). Given the partly coloured costumes and the coloured directional lighting the effect must have seemed bizarre (Plate 152). Here, 'liberated from the weight of the earth's gravitation, we whimsically arrange our belongings as if a rich kingdom is moving'.[24]

Malevich's set is closely related to his painting *Musical Instruments* (Plate 153) in which many of the same forms appear, although what was a still life is now the construction of a house. This painting in turn relates closely to Picasso's *Violin* (Plate 154), bought by Shchukin in 1912, copied by Rozanova and later drawn by Malevich (Plate 155). As the Fatman (Plate 156) asserts in the sixth scene of the opera: 'Yes, everything here is not that

149, left. Kazimir Malevich *The Many-and-the-One*, 1913. Black chalk, Indian ink and watercolour. 27.1 × 21 cm. Museum of Theatre and Musical Arts, St Petersburg. This silkscreen edition, 1973. Collection of Mr and Mrs N.D. Lobanov-Rostovsky, London.

151, right. Kazimir Malevich *The New Man*, 1913. Black chalk, Indian ink and watercolour. 26 × 21 cm. Russian Museum, St Petersburg. This silkscreen edition, 1973. Collection of Mr and Mrs N.D. Lobanov-Rostovsky, London.

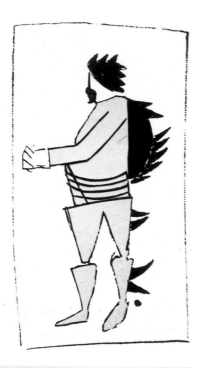

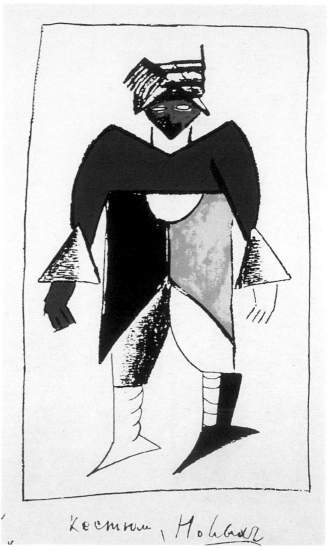

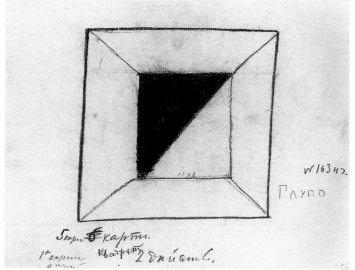

150, left. Kazimir Malevich Design for scene five of *Victory over the Sun: The House*, 1913. Black chalk, Indian ink and watercolour. 26.7 × 21 cm. Museum of Theatre and Musical Arts, St Petersburg. This silkscreen edition, 1973. Collection of Mr and Mrs N.D. Lobanov-Rostovsky, London.

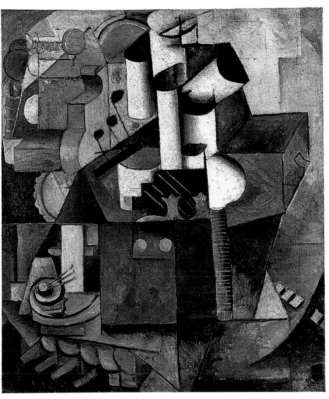

Кааиии варуанилих

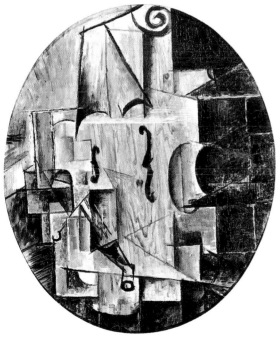

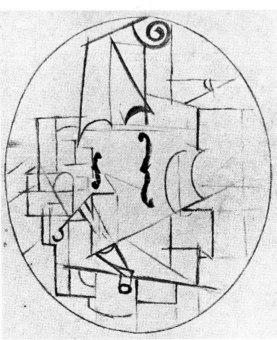

152, far left. Kazimir
Malevich *Coward*, 1913.
Black chalk, Indian ink and
watercolour. 26.9 × 21 cm.
Museum of Theatre and
Musical Arts, St Petersburg.
This silkscreen edition,
1973. Collection of Mr and
Mrs N.D. Lobanov-
Rostovsky, London.

153, left. Kazimir Malevich
Musical Instruments, 1913.
Oil on canvas. 83.5 ×
69.5 cm. Stedelijk Museum,
Amsterdam.

154, far left. Pablo Picasso
Violin, 1912. Oil on canvas.
55 × 46 cm. Pushkin
Museum, Moscow.
Formerly in the S.I.
Shchukin Collection.

155, left. Kazimir Malevich
*Transformation from a
Representation of 'Nature'*.
This is one of a series of
drawings published by
Malevich in 1927.

simple, though at first glance it seems to be a chest of drawers – and that's all! But then
you roam and roam.'[25] In their ambiguity the written text and paintings are directly
comparable and both suggest new perspectives and a new unity of time and space, themes
common to the painting and to the backdrop (Plates 157–9).[26] Time, after all, can here
be measured backwards or forwards: 'Look here, dummy, which way is your watch

157. Kazimir Malevich *Reciter*,
1913. Black chalk, Indian ink and
watercolour. 27.2 × 21.4 cm.
Museum of Theatre and Musical
Arts, St Petersburg.

158. Kazimir Malevich *Old Timer*,
1913. Black chalk, Indian ink and
watercolour. 27 × 21 cm. Museum of
Theatre and Musical Arts, St
Petersburg. This silkscreen edition,
1973. Collection of Mr and Mrs N.D.
Lobanov-Rostovsky, London.

156, above. Kazimir
Malevich *Fatman*, 1913.
Black chalk and
watercolour. 27.2 ×
21.2 cm. Museum of
Theatre and Musical Arts,
St Petersburg. This
silkscreen edition, 1973.
Collection of Mr and Mrs
N.D. Lobanov-Rostovsky,
London.

running?' [27] In this world, which is very like that described by Ouspensky, 'very likely yesterday there was a telegraph pole here but today it is a snack bar, and tomorrow there will be bricks'.[28]

Suddenly the Aviator flies into all this, crashing his plane in the land where 'all roads come from all directions' – a land definitively in need of new perspective systems, such as Malevich developed in his lithograph *Universal Landscape* of 1913 (Plate 160). The Aviator is undisturbed by the damage to his plane and he sings his *zaum* (trans-sense) song:

l l l
kr kr kr
tli . . .

This continues until the Strongmen close the opera much as it began: 'All's well that begins well and has no end. The world will die but for us there is no end.'[29] The final curtain was the diagonal division of black and white in which the black must have appeared as a gulf or hole on stage (Plate 161). This is the most simple and most radical set of all Malevich's known designs.

The libretto nowhere mentions a black square but Malevich mentioned it in a letter to Matyushin: 'The decoration shows a black square, the embryo of all possibilities, which

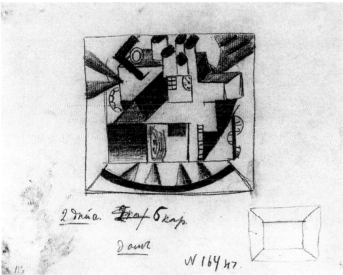

159, above left. Kazimir Malevich *Attentive Worker*, 1913. Black chalk and watercolour. 27.2 × 21.2 cm. Museum of Theatre and Musical Arts, St Petersburg. This silkscreen edition, 1973. Collection of Mr and Mrs N.D. Lobanov-Rostovsky, London.

160, above right. Kazimir Malevich *Universal Landscape*, 1913. Lithograph. Published in 1914, tipped into A. Kruchenykh's *Stikhi Mayakovskogo (Verses of Mayakovsky)*. 8.5 × 11.5 cm.

161, left. Kazimir Malevich Design for *Victory over the Sun*, 1913. Black chalk on card. Inscribed '10 × 8'. 21 × 27 cm. Museum of Theatre and Musical Arts, St Petersburg. This silkscreen edition, 1973. Collection of Mr and Mrs N.D. Lobanov-Rostovsky, London.

in the course of its development acquired a terrible power.'[30] Nothing here contradicts its appearance in the scene of the burial of the sun, but it is still possible that a design is missing or that it was an adaption of surviving schemes. For example, Malevich's sets feature a frame-like motif throughout. If the centre panel were black or missing it could appear as a deep void.[31] In that very year, 1913, the poet Gnedov declared the 'Death of Art' (*smert' ikusstva*) and Ouspensky's *Tertium Organum* had only recently cited Professor Oumoff's conviction that 'We are present at the funeral of the old physics'.[32] The nihilism of Malevich was not unique in 1913 and there is no reason to suppose that the concept of the black square did not date, as Malevich has said, from that year. The mathematics of the square was to provide Malevich with a generative system of harmonic proportions and perspective. Since he worked closely with Matyushin, Khlebnikov, Kruchenykh and Rozanova in 1913, he could not have been more fully aware of this aspect of Russian

Futurism, as the paintings related to the operatic venture make clear. The result was not at once wholly geometric and imagery remained important until 1915, but, as Livshits put it: 'The secret irrational ties between objects are not the pain of muteness for us any more, but the joy of the first namegiving. On the border of the fourth dimension – the dimension of our times – one can speak only the language of Khlebnikov.'[33]

Two more major paintings, themselves closely interrelated, derive from *Victory over the Sun*. These are *The Aviator*, 1914 (Plate 162), and the *Englishman in Moscow*, also of 1914 (Plate 164). *The Aviator*,[34] a large painting compared with the *Englishman in Moscow*, features one of the opera's Futurist protagonists and it may be taken as the major work. At 28 × 14 *vershok* it is a large double square canvas divided just above its playing card motif. The Golden Section is closely related to the diagonal of a double square; indeed, this is one of the simplest ways to produce the ratio geometrically. We may by now assume that Malevich was fully aware of these systems of proportional harmony, and adept at using them.

The Aviator as a character in *Victory over the Sun* embodied the Futurist Universal or New Man, at ease with new dimensions of time and space, and his arrival effectively replaced the sun as the focus of the opera. He echoed, to a degree, the Traveller through the Centuries (Plate 138) who rode on aeroplane wheels. In the painting, his vigorous pose and cylindrical shine are those of the Futurist Strongman. The vertical saw motif links this image to the peasant genre paintings of 1912–13 and to the *Portrait of Ivan Klyun* (Plate 105), but the Ace of Clubs, symbolizing worldly power, reveals him as indeed the Futurist Strongman (Plate 132) seen in the early costume designs for *Victory over the Sun*, with a head derived from the Ace of Clubs. As in that design, the Aviator (Plate 162) is a protagonist playing a role. The lettering across the top of the painting reads АПТЕКА (*apteka*, 'chemist', 'apothecary'). Significantly, the vertical saw has cut up this word into А-ПТЕ-КА (*a – pte – ka*). Of these fragments КА is most independent and may indicate an elaborate play upon words. KA is the name of the time-traveller who flits effortlessly through the centuries in the poem *Ka* (and in other poems) by Khlebnikov.[35] KA was also part of the ancient Egyptian belief in the afterlife and this provided the basis of Khlebnikov's figure of Ka. On the other hand, it is also the first syllable of Kamensky, the Russian Futurist poet who had only recently retired from flying after crashing his plane, rather as the Aviator crashed his flying machine in *Victory over the Sun*. It is conceivable that *Victory over the Sun* is in part a group portrait of the Russian Futurists.[36]

Other wordplay may be evident here. The letters ПТ (*pt*) suggest ПТИЦА (*ptitsa*, bird) with its connotations of flying (also *pterodactyl*). *Ptenets* is a fledgling. The whole word АПТЕКА (*apteka*) may suggest alchemy or an 'alchemy of the word'.

The Aviator's hat is essentially a black square, which in the opera belonged to the sun's Pallbearers. Here is it associated with zero and the diagonal 'ray' which splits the word *a/pteka*. It is perhaps already the 'zero of form'. The Ace of Clubs perhaps indicates the number 1, and the figure 2 is visible above KA. Zero (0) and the eye (*oko*) are close again (as in *Troe*).[37] The 2 may also refer to the double square of the canvas. The whole placing of the figure of the Aviator recalls Dürer's proportional construction figures (Plate 163).

In terms of overlapping images, the Aviator is trapped between the saw and the fish. The reason may be a verbal investigation built on the letters ПИ (PI), hence *pila* is saw, *pilot* is the pilot or aviator, *pilshchik* is a sawyer, *pilulya* a pill from the apothecary, *piksha* is a haddock and so on. Finally the Aviator adopts the stance and the role of *The Scyther* or *Mower* (Plate 60). By contrast, the *Englishman in Moscow* (Plate 164) is Malevich's latest version of the frontal portrait after the *Head of a Peasant* (Plate 52) and of the constructor

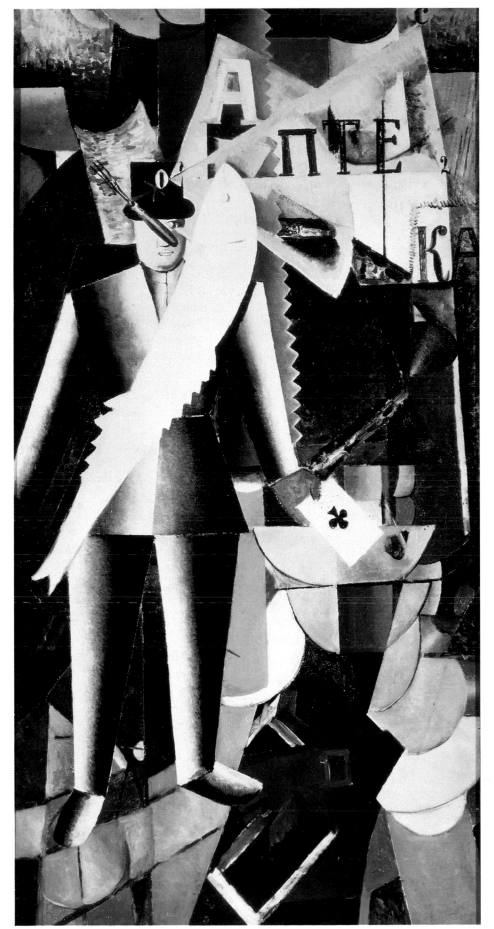

162. Kazimir Malevich *The Aviator*, 1914. Oil on canvas. Inscribed on the reverse '1914g Awiator' (year 1914 Aviator). 28 × 14 *vershok*. 124.46 × 62.23 cm (given as 125 × 65 cm). Russian Museum, St Petersburg.

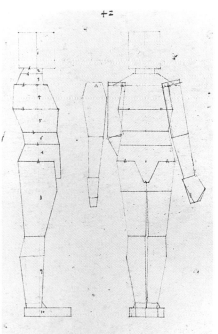

163. Albrecht Dürer *Proportional Studies of the Figure*, c.1527. Ink drawing. 29.3 × 20.8 cm. From the Dresden Sketchbook (f.142r.). Sächsische Landesbibliothek, Dresden.

Klyun (Plate 105).[38] This painting has been interpreted as a cryptic portrait of Kruchenykh, whom Khlebnikov mockingly described as 'a little London ghost'.[39] Certainly Kruchenykh was a protagonist of *Victory over the Sun*. If this is true, he takes his place alongside Matyushin and Kamensky. Only Khlebnikov is missing. If it *is* Kruchenykh, he is, like Kamensky, sandwiched between the saw and the fish. Now, however, there are many cutting implements including scissors, bayonets and a sabre. As 1914 saw the outbreak of war it is perhaps not surprising that a military theme emerges here, though in fact the sabre goes back to early designs for a Turkish Warrior in *Victory over the Sun*. The Balkan element which ignited the First World War makes it possible to reconcile these two readings. Malevich, Kruchenykh and certainly Khlebnikov were aware of the worsening international situation in 1913.[40] It is perhaps significant that the *Englishman in Moscow* (Plate 164) contrasts the sabre with a church.

Many features link the *Englishman in Moscow* with *The Aviator*. The protagonist in each case wears the top hat largely square in profile.[41] Both figures stare straight at the viewer with one eye obscured. In both paintings the figure is caught between a saw and a fish as images are piled up one in front of another. The saw occupies roughly the same position in *Englishman in Moscow* as in the *Portrait of Ivan Klyun*, and the fish was associated with a warrior design for *Victory over the Sun*. There is a startling inconsistency of scale in *Englishman in Moscow* paralleled only by the *Cow and Violin* (Plate 123) painting or in certain effects employed by Chagall (and perhaps in a different sense by Boccioni or Severini). The imagery refers to three settings. Country life is indicated by reference to racing stables (inscription centre right) and carpentry; the religious life is indicated by the church with the fish (an early Christian symbol) and the candle which is placed here before the image like a real candle before an ikon, and finally the military life is indicated by fixed bayonets and the sword. There are many signs of change and adjustment on this canvas, which suggests that the painting was not easily resolved.[42]

The inscription on *Englishman in Moscow* (Plate 164) reads like a description of the overlapping of images used by Malevich: ЗАТМЕНIЕ ЧАСТИЧНОЕ (*zatmenie chastichnoe*) means literally 'partial eclipse'. This phrase, however, contains at least *three* other clues to the meaning and methods of Malevich's painting.

First, the mention of eclipse at once refers back to *Victory over the Sun* where scene two has a Strongman say that 'The sun lies slaughtered! Start the fight with guns'[43] and concludes: 'The sun hid/Darkness fell/We will all take knives/And wait locked up.'[44] In the stage design illustrated on the cover of the libretto, half of the sun appears and so is partially eclipsed; alongside, the letters KP (KR) refer to Kruchenykh. This is further evidence that the *Englishman in Moscow* may allude to Kruchenykh, the librettist of *Victory over the Sun*.

The second major clue in the inscription lies in the way that Malevich has cut up and coloured his words. At the top right ЗА/ТМЕНIЕ (*za/tmenie*) refers to the onset of darkness, but the lower inscription ЧАС/ТИЧ/НОЕ (*chas/tich/noe*) means 'partial' from the word ЧАСТЬ (*chast'*) meaning a 'part'. These fragments isolate roots of words just as Khlebnikov fragmented and reconstructed words in his poetry. Kruchenykh also employs the technique in *Victory over the Sun*. Similar effects were observed in *The Aviator* (Plate 162), where the word АПТЕКА (*apteka*) was split and manipulated. The most significant verbal fragment in the *Englishman in Moscow* is ЧАС (*chas*) in the lower left segment of the painting which means 'hour' or 'time', a central theme of Russian Futurism and of the recent opera in particular. No clock is in evidence here, but a Russian word for time dominates the painting. When we consider that Khlebnikov's mathematical interests were currently being applied to the rhythms of historical events, it becomes clear that Malevich

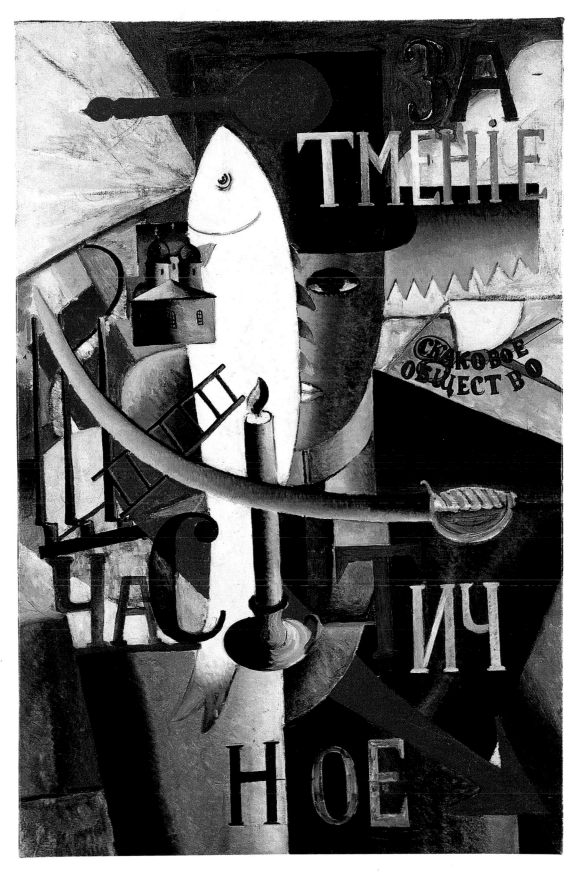

164. Kazimir Malevich
Englishman in Moscow, 1914.
Oil on canvas. 20 × 13
vershok. 88.8 × 57.79 cm
(given as 88 × 57 cm).
Stedelijk Museum,
Amsterdam.

165. Mikhail Larionov *The Clock*, an illustration for the book *Le Futur*, 1913. Lithograph. 19.9 × 15.5 cm. Courtesy of Chadwyck-Healey Ltd.

168, opposite page, left. Lyubov Popova *The Clock*, 1914. Whereabouts unknown.

169, opposite page, right. Marc Chagall *The Clock*, 1914. Gouache and oil on paper. 49 × 37 cm. Tretyakov Gallery, Moscow.

was so closely involved with Russian Futurist writers, in particular, that he illustrated not only their ideas but their methods too.

ЧАС (*chas*) can be pursued further. As a verbal fragment it implies 'part' or 'time'. It is worth noting in passing that in the upper-right inscription the fragment ТМЕНIE (*tmenie*) contains the Latin letters of the word TIME. Reading across alphabets was an activity occasionally used by Russian Futurists. The 1913 manifesto *Bukva kak takovaya* (The Letter as Such) encouraged such comparisons. A specific instance produced the fictitious name Eganbyuri, whose book on Larionov and Goncharova was actually by Zdanevich. The name Eganbyuri was developed by writing Zdanevich in Russian but reading it as if it were handwritten Latin script. It is possible therefore that Malevich has hidden (or found) the English word *TIME* in the Russian fragment *TMEHIE*. This may further explain the 'Englishman' of the painting's title and in any case echoes the ЧАС (*chas*, 'time' or 'hour') inscribed bottom left. We should also remember in this context that Malevich was working closely with Matyushin, the composer of *Victory over the Sun*, who in turn had books on space and time by the Englishman Hinton.

The third clue in the inscription allows us to pursue the fragment ЧАС (*chas*) further by considering related words that employ this syllable. These are startling in their closeness to the images contained in the paintings. As indicated above, *chast'* itself means a 'part' or 'fragment', including a military unit, while *chas* means 'time' or 'hour'. *Chastota* is 'frequency'. *Chasovnya* is a 'chapel'. *Chasovoy* is a 'sentry' or 'guard'. *Chastnik* is a 'business (or shop) owner'. ЧАСТИЧНОЕ (*chastichnoe*), which fills the lower canvas, means 'partial' but also it means a 'quotient' in mathematics. It may be possible to pursue such links further into the network of verbal and visual interactions in Malevich, but the arrow at least is emphatic: it seems to sweep down and right to indicate movement in time and space.[45] Time was the subject of *Victory over the Sun*, for conquering the sun meant escape from its divisions of the day and of the seasons of the year. In the fourth dimension, as Hinton, Bragdon and Ouspensky had described it, a clock would be of little use. They linked past, present and future in a four-dimensional continuum, just as the Time-Traveller did in *Victory over the Sun*. In view of this, the word ЧАС (*chas*, 'time' or 'hour') in the *Englishman in Moscow* provides rewarding material for further consideration in relation to the work of other artists of Malevich's immediate circle. Larionov, for example, in illustrating the Russian Futurist book *Le Futur* (Plate 165) introduced four or five arrows, which, like liberated clock fingers, arch this way and that through the overlapping transparent planes of his clock. Malevich perhaps found his own arrow here. Larionov's 24 (lower right) suggests the twenty-four hours of a day but his I, II and III have escaped from the clock face into a new and more complex continuum of time and space. In Malevich's painting the arrow may well derive, then, from the hand of a clock. Moving forwards and down through overlapping images, it may suggest 'the hour of eclipse' and a progression from the experiences of the riding stables and woodcutting in the countryside to the church and on to military commitments. The year after all was 1914 and Grand Duke Ferdinand was shot in June at Sarajevo. Several months of rapidly intensifying military tension followed before the outbreak of war.

The paintings of Lyubov Popova in 1914 (Plate 166–8) provide a close commentary upon this reference to ideas of time and seem to refer directly to the *Englishman in Moscow*. Popova repeatedly painted a wall clock with a pendulum swinging far to the left and depicted in three positions 9° apart. She employed woodgraining and collage in the manner learned in Cubist Paris, but time is her theme and she indicated it in four ways. First, the swinging of the pendulum established a rhythmic beat as it swung through

166, far left. Lyubov Popova *The Clock*, 1914. Oil and pasted wallpaper on canvas. 16 × 11 *vershok* (1 *arshin* high). 71.12 × 48.9 cm (given as 70.5 × 47 cm). Private collection, Moscow.

167, left. Diagram of the lines of the pendulum's swing, lettering and numerals from the clockface in Plate 166.

space. Second, the clock-face indicates that it is 9.40am or pm, but the clock-face itself is out of place having sprung from its casing. Third, Popova, like Larionov, has scattered some Roman numerals off the face of the clock, so that I, II and V spill through the air

170, above left. Olga Rozanova *The Hairdresser's*, c.1915. Oil on canvas. 16 × 12 *vershok* (1 *arshin* high, ratio 4:3). 71.12 × 53.34cm (given as 71 × 53.3cm). Tretyakov Gallery, Moscow.

171, above right. Olga Rozanova *Clock and Cards (The Gambler's Dream)*, c.1914–15. Oil on canvas. 61 × 40.5cm. Samara Art Museum.

above the centre of the painting. Fourth and finally, Popova has incorporated lettering which once again indicates ЧАС just as Malevich used this device. This confirms the interpretation of the *Englishman in Moscow* as a painting on the subject of time.

Popova's *Clock* series of 1914 permits us to go a little further towards understanding Malevich. The time of 9.40 may be significant (or not), but if a clock-face is viewed as a protractor it clearly covers 360° in which 9° comprises 9 seconds or 9 minutes. It was Malevich who made use of 9° intervals in geometry and here Popova seems to link it also to time. Multiples of 9° proliferate in Popova's painting too (9, 36, 45, 54, 72). The same rhythm echoes through both time and space in these canvases even though, according to the old method of measuring time, everything seems 'out of joint'. A lost painting, *Clock* (Plate 168), painted by Popova c.1914, repeats the motifs of weight, pendulum (in three stages of its swing), of liberated Roman numerals (here V, II, X) and of the lettering ЧАС (*chas*) across the whole painting. The same theme, or similar, occurs in Chagall's paintings. His *Clock* of 1914 (Plate 169) has a discontinuity of scale as extreme as that in Malevich. His small and melancholic figure is dwarfed by time in the shape of the gigantic pendulum clock inscribed on its face '*LE ROI DE PARIS*', a pun upon the maker's name Le Roi of Paris, but meaning also 'The King of Paris' as if time itself were the King of Paris. Confirmation of this lies in the pendulum weight inscribed *KA*, the name of the time-traveller from ancient Egypt who appeared in Khlebnikov's verses and also in the

Aviator. Chagall and Popova worked in Paris where the theme of time was as persistently pursued as it was in Russia. It was the theme, for example, of one of the shaped poems in Apollinaire's *Calligrammes*; it was equally a theme in Chagall's painting *Homage to Apollinaire*.

It would be surprising if these themes did not also occur in the paintings of Olga Rozanova in 1914–15. As the wife of Kruchenykh she had the fullest knowledge of *Victory over the Sun* and she may have designed some of its costumes. Certainly she made posters for these Futurist theatrical performances. Her involvement with Malevich and his ideas can be traced from 1913 right up to her early death, and her painting *The Hairdresser's* (Plate 170) belongs with the sequence just examined. It is oval, like Popova's. Its Roman numerals have spilled out of a clock face (IV and I, lower centre) and it has the О (*o*) and ПТ (*pt*) of Malevich's *The Aviator* where the inscription АПТЕКА (*apteka*, 'apothecary') yielded the ПТ (*pt*) of ПТИЦА (*ptitsa*, 'bird'). As *o* is also eye (*oko*), here the link with ОПТИКА (*optika*, 'optician') is firmly feasible too.[46]

Just as the earlier costume designs by Malevich associated suits of cards with figures from *Victory over the Sun*, so Rozanova was to develop the theme of the card game. In *Clock and Cards* (*The Gambler's Dream*) (Plate 171), *c.*1914–15, from the Samara Art Museum, she linked the motifs of clock and playing cards as if they were a metaphor of the inevitability of war, played out in Khlebnikov's calculations like a game of cards in a structured blending of chance and control.

A whole sequence of paintings made by Malevich in 1914–15 explore ideas from *Victory over the Sun*. *Composition with 'Mona Lisa'* (Plate 172), a damaged collage painting of 1914, is inscribed 'partial eclipse' just like the canvas *Englishman in Moscow*, and, indeed, the smaller collaged letter includes the phrase 'in Moscow'. A reproduction of Leonardo da Vinci's *Mona Lisa* is torn and crossed out with 'apartment changing hands' written beneath it. Whether Malevich is deleting the ikon of high art or simply rejecting Leonardo's pictorial space and conventions is not clear. *Mona Lisa's* image was partially eclipsed when the painting was stolen from the Louvre in 1913. Apollinaire was among those arrested for the theft; there was an actual 'space to let' and an 'eclipse'.[47] But this damaged work is important also in two other ways: it employs forms frequently repeated in other paintings, including the S-curve, lower centre, and the half-cylinder curve (slightly conical). Finally, it introduces flat planes among the shading and the images as if it to depict collage, and two of these planes are rectangles around the central vertical axis. They comprise perhaps a still life of a violin upon a table and may be compared with the 1912 Picasso *Violin* owned by Shchukin and now in the Hermitage Museum in St Petersburg. Malevich clearly responded with a vigorous and independent view to all that he learned of West European Cubism and Italian Futurism.[48] In these paintings of 1914–15 he assembled several different techniques within each painting. Here, for example, he collated photographic reproduction, lettering, shaded forms and flat geometric planes, all in themselves elements derived from Parisian Cubist painting.

The oil and collage *Woman at a Poster Column* (Plate 173) is comparable in terms of the mixture of techniques used. At 16 × 14 *vershok*, it is a standard *arshin* wide. Again it displays photographic imagery, lettering, shaded forms and flat geometric planes. A half-head is visible almost precisely upper centre and is partially eclipsed, as is the dancer further to the right. The 'apartment' is mentioned again and small repeat patterns are attached in spots, paper lace and lines. A large У (*u*) dominates upper left while an even larger В dominates the right. There may be a word game on КВАДРАТ (*kvadrat*, a square in mathematics) and КВАРТИРА (*kvartira*, quarters, as in military quarters). The long S–

ЧАСТИЧНОЕ

ЗАТМЕНIЕ

ПЕРЕДАЕТСЯ КВАРТИРА

въ Москвѣ

Малевичъ

173. Kazimir Malevich *Woman at a Poster Column*, 1914. Oil and collage on canvas. 16 × 14 *vershok* (1 *arshin* high). 71.12 × 62.23cm (given as 71 × 64 cm). Stedelijk Museum, Amsterdam.

172, opposite page. Kazimir Malevich *Composition with 'Mona Lisa'*, 1914. Oil, collage and graphite on canvas. 62 × 49.5 cm. Russian Museum, St Petersburg (acquired 1990).

shape recurs left of centre. Malevich has assembled his elements to make a pictorial construction set up like a still life, and partially masked by the yellow plane lower left.

The large B-shape (a Cyrillic V), may provide insights as this work was exhibited in March 1915 at the exhibition 'Tramway V' and was listed as catalogue entry no. 11: *Woman at a Poster Column* (1914). The B perhaps relates to an actual tramline V. However, this painting is related to a print (Plate 174) also dominated by a large B. Indeed, the P-shape (a Cyrillic R), most evident to the lower left of a tall plane in the print, can be discerned in the same position in the painting. These two works are, therefore, closely connected. But the numerous inscriptions on the print do not correspond to the poster column theme; instead, they concern astronomy and space flight, or possibly the flight in time and space that was the theme of *Victory over the Sun*. This print is sometimes considered a design for a curtain in *Victory over the Sun* and is perhaps related to the Prologue. The image is inscribed as follows (working clockwise from top left): 'Gas collection. From the sun 4,00 (9) . . . The gas from Saturn's morning is helium. Flight. 5000 in a vacuum. Calculation of the ether. On earth 1,000 . . . 09 0/0. Neptunian takes . . . gas.' A 'board' inserted left of centre is barely legible but includes the words 'fate' and '1895' like the board of calculations visible in the photograph of scene four of *Victory over the Sun* (Plate 148); both are inspired by Khlebnikov's calculations, which he called the 'Boards of Fate'. Diminutive figures move busily about the level lines of Malevich's drawing at centre and below. A larger hand places a rocket-like object above a boot. Other features are familiar from the designs for *Victory over the Sun*, including hooks (top, left of centre) and clouds of steam or smoke (top, right of centre). There is a wheel and perhaps small buildings. At top right is a kind of planetary system.

174, below left. Kazimir Malevich Curtain design for *Victory over the Sun*, 1913–14. Whereabouts unknown.

175, below right. Diagram of geometric forms in Plate 174.

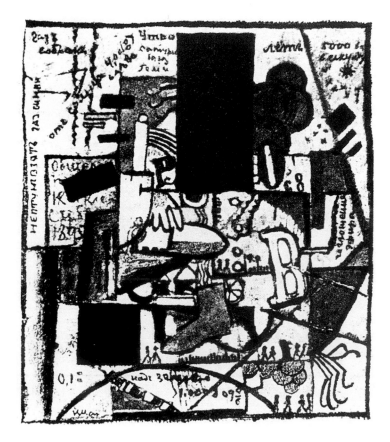

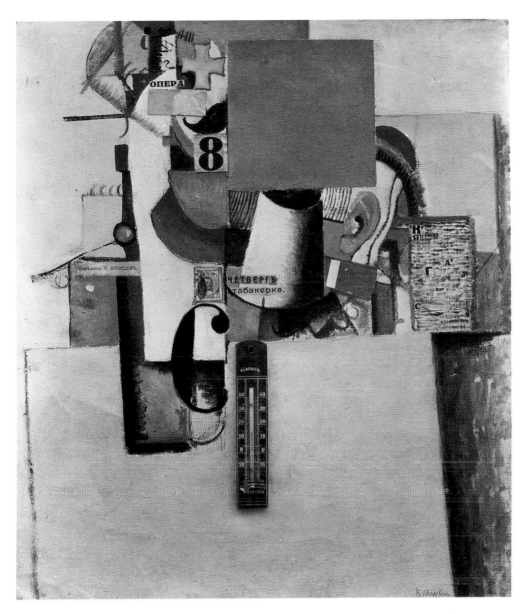

176. Kazimir Malevich *Reservist of the First Division*, 1914. Oil and collage on canvas. 12 × 10 *vershok*. 53.34 × 44.45 cm (given as 53.6 × 44.8 cm). Museum of Modern Art, New York.

There are several ways to analyse this work as several techniques are superimposed, but the words, small figures, measurement scales and stars all suggest flight in space or time. This is overlaid by the rectangular forms (Plate 175) encountered in *Woman at a Poster Column* and so on. One of these forms is the black square visible lower left. A tracing of these rectangles reveals a geometry in Malevich's design which he was later to strip of its imagery.

His *Reservist of the First Division*, 1914 (Plate 176) marks the military theme again in the year when the First World War began. The military cross (top, left of centre) is linked to the word 'opera', referring most probably to *Victory over the Sun*. The large 'C' (Cyrillic S) recalls the letter in this position in the *Englishman in Moscow* (Plate 164). Central is the collaged message ЧЕТВЕРГ (*chetverg*, 'Thursday') and ТАБАКЕРКА (*tabakerka*, 'tobacconist') and the Tsar's portrait on a postage stamp. In addition, there are two numerical references: the figure 8 and the scale inscribed upon the real, applied Réamur thermometer,

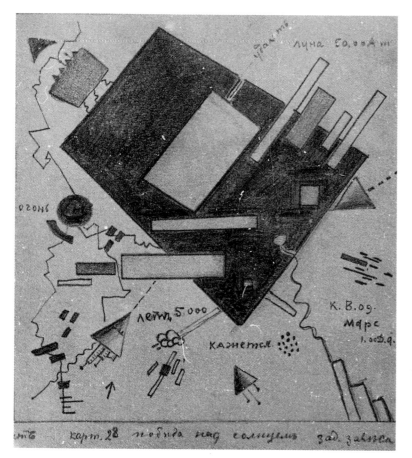

177, above left. Kazimir Malevich *Space Flight Theme, c.*1915–20. Graphite pencil on paper. 11.3 × 12.2 cm. The Literary Museum, Moscow.

178, above right. Kazimir Malevich *Drawing, c.*1914–15. Crayon on squared paper. Inscribed 'Portnoy' (tailor). 16.2 × 11 cm. Collection Ludwig, Cologne.

179. Vasily Kamensky *Shchukin's Palace: Ferro-Concrete Poem*, 1914. Published in V. Burlyuk and D. Burlyuk's *Tango with Cows*, Moscow 1914. 19.7 × 19.7 cm.

callibrated from $-20°$ to $+40°$ and therefore incorporating the figures 0 and 10, soon to prove important. The thermometer may be a covert reference to the metal (and god) Mercury. Finally there are again imposing planes of geometry which appear to eclipse these more complex forms in at least part of the painting.

This 'space flight' print (Plate 174) has a sequel (Plate 177) which appears, on stylistic grounds, to be considerably later in execution than *Victory over the Sun* in December 1913; it perhaps dates from 1915. These two works may be for a later version of *Victory over the Sun* or they may relate to another project which was more specific in its detail concerning the theme of flight in outer space. In this drawing there are references to flying cities, the moon and fire. The relationship of geometric forms suggests an aerial view of planes in flight. This is not, as such, a theme in *Victory over the Sun*, to which this drawing is unlikely to be related as its mathematics and perspective are of a wholly different order.

Other drawings pick up some of the themes that emerged in 1913 and 1914. An *Alogical Drawing of a Woman* in crayon reshuffles familiar images: the fork from *The Aviator* (Plate 162), the music staves and notes from *Matyushin* (Plate 125), a flying fish and a line of hooks. Other drawings include lettering and numbers.[49]

This mixture of geometric forms, recognizable images and lettering emerged first in the paintings. In a suite of drawings featuring a fish it is both surprising and baffling. One such drawing (Plate 178) incorporates the word ПОРТНОЙ (*portnoy*, tailor) together with a fish inscribed with the familiar B and associated with the Aviator's Ace of Clubs. These drawings may be inspired by hanging shopsigns, but no logical link is readily grasped.

At the Paris Salon des Indépendants from 1 March to 30 April 1914 Malevich exhibited *Samovar* (Plate 109) catalogued as no. 2154, *Portrait of Ivan Klyun* (Plate 105) catalogued as no. 2155, and *Morning after the Storm* (Plate 77) catalogued as no. 2156. A sign of his continuing respect for Parisian Orphism is a letter of 5 March 1914 in which he referred to his new technique as 'Orpho-Cubism'.[50] This followed the visit of the Italian Futurist leader F.T. Marinetti to Russia in January February 1914.

March 1914 also saw the opening in Moscow of Larionov's 'Exhibition No. 4 – Futurists, Rayists, Primitives'.[51] Alongside paintings by Goncharova, Larionov, Exter, Le-Dantyu, Shevchenko and Zdanevich were a series of 'ferro-concrete poems' by Kamensky (catalogue entry nos 76–86).[52] These were exhibited barely three months after *Victory over the Sun*. What distinguishes Kamensky's poems is their move towards a pictorial structure, just as Malevich at this time was incorporating structures derived from words. Kamensky's square ferro-concrete poem *Shchukin's Palace* (Plate 179)[53] sums up so much that was of importance to Malevich and his contemporaries in 1914 that it rewards close inspection. Here is a glimpse of Shchukin's palace and what it offered. In the centre it reads 'Picture palace S.I. Shchukin'. Below this and then clockwise it reads in broken words as follows in eight sections: 'staircase. Matisse. Pikas [i.e. Picasso], Luxembourg Gardens. Blue-Red-Yell. Fragrant days. Bois de Boulogne. Da-nce of nasturtiums. Arab café. But to the Maroccan Vase of Flowers. Youth side by side. I love the *vesmanky*. Picasso . . .' It speaks of Gauguin's *Vairumati*, of Van Gogh, Le Fauconnier, Denis, Derain and Meunier. It lists Monet and Cézanne, and at lower left '*Vozdukh slova*' (air words), *tsvet kraski* (colour pigments) and '*svet muzyka*' (light music).'

Just as Apollinaire used varied typefaces in Paris, so Kamensky did in publishing his 'ferro-concrete poems' in Moscow. Even on the eve of war links could not have been closer. On 16 April 1914, for example, the painter Yakulov, the composer Lure (Lourié) and writer Livshits published with Apollinaire their manifesto *My: zapad* (We and the West). To all of these people the sun provided a special image – as important to Yakulov

180, above. Vasily Kamensky *Ferro-Concrete Poem: The Sun (lubok)*, 1914–15. Photograph Szymon Bojko.

181, right. Natalya Goncharova *Mystical Images of War*, 1914. Lithograph. 33 × 25 cm.

182, far right. Kazimir Malevich *Look, Oh Look, near the Vistula . . . !*, 1914. Colour lithograph. Published as a poster by the company Contemporary Lubok, Moscow. 51.3 × 33.4 cm. Russian Museum, St Petersburg.

as to Delaunay; it was a central feature in *Victory over the Sun* and was the focus of Russian Futurist time imagery. A *Ferro-Concrete Poem: The Sun (lubok)* (Plate 180) by Kamensky confirms the vitality of this image in the seasonal themes of paintings by Larionov and Goncharova. Here Kamensky made the sun central and surrounded it with neologistic words indicating that the sun's brightness is 'the face of genius'. Vowels divide the space around it, which is marked like a calendar for the summer and winter solstice and the spring and winter equinox. It is a hymn to the sun within the cosmos with Kamensky as its star (lower right) and Futurism as its moon, while on the left are inscribed the names of David Burlyuk, Mayakovsky and Khlebnikov.[54]

If Malevich was an eclectic and collaborative artist in 1913 and 1914 it was because he was intimately involved in Russian Futurist thought and theory. Throughout all of this, his interests in mathematics and proportion were signs of cosmic interests and ideas of the fourth dimension. In 1915 he found a resolution of all these strands in the movement he called Suprematism. Its origins lay in *Victory over the Sun*. He had already mentioned the word Suprematism to Matyushin in a letter on 24 September 1914.[55] From this point forwards the mathematical element in his work was of primary importance, but the roots of its meaning lay in all of those concerns that gave shape to *Victory over the Sun* and *The Aviator*.

By autumn 1914 Russia was at war. The military theme was evident in numerous works by Malevich and his colleagues. It should not be forgotten that his new movement Suprematism was launched in a time of war and before the Revolution. The context of war was to make an immediate impact on several of his works.

War in August 1914 stopped the cosmopolitan interaction of the French and Russian art capitals. Larionov and Goncharova had taken Russian Futurism to Paris in 1914. Goncharova designed *Le Coq d'or* by Rimsky-Korsakov and Benois designed for Diaghilev's *Ballets Russes* in May 1914. By June Larionov and Goncharova were jointly exhibiting Rayist paintings at the Galerie Paul Guillaume, where they were reviewed by Apollinaire who noted in his newspaper *Les Soirées de Paris* that 'these experiments show that a universal art is being created, an art in which painting, sculpture, poetry, music, and

even science in all its manifold aspects will be combined'.[56] Apollinaire also inspected Chagall's large exhibition prepared for the gallery of Der Sturm in Berlin in 1914 and still visible before it left Paris.[57] In addition, Apollinaire could see paintings by Malevich at the Salon des Indépendants in Paris. Robert Delaunay's watercolour synthesis of the verbal, and visual, designed to illustrate Rimbaud's *Alchemy of the Word*, is one indication of the closeness of French and Russian artistic preoccupations in 1914. Whilst the Italian Futurist Marinetti considered Khlebnikov's poems to be in 'the language of the prehistorical period',[58] the writer Benedikt Livshits commented: 'We emphasize the continuity of the verbal mass, its elemental cosmic essence. . . This is not archaism, but the practice of cosmology.'[59] Much the same could have been said of Malevich's work in 1913–14. It was an attitude traceable to Gauguin's painting and communicated to Moscow via Shchukin, Morozov, Denis and others. Sérusier and Denis were, of course, still active in Paris. By 1914 they were teaching mysticism, mathematics and art to Cubist painters at the Académie Ranson in Montparnasse. With the coming of war Sérusier retired to Châteauneuf-du-Faou in Brittany: 'It seems to me,' wrote Sérusier, 'that I am reading a page of the Apocalypse or of the Baghavad Gita. I often think of discussions with Ranson on the battle of nations.'[60] This was exactly Khlebnikov's concern, too.

It was also in 1914 that the Russian mystical philosopher, mathematician and monk Father Pavel Florensky published his 800-page collection of essays, *The Pillar and Foundation of Truth*,[61] in which he discussed subjects ranging from the mathematics of infinity to the books of Lewis Carroll, and from the meaning of ikons to the nature of time. His knowledge of mathematics was extensive and fully annotated in his essays. His interest in art assured him of the closest contact with artists. He discussed in detail the mathematics of Lobachevsky, Poincaré, Cantor, Russell and many others. His discussion of irrational numbers included a consideration of squares that seems highly relevant to Malevich. Not surprisingly, perhaps, theories of time were also a preoccupation for Florensky.[62] He read and discussed the writings of Bergson and in an essay, '*Time and Destiny*' he touched upon concerns identical to those of Khlebnikov. 'Death,' says Florensky, 'is an instant of time; Time is a prolonged death.'[63] He continued: 'Black Death does not strike at White Life from beyond . . . The process of death is a condition of life. There is no present without a past and no life with death.'[64] Like a Russian Futurist he even made investigations into words: according to Florensky the word *rok* means 'destiny', but among some Slav tribes it once meant 'twelve months'. In Old Russian, he says, it meant 'a lapse of time, a period, an age or fate',[65] which he compared with the Russian word *vremya* (time) from an old Slav word meaning 'turn'.[66] Russian mysticism seems to have been frequently inseparable from the concept of time.

When Autumn 1914 brought Russia into war with Germany, many artists were almost immediately affected. Chagall drew wounded soldiers. Goncharova published a magnificent lithographic series of angels and aeroplanes entitled *Mystical Images of War* (Plate 181).[67] Malevich turned to propaganda work in an extraordinary series of popular patriotic posters ridiculing the German forces (Plate 182). These were executed in strident colours for the Contemporary Lubok lithographic presses in Moscow.

It has been suggested that *Victory over the Sun* and the *Englishman in Moscow* may refer to contemporary military events. In the posters this military aspect is overt and partisan. Malevich's own Polish connections may have sharpened his awareness of fighting there. *Look, Oh Look, near the Vistula* (Plate 182) is only one example of Polish settings in his propaganda posters. The overfed Germans advance like malevolent toys or automatons in Malevich's poster. Yet the main figure here is not as crude as it first appears. As in the costume designs for *Victory over the Sun*, a protagonist participating in great events is

183. Kazimir Malevich
Costume for a Masked Ball,
1913–15. Pencil on paper.
16.5 × 10.8 cm. Collection
Ludwig, Cologne.

presented full-length and surrounded by the 'action' and activities which define his meaning. The heroic peasant defending Lomzha against Germany's 'toy soldiers' is likewise drawn in a deceptively sophisticated neo-primitive style.

Malevich's friend and collaborator Khlebnikov took a particular interest in the war and in 1915 some of his theories were being published. In 1915, for example, Khlebnikov wrote the poem *Ka* which was published in 1916. Ka, Khlebnikov's time-traveller, is studying 'the procedures of playing on seven strings',[68] which represent the planets, upon an instrument whose music is literally the rhythm of history: 'Ka posed an elephant tusk in the air and on the upper surface, he fastened some years to serve as pegs for a stringed instrument. They were the following years: 411, 709, 1237, 1453, 1871. Below, on the lower slat of the tusk, he fastened these years: 1491, 1193, 665, 449, 31. The strings, ringing faintly, united the upper and lower points of the elephant tusk.'[69] This poetic and evocative image links historical wars across the centuries to create the unknown harmony heard when the strings 'emitted the rumble of a flock of swans just landed on a lake'.[70] Ka observed the secret connections of events across time:

> every string consisted of six parts, each of which held 317 years, for a total of 1902. Furthermore, while the upper pegs signified the east overrunning the west, the pegs at the lower ends of the strings signified the movement from west to east. Vandals, Arabs, Tartars, Turks, Germans were above; below were the Egyptians of Hatshepsut, the Greeks of Odysseus, the Scythians, the Greeks of Pericles, the Romans.[71]

Time has no barriers for Ka who 'occupies the centuries as comfortably as he does a rocking chair'.[72]

Ka clearly has a lot in common with the Time-Traveller and the Aviator who appeared in Kruchenykh's *Victory over the Sun*, for which Khlebnikov had provided the prologue. Ka, for example, introduces a scientist from the year 2222, just as *Victory over the Sun* had its traveller from the Tenth Land. These travellers are, in essence, reincarnations of the ancient Greek Hermes, flying between gods and mortals with messages, fulfilling destiny and guiding the souls of the departed. This hermetic traveller is aware of history, of war, of aeroplanes and he knows the fourth dimension into which he may vanish at a moment's notice: 'Ka saluted, touched his cap and disappeared, gray and winged.'[73] The hermetic tradition is also the alchemical tradition. There were signs of it in Delaunay's thinking and Apollinaire called a whole aspect of Cubism *hermetic* Cubism, the Cubism of Hermes. In Russia the theme was equally evident. Ouspensky discussed alchemy, for example, and alchemical imagery appeared in Chagall's paintings. The cosmology of Khlebnikov linked these ancient systems to contemporary events, to the rhythms of wars and to the history of cosmology itself. As Ka declares: 'I drifted from the dust of Copernicus to the dust of Mendeleev, constantly aware of the noise of a Sikorsky airplane', and 'I thought about bits of time melting into the universe, and about death'.[74]

Malevich and Popova used such ideas in 1914–15, featuring clocks or verbal references to time in their paintings (Plate 185). Rozanova also featured clocks, along with playing cards such as the Aviator evidently carried, perhaps seeing in their games and ancient forms an image of battle and warfare revealing chance at work within a rigid structure. Cards, as Ouspensky pointed out, retained the cosmological and mystical aspects of their origins in the tarot pack. Their battles could reflect the battles of war in 1915.[75] Exhibiting at the Leftist Tendencies exhibition, at the N.E. Dobychna Bureau in Petrograd in 1915, Rozanova showed a whole series of paintings based upon playing cards. These included *The Four Aces, The Knave of Clubs* (Plate 184), *Simultaneous Representation of the King of Diamonds and the King of Hearts* and nine other canvases.[76]

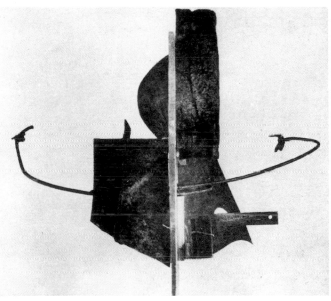

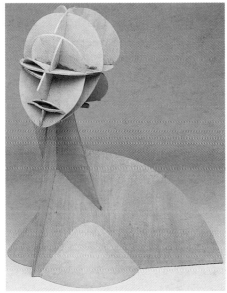

184, above left. Olga Rozanova *The Knave of Clubs*, *c*.1915. Oil on canvas. 83 × 66 cm. Ivanovo Regional Art Museum.

185, above middle. Lyubov Popova *Still Life*, 1915. Oil on canvas. 12 × 8 *vershok*. 53.34 × 35.56 cm (given as 54 × 36 cm). Nizhny-Novgorod Art Museum (acquired 1920).

186, above. Lyubov Popova *Study for a Portrait*, *c*.1916. Coloured pencil on paper. An *arshin* and *vershok* scale is at right. 27.5 × 20.5 cm. Private collection, Moscow.

Popova was more obviously philosophical but her involvement with the theme of time is beyond doubt since her series of clock paintings. A *Still Life* (Plate 185) of 1915 in Nizhny-Novgorod depicts bottles and glasses on a table; here Parisian Cubist techniques are employed including collage and woodgraining. Lower left is the inscription KA which could refer to КАФЕ (*kafe*, café) or it could refer to Khlebnikov's time-traveller (or to both). The form of the letters exactly follows that employed by Malevich in his painting of *The Aviator*. The proportions of her canvas also suggest an awareness of Malevich's incorporation of geometry. *The Aviator* is a double square. This canvas at 12 × 8 *vershok* is in the ratio 3:2. This can be seen in the work: the strong central vertical axis is divided into thirds horizontally. Popova's brother appears in her *Portrait of a Philosopher* (Russian Museum, St Petersburg) in 1915, clad in top hat, a Cubist glass of wine to hand (lower left) and a copy of the *Revue philosophique*. A related drawing *Study for a Portrait* (Plate 186) illustrates well her use of the vertical central axis with divisions across it to correspond to

187, left. Vladimir Tatlin *Central Relief*, *c*.1915. Various materials and objects including palette and set square. Whereabouts unknown.

188, right. Naum Gabo *Constructed Head No.1* (*C.R.3.2*), 1915. Triple layered plywood. *c*.54 cm high. Collection Nina Williams. © Nina and Graham Williams.

189, right. Albrecht Dürer *Head Constructed by the Parallel Method*, *c*.1507. 29.5 × 20.6 cm. From the Dresden Sketchbook (f.91).

190, far right. Nikolai Kulbin *Portrait of F.T. Marinetti*, *c*.1914. Charcoal on yellow paper. 35.7 × 22 cm. Collection Ludwig, Cologne.

a scale of *vershok* and *arshin*, marked out along the right edge of the paper. Popova's drawing reveals a process of construction comparable on the one hand with the material constructions being undertaken at the time by Tatlin (Plate 187) and Gabo (Plate 188) or with the constructions of Dürer (Plate 189) or Leonardo on the other hand.[77] Generalizing from observation, Dürer, for example, constructed figures with circles to define the ratios or proportions of the parts. Russians adapting the geometry of Cubism undertook a comparable procedure. In three-dimensional works the process can literally construct a figure. The sculptor Naum Gabo began this way in 1915. In his plywood sculpture *Constructed Head No. 1* of 1915 (Plate 188), he built up the head and neck from planes of wood to make the rigid structure.

Tatlin was exhibiting his constructed reliefs at the Tramway V exhibition in Petrograd by March 1915 and Malevich was fairly thoroughly represented there, with major canvases including *The Aviator* and the *Englishman in Moscow* (1914) and the *Portrait of M.V. Matyushin, Composer of the Opera 'Victory over the Sun'* of 1913. Other exhibitors included Klyun with his *Swift Landscapes* and *Ozonator*, Morgunov's *Aviator*, Popova's *Figure + House + Space* and Ivan Puni's construction *Cardplayers*.[78] Malevich also included paintings from 1911 as well as five works (catalogue entries 21 to 25) the contents of which were 'unknown to the artist'.[79] Malevich was working on startling new developments which he was perhaps unready to reveal in March 1915. In January 1915 he had suggested that a new development was emerging in his work.[80] In May 1915 he sent drawings to Matyushin for a second edition of the *Victory over the Sun* pamphlet including 'three backdrop curtains. Among them a backdrop with a black square, which has served me well by generating a mass of material. I very much wish you to find a place for it, either on the cover or inside.'[81] This sounds remarkably like one of the two drawings associated with calculations and space flight. He also spoke of 'a truncated cone for the second act representing the moment when the sun is engulfed'.[82] Small cones fly through

the other drawing like strange aircraft. These drawings perhaps show what Malevich was developing in 1914–15, as a basis for the new style which by September 1915 he had named Suprematism.[83]

These drawings are characterized by a dominance of geometric forms engaged in complicated relationships; they suggest space and perspective alongside small images and words that apparently refer to spaceflight. Yet at this point in his career more than at any other time, Malevich was engaged in a process of eclectically gathering styles together within each canvas. Cubist and Futurist elements appear this way, for example, in his paintings of 1914. In view of this it may be significant that the painter Nikolai Kulbin invited the Italian Futurist Marinetti to Russia. Malevich seems to have been supportive of Marinetti when his colleagues were not. It was Kulbin who suggested Malevich send work to the Salon des Indépendants in Paris in 1914 and Kulbin exhibited portraits of Marinetti at the Leftist Tendencies exhibition held in Petrograd in 1915.[84] One of Kulbin's drawings of Marinetti (Plate 190) used only geometric blocks floating on the page to assemble a profile image. These blocks are similar to the geometric forms that Malevich was using in his 'space flight' drawings. They may also indicate that Kulbin was aware of the contemporary British Vorticist group in London, and of Wyndham Lewis in particular. He may have learned of the Vorticists from the theatre director Alexandr Tairov, who in 1914 was studying at the British Museum and staying with his aunt, the critic and writer Zinaida Vengerova.[85] She met the Vorticists whilst writing an article about them for the Russian Futurist journal *Strelets* (The Archer, Sagittarius). This article, 'The English Futurists', illustrated Wyndham Lewis's *Portrait of an Englishwoman* (Wadsworth Athenaeum) whose geometric forms relate directly to the latest innovations found in the work of both Kulbin and Malevich.[86]

Zero

Late in 1915 the poet Velimir Khlebnikov adopted the title of the 'King of Time'. With the writer Grigori Petnikov, he launched the Society of 317 to promote his mathematical analyses of historical intervals which had, not surprisingly, intensified since the outbreak of war.[1] Proposals, written by Khlebnikov in 1915–16, isolated the numbers 365 and 317 as important indicators in his theory of the rhythms or waves of history.[2] They also envisaged 'the end of the world war with the first flight to the moon',[3] a proposal that seems closely related in subject to contemporary drawings by Malevich. Khlebnikov also called for 'a recognised class of artists who work with numbers',[4] a description that would fit Malevich. Soon Khlebnikov was to name 'Presidents of the Globe' to rule time rather than space: Malevich was the only painter among them.

On 29 May 1915 Malevich wrote to Matyushin to discuss *Zero* as a magazine title: 'In view of the fact that in it we intend to set everything back to zero, we made up our minds to call it *zero*, while we ourselves will go beyond zero.'[5] Zero was seen as a mysterious threshold. It appears in this guise in *The Aviator* where it is also associated with the letter *o* in the eye (*oko*). In December 1915 zero featured in the title of the 'Last Futurist Exhibition of Paintings 0,10 (Zero-Ten)' (Plate 191). This exhibition was of immense importance to Malevich for it provided the platform from which he launched a whole new movement and attitude to art. The exhibition in Petrograd was organized by Puni, Malevich and Tatlin and its private view took place on 19 December 1915. It opened to the public the following day.

There have been numerous explanations of the title '0,10' (*nul'– desyat'*, 'zero – ten'), which is not identical to the decimal fraction 0.1. As Malevich suggested that he and his colleagues would pass zero, one possibility is that it signifies ten artists beyond zero in some sense. Furthermore, Malevich had recently exhibited a painting to which he had affixed a Réamur thermometer calibrated from −20 to +40°, which obviously includes the range of −10 to +10°. The comma in 0,10 is problematic but the use of grids by Malevich to organize the proportions of his canvases in *vershok* and *arshin* units suggests a possibility that 0,10 is a grid reference signifying 0 along one axis and 10 along the other. This would produce the line along one of the co-ordinates of such a grid: it suggests two dimensions but offers only one.[6]

The 0,10 exhibition included corner reliefs by Tatlin; these do indeed interslot various elements to form a three-dimensional set of co-ordinates, making a stereometric cube, effectively, from the corner space that they occupy. Intensely dramatic and innovatory as these works are, they appear evidently hand-crafted objects. As constructions they perhaps relate to maquettes for a theatre construction. Tatlin was working on designs for Wagner's *Flying Dutchman* in 1915 and one of his reliefs is constructed on a motif of rigging. Wagner's opera calls for the haunted ship to be tossed in restless movement while Daland's ship is still: this convincingly characterizes two of Tatlin's corner reliefs which should be studied alongside his gold and blue design for the curtain. A painted study for this is in the Bakhrushin Theatre Museum in Moscow.[7]

Malevich had also been involved in Futurist theatre design when *Victory over the Sun*

191. Poster for The Last Futurist Exhibition '0,10' (Zero–Ten), 1915. Lithograph. 74 × 55 cm.

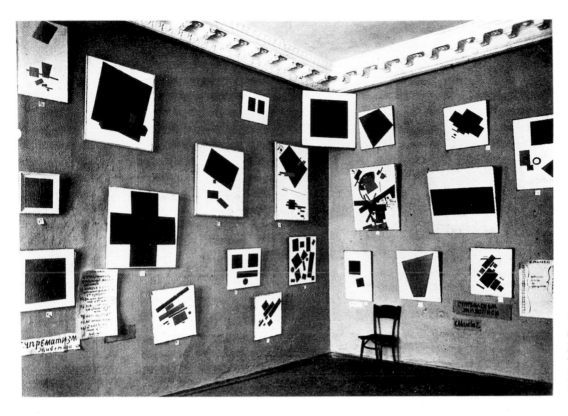

192. Paintings by Malevich at The Last Futurist Exhibition '0,10' (Zero–Ten), Petrograd, 17 December 1915–17 January 1916.

was staged in 1913 as already seen. Now the winter solstice two years later saw him launch Suprematism in Painting, a unique display in which control and coherence led to extensive influence. Malevich emerged as the geometer of a new vision in which proportion and perspective were manipulated apparently without reference to imagery.

Something of the display as a whole, as arranged by Malevich at the exhibition '0,10', is recorded in a single surviving photograph (Plate 192) of one corner of the room: twenty one canvases are visible. The catalogue listed thirty-nine works by Malevich, so eighteen were missed by the camera. Many of those visible in the photograph survive. Related works also survive which may or may not have been included in the exhibition. On each of the two visible walls Malevich has hung a handwritten sign inscribed 'Suprematism of Painting' (*suprematizm zhivopisi*). The catalogue lists his exhibits as follows:

39. Quadrilateral.
40. Painterly Realism of a Footballer. Colour Masses in Four Dimensions.
41. Painterly Realism of a Boy with a Knapsack. Colour Masses in Four Dimensions.
42. Movement of Painterly Masses in Four Dimensions.
43. Painterly Realism of a Peasant Woman in Two Dimensions.
44. Self-Portrait in Two Dimensions.
45. Automobile and Woman. Colour Masses in Four Dimensions.
46. Woman. Colour Masses in Four and Two Dimensions.
47. Painterly Realism of Colour Masses in Two Dimensions.
48–59. Painterly Masses in Movement.
60–77. Painterly Masses in a State of Rest.

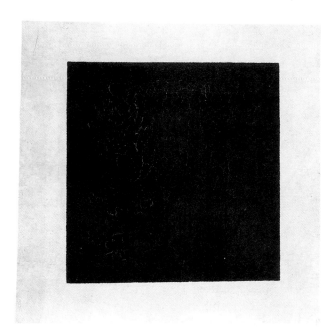

193, above left. Kazimir Malevich *Quadrilateral (The Black Square)*, 1914–15. Oil on canvas. 18 × 18 *vershok*. 80.01 × 80.01 cm (given as 79.6 × 79.5 cm). Tretyakov Gallery, Moscow.

194, above right. Diagram of the compositional structure of Plate 193.

This list, together with the installation photograph, provides the only basic reliable information about the Malevich display *as a whole*. This firm basis alone permits substantial conclusions as, on this occasion at least, Malevich made a clear statement of his new achievements by means of the layout of the exhibition itself. No exhibition like this had been seen anywhere before 1915. By this display alone Malevich raised himself from an adventurous follower and collaborator of Russian Futurists into the unquestioned leader and initiator of a form of art based upon geometries both old and new, in which the concerns of Russian Futurism were welded into a new, precise and infinitely adaptable configuration.

The catalogue's listing of titles provides several insights into Malevich's aims at an early stage of this new revelation. Surprisingly, as no imagery is overtly visible in these works, Malevich used titles which in three cases referred to subject matter that he had used before: these subjects were a boy with knapsack (see Plate 215), a peasant woman (Plate 197) and a self-portrait (Plate 222). In a further two cases he refers to subjects that he *may* have used before: footballer and automobile. All of these works may retain some residue of imagery or Malevich may have derived some of his Suprematist canvases from images as a way of further developing earlier works.

Surprisingly, Malevich refers to a geometric shape only once in the catalogue: the title, *Quadrilateral* (Plate 193, commonly known as *The Black Square*), opens the list of his works. It is given the same priority in the installation of the exhibition where it was suspended high across the corner of the room. This was a work of primary importance (Plate 194).

On the other hand, twenty-six out of the thirty-nine paintings are works in two or four dimensions, and in one case (catalogue entry no. 46) the painting is in both 'two and four dimensions'. The use of the term 'dimensions', and especially reference to 'four dimensions', immediately recalls the writings of Ouspensky, Hinton, Bragdon and others, although it is not certain that Malevich is using the word 'dimension' in quite the same way. Viewed as flat surfaces, his canvas are effectively two-dimensional whatever their painted forms may suggest. As manufactured objects with a thickness or depth they are inevitably three-dimensional objects but Malevich makes no mention of three dimensions. The location of the fourth dimension is unexplained.[8] Discussion of the fourth

dimension by Hinton almost always related time and space to the viewer's perception, so that in effect it proposed a new perspective system. As some of these paintings employ effects of recession and distance, this aspect requires consideration On the other hand, Malevich may have used 'dimension' as a term denoting another physical quality, such as colour, which is additional to the geometry, but only five of his titles refer to 'colour masses'.

Two last points emerge from the list of titles: Malevich refers to 'painterly realism' or 'painterly masses' in almost every case. These 'painterly masses' can be in 'two dimensions in a state of rest' (nos. 60–77) or they can be 'in movement' (nos. 42, 48–59). Movement, as Hinton and others emphasized, involves extension in both time and space. Russian and Italian Futurists both accepted this idea. As Malevich is speaking of the dynamics of his geometric compositions he suggests that simple flat forms are static, while forms that appear to recede are dynamic. Visual evidence supports this view, as we shall see.[9] What Malevich meant by 'painterly realism' is still the subject of speculation. It is possible, for example, with hindsight to interpret 'painterly realism' as a determination to accept the physical qualities of the canvas and pigments without recourse to the illusions of recognizable imagery. But it can be readily argued that a square, for example, *is* a recognizable image, and also that Malevich remains convincingly adept at the painter's art of conjuring up credible illusions of space in paintings.

In conjunction with the exhibition, Malevich and his colleague the painter Ivan Puni both gave lectures at the Tenisheva College Concert Hall on 12 January 1916 in an attempt to explain their views. The outline of Malevich's speech indicates an historical framework for these new developments: (1) The Fall of the Classics and Aestheticism; (2) Nineteenth- and Twentieth-Century Naturalism as a Renaissance of the Primitive; (3) The Theory of Cubo-Futurism; (4) New Realism in Art; (5) The Academy and Deadart;[10] (6) Inquisition in Art; (7) Nero and You; and (8) Alogism in Poetry.

When Malevich gave his lecture five days before the close of the exhibition on 17 January 1916, he touched upon all the major issues in his work since 1913, summing up the two years of vigorous investigation that led him to Suprematism. His concern for the primitive, for Cubism and for Futurism, even his interest in Russian Futurist poetry, all of these are evident in his lecture headings just as they were in his paintings. As Suprematism itself was not listed it must mean that 'New Realism in Art' meant Suprematism.[11] His use of the term 'painterly realism' in his catalogue entries confirms this.

The lecture topics alluding to 'The Fall of the Classics and Aestheticism', 'The Academy and Deadart' and finally 'Nero and You' all indicate a shaking off of academic conventions. In this Malevich is thoroughly Futurist in his attitudes. Malevich referred to Nero as he appeared in the opera *Victory over the Sun*, where he proclaimed how disrespectful the new times are. Two years had passed between *Victory over the Sun* in December 1913 and the exhibition '0, 10' in December 1915. Working with poets and the composer Matyushin had made Malevich a central protagonist of Russian Futurism, developing equivalents for their verbal, spatial and temporal ideas. Whether on stage or in Russian Futurist books Malevich was finding pictorial expression for their ideas: this meant devising new ways of working which quite suddenly at '0, 10' were stripped of all imagery and presented in their most economical and elementary form, rather as the Russian Futurist book *The Word as Such* led rapidly to the writing of *The Letter as Such*.[12] Malevich at '0, 10' had established his own elemental language. But his study of poetry through collaboration with Kruchenykh and Khlebnikov had been an essential element of this process, as the paintings of *The Aviator* (Plate 162) and the *Englishman in Moscow* (Plate

164) revealed. It is not surprising that Malevich's lecture included a section on 'Alogism in Poetry' or that he began to compose Russian Futurist poetry himself. A text preserved in the Stedelijk Museum in Amsterdam and written in about 1915 again uses the vision that motivated *Victory over the Sun*: 'In the new miracle there is no/sun, no stars. The light of Paradise/has gone out./The era of the new beginning has dawned.'[13] This new and sunless dawn Malevich associated with his own achievements and even with his own self-portrait: 'Now is the first day of the creation/of the New Dimension, of the basis/of the beginning/of my Face transformed into a new/being.'[14]

On several occasions Malevich had previously produced self-portraits that situated the painter within the context of a new style. At other times the same format was used, often on a square canvas, to present 'the face of his time' – hence *Head of a Peasant* (Plate 52) and the *Portrait of Ivan Klyun* (Plate 105). At the 0, 10 exhibition, exhibit no. 44 was a *Self-Portrait in Two Dimensions*. Malevich's notes, written perhaps in 1915, reveal a characteristic interweaving of these themes of self-portrait, new beginning, and the face of his time: 'I am the beginning of everything for in my consciousness worlds are created. I search for God/search within myself for myself.'[15] The same text discusses the evolution of man,[16] or 'the face of man',[17] and how 'deep down in man there lies a path to reincarnation'.[18] It seems clear that in 1915, at the time of the exhibition '0, 10', Malevich was still in some ways close to the ideas of Ouspensky, or at least to their adoption and mediation by Russian Futurists in which time past and time future were allowed to co-exist in a fourth dimension.[19] Malevich also referred to reincarnation, a theme that interested both Ouspensky and Khlebnikov. Khlebnikov's ideas of rhythms in time and space fabricating human history were known to Malevich. To seek some equivalent in visual terms must at least have occurred to Malevich as he worked with Kruchenykh, Matyushin and Khlebnikov. In 1915 he concluded that what was elemental in painting in this respect was also geometric: 'The artist of colour, the artist of sound and the artist of volume – these are the people who open the hidden world and reincarnate it into the real. The mystery remains – an open reality and each reality is endlessly multifaceted and polyhedral.'[20]

Geometry was the single unifying feature that dominated and characterized the display of Malevich's Suprematism at the exhibition '0, 10'. It was to be more than a new style, for personal style was superseded here and seemed of little concern to Malevich. This whole display was designed to appear as a revelation of form, means and method. Its rhythmic coherence matched the blatant optical impact of its individual canvases. Geometry was the means chosen to articulate this rhythm. In effect, Malevich used it to devise a new perspective that had no horizon, but which had an energy generated by its sense of proportion. The dynamic force of both of these characteristics burgeoned, like a seed, not only in the individual canvases, or in their growing complexity and colour, but most strikingly of all, and as a kind of manifesto, in Malevich's decision to use his new system to organize the whole installation and layout of his display. He made it a dramatic exposition of his breakthrough and turned his whole exhibition into a single Suprematist work.

The photograph of the Suprematism of Painting, even though it shows only part of his display, indicates that it was no ordinary, casual or conventional hanging of paintings but an application of Suprematist dynamics to the exhibition as a whole (Plate 195). The compositional sophistication of the canvases is also used in their arrangement on the walls, where every detailed judgment is geometrically determined and resolved in relation to the others. The display is a manifesto of Suprematism exploding with all the energy that Malevich developed from his study of the square. It is the square, catalogue entry no. 39,

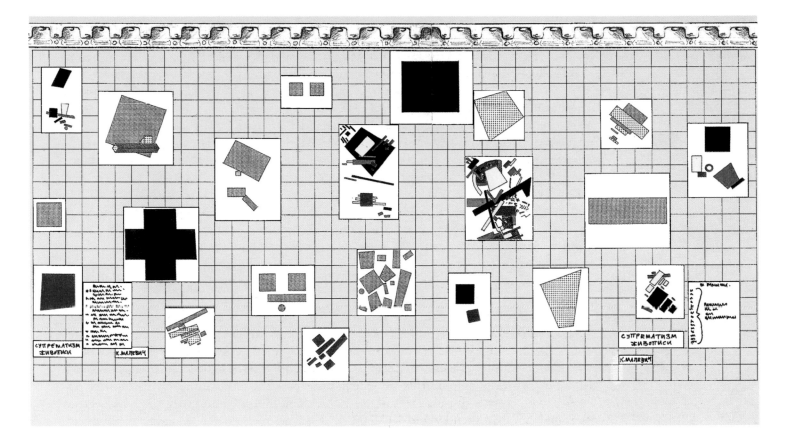

Quadrilateral (Plate 193) – the first of his works listed – that forms the focus of the exhibition. Hung, as Russians often hang domestic ikons, across the corner of the room, it appears as the source and generator of all that radiates from it. Hung against the ceiling it reveals all that it is descended from it.

On 1 December, just before the 0,10 exhibition opened, Malevich completed his essay 'From Cubism and Futurism to Suprematism: New Realism in Painting'. In it he declared that 'The square is not a subconscious form. It is the creation of intuitive reason. It is the face of the new art. The square is a living, royal infant. It is the first step of pure creation in art.'[21]

His vision of outer space had been instrumental both in this breakthrough and in *Victory over the Sun*, which had first revealed the black square to Malevich. Without the sun's presence, time, space and gravity demanded proportions and perspectives with no vanishing point fixed on the earthly horizon. This was both an end and a new beginning. It was a system of space that had no horizon. As Malevich expressed it: 'I have transformed myself in the zero of form and dragged myself out of the rubbish-filled pool of Academic art. I have destroyed the ring of the horizon and escaped from the circle of things, from the horizon ring which confines the artist and the forms of nature.'[22]

Malevich had long shown particular regard for the square format. As he had painted an extraordinary number of square canvases, the square had been significant to him for several years before Suprematism. When Malevich stretched a canvas he made conscious decisions concerning the size and the proportion of one side to another. As we have seen, Malevich employed the old measuring system used in Russia: he worked in *arshin* (71.12 cm) and its subdivision into 16 *vershok* or *vershki* (each 4.45 cm). Sixteen units is unusual as a measuring system but it has the advantage of resulting from the equal

195. Diagram of the installation of Malevich's display 'The Suprematism of Painting' at The Last Futurist Exhibition '0,10' (Zero–Ten), Petrograd, 17 December 1915–17 January 1916. Each square of the background grid corresponds to a ½ *arshin* or 8 *vershok*. Diagram © Henry Milner 1995.

subdivision of a line, sheet of canvas, or whatever, into 2, 4, 8 and finally 16. Malevich used this framework for his Suprematist canvases, as he had for earlier paintings. But he also used it for the extraordinary installation of Suprematist canvases at 'The Last Futurist Exhibition of Paintings 0,10'. This meant that the rhythmic relations established *within* paintings also applied *between* paintings, so that the contents of one canvas related to those of another and the placing of each canvas related to all of the others. An appreciation of this leads inexorably back to the square and the painting known as *The Black Square* (Plate 193), which connects both of the walls that are visible in the surviving photograph of the display.

This permits the interrelation of works to be examined: the operation of *The Black Square* can be studied in specific terms. It indicates how the square, for Malevich, was 'the first step of pure creation in art', because it reveals how the square was used to generate other forms. In this it was precisely like a geometric series, particularly the Fibonacci series, to which it is related in certain ways, because it could *generate* systems and proportions in a harmonic way to organize not only the canvases but also the spaces between them.

Beyond this Suprematist analysis there are two other advantages in making a close study of Malevich's handing of his 0,10 display. Once the proportional system is defined it becomes possible to define the size of lost paintings that appear in photographs of exhibitions. Works painted on canvases not measured in *vershok* and *arshin* seem to be scarce. It now becomes possible to consider the paintings of Malevich in a new way: generating a dynamic world of geometric harmonies that demanded procedures, techniques and equipment. Signs of these 'tools of the trade' or underlying structures might not be expressed overtly in the final form of the painting, yet, as a means of production, they were *constructive*. Their mathematics could be applied to a canvas, a building or a city. In this it was like the systems of Dürer or Leonardo. This is what gives Suprematism its ambition and its importance. Malevich was quick to use the word 'system'. Once defined it could be understood, used as a blueprint for society, and be viewed as utopian and ideal in its aims. In this way mathematics played a central role in defining images of the future. After all, in the Russian Futurist or Ouspensky's mode of thinking, the future might in some sense exist alongside the past and present. For Malevich space flight, for example, was an aspect of growing technology, just as he considered that the aeroplane hatched from the train, like a mechanical butterfly from its caterpillar. 'Objects,' he explained in 1916 'embody a mass of moments in time.'[23] This was exactly Khlebnikov's view of language; Malevich was still in many of his attitudes a Russian Futurist. Because of this view he considered that 'a painted surface is a real living form'.[24] For these reasons time was still a consideration linking, for Malevich, the geometries of Pythagoras, Euclid and Fibonacci with those of more recent mathematicians including Lobachevsky, Minkowski and mathematicians of the future.

The coherent system which produced the display at '0,10' may be analysed in many ways. By joining each corner of a square to the centre of the two opposite sides, for example, a network of lines is produced using multiples of 9° angles and incorporating the Golden Section, one procedure for which involves the diagonal of a double square (or as here a half-square). Crossing points in this crystalline structure can also be used to divide the square into thirds or quarters. Hence, the hexagon and octagon can be developed from it, as too in fact can the pentagon, which is remarkable not least for the fact that all of its internal ratios exemplify the Golden Section. This gives some indication of the network of lines, angles and rhythms (or ratios) emanating from Malevich's *The Black Square*: it establishes a modular pattern across the walls to which the corners, edges and

even contents of canvases are addressed. It is possible, for example, for the direction or line of a plane in one canvas to connect up with that of another canvas. In other words, for all their diversity, these paintings are the result of a generating system so that the relation between them is harmonic: each canvas, partaking of the system, can be used to create further works without the relation of forms becoming arbitrary or incoherent. *The Black Square* is the simplest and therefore the primary 'generator', but all other Suprematist canvases have this potential for harmonic organization of infinite variety. This impressive achievement is like the Fibonacci series which begins 0, 1, 1, 2, 3, 5, 8, 13, 21 . . ., each term after '0, 1' being the sum of the two preceding terms: subdivision releases the same system. Thus if we take the section '13, 21', the difference is 8 which is 5 + 3 and so on. This is equally simple in geometric terms, where it again reveals the generative role of the square and where it can produce spirals and other forms.

Similarly modular grids can be created inside and outside the square. These can then be used to generate a modular system for the hanging of the paintings so that every part is related to every other part. Just as readily, and this is geometry becoming the construction of society, such grids can become the tools with which to build ground plans and elevations for buildings. Nothing in such a system is arbitrary: everything is determined by the same procedures and embodies the same dynamic. This is the spatial system at work.

These considerations make plain the power that Malevich discovered in the square. Economical as an image, it is infinitely prolific as a generating force. Morever, it could be seen to blot out academic and even recent Cubist conventions of painting, in which context it appeared as a zero, an end, or the death of the sun, from which the new system would spring into such prolific life. Yet there remained one sense in which past precedents remained necessary. The geometry studied by Malevich was used more overtly in architecture than in painting. Malevich did not abandon the Roman Vitruvius or the architect Alberti in his studies any more than he abandoned Fibonacci or Khlebnikov. They had made proportion and mathematical rhythm into an analytical and a constructive tool. This was what Malevich was doing.

Finally, in some way, *The Black Square* is an ikon, as its position shows. It has the frontality of earlier square paintings of heads by Malevich and it is the proclamation of 'the face of the new art'.[25] Square processional ikons were not rare in Russia and ikons in any case frequently relied upon geometry. Malevich's *The Black Square* had another ikon-like quality: in the context of '0,10' it opened the door to a world parallel to our own. It was as an assertion of faith and as a sign of revelation to Malevich that the square appeared to be a 'living royal infant'.

As a spiritual search for harmony Malevich's quest is wholly within the hermetic tradition, which for twenty years had attracted attention in Moscow, St Petersburg and Paris. Alchemy focused upon the relation of square, circle and triangle in order to study the relation of man and woman to god and to the whole of creation. In alchemy the blackest moment of despair is the stage of *nigredo* which, in one source at least, was represented by the black quadrilateral (Plate 196). As alchemical sublimation and purification continue the philosopher's son is born to Sol and Luna, the elemental male and female forces, and is clearly 'a living royal infant'. It may very well be that from *Victory over the Sun* to Suprematism as seen at '0,10', Malevich was seeking a spiritual, alchemical or hermetic rebirth, for as in alchemy Sol, or the sun, must die and decay before purer rebirth can occur. This suggests an explanation for Malevich's development over the two years between *Victory over the Sun* and '0,10'; a letter written to Matyushin in 1915 shows its importance 'The backdrop represents a black square. It is the embryo of all poten-

196. M. Merian *Et sic in infinitum (And so into infinity)*. An alchemical image of the nigredo from Robert Fludd's *Utriusque cosmi maioris scilicet et minoris metaphysica atque technica historia*, Oppenheim 1617.

tialities and acquires a fearful force in the course of its development. It is the progenitor of the cube and the sphere, and its disintegration outlines an astounding cultural life in painting and the opera. It signified the beginning of victory.'[26]

Analysis of the installation photograph reveals that the size of *The Black Square*, given such a position of importance, was 18 × 18 *vershok* (equivalent to 80.01 × 80.01 cm). This is the size of the canvas also known as *The Black Square*, in the Tretyakov Gallery, Moscow (Plate 193), to within a margin of less than half a centimetre,[27] and substantially confirms this canvas as the one exhibited at '0,10'.

As the painting is colourless, it has no atmospheric perspective: that is, it has no suggestion of colours receding or advancing within the picture space. It is possible, by an effort of will, to read the black area as a square hole, but it is easier to read it as a black form against a white background. As it is symmetrically placed it appears to hover weightlessly parallel to the picture plane and to the edges of the canvas. All of this strengthens the sheer force of confrontation that comprises much of the visual impact of the painting.

As the square could have been smaller or larger in relation to the canvas, a consideration of proportion persists which assumes a paramount importance when so little else is depicted (Plate 194). The diagonal of the black square is almost the same length as the edge of the canvas, so that it approaches a ratio of $1:\sqrt{2}$, an irrational number. These internal relationships reveal rhythm and energy within the form. They are the first signs of the potential dormant within Malevich's 'zero of form'.[28] The ratio $1:\sqrt{2}$ also relates to the 'progression of the square', that is the size of square produced within a circle drawn within a square. The relation is also made evident by drawing a second square at 45° to the first to form an octagon. Many other possible progressions and developments illustrate *The Black Square*'s power as a generator of forms once its internal relationships begin to be apparent.

The importance that Malevich attributed to *The Black Square* at '0,10' in his later retrospective writings seems appropriate, but here lies an interesting and instructive difficulty. The canvas in the Tretyakov Gallery (Plate 193) shows signs of ageing: it has developed a network of fine cracks visible across most of the black area. Now these cracks reveal lighter paint underneath, but they also show signs of a painting made up of overlapping geometric forms consistent with a later style of those Suprematist works at '0,10'. This means, quite simply, that this canvas is not chronologically the first Suprematist painting. It is still possible that this canvas is a later version of the painting exhibited at '0, 10' or that it is the original *The Black Square* but *not* the first Suprematist painting to be executed. It could be a subsequent reduction of Suprematist ideas to their simplest and most elemental form.[29] In either case the primary significance of the form itself remains.

The proportion of the black square motif to its white surround does have one perspective effect as the white can be read as a kind of frame such as Malevich incorporated into his designs for backdrops to *Victory over the Sun*. These diagonal corner-to-corner alignments suggest lines that appear to recede towards the centre so that this area is hollowed out visually. This makes the square seem to stand in a kind of middle-distance.[30] But in fact Malevich here has not marked in the diagonals and has even dispensed with the real frame too.[31] The margin of white can also be determined by taking an angle of 18°, again the multiple of 9°, from the corner of the canvas. The margin is 3 *vershok* wide around a black square 12 vershok wide. The ratio is therefore 3:12:3, simplifying to 1:4:1. There are several other versions of *The Black Square* which all employ different proportions and have brought confusion to the subject. Some are

larger (110 cm and 116 cm) and therefore incompatible with the scale of the 0,10 installation. They are later versions.

The black square motif acts as a protagonist in many Suprematist paintings where it appears in diverse situations and is accompanied by many other shapes. But in concept the original *The Black Square* was later described by Malevich as *moving* to form other shapes – rotating to form a circle or moving over the flat picture surface to form a cross. In fact, Malevich exhibited at '0,10' several paintings in which the square appears distorted by movement *into* the picture space. The monochrome pigments in which these forms were painted create a tension between perspectival readings and flat surfaces of the colour.

Among the exhibits visible in the 0,10 photograph, three canvases develop a single plane in this way and at least one of these canvases survives. This can be seen at bottom left of the installation photograph and was listed as no. 43 in the catalogue: *Painterly Realism of a Peasant Woman in Two Dimensions* (Plate 197). The painting, now in the Russian Museum in St Petersburg, is inscribed on the reverse '*Krest'yanka supre...*' (a fragmentary inscription signifying 'Suprematist peasant woman') and the canvas is 12 × 12 *vershok*. Beginning, as it were, with a line on the top of the form in the proportion 2:8:2 (expressed *in vershok*), Malevich has in effect drawn down one corner to 'stretch' the square shape into a distorted configuration (Plate 198). The diagonals of this form still cross at right angles in the central point of the canvas. It appears tensely asymmetrical, but in fact it is symmetrical about one diagonal axis. Malevich has begun to manipulate his basic form. The 'extended' point here seems to be determined by the diagonal crossing a line 3 *vershok* from the corner. This shift has an intense visual effect – as if a square had been distorted in the picture plane, or as if its form had begun to bend. As the brilliant red of this form was flatly applied, this makes for startling ambiguity. The title is not easily related to the canvas except that it may suggest a reconsideration of the shapes of an earlier canvas where the kerchief or scarf of the peasant woman made a comparable

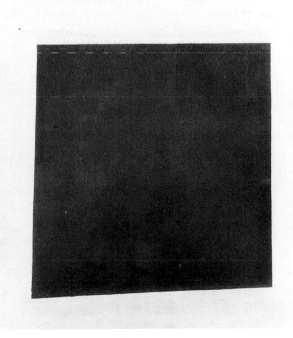

197, below left. Kazimir Malevich *Painterly Realism of a Peasant Woman in Two Dimensions*, 1915. Oil on canvas. 12 × 12 *vershok* (¾ × ¾ *arshin*). 53.34 × 53.34 cm (given as 53 × 53 cm). Russian Museum, St Petersburg.

198, below right. Diagram of the compositional structure of Plate 197.

199, right. Kazimir
Malevich *Suprematism*.
Lithograph. Published in
K. Malevich's *34 Drawings*,
Vitebsk 1920.

200, far right. Kazimir
Malevich *Suprematism*.
Lithograph. Published in
K. Malevich's *34 Drawings*,
Vitebsk 1920.

pointed shape (Plate 95). If this *is* the source in some way, Malevich has rotated the image. The reference to two dimensions may be literally a reference to the single planar surface here.

When Malevich installed his work at '0,10' he selected a 12-*vershok* square painting (see Plate 192) of a single plane to hang alongside *The Black Square*.[32] Here Malevich has constructed a plane touching the edges of the canvas, but readable also as a surface seen in perspective twisting up and away from the viewer like a kite. In fact, all of its angles seem to be multiples of 9° so that Malevich is manipulating his plane with calculated effect: the point of contact at the right emphasizes this control of energy and means. It is halfway up the canvas edge and its three angles appear to comprise 36°, 54° and 90°. The plane itself may be seen as sloping down to the right, to the bottom edge, or to the left as if it were a square plane seen in perspective. Such a plane has distant vanishing points but no horizon. As a result it has been usefully argued that Malevich took a precise interest in projective geometry. However, as projective geometry was always inherent in any form of linear perspective system, if Malevich is devising a new spatial system such an interest is not surprising.

A third painting (see Plate 192) manipulating a single plane appears on the lowest row of the right-hand wall of the installation. Here no points touch the edges of the 15 × 13 *vershok* canvas but the edges of the painted plane are on lines that move towards significant points along the edge, including the corners of the canvas. The apparent depth of picture space caused by the sharp reduction of the plane to its top edge from its bottom

edge suggests a dynamic arrival or departure in relation to the viewer – in other words a steep perspective – yet this surface and its background are painted in flat pigment and the edges are determined with reference to the canvas edge.[33]

In these three works Malevich has developed procedures that can make forms seem flat or make them seem to tilt and turn dynamically into the picture space. He has in the process developed new protagonists for the drama of more elaborate works. This last example was exhibited again in Moscow in 1919. It can, as Malevich frequently proved, be inverted at will without loss of effect. Like the diagrams of a geometer, these works have no 'right way up' – nor do they as such have a unique scale. But they do have control of specific proportion and perspective which determine the relative size of the forms that they contain.

Elsewhere at the 0,10 display Malevich probably showed other single-form works. Klyun certainly did so later on, almost devising an alphabet of forms, several of which are preserved in the Costakis Collection. Malevich later published lithographic images of this kind (Plates 199 and 200) and one other such canvas at least certainly existed in 1920 when it was on display in Moscow (Plate 201). This lost canvas of some 18 × 16 *vershok* presented an almost vertical plane at an acute angle to the picture surface and floating weightless in white space (Plate 202). It creates a convincing illusion that within the canvas lies the white space of another world inhabited by floating geometric forms ceaselessly moving and caught in sunless light. These planes, which seem to tilt at an angle to the picture plane, may be compatible with the diagrams of Bragdon and the ideas of Ouspensky when he imagined cubes of a fourth dimension passing through the screen of our familiar space.

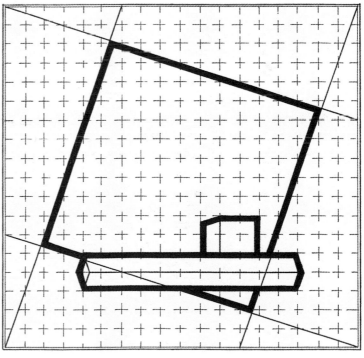

202, below. Diagram of Kazimir Malevich's *Suprematist Painting with Architectonic Forms*, 1915. Oil on canvas. Estimated size 18 × 18 *vershok*. (80.01 × 80.01 cm). Whereabouts unknown. Exhibited at 0,10, Petrograd, 1915.

201, left. Kazimir Malevich *Suprematist Painting*, 1915. Oil on canvas. Whereabouts unknown. Estimated size 18 × 16 *vershok* (80.01 × 71.12 cm). Exhibited at the Sixteenth State Exhibition, Moscow, 1919–20.

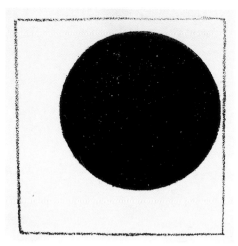

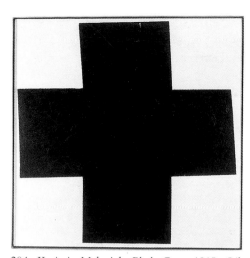

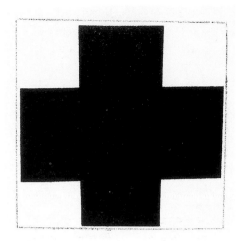

203. Kazimir Malevich *Black Circle*. Lithograph. Published in K. Malevich's *34 Drawings*, Vitebsk 1920.

204. Kazimir Malevich *Black Cross*, 1915. Oil on canvas. 18 × 18 *vershok* (1⅛ × 1⅛ *arshin*). 80.01 × 80.01 cm (given as 80 × 80 cm). Beaubourg Foundation: Gift of Scaler Foundation, Paris. Exhibited at '0,10', Petrograd, 1915.

205. Kazimir Malevich *Black Cross*. Lithograph. Published in K. Malevich's *34 Drawings*, Vitebsk 1920.

206, right. Kazimir Malevich *The Second Basic Suprematist Element*, 1913. Drawing used in Malevich's book *The Non-Objective World*, 1927. Malevich incorporated the date 1913.

207, far right. Ikon of St Vlasius, fifteenth century. Tempera on wood. Whereabouts unknown.

The constructive aspect of this system received a clear illustration at '0,10' in a canvas (see Plate 192) that first proposed an architectural potential that Malevich was unable to explore for several years. This 'spatial Suprematism' incorporated images of three-dimensional forms in front of the plane of the titled rectangle. A reproduction of a related architectural drawing was published in 1919. Each form of this sequence manipulated the picture space further into a shadowless depth. Proportion and perspective grew from a static beginning into a richly proliferating sequence, any stage of which could undergo further development.

Malevich moved from simplicity to complexity at '0,10'. Soon his writings would describe this process as a history of basic forms, but this version of events may again give priority to artistic considerations over the historical sequence of events. What he later decided was most important may not have happened first. It can be asserted, as Malevich was to argue later, that Suprematism developed out of *The Black Square* (Plate 193) into

the *Black Circle* (Plate 203), to the *Black Cross* (Plates 204–6) and so on, as if he were establishing the elements of a new formal alphabet to be studied for its properties, just as the poets of his acquaintance were studying words and letters. This is credible thematically but problematic in other ways. The *Black Circle*, for example, exists as a canvas in the Russian Museum in St Petersburg but is larger than the 18 *vershok* (80.01 cm) *Black Square* there. It is a later version that coincides in scale with large versions of *The Black Square* and *Black Cross*. Malevich never in any case explained how spinning the square could produce this single, off-centre *Black Circle*. It is as well perhaps to consider the iconography of such forms whereby the solidity of the square is contrasted against the infinity of the circle (it has no end): the circle is associated with the halo in ikon painting, suggestive perhaps of heaven (Plate 207).

Other apparently elemental works, referred to later by Malevich, do not appear in the installation photograph. The quartered square (Plate 208) is an example of this. He also spoke of the 'Elongation of the Suprematist Square' (Plate 209) and of the 'Movement of the Suprematist Square Producing a New Bi-Planar Suprematist Element'. Malevich frequently dated such works to 1913, which is unlikely to be the date such ideas were actually put on canvas. The single bar motif was perhaps represented in a modified or earlier form at '0,10' where it is visible in the horizontal format and on an 18 × 20 *vershok* canvas central to the right-hand wall in the photograph (Plate 192). A double bar or zigzag motif canvas is apparently lost but seems to be recalled in a later drawing (Plate 210). This too can be constructed using the 63° triangle within the square by which each corner is connected to the central point of the opposite two sides (Plate 211). Here the form can be read as a dislocated, or divided and sheared, square of the ratio 2:3 to the canvas (or drawing) edge.

By far the most enigmatic of these 'primary' forms is the *Black Cross*. In all of its versions it avoids symmetry by means of small but precise adjustments comparable with that of the *Painterly Realism of a Peasant Woman in Two Dimensions* (Plate 197): the *Black*

208, below left. Kazimir Malevich *Suprematist Composition of Squares*, 1913. Drawing used in Malevich's book *The Non-Objective World*, 1927. Malevich incorporated the date 1913.

209, below right. Kazimir Malevich *Elongation of the Suprematist Square*, 1913. Drawing used in Malevich's book *The Non-Objective World*, 1927. Malevich incorporated the date 1913.

210. Kazimir Malevich
Movement of the Suprematist Square Producing a New Bi-Planar Suprematist Element, 1913. Drawing used in Malevich's book *The Non-Objective World,* 1927. Malevich incorporated the date 1913.

211. Diagram of the compositional structure of Plate 210.

Cross twists and arches visually so that its apparent simplicity gains power and a restless vitality. Again more than one version of this motif exists. Analysis of the installation photograph and layout (Plates 192 and 195) suggests a canvas of precisely 18 × 18 *vershok* (80.01 cm), the same size as *The Black Square* (Plate 193) exhibited at '0,10'.[34] A painting (Plate 204) acquired by the Beaubourg Foundation, Paris, in 1979 is precisely this size and is therefore likely to be the original *Black Cross* from the exhibition. The art historian Patricia Railing has identified this as no. 44 in the exhibition catalogue: *Self-Portrait in Two Dimensions.* A different work is sometimes given this title but there may be good reason to accept the reattribution.

Iconographically the cross is perhaps a Christian reference from Malevich, as the fish may have been a little earlier. Certain drawings in fact introduce the fish into a geometrical context. Ikons of Christ may carry the circle of his halo with the cross of his Crucifixion within it and Christ's face before it. Even Gauguin had come close to this in his own identification with Jesus in several paintings. The cross also appears on the robes of certain saints in ikons (Plate 207) where it may form various patterns. There are numerous ways of constructing the cross, either by division into thirds or by angles derived from 9°. A later print of a cross suggests flight, evoking the image of an angel or an airplane (Plate 212).[35]

In his book *Concerning the Spiritual in Art,* the painter Kandinsky gave special importance to the motif of the triangle which Malevich seems at first to neglect. The circle, square and triangle were essential elements in the study of alchemy, but Malevich tends to discuss instead the square, circle and cross as his basic elements (Plate 213). The large triangle only appears after '0,10', as far as is known, and then together with more complex shapes.

The square as a generating form can be studied in another way in the works visible at '0,10' and in related paintings and prints. A lost work (see Plate 214), level with *The Black Square* on the left wall, incorporates two rectangles side by side and so initiates compositions of multiple elements parallel to the picture plane. Forms that also overlap or appear to recede at an angle to the picture plane comprise the final and most complex rhythmic structures among the paintings by Malevich at '0,10'. In this work two black squares are

134

symmetrically balanced but they have opened up the whole range of compositional possibilities of multiple forms.

Lower down the same wall asymmetry begins in a related canvas (see Plate 214). In the case of this lost work, exhibited at '0,10' and again in Moscow in 1919, a drawing survives that has significant implications. Analysis of the installation photograph suggests this canvas to be 12 × 15 *vershok* (53.34 × 66.68 cm). The drawing is indeed executed on squared paper where it measures precisely 12 × 15 units, so that it was either transferred from the squared paper to a grid of *vershok* squares marked on the canvas, or the drawing is a later record of the painting. The drawing also reveals something unexpected. The black circle has faint lettering either side of it. Taking the circle as *o* it says КУСОКЪ (*kusok*, a piece or slice of something). Verbal elements had only recently played a major role in the paintings of Malevich and they continued to do so – even here.

A series of paintings tilts forms without developing a deep receding space.[36] No. 41 in the catalogue at '0,10' is the simplest of these. As a series they each bear some relationship to the theorem of Pythagoras which they resemble. In the 'Double Square' and '*kusok*' paintings the square was a double presence, but in this 'Pythagorean' series the single square now becomes a protagonist, rather as Klyun was a protagonist in the peasant paintings. No. 41 in the catalogue has been identified from a photographic postcard preserved in the Costakis Collection and inscribed 'Suprematist composition: Boy with Knapsack'. At '0,10' it was called *Painterly Realism of a Boy with a Knapsack. Colour Masses in Four Dimensions*. The canvas (Plate 215), which survives, can be seen lower left on the right-hand wall in the installation photograph. The canvas measures 16 × 10 *vershok* (i.e. it is 1 *arshin* high) and is therefore in the ratio 8:5, both numbers in the Fibonacci series,

212. Kazimir Malevich *Cross*. Lithograph. Published in K. Malevich's *34 Drawings*, Vitebsk 1920.

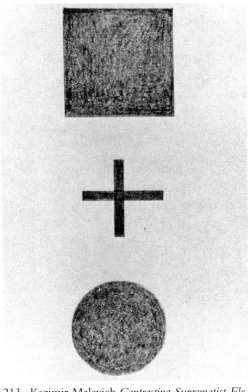

213. Kazimir Malevich *Contrasting Suprematist Elements*, 1913. Drawing used in Malevich's book *The Non-Objective World*, 1927.

214. Installation photograph of an exhibition showing a sequence of Suprematist paintings by Malevich, 1915.

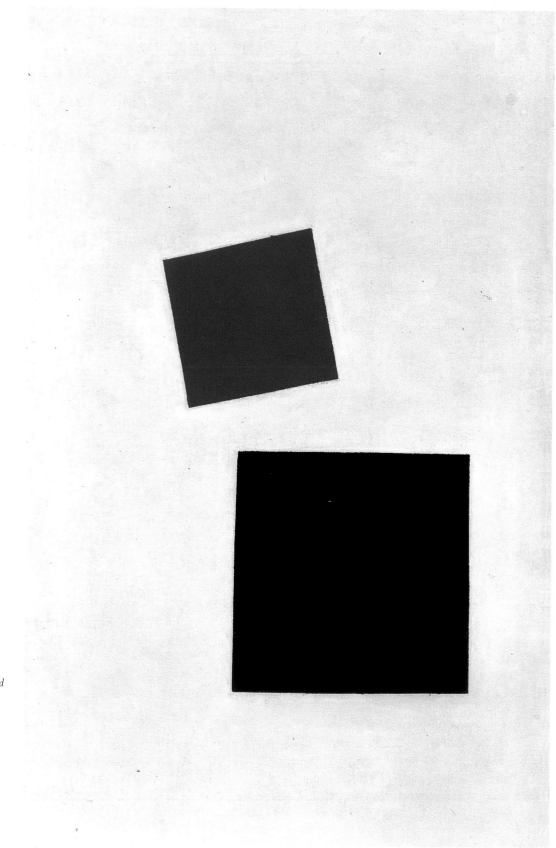

215. Kazimir Malevich
Suprematist Composition (Red Square and Black Square): Painterly Realism of a Boy with a Knapsack. Colour Masses in Four Dimensions, 1915. Oil on canvas. 16 × 10 *vershok* (1 *arshin* high, ratio 8:5). 71.12 × 44.45 cm. Museum of Modern Art, New York. Exhibited at '0,10', Petrograd, 1915.

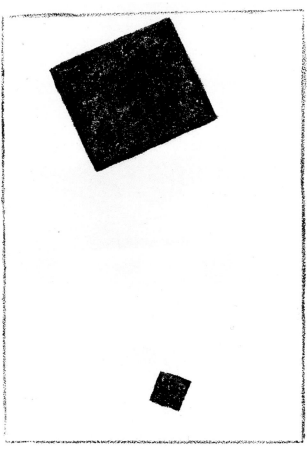

and therefore a Golden Section rectangle. (Malevich hung his paintings one way up or another in different exhibitions. In the present text paintings featuring a square parallel to the picture's edges are reproduced with this stable square at the bottom for ease of comparison.)

There are numerous ways of constructing or of analysing this painting. The black square is shifted to the right and the smaller red square appears to move in an arc up and left. As a result, the black square appears static and the red square dynamic, with its pungent red equivalent in visual energy to the larger black to which it seems related, both by shape and by position. The two squares are indeed closely related. For example, the left edge of the red square, if extended, would meet the lower left corner of the black square. The right edge of the red square would extend down to the centre point of the top of the black square. There are many other echoing links that testify to a dynamic harmony between the two: their edges, for example, are in the Golden Section ratio like the sides of the canvas. Building a square on the whole canvas base would produce a line 10 *vershok* up the canvas. A triangle rising at 63° from this base to the centre point of this line passes through significant points of the black square – namely, its top left corner, its upper side's centre point and its lower right corner. The angles involved are multiples of 9° (Plate 216). These are all the usual signs of Malevich's spatial system: it was already present in *Arithmetic* and it is a constructive device used to organize the Suprematist works (Plate 217).

216, above left. Diagram showing the relation of the golden triangle to the structure of Plate 215.

217, above right. Kazimir Malevich *Suprematist Composition*. Lithograph. Published in K. Malevich's *34 Drawings*, Vitebsk 1920.

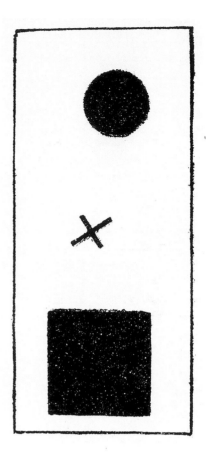

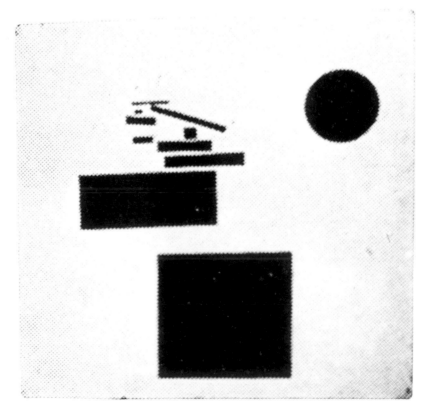

218, right. Kazimir Malevich *Rectangle and Circle*, 1915. Oil on canvas. 10 × 7 *vershok*. 44.45 × 30.05 cm (given as 43.1 × 30.7 cm). Busch-Reisinger Museum (Alexander Dorner Trust Association Fund), Harvard University Art Museums, Cambridge, Mass.

219, far right. Kazimir Malevich *Suprematist Drawing (Circle, Square and Cross)*. Lithograph. Published in K. Malevich's *34 Drawings*, Vitebsk 1920.

220. Kazimir Malevich *Suprematist Painting*, *c.*1915. Oil on canvas. Whereabouts unknown. Estimated size 20 × 20 *vershok* (88.9 × 88.9 cm). Exhibited in Moscow in 1919.

Such a diagrammatic system no more has a top or bottom than the theorem of Pythagoras, nor, in a sense, does it require a specific size of canvas as long as the proportion is correct. One 'Pythagorean' painting was hung at '0,10' close to *The Black Square* so that other works seemed to stream down and out from it like rays from a new sun. The theorem of Pythagoras, as spelled out in modern primers of Euclid, states that in a right-angled triangle the square of the hypoteneuse equals the sum of the squares of the other two sides.[37] One such right-angled triangle in particular has a very ancient history because of its sheer and simple usefulness. This triangle has sides that measure 3, 4 and 5 units. It could be used to mark out a right angle on the ground. It was used in ancient Egypt and has been called the 'Egyptian triangle'. Its angles are very close to 54° and 36° and it can be related to the golden triangle which is a formulation of the Golden Section. The golden triangle is also a segment of the decagon and therefore related to the pentagon. In practice it is simple to use as a set square for constructing ratios, squares, angles and other measurements within a harmonic system of the kind used by artists from the time of the pyramids through to that of Malevich. Dürer, for example, used such measuring instruments. The Golden Section ratio could be approximated, using single figures, to 8:5 or, with greater accuracy, 13:8, etc. It could be constructed and calibrated to any scale, including *vershok* and *arshin*. In this way the theorem of Pythagoras, or a specific instance of it, was in constant use, providing not only right angles and area measures but a whole proportional system. The Theosophist Edouard Schuré and other followers or students of Pythagoras had recognized its importance: it provided all of their sacred measures from 1 to 5. It is exactly these mathematical links between the forms used by Malevich that keeps them connected in a dynamic, clear and coherent way.

A small painting (Plate 218) recently rediscovered, not visible in the 0,10 installation photograph but exhibited in 1919, appears to make use of the same system as that employed in the putative *Boy with a Knapsack*. This canvas, only 10 × 7 *vershok*, employs again the angle of 63°. This time the triangle is constructed on the whole width across the canvas level with the base of the black rectangle. It rises at left to fix the top left corner of the rectangle and also to mark a point on the circle's circumference. The right side of the triangle marks the same point. A 3:4:5 triangle can be constructed to give the centre point of the circle.

More complex sequences and series could be built up from such relationships into constellations of forms on a larger or smaller scale to provide a major organizing structure as well as smaller groupings within it. Some of these clusters might appear closely related to the square or rectangle of the canvas while others more immediately relate to forms within it. In fact, the dynamic system relates every part to every other part and these relations are permutated as the number of elements increases. The white space between two forms can be either sensed or measured to show the lines, angles and rhythms connecting the two forms: the white therefore has energy passing through or across it. Three forms already multiply the relationships to include every permutation. They rapidly become incalculable to the eye. With eleven or more forms the canvas (see, for example, Plate 226) is alive with thousands of interrelationships. The forms themselves are clear and few but the prolific power of the black square becomes evident in the sheer multiplicity of its offspring all organized within the same system of harmony. It is an endless series that opens up at every point of inquiry or innovation (see, for example, Plates 219 and 220).

This series, which I have characterized as Pythagorean, has relied upon relationships implying movement across the flat picture surface as if the forms were sheared sideways into position. The series is extended by a further group of canvases in which movement in depth apparently *into* the picture space commences. A Suprematist painting from

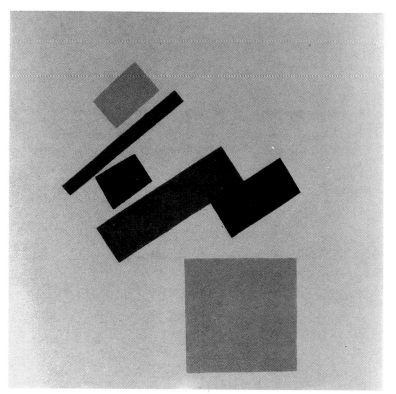

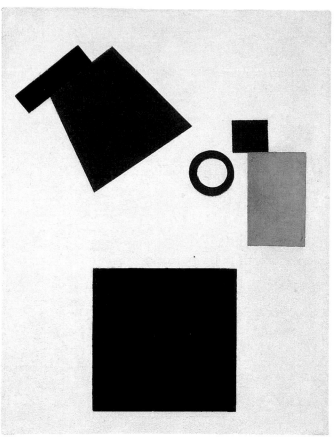

221. Kazimir Malevich *Suprematism*, 1916. Oil on canvas. 12 × 12 *vershok*. 53.34 × 53.34 cm (given as 53.5 × 53.7 cm). Ivanovo Regional Art Museum. Exhibited in Moscow in 1919.

222, above right. Kazimir Malevich *Suprematism* (possibly *Pictorial Masses in Motion*), 1915. Oil on canvas. 18 × 14 *vershok*. 80.01 × 62.23 cm (given as 80 × 62 cm). Stedelijk Museum, Amsterdam. Exhibited at '0,10', Petrograd, 1915.

Ivanovo Regional Art Museum (Plate 221) is three-quarters *arshin* square, that is 12 × 12 *vershok*.[38] It incorporates a square, at some time enlarged, and this stands to the right of centre. Above this, five forms tilt and fan out. Four of these are rectangles with parallel sides, but the third from the square is a black shape with two parallel sides, joined by one perpendicular edge and also by a sloping edge. As a result, it tips away visually from the forms to either side and seems to sink into the picture space away from the viewer creating an impression of perspectival recession. Malevich had introduced non-rectangular planes into Cubist works but here he is articulating the illusion of space with a new precision. In both cases he avoided any suggestion of an horizon or its concomittant single viewpoint. He also painted each plane in a single flat colour so that the evenness of pigment and colour emphasized flatness even when converging lines proposed a reading in depth.

Another painting (Plate 222) exhibited at '0,10' shows this clearly within the broadened framework of the Pythagorean sequence. This painting, visible to the far right of the installation photograph, is sometimes identified as no. 44 in the exhibition, namely *Self-Portrait in Two Dimensions*.[39] At '0,10' it was exhibited with its black square uppermost, again perhaps to emphasize a comparison with the *Quadrilateral* that dominated the display. This canvas of the 18 × 14 *vershok* develops its clusters of forms out of the square and makes use of the 63° triangle within this square just as other works do. A triangle of this kind built across the whole width of the canvas edge (here top) has its point at the centre of the black square and many related rhythms are established. This angle of 63° also provides an edge of the new non-rectangular form which is painted blue. This form

appears to glide through the picture plane with its longer, most central edge nearest, like a rectangle in perspective, imparting depth to the white of the canvas. Changes of scale reinforce this: the canvas no longer appears as a flat surface across which forms might be slipped into place, but as a deep empty space within which forms glide. These forms remain flat – that is, they appear to have no thickness or substance and the white space, as Malevich was to demonstrate, was infinite in its depth.

This canvas consistently employs angles that are multiples of 9°. Such angles can splay like the lines of a protractor from the corners of a canvas to produce an impression of deep space without any horizon and yet still preserving the relationships of the 3:4:5 triangle, Pythagoras's theorem, the Fibonacci series and the Golden Section, all of which are, in any case, related one to another. These angles can also form the golden triangle of 72°, and 36° which is part of the pentagon and decagon. For this reason it is possible to analyse certain Suprematist paintings in terms of the geometry of the pentagon and decagon. The sloping plane of this painting has angles of 99° and 81°, which means that its diagonals cross at right angles. Placed within a square parallel to the canvas edges its corners mark off precise whole *vershok* points around the 6-*vershok* square, and its sides depart from the horizontal and vertical sides of the square at angles of 36, 45 and 54° and so on from the square (Plates 223 and 224).

A final innovation of this Pythagorean sequence is the overlapping form, so familiar from such earlier paintings as the *Englishman in Moscow*. This may be achieved with planes parallel to the picture plane or at various angles to it. One of the simplest examples is the Suprematist painting with blue triangle and black rectangle in the Stedelijk Museum in

223, above left. Diagram of the relation of the *pentagon* to the compositional structure of Plate 222.

224, above right. Diagram of the relation of the *square* to the compositional structure of Plate 222.

141

225. Kazimir Malevich *Suprematism (with Blue Triangle and Black Rectangle)*, 1915. Oil on canvas. 15 × 13 *vershok*. 66.68 × 57.79 cm (given as 66.5 × 57 cm). Stedelijk Museum, Amsterdam. Exhibited in Moscow in 1919.

Amsterdam (Plate 225). This canvas is not visible in the 0,10 photograph but may have been exhibited there. It shows signs of adjustment that confirm that there is an underlying grid that has been overpainted. The canvas is 15 × 13 *vershok* and is executed in white, black and blue. The blue triangle appears to overlap the rectangle (actually the blue paint does physically overlap the black). Yet the two are closely interlocked. The upper tip of the triangle is in line with the edge of the rectangle.

One of the most spectacular of the paintings (Plate 226) at '0,10' employs *all* of these techniques. The 'Pythagorean' square is parallel to the canvas edges, with forms tilting across the canvas or gliding at angles to the picture plane, overlapping and diminishing in scale (Plate 227). This canvas, hung high on a level with *The Black Square*, is visible top left in the installation photograph. At 16 × 10 *vershok*, it is a Golden Section rectangle the same size as the putative *Boy with Knapsack* (Plate 215). It has been identified with the painting listed as no. 40 in the 0,10 catalogue: *Painterly Realism of a Footballer: Colour Masses in the Fourth Dimension*, as the back of the canvas is inscribed '*futbolist 1915 god*' (footballer year 1915).

Insofar as there is a circular form the footballer may appear to have a ball. But whether representational intent is evident at all is difficult to tell. Malevich appears to deny access to the image of a footballer illustrated elsewhere by Gleizes, Delaunay and Boccioni. It is, however, just possible that Malevich has derived his composition from a figurative source. The black square again appears as both a protagonist and as a generator of the other forms that dip and spiral about it. The 63° triangle again plays a structural role, but the sense of flight, space and dynamic movement reveals how articulate, moving and coherent

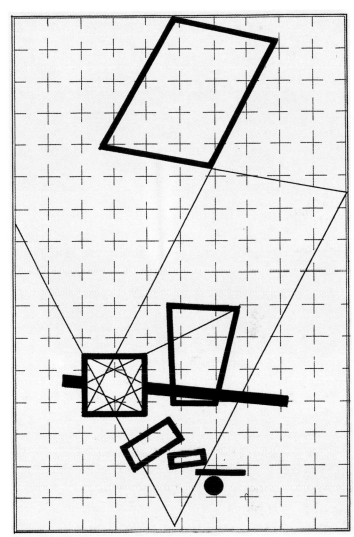

226, left. Kazimir Malevich *Suprematism. Painterly Realism of a Footballer. Colour Masses in Four Dimensions*, 1915. Oil on canvas. 16 × 10 *vershok* (1 *arshin* high, ratio 8:5). 71.12 × 44.45 cm (given as 70 × 44 cm). Stedelijk Museum, Amsterdam. Exhibited at '0,10', Petrograd, 1915.

227, above. Diagram of the relation of the square to the compositional structure of Plate 226.

Malevich's system could be. Analysis reveals the golden triangle, various spirals and other expressions of the relationship of these forms which seem to take a distant disk as a far point and leap forward to the angled plane of the opposite end of the canvas. There is no horizon, gravity or dominant direction in this space. It has no shadows for it has no sun, yet its light is undiminished and its movement untiring. As a result it begins already to resemble the outer-space that was the subject of the drawings that may have preceded '0,10'. What Malevich could not do was return to that picture space where 'reason has imprisoned art in a box of square dimensions.'[40]

A lost Suprematist canvas (Plate 228) had fourteen forms all painted as if flat and adjacent across the canvas, and all apparently the same tone in the photograph so they may be the same colour, which was likely to be black.[41] This work could justify inclusion in the Pythagorean series as it has a square lower right apparently parallel to the adjacent canvas

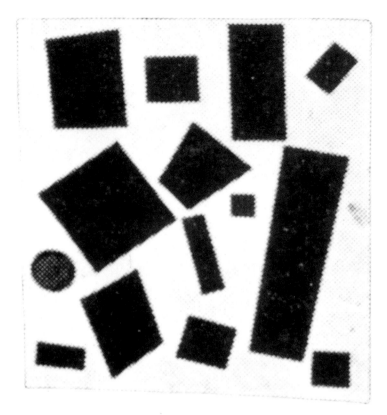

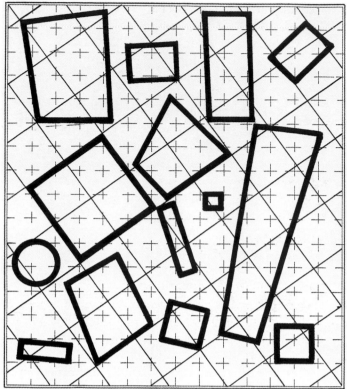

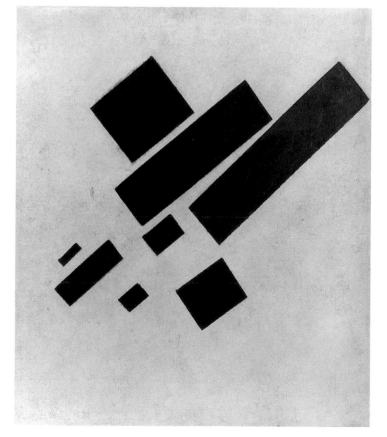

228, above left. Kazimir Malevich *Suprematism (with fourteen shapes)*, 1915. Oil on canvas. Whereabouts unknown. Estimated size 16 × 14 *vershok* (1 *arshin* high) (71.12 × 62.23 cm). Exhibited at '0,10', Petrograd, 1915.

229, above right. Diagram of the relation of the square to the underlying grid structure of Plate 228.

230, right. Kazimir Malevich *Suprematism. Eight Red Rectangles*, 1915. Oil on canvas. 13 × 11 *vershok*. 57.79 × 48.9 cm (given as 57.5 × 48.5 cm). Stedelijk Museum, Amsterdam. Exhibited at '0,10', Petrograd, 1915.

edges, but there is no overall dominance by this square, so that it appears simply one form among many. Yet this canvas, which contains rectangles, non-rectangles and a circle, is by no means arbitrary in its organization and it is again to the square that this sense of dynamic organization pays homage (Plate 229). The key form here is the large square left of centre tipped almost into the diamond or lozenge format. Extending the edges of this square exposes the underlying grid of the composition which is turned, as the square is turned, so that its lines divide the corners of the canvas 54°:36°. In other words, this working grid is tipped at the angle of the 3:4:5 triangle. Whilst there is a superficial resemblance to Hinton's diagrams Malevich avoids Hinton's triangle. It might be added that Hinton lacks the overall coherence of Malevich.

The diagonal grid dividing the corners of the canvas into angles of 54° and 36° is also an underlying feature of the painting known as *Suprematism: Eight Red Rectangles* (Plates 230 and 231).[42] The tilt that dominates the floating forms of this 13 × 11 *vershok* painting is the 54°/36° lean which can be seen in the installation photograph leading up towards and into the fourteen-form painting (see also Plate 232). In both of the paintings the grid is organized so that, for example, the bottom right corner is divided 54° from the horizontal and 36° from the vertical, whereas the other 13 × 11 *vershok* canvas (Plate 233) visible in the installation photograph is based upon the opposite, more horizontal division of the angle with 36° to the lower edge and 54° to the vertical (Plate 234). This canvas, known as *Suprematist Painting: Aeroplane in Flight* also uses four colours which suggest differentiated mechanical functions. One of the black forms, lower left, is almost square. This fixes the axis, a role carefully maintained in later graphic versions (Plates 235–7).

Two square 12-*vershok* canvases have some of these features. They were exhibited at '0,10' and appear in the photograph, bottom centre on the left wall and top centre on the right wall (see Plate 192). These too stress the dynamic diagonals of flight. Being square

231, below left. Diagram of an underlying grid in the structure of Plate 230.

232, below right. Kazimir Malevich *Suprematism: Seven Rectangles*. Lithograph. Published in K. Malevich's *34 Drawings*, Vitebsk 1920. The print is inverted for comparison with Plate 230.

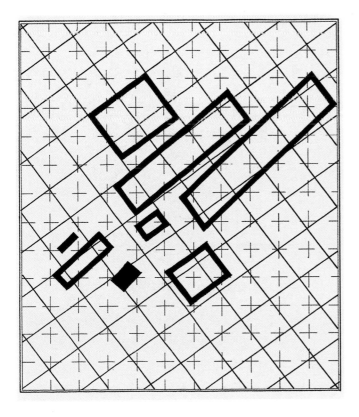

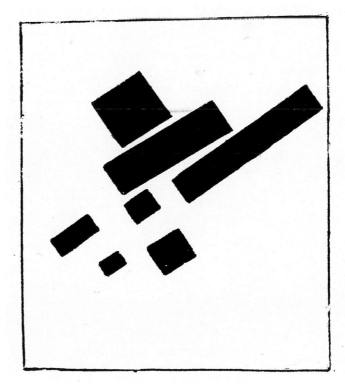

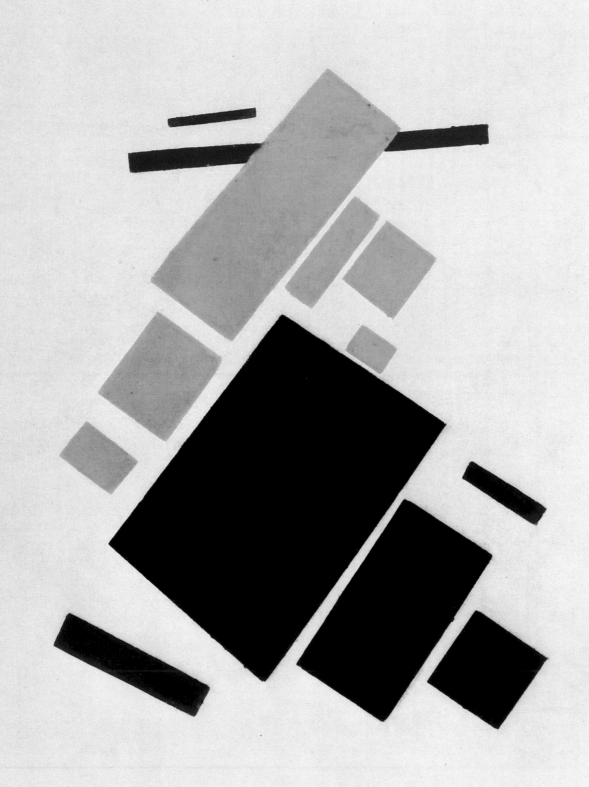

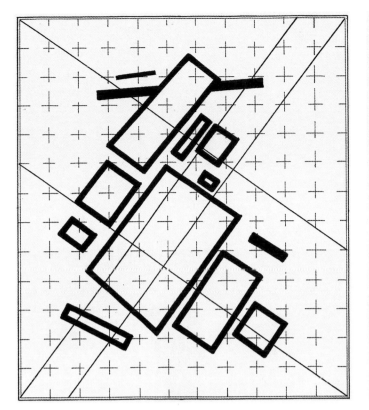

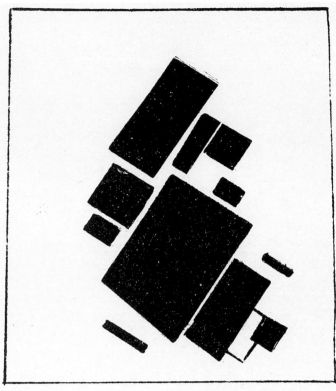

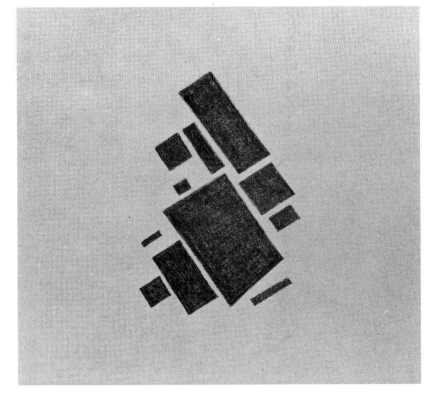

234, above left. Diagram of dominant angles in the structure of Plate 233.

235, above right. Kazimir Malevich *Suprematism*. Lithograph. Published in K. Malevich's *34 Drawings*, Vitebsk 1920.

236, left. Kazimir Malevich *Composition of Suprematist Elements*, 1913. Drawing used in Malevich's book *The Non-Objective World*, 1927.

233, opposite page. Kazimir Malevich *Suprematist Painting. Aeroplane in Flight*, 1915. Oil on canvas. 13 × 11 *vershok*. 57.79 × 48.9 cm (given as 57.3 × 48.3 cm). Museum of Modern Art, New York. Exhibited at '0,10', Petrograd, 1915.

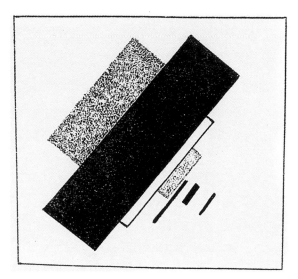

237. Kazimir Malevich *Suprematism*. Lithograph.
Published in K. Malevich's *34 Drawings*, Vitebsk
1920.

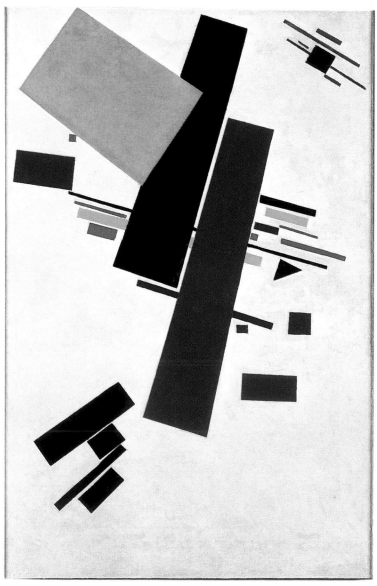

238. Kazimir Malevich
Dynamic Suprematism, 1916.
Oil on canvas. 23 × 15
vershok. 102.24 × 66.68 cm
(given as 102.4 × 66.9 cm).
Collection Ludwig,
Cologne.

148

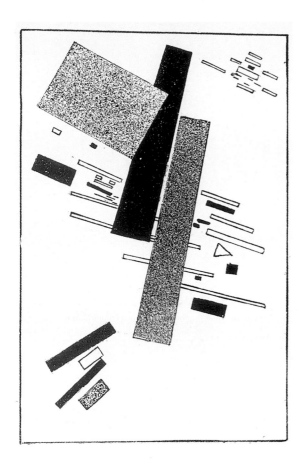

239. Kazimir Malevich
Suprematism. Lithograph.
Published in K. Malevich's
34 Drawings, Vitebsk 1920.

canvases they are also susceptible to analysis by the drawing-in of the 63° triangles to form a star within the square. This immediately establishes major points of importance. The third of these paintings survives although it does not appear in the 0,10 installation photograph. This is *Suprematism No. 18. Construction* now in the Stedelijk Museum, Amsterdam.

Only one other relatively 'simple' work from the 0,10 installation photograph remains to be considered and this leads directly into new territory. It is visible to the right of the *Black Cross* and upwards diagonally. This painting has only four shapes which, like most of Malevich's forms, are four-sided. Two of them, including a diminutive square, are parallel to the edges of the canvas. The largest form is tilted at perhaps 27° to the horizontal. The fourth, at another angle, almost touches the corner of the large static shape, as the small square touches the large shape.[43] The 63° angle is once more in evidence, but a more revealing fact about the work is that it assembles a constellation of forms that are later repeated on another canvas. The larger painting, known as *Dynamic Suprematism* (Plate 238) is in the Ludwig Collection in Cologne. The motif is visible as the top left section of the large painting where it appears at approximately half-scale but is easily recognizable. This painting also contains other quotations and references (Plate 239). The arrangement of four splaying rectangular forms lower left recalls one of the 12-*vershok* square paintings and the small near-square top right closely resembles the lower part of the tallest painting visible in the installation photograph. A comparable canvas is known as *House under Construction* (Plate 240). There could scarcely be a more imposing demonstration of the dynamic plenitude of Suprematism than its motifs, lines and rhythms

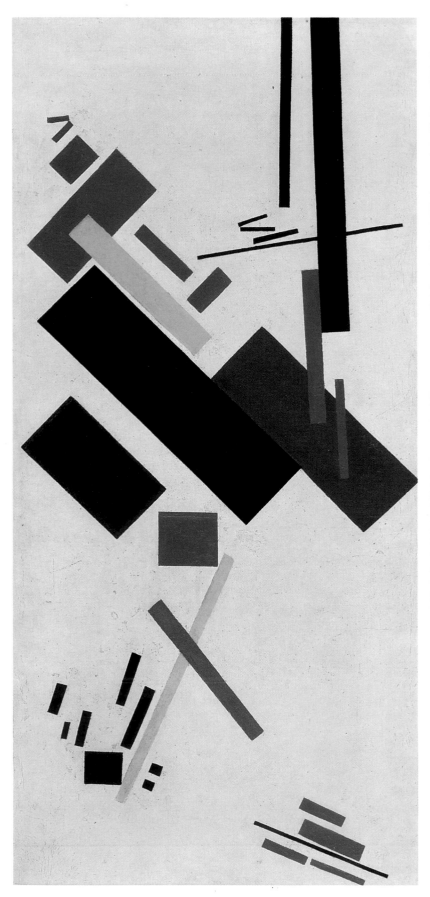

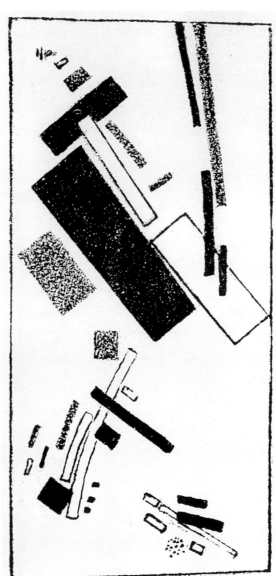

241. Kazimir Malevich *Suprematism*. Lithograph.
Published in K. Malevich's *34 Drawings*, Vitebsk 1920.

240, left. Kazimir Malevich *House under Construction*,
*c.*1916. Oil on canvas. 96 × 44 cm. National Gallery of
Australia, Canberra.

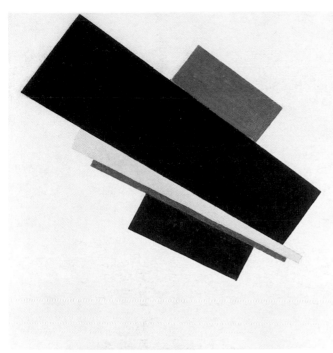

242. Kazimir Malevich *Suprematism no.18. Construction*, c.1915. Oil on canvas. 12 × 12 *vershok*. 53.34 × 53.34 cm (given as 53 × 53 cm). Stedelijk Museum, Amsterdam.

243, below left. Kazimir Malevich *Suprematist Painting*, 1915. Oil on canvas. 20 × 16 *vershok* (1¼ × 1 *arshin*). 88.9 × 71.12 cm (given as 88 × 70.5 cm). Stedelijk Museum, Amsterdam.

244, below right. Kazimir Malevich *Suprematism*, 1915. Oil on canvas. 20 × 16 *vershok* (1¼ × 1 *arshin*). 88.9 × 71.12 cm. (given as 87.5 × 72 cm). Russian Museum, St Petersburg.

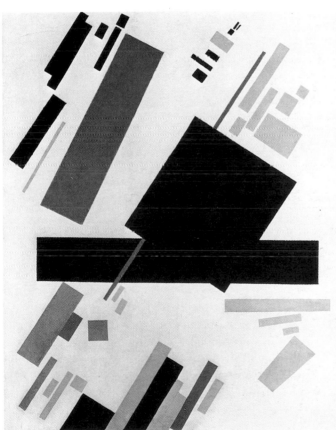

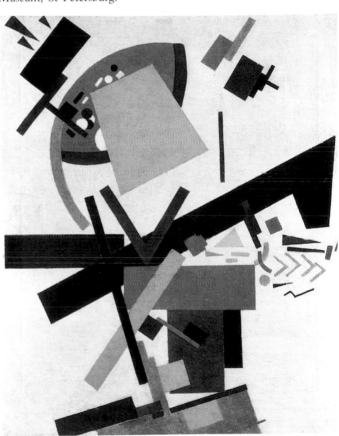

leaping from one canvas to another.[44] That one of these so closely resembles a drawing associated with *Victory over the Sun* testifies to a special resonance between the opera and the exhibition that followed it two years later (see also Plates 241–3).

The busiest canvas visible at '0,10' is known simply as *Suprematism* (Plate 244). It is

preserved in the Russian Museum, St Petersburg, and measures 20×16 *vershok*. It has the explosive impact of a tumbler or clown with more forms, colours and shapes than any other work visible in the photograph. If any of these works has a figurative content then this combination of crossing, tipping and curved forms most resembles the movements of a human being. In a comparison with *Victory over the Sun* this would characterize the Time-Traveller or Aviator. It is, in a sense, the anthithesis of *The Black Square* that to Malevich was so full of potential, for here that potential bursts with vitality just as the Aviator burst into the last scene of *Victory over the Sun*. Swirling arcs and a tilted 'crossbar' are exactly the rhythmic devices found in the motif of the peasant woman or reaper which dominated the cover of *The Word as Such* (Plate 93) in 1913 and this suggests a source for this and other canvases. But in losing the figure Malevich has also elevated the energy of his geometric elements to suggest a cosmic force, that at any point might diversify into new variations and new growth.

Many new themes emerged in Suprematist painting over the next year or two. Some of these developments were probably displayed at '0,10' (Plates 243 and 245). They testify to the sheer inventiveness and vitality of Malevich, who must have seemed so nihilistic with his talk of destroying the sun which he seemed to wish to replace with a black square. Yet it should not be forgotten that in 1915 Russia was at war and performing badly against the German forces that Malevich had caricatured in his *lubok*-like propaganda posters. Goncharova depicted war, as did Rozanova. Larionov fought and was wounded. Kruchenykh and Khlebnikov wrote books about war. For Khlebnikov especially war was an inevitable consequence of history's rhythms: it was an essential aspect of his extensive mathematical studies. It would be surprising if no element of this informed the Suprematism of Malevich which, after all, was just as mathematical as the writings of his erstwhile collaborator Khlebnikov. *The Aviator* had military potential and the *Englishman in Moscow* displayed sabre and fixed bayonets. There followed the propaganda posters. Yet no overt reference to war appears in the works photographed together at '0,10'. Perhaps *The Black Square* (Plate 193) really was for Malevich the new beginning that he said it was. But traces of the war may remain. *Suprematist Painting: Aeroplane in Flight* (Plate 233) could be military and its picture space without top or bottom or horizon could find its inspiration in the aerial photography that war was now employing.[45]

As Khlebnikov included Malevich in his Society of Presidents of the Terrestrial Globe he must have respected the achievements of Malevich as compatible with his own.[46] Khlebnikov was acutely aware of the importance of war in his calculations and as empires now collapsed his predictions seemed prophetic. He calculated that 413 years divide the beginnings of states and that 951 (i.e. 3×317) years divided great military campaigns repulsed. 'In 534,' he wrote, 'the Kingdom of the Vandals was conquered. Should we not expect the end of a state in 1917?'[47] His text *Dream* of 1915–16 linked visions of the fighting at Gallipoli with 'the exhibition of $\sqrt{-2}$' where there were images of Adam, Eve and the serpent, and a painting that Khlebnikov felt too far removed from the events of war.[48] The square root of two ($\sqrt{2}$) is an irrational number and the diagonal of a square, but the square root of minus two ($\sqrt{-2}$) is an imaginary number, corresponding to the diagonal of an unknown square. Khlebnikov was perhaps referring to *The Black Square* (Plate 193) at '0,10'. It is possible that Suprematist works did take on the rhythms of war. Malevich had done this readily enough in posters and there are Suprematist canvases in which forms fly apart centrifugally as if caught in 'explosions of ammunition dumps' that were 'filling up the mask of battle with black lace'.[49]

A large lost Suprematist canvas exhibited in 1919 had this explosive rhythm (Plate 245).

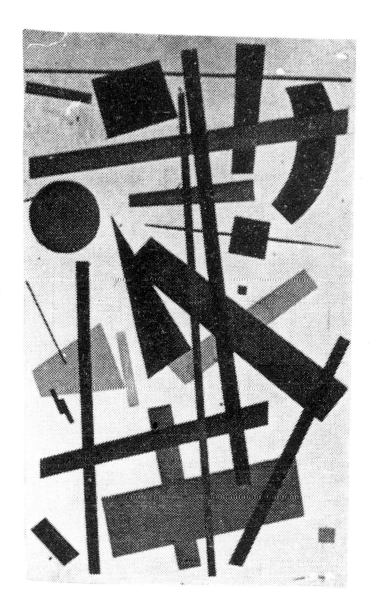

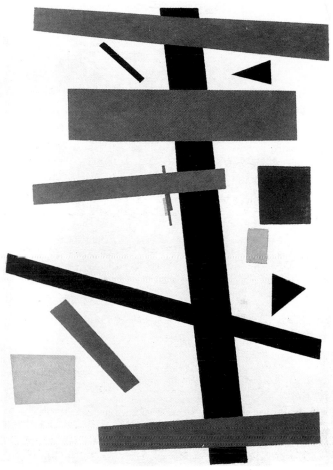

246. Kazimir Malevich *Supremus No. 50*, 1915–16. Oil on canvas. 22 × 15 *vershok*. 97.79 × 66.68 cm (given as 97 × 66 cm). Stedelijk Museum, Amsterdam.

The largest of his paintings in these years, it is more likely to have carried an important theme. Comparisons suggest a height of 2 *arshin* (32 *vershok*) and a width of 10 *vershok*, giving a Golden Section ratio of 8:5. Other 'stick-like' assemblages survive, including the smaller painting known as *Supremus No. 50*[50] (Plate 246) in the Stedelijk Museum in Amsterdam and dating from 1915 or 1916.[51] The phase that Malevich entitled his 'magnetic series' can also be read as exploding outwards from a central core. A major Suprematist oil painting on canvas (Plate 244) and preserved in the Russian Museum shares this dynamic whilst others appear to exhibit the rhythm of ticking machinery or a pendulum measuring out time (Plate 247, and see also 248). There are related drawings that feature calculations on squared paper.

To rush too quickly from the outbreak of war to the outbreak of Revolution is to underestimate the war period itself. Malevich was required to report for military duty in June 1916 and was posted to Smolensk. Kruchenykh, the librettist of *Victory over the Sun* with whom Malevich had worked so closely, and Olga Rozanova collaborated in 1916 to produce two books on the subject of the war. The first of these, entitled simply *War*,

245, left. Kazimir Malevich *Suprematism*, 1916–19. Oil on canvas. Whereabouts unknown. Estimated size 32 × 16 *vershok* (2 × 1 *arshin*) (142.24 × 71.12 cm). Exhibited in Moscow in 1919, and in Berlin in 1927.

247, right. Kazimir Malevich *Suprematism*, 1915–16. Oil on canvas. 11 × 10 *vershok*. 48.9 × 44.45cm (given as 49 × 44.5 cm). Collection Wilhelm Hack, Ludwigshaven.

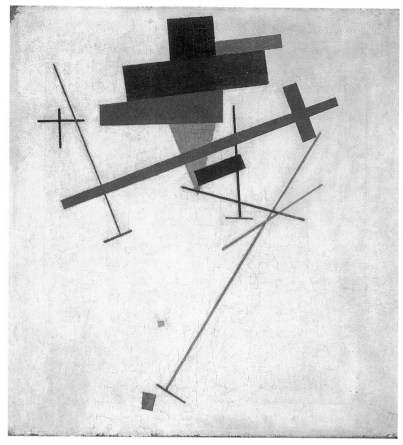

248, below left. Kazimir Malevich *Suprematism*, *c*.1916. Oil on canvas. 12 × 12 *vershok* (¾ × ¾ *arshin*). 53.34 × 53.34 cm.(given as 53 × 53 cm). The Peggy Guggenheim Collection/The Solomon R. Guggenheim Foundation, Venice. Photograph © The Solomon R. Guggenheim Foundation.

249, below right. Olga Rozanova Illustration for A. Kruchenykh's book *War*, 1916. Linocut on paper. 41.2 × 30.4 cm.

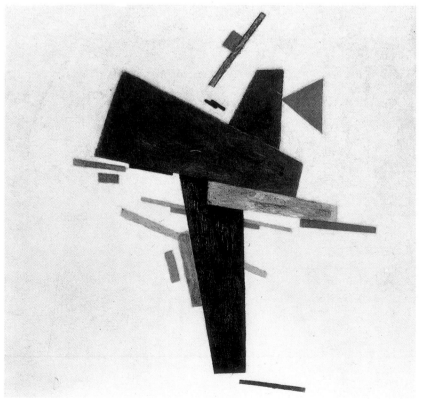

featured a collage cover by Rozanova that shows an immediate response to Suprematism (Plate 249).[52] It suggests that Malevich may conceivably have harboured similar thematic intentions and it shows how rapidly Kruchenykh and Rozanova adopted the pictorial innovation so dramatically and recently revealed by Malevich. Yet inside the book Rozanova's series of stylized and figurative linocuts (Plate 250) are equally dynamic but not Suprematist. They depict an allegory of war featuring cavalry fighting with lances and a conflict of aeroplanes. The energy of these graphic works is muscular and fast, but they appear to be an impressive response to Goncharova's prints in her portfolio *Mystical Images of War* (Plate 181).

The second book on war produced by Kruchenykh and Rozanova in 1916 was entitled *Universal War* (Plate 251).[53] It was illustrated wholly with coloured collages which gave

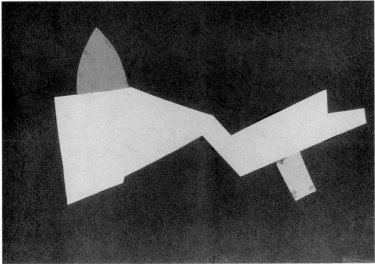

250. Olga Rozanova Illustration for A. Kruchenykh's book *War*, 1916. Linocut on paper. 31.7 × 40 cm.

251, left. Olga Rozanova and A. Kruchenykh *Universal War*, 1916. 21 × 29 cm. Collection George Costakis.

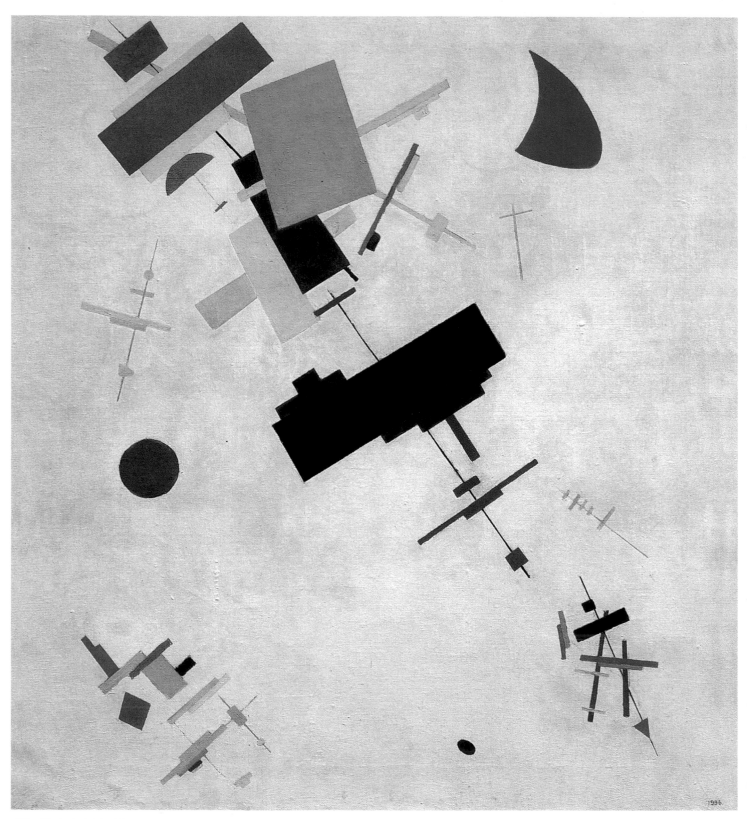

252. Kazimir Malevich *Supremus No. 56*, 1916. Oil on canvas. 18 × 16 *vershok* (1 *arshin* wide). 80.01 × 71.12 cm (given as 80.5 × 71 cm). Russian Museum, St. Petersburg.

253. Kazimir Malevich
Suprematism. Lithograph. Published
in K. Malevich's *34 Drawings*,
Vitebsk 1920.

Suprematist forms particular roles in the dynamic action depicted. This was a use of
Suprematism in which shapes were characterized with a hint of representational imagery
– one sheet, for example, features a pointed arch or pointed dome form. Remarkably,
angles that are multiples of 9° are again in use.

The weightless, horizonless world that Malevich created in Suprematism found a partial
echo in the aeroplane flights of his day. A painting executed before 1919, for example,
he later described as a *Composition of Suprematist Elements Expressing the Sensation of Flight*.[54]
There is in this canvas a motif of two crossed rectangles that loosely resembles, or at least
isolates, this aspect of aeroplane design. Additional smaller forms suggest deep space
around this form to create the sensation of flight.

Similar observations can be made about the much more elaborate and ambitious
painting *Supremus No. 56* (Plate 252), a canvas of 18 × 16 *vershok*, together with a related
print (Plate 253), which features major and minor conjunctions of forms that appear to fly
loosely in convoy through a deep and empty space. The use of the circle here is like that
by Rozanova in her cover for *War*, but in fact Malevich has also introduced other curved
forms, not seen before in his Suprematist paintings. A section of a circle appears upper
left; a small ellipse appears lower right of centre, and top right is a crescent formed by
cutting a blue ellipse with a circular curve. The network of relationships between all of
these elements is enormous. Within this field of connections Malevich has defined areas
of local attraction where conjunctions coalesce as if by magnetism. This is true of the
main assemblage but also true of the conjunctions lower left and right which resemble
more distinct equivalents to the large assemblage. Malevich has also used a line or axis to

simplify the network of possible relationships. This in turn suggests the linkage of a mechanism, drive shaft or comparable structure. Without any depiction of machinery as such, Malevich has indicated the will to flight; for him actual mechanisms would merely illustrate his point. What Malevich has developed is literally a new sense of space and proportion – in a word, a new perspective.

As Malevich became increasingly articulate in the mathematics and geometry of his new spatial system he nevertheless retained his grip on the units of *vershok* and *arshin*. *Supremus No. 56* (Plate 252), for example, like so many of his works, is one *arshin* wide. The white space of this canvas is fluent and deep. For Malevich aerial battles or reconnaissance flights would show mankind using this kind of space. His paintings could define or illustrate the space, flight and escape from gravity that human beings now evidently needed. The fluidity of this new sense of space found its way into geometry and into non-Euclidean geometry in particular.

Malevich's composer colleague Matyushin wrote in Spring 1916 of the importance of the mathematicians Lobachevsky, Riemann, Poincaré, Hinton, Minkowski and others.[55] The Russian Futurists' view, as well as that of Hinton and Ouspensky,[56] was that the new mathematics had implications for time as much as for space, a point made explicit by Khlebnikov in his publications in 1916. *The Martian Trumpet* (*Truba marsyan*) for example, published in Kharkov in 1916, was signed by him as 'Velimir I, King of Time'. He also published *Ka* in 1916 and *The Scythian Headdress: A Mysterium* in which the time-travelling figure of Ka reappears like Hermes with his staff of entwined snakes: 'From his arm, as if from a tree, hung a beautiful boa constrictor . . . it wound itself twice around the priest's arm, and its body swayed – a living, thinking staff.'[57] Khlebnikov declared that in seeking the 'numbergod' he faced three challenges or seiges: 'the seige of time, of language and of number'.[58] Time, language and number – these Khlebnikov made aspects of the same search. History, for Khlebnikov, was inseparable from rhythm and a large part of his study of this concerned warfare. As Khlebnikov put it: 'We climbed aboard our $\sqrt{-1}$ and took our places at the control panel. Our Tracksubplane was a merge of glass, steel and ideas . . . Centuries of warfare passed before me.'[59]

In 1916 Matyushin published Khlebnikov's book *Time, the Measure of the World* in Petrograd.[60] This remarkable mass of calculations, in which Khlebnikov attempts to show rhythmic waves in the events of history, includes a chart that he headed 'a collection of the laws of Velimir. A statute book with no need of government, courts or chains, requiring only the stars above. Who are they? Pairs of similar people born 365 years apart and so on.' Khlebnikov then lists pairs of people whose dates of birth or death were separated by multiples of 365 years: 'Two believers in Nirvana, Moses 1153 and Buddha Gautama 58 = 365 × 3.' Others follow, including 'Jesus Christ 6 and Walt Whitman dies 1819 = 365 × 5, . . . Abraham 2040 and Pythagoras 580 = 365 × 4' and so on. Further down the list come the painters 'Vasnetsov 1848 and Raphael 1483 = 365' as well as scientists of the sky 'Ptolemy 86 and Tycho Brahe 1546 = 365 × 4' and 'Aryabhatta 476 and Kepler 1571 = 365 × 3'. Khlebnikov concludes that 'Measure, having overcome faith, is the equation of the prophets. The equation of thoughts. The patchwork of nations woven into humanity.' He also made a chart to show that the number 365 determined a rhythm in the heartbeats of men and women and in the incidence of geological events. He even provided formulae showing Russian Futurist calculations devoted as much to time as space.[61]

In the aftermath of the exhibition '0,10' it appears that the painter-constructor Tatlin showed little sympathy for the Suprematism of Malevich. There was evidently a disagreement at the exhibition. In any case Malevich refrained from showing Suprematist canvases

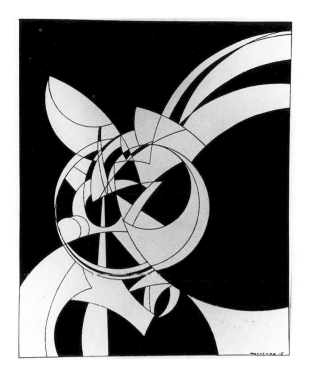

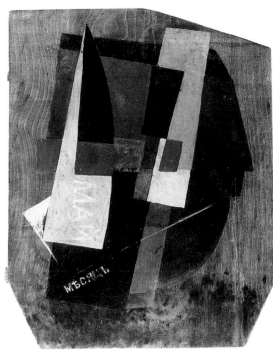

254, far left. Aleksandr Rodchenko *Untitled Composition*, 1915. Ink on paper. 25.5 × 20.5 cm. Rodchenko Archive, Moscow.

255, left. Vladimir Tatlin *Composition: Month of May*, 1916. Tempera, oil and gouache on board. 52 × 39 cm. Staatliche Museen zu Berlin, Preussischer Kulturbesitz Nationalgalerie.

at the exhibition 'Magazin' (magazine as in 'armaments depot') in Moscow in March 1916. Instead Malevich showed paintings from 1913–14 including *The Aviator* and the *Englishman in Moscow*. Klyun exhibited an *Arithmometer* and the *Head of a Woodcutter*. Tatlin showed corner reliefs. Popova's exhibits included *Card Playing* whilst Aleksandr Rodchenko made his Moscow debut with ten graphic works (Plate 254). It was November 1916 before Malevich exhibited Suprematist works at the Knave of Diamonds exhibition in Moscow. On that occasion he showed nine Suprematist paintings and emerged as the leader of a whole group of like-minded painters including Klyun, Popova, Puni and Rozanova.

Malevich had written to Matyushin on 4 April 1916 to say that 'Khlebnikov came to see me, took some drawings to measure the proportions in them and found the number 317 and also, I think, 365 in them. These are the numbers on which he bases his laws of various causations.'[62] A few days later, on 13 April 1916, Khlebnikov completed his text *Artists of the World* (*Khudozhniki mira*) in which he discussed in detail the correspondence of shapes and sounds and recommended that artists construct their own language by these means. Both Tatlin and Malevich seem to have responded to this idea. Malevich was no longer prepared to reconsider his position in the face of criticism. He wrote to Benois, for example, in May 1916: 'You will never see sweet Psyche's smile on my square. And it will never be a mattress for love making.'[63] Later the same month, on 25 May 1916 in Tsarytsyn, Khlebnikov's poet friend Dmitri Petrovsky and Tatlin delivered a Futurist lecture entitled 'Iron Wings'. Tatlin's painting inscribed 'The Month of May' (Plate 255) may relate to this event,[64] whose topics included 'the route from space to time. Whether pure laws of time exist. Khlebnikov's *Time, Measure of the World* and Futurism as a periscope of the future.'[65]

In his scroll *The Martian Trumpet*, published in Kharkov in 1916, Khlebnikov had declared that 'our questions are shouted into outer space where human beings have never yet set foot'.[66] Malevich was expressing similar ideas in a letter to Matyushin on 22 June

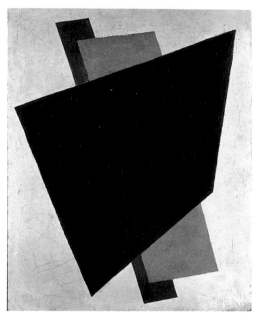

256, right. Lyubov Popova Cover design for the proposed journal *Supremus*, 1916–17.

257, far right. Lyubov Popova *Painterly Architectonics with Black Rectangle*, 1916. Oil on canvas. 20 × 16 *vershok* (1 *arshin* wide). 88.9 × 71.12 cm (given as 89 × 71 cm). Tretyakov Gallery, Moscow: Gift of George Costakis.

1916: 'space is greater than heaven, stronger and more powerful, and our new book is the teaching of the desert's space.'[67]

By November 1916 Malevich had gained a powerful following. His systematic use of geometry encouraged his followers to examine Suprematist perspectives for themselves. Malevich never seemed to explore all possibilities, so other painters found much to develop in Suprematism. Rodchenko began to compose drawings and paintings solely using a compass and ruler from 1915 onwards, devising elaborate structures from the relations of the circle and square (Plate 254). Embedded in this attitude and these results were mathematical interests as lively as those of Leonardo or Dürer for whom geometry and mathematics had similarly provided a common ground for art and science. Rodchenko's increasingly elaborate watercolours never established an empty white background space as Malevich had developed it. Conversely Malevich never locked forms together but let them fly.

Among those inspired by Malevich, Olga Rozanova produced Suprematist paintings which seem close to the work of both Wyndham Lewis and Malevich. They suggest maps or the interlocking of forms seen from aerial reconnaissance. Similarly, the painter Alexandra Exter developed dynamic compositions of overlapping Suprematist planes and soon she applied these to stage design for Tairov's Kamerny (Chamber) Theatre in Moscow. But there was sufficient cohesion among the followers of Malevich to justify an attempt to organize a periodical and a formal group called Supremus, or the Supremus Society of Artists. The designs that Popova made for Supremus (Plate 256) in 1916–17 confirm her enthusiastic conversion to the new system. Her paintings represent a close study of Malevich and his mathematics. They also use *arshin* and *vershok* to establish a grid. *Painterly Architectonics with Black Rectangle* of 1916 (Plate 257) is 20 × 16 *vershok*, that is $1\frac{1}{4} \times 1$ *arshin* or in the ratio 5:4. Like several of her contemporaries she moved rapidly from Cubist still life compositions in 1915–16 to works from which the motifs of guitar, table and bottle rapidly vanished. Once she had become a convert to Suprematism she rapidly developed her own concerns (Plate 257). In November 1916 for example, at the Knave of Diamonds exhibition, she named six paintings 'pictorial architectonics', empha-

sizing their sense of construction. She gave the series the title *Shakhi-Zinda*, the name of the complex of Islamic tombs at Samarkand in Uzbekistan.[68] Arab tiles and architecture provided a vast repository of mathematical motifs and learning to which Popova was already attracted in 1916. Klyun also showed Suprematist works at this exhibition together with a '*Sculpture in the Construction of Cubic Form*', a so-called *Flying Sculpture* and a *Spherical Sculpture*.[69]

The revolutions of 1917 seemed to confirm the dreams of the Russian Futurists. Khlebnikov had predicted the fall of an empire in 1917 and his prediction was realized. He wrote to Petnikov on 1 March 1917: 'Aryabhatta and Kepler! We see again the year of the ancient gods, great sacred events repeating themselves after 365 years.'[70]

On the eve of Revolution, one year before the installation of the Bolshevik communists, when Russia was still at war, Malevich had displayed fifty-nine Suprematist canvases which were the crowning achievement of two years' prolific work. From that moment Malevich was no longer a follower: his new spatial system decidedly made him a leader.

His achievement, it should be stressed, was not a function of the Revolution but was established during the preceding years of war. A trio of paintings in which Suprematist clusters of forms assemble before a larger and paler background shape illustrate the continued confidence and the development of his achievement. The painting known as *Supremus No. 58* (Plate 258) is 18 × 16 *vershok* and has a large curved form. *Supremus No. 57* (Plate 259) by contrast is square (18 *vershok*) and features a large triangle. The third painting, now in the Lunacharsky Museum at Krasnodar, is again 18 *vershok* and square and features a large circle. Together they make a suitable triptych summarizing the achievement of Malevich at the height of the first and founding phase of Suprematism. Each conglomeration of shapes is potentially a painting in itself drawn together and

258, below left. Kazimir Malevich *Supremus No. 58*, 1916. Oil on canvas. 18 × 16 *vershok* (1 *arshin* wide). 80.01 × 71.12 cm (given as 79.5 × 70.5 cm). Russian Museum, St Petersburg.

259, below right. Kazimir Malevich *Supremus No. 57: Dynamic Suprematism*, *c.*1916. Oil on canvas. 18 × 18 *vershok*. 80.01 × 80.01 cm (given as 80.2 × 80.2 cm). Tate Gallery, London.

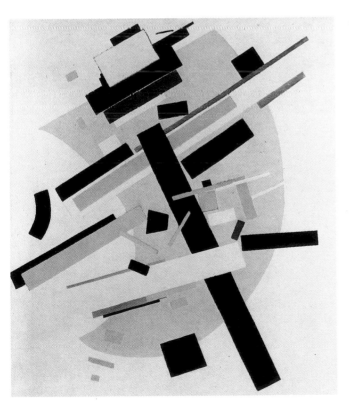

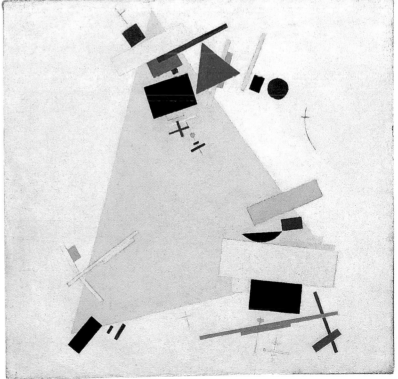

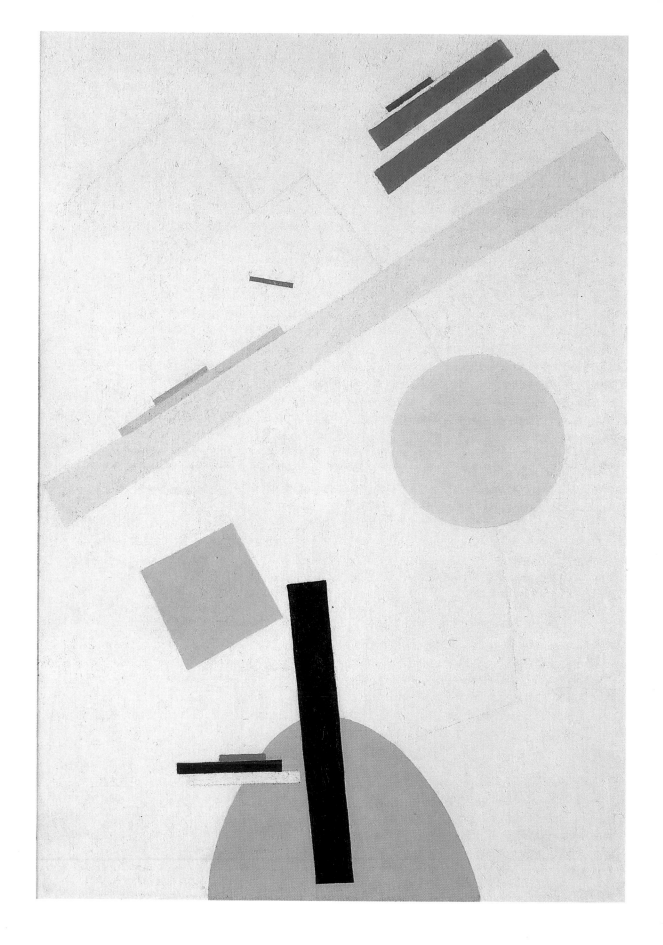

organized by rhythms, ratios and proportions that apply equally to the arrangements of these 'constellations' in relation to each other. In this way any set of forms may proliferate into new smaller or larger arrangements within the overall harmony. This is especially evident in *Suprematism No. 57* in the Tate Gallery, London, in which each cluster of shapes is drawn towards the points of the triangle. Contrasts of size among these forms illustrate the control of scale through from detail to overall structure. The Suprematist painting with circle in the Krasnodar museum is itself like a detail or close-up of part of the Tate Gallery's painting but it too has an intricate structure in which the background circle is overlapped by the droplet shape of its foremost form.[71] The dynamic *Supremus No. 58* (Plate 258) brings together features of the background circle and triangle. A related lithograph already shows a curved triangle, but here the form is composed from one straight edge and two *spiral* curves. Visually this suggests a curved concave surface spread like a sail catching energy from the profusion of forms before it, as if they were some kind of solar wind.

Malevich has moved on from the square, cross and circle to use the triangle, ellipse and spiral. These play a role in the drama of his paintings but they also lend an increasing sophistication to his rhythmic manipulation of space. In this perspectival and proportional system contrasts of size and scale are instrumental in locating surfaces in space. In addition, Malevich made use of the spatial effects of overlapping and modulated colour. By 1917 Malevich was employing a wide range of colour effects to create a Suprematist version of aerial perspective. A painting (Plate 260) in the Museum of Modern Art, New York, provides a thorough catalogue of these effects. By contrast with saturated colours, paler objects appear more distant; here the red, black and green stay forward in space, while the pale pink bar, pale salmon-pink square, the circle and ellipse recede. Contrasts of scale may support or counteract this: the small intense red bar flies in front of the large pink bar by virtue of its colour, although contrast of scale suggests that it is far away. Similarly, as colours recede when cool, the green bars become ambiguous in their location: their strength of colour brings them forward but their smaller size and cooler hue in relation to the pink bar pushes them away. Such effects build up a densely interwoven network of relationships in space. These remain discrete elements and their position in space can never finally be determined because space and scale in Suprematism is in every case *relative*. This is precisely what proportion and perspective organize. Malevich has defined a system of perspective appropriate to an age of flight. Forms appear to recede or advance, to veer away or to come forward, so their movement may be backwards or forwards in space and time. These weightless surfaces have no thickness; they are caught up in a field of space, depth and energy and they partition empty space establishing rhythms there. By 1916–17 Malevich had found a new technique of doing this. This technique is also indicated in the New York painting: two overlapping quadrant arcs of white are just visible within the white background pigment, as if emerging from the insubstantial ether to signal the sheer potential energy of empty space. These arcs are visible in a related lithograph which also shows how one Suprematist work can more or less include another. This network of relationships seems to act like gravity in space, forming orbits, establishing attraction across a void. It manipulates the geometry of forces suggested by the scientific and mathematical study of the period. But for Malevich this process was not necessarily divorced from the mysticism that motivated Matyushin, Ouspensky and others. That forms might appear within space itself was a sign of their belief in the fecund harmony of the universe. Malevich focused upon this in the early Revolutionary years: he described a motif which he dated 1917 as a *Suprematist Composition Conveying the Feeling of a Mystic Wave in the Cosmos*.

260, opposite page. Kazimir Malevich *Suprematist Composition*, c.1916–17. Oil on canvas. 22 × 15 *vershok*. 97.79 × 66.68 cm (given as 98 × 67 cm). Museum of Modern Art, New York.

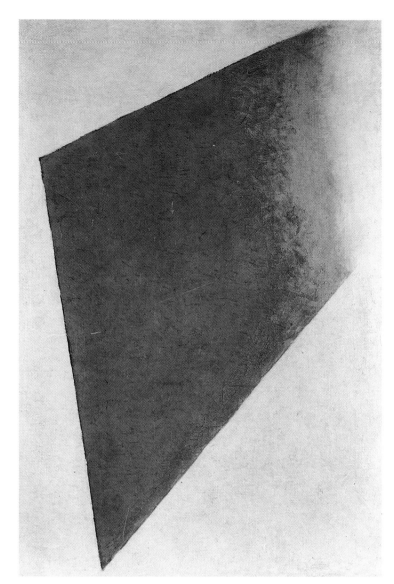

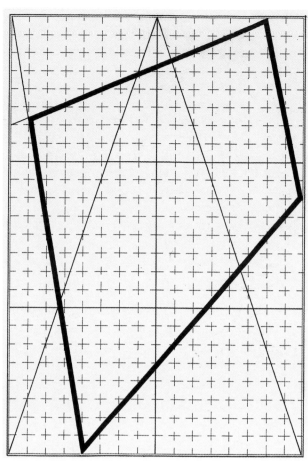

262. Diagram of the compositional structure of Plate 261.

261, left. Kazimir Malevich *Yellow Quadrilateral*, *c.*1917–18. Oil on canvas. 24 × 16 *vershok* (1½ × 1 *arshin*, ratio 3:2) 106.68 × 71.12 cm. Stedelijk Museum, Amsterdam.

In the elemental painting *Yellow Quadrilateral* (Plate 261) Malevich presents a brilliant yellow surface fading away along its shortest side, or, to reverse the reading of time and space once again, emerging forcefully into a clear sharp edge like the blade of an axe solidifying from thin air or empty space. A whole series of drawings on squared paper show alternative variations on the theme, and similar ideas were taken up by Popova and Rodchenko. Visual analysis reveals that Malevich was still articulating his harmonic system (Plate 262). The canvas itself is 24 × 16 *vershok*, that is 1½ × 1 *arshin*, in the ratio 3:2. It can therefore accommodate a golden triangle of angles 72, 72 and 36° to which the yellow form is closely related. The drawings show variations on the angles but these remain multiples of 9°. Popova used comparable devices but without Malevich's white background. The theme of an arriving or departing geometric surface linked infinite distance with the immediate foreground. A leading edge of this kind crossed by three 'fading' arcs provided a recurrent motif in works before 1920, culminating in a wholly white version of the motif in 1918. The geometry is barely visible as Malevich's geometric surfaces have become less and less substantial.[72]

The Suprematism developed by Malevich from late 1913 and exhibited two years later at '0,10' seems to have little direct connection with the political revolutions of 1917, although as the *White on White* series shows, Malevich was continuing to explore and elaborate the implications of his discoveries throughout the Revolution. He constantly introduced new technical means requiring considerable experiment and examination. Suprematism appears to repeat its basic history with new motifs, techniques or criteria and to rework its themes. Malevich frequently devised and illustrated the history of Suprematism. In a way this is not surprising for, as Malevich began to publish essays and to teach, he needed clear explanations of these developments. His accounts stressed the elemental quality of Suprematism and then its audacity, its prolific energy and its inventiveness. These histories and canvases by Malevich were perhaps erected periodically, just as Khlebnikov intended to erect his poems, like sails in time: 'But we are from our own time, with our time and forms, and place the stamp of our face, leaving it in the flow of centuries where it will be recognised.'[73]

The Perspective of Revolution

Malevich's involvement with the Bolshevik Communist Revolution is relevant to his attitude to mathematics and geometry in one important way. For Malevich it meant that the system he had developed throughout the war had now to be related to the aims and demands of the Revolution. In other words, his geometric iconography had to be examined in relation to a new political ideology and circumstance. It is one of the formidable strengths of certain kinds of imagery that they can respond to change without loss of identity – this is part of the whole purpose of such a convention: as times change the convention adapts. Malevich had spoken more than once of the 'face of his time', but what had been an intellectual search now needed to be considered with regard to the ideology of a movement publicly committed to the international Communist movement. After the February Revolution in 1917 Malevich joined the Federation of Leftist Artists. On 12 November 1917 he was appointed Interim Commissar for the Preservation of Monuments and Antiquities in the Moscow Kremlin. His political stance became clearer in a series of articles written for the periodical *Anarkhiya* (Anarchy) published in March and April of 1918. His language was rhetorical but can be understood in terms of his belief in the dawn of a new age. The international ambitions of Communism encouraged his global view of history and geography to encompass the whole of planet earth. This vision was easy to accommodate within his Suprematist system so that iconography and ideology were reconcilable. On the other hand, no specific political purpose was discernible in the pre-1917 Suprematist works: it was a question not of political commitment but of compatibility: 'We,' wrote Malevich in *Anarkhiya*, 27 March, 1918, 'like a new planet on the blue dome of the sunken sun, we are the limit of an absolutely new world, and declare all things to be groundless.'[1] Having organized the basis of a new perspective Malevich was able to use it analytically or constructively to provoke an image of new-found freedom and this in turn could also be turned to political and ideological ends insofar as it was a vision of a future at odds with the conventions of the old regime: 'We tear ourselves from our earthbound shackles,' wrote Malevich in *Anarkhiya*, 'our motors daily enter the chasm of space.'[2]

Circumstances also influenced the output of Malevich. After the Revolution, for example, he began to teach, moving to Petrograd with Tatlin, Morgunov and others to direct the Free State Studios there. Teaching and writing were rapidly established as adjuncts to his painting. These activities spread the understanding of his ideas and the inventive potential of this art that still contained many possibilities scarcely explored by Malevich. Klyun, Popova, Rozanova, Rodchenko and Exter all responded to his example. Malevich even prepared a text on the 'Numerical Foundations of Art' for a proposed seven-language journal *Internatsional iskusstv* (The International of Art) of which he was to be an editor.[3]

On 5 November 1918 a decree was issued 'nationalizing' the merchant Sergei Shchukin's collection, which had had such a profound and formative influence upon early twentieth-century Russian art. It reopened as a state museum the same month.[4] Gauguin had been one of its greatest strengths and was central to the influence of the collection

on young Russian artists, for Gauguin presented primitive religious themes. Gauguin's book *Noa-Noa* spelled out his version of Tahitian cosmic myth. Significantly, when it was republished in Russia in 1918[5] it was the future Suprematist El Lissitzky who designed the cover (Plate 263), featuring Gauguin's image centrally aligned within a square. The effect is comparable with the ikon-like effects of Malevich's *Portrait of Ivan Klyun* and related works. In France, Paul Sérusier had done more than anyone to communicate Gauguin's principles and the rudiments of mystical mathematics to the pre-war Cubist generation. It is curious to note that Maurice Denis in 1918, recording his impression of Sérusier after a recent visit, used terms wholly applicable to Malevich: 'He loves neither the sea nor nature; he is more and more engaged in his abstractions.'[6]

With the war over and the Revolution underway, in 1918 Malevich worked on a whole series of white on white canvases, which were exhibited in 1919. These comprised the latest avenue of exploration within the Suprematist system, ranging from the 'arrival' of forms by graduated distinction from the white background, to the clear-edged white on white of the New York painting. They show that Malevich progressed from *The Black Square* (Plate 193) exhibited in 1915 to the *Suprematist Composition White on White* (Plate 264) exhibited four years later by way of an explosion of colour and form. Malevich himself spoke of the black, red and white squares as characterizing distinct stages of Suprematism.[7] This process, complete in its way, nevertheless left a rich trail of possibilities undeveloped. Malevich and Lissitzky, for example, were to explore 'three-dimensional' Suprematism. Popova, Rodchenko and others learned from Suprematism whilst developing Constructivism. In the context of the Revolution the overt mysticism of Malevich was less than comfortable to emulate, but some painters, following the sheer

263. El Lissitzky Binding for a Russian edition of Paul Gauguin's *Noa-Noa*, Moscow 1918.

264, right. Kazimir Malevich *Suprematist Composition: White on White*, 1918. Oil on canvas. 18 × 18 *vershok*. 80.01 × 80.01 cm (given as 78.7 × 78.7 cm). Museum of Modern Art, New York.

inventive example of his use of geometry and mathematics, developed their own adaptations of mathematical principles. There was Popova's visit to Uzbekistan in Central Asia where she studied great mosques and tombs of the Shir-Dar and Shakh-i-Zinda at Samarkand. Samarkand had been part of Tamerlane's empire along with Damascus, Baghdad, Kabul and even Lahore. It provided an important focus of Arabic mathematical and astronomical learning. Tamerlane's grandson, Ulugh Beg, who died at Samarkand in 1449, built a great observatory near Tamerlane's black onyx tomb and compiled there the first astronomical tables since those of Ptolemy. Arabic geometry also informed every shape, surface, dome and tile of its mosques. The increasingly elaborate geometry of Popova's paintings suggests that her enthusiasm for Arabic mathematical achievements was as strong as that of Khlebnikov.

This interest has an historical dimension familiar to Russian Futurists but quite unlike Italian Futurist attitudes. In the systems described by Khlebnikov, Hinton or Ouspensky the past seemed to be directly connected to the present and future. Visual forms as much as words could be seen to have roots and a material development through history.[8] When the new periodical *Izobrazitelnoe iskusstvo* (The Plastic Arts) was first published in 1919, it not only published Malevich's essays on colour, volume and poetry but also listed books considered to be publications of great importance for the educational courses of new art schools. These included the books of Alberti, Palladio and Vitruvius, for all of whom the traditions of proportion and perspective were crucially important in creating harmony in architecture.[9] This chain through time ran from the ancient Rome of Vitruvius, via the Renaissance of Alberti, through the sophistication of Palladio to Soviet Russia. Significantly the periodical also called for the publication of books on Orphism and Suprematism as well as Apollinaire's writings on Cubism.[10] When Stepanova revealed in her article marking Olga Rozanova's 1919 memorial exhibition that 'Malevich constructed his works on the composition of the square', she was only pointing to the latest form of ancient traditions long visible in architecture and also vigorous in painting. Insofar as it was ever either imaginable or politic to argue that Soviet Russia might provoke a new Renaissance of culture, this tradition seemed highly appropriate once stripped of its aristocratic and ecclesiastical trappings.

In this respect, as we have seen, ikon painting played a significant cultural role in Russia through its long-sustained importance in the orthodox church, but also more recently as a sign of Russia's cultural independence from the Western European example. Goncharova had stressed this point at the Donkey's Tail exhibition only four years before the Revolution. Yet the religious aspect of this tradition could not be its foremost significance for Bolshevik Communists after 1917, even when its importance in a distinct Russian culture was acknowledged. So the ikons of Andrei Rublev appeared as sources of an independent Russian culture and not so much the equipment or evidence of religious devotion from a time of autocratic tsarist rule. The *Virgin of Vladimir* (Plate 265) for example, a Byzantine ikon that predated and survived the Tartar-Mongol invasions, was moved to Moscow in 1395 where it provided a sacred and potent precedent for Russian painters, Rublev among them. The *Virgin of Vladimir* became the Palladium, the protective image of Russia.[11] How a powerful cultural ikon of this kind could be transmitted and interpreted in terms of a new mathematical art can be seen by an examination of works by Naum Gabo and Aleksandr Rodchenko.

Gabo had studied engineering and art history in Germany before the war drove him to Norway and eventually from there back to Russia. His monumental construction *Head No. 2*,[12] devised in 1916, opened out the solid form to admit space by means of a construction of planes radiating, broadly speaking, from a central core. The half-figure's

265. *The Virgin of Vladimir*, c.1408. Tempera on wood. 101 × 69 cm. Vladimir Museum.

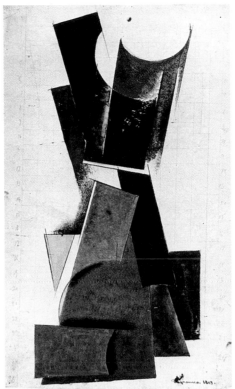

266, far left. Naum Gabo *Constructed Head No. 3 (Head of a Woman)*, c.1917-20. Celluloid and metal on wood. 14 × 11 *vershok*. 62.23 × 48.9 cm (given as 62.2 × 48.9 cm). Museum of Modern Art, New York. © Nina and Graham Williams.

267, left. Aleksandr Rodchenko *Construction*, 1919. Gouache on paper. 38 × 23.5 cm. Rodchenko and Stepanova Archive, Moscow.

pose recalls paintings by Picasso and Boccioni and in its planar qualities it recalls drawings by Dürer, but it also has the anonymity of African carvings. But Gabo's *Head of a Woman* (Plate 266) of *c.*1917–20, which is constructed in a corner space, makes other references. Here Gabo, like Malevich and Tatlin in 1915, used the space like the ikon corner of an Orthodox home. This forms a space within which to construct a kind of relief: in this it is again comparable with Tatlin's reliefs. On the other hand, the front edges of the 'walls' to either side make a rectangular format at the front of the work, like the diagonal of a sterometric cube, behind which the relief is assembled rather like a head behind a window or a portrait head behind a picture surface. This is like a painting in which the stylized curves, the elongated nose, jaw and the tilt of the head directly reflect the ikon-painting traditions of Russia. The expressive qualities of the ikon are preserved in Gabo's construction even when the Christian theme is lost. This motif is from the *Virgin of Vladimir*. The theme of the Virgin and Child, shown with cheeks touching, is known as the *Virgin of Tenderness*. It can be found in the work of Rodchenko. The close proximity of the faces of the Virgin and Child requires one halo to overlap the other. These remain circular in the otherworldly golden surface of the ikons, so that the edge of the Virgin's halo passes through the centre of the halo of the infant Christ, a device that locks the figures together in an expression of tenderness and care. In the Communist period Rodchenko by contrast shows no hint of Christ-child or Virgin Mary, but in a whole series of paintings of circles from 1917–18 he made precisely this incision of one circle by another. In both the ikon and the non-objective painting the same system of proportion and rhythmic harmony is at work. Other studies by Rodchenko perhaps take this further. A squared-up gouache of 1919 (Plate 267), for example, is suggestive of torso, neck and head with a smaller, lighter form enclosed. As Rodchenko favoured geometric forms made with compass and ruler

this is not a religious painting, but the image of the protective mother was a potent inspiration for propaganda kiosks in which a vestigial division into a head, neck and body can be detected. As Rodchenko's gouache is constructed within a double square and incorporates angles that are multiples of 9°, it appears that he made close studies of Suprematism and ikon painting, finding them surprisingly compatible. Rodchenko became a constructor who could move easily from the pictorial to the practical and use proportion as a means of pictorial analysis or as a means of constructing propaganda kiosks in a politicized world. Tatlin also achieved this: he encouraged the analysis of Old Master paintings, for example, and this attitude may inform his surviving *Relief* of 1917 in the Tretyakov Gallery, for its enclosing surfaces again display a function comparable with that of the *Virgin of Vladimir*.

During the period 1917–18 Rodchenko painted a whole series of works based upon the circle.[13] Malevich used the circle sparingly although he acknowledged the black circle as a primary Suprematist form. His proportional system was based upon the relation of the circle and the square, but as a motif in his paintings the circle rarely appeared before the advent of the more elaborate Suprematist canvases. Rodchenko's two-circle *Non-Objective Composition 56 (76)* (Plate 268), at $1\frac{1}{4} \times 1$ *arshin*, 20×16 *vershok*, ratio 5:4, exemplifies a proportion familiar to Malevich. Here it is cut through by the line of the two centres of the circles, an invisible structural line at just 72° to the lower edge. Because of this a golden triangle will fit the canvas if another line at 72° rises from the lower right corner (Plate 269). In fact, the golden ratio occurs here in numerous forms, including that of the radii. Dividing the canvas gives two rectangles in the ratio 5:8, both Fibonacci numbers which at 0.625 closely approximate the Golden Section. Other paintings provide variations on the theme, projecting smaller and larger related circles; this occurs on canvases of 20×16 *vershok* and also in gouaches and even linocuts. Dürer in *The Painter's Manual* of 1525 had devised a comparable procedure for constructing intersecting circles related to squares on the diagonal so that $\sqrt{2}$ came into play with each shift of scale. Rodchenko used similar angles and proportions to those enumerated in the work of Malevich. This was even the case in Rodchenko's *Black on Black* response to the *White on White* series exhibited by Malevich in 1919, and some of these paintings by Rodchenko are square. Rodchenko's *Composition 64 (84)* is a one-*arshin* square black painting in the Tretyakov Gallery in Moscow. It presents a black circle on a black ground together with two forms built from the arcs of circles related to the edges of the canvas. These 'fish' forms are known as the *vesica piscis* and they were frequently used by Rodchenko in 1918. In each case it is the relations of the circle and square that, in the manner of Malevich, provide his proportional system.

The adoption of geometric shapes as motifs was widespread in the early Revolutionary years. Chagall illustrated the phenomenon with great succinctness in a small characteristic gouache which shows the painter at his easel painting a sphere and a pyramid before an immense night sky of whirling geometric forms. Petr Miturich, close friend and brother-in-law of Khlebnikov, constructed standing 'spatial paintings' in 1918–20 which were again based upon the cube and cylinder. Some of these large constructions featured cubes rising from other cubes as if from a fourth dimension as described by Bragdon or Hinton. Geometry and mathematics, as Chagall and Malevich showed, are forms associated with the great geometry of astronomy and of apparent movements in the sky. In Malevich's paintings they indicate a kind of cosmology for a viewer with no fixed viewpoint, in which all is relative and without the benefit of any final arbiter in a world of measureless time and space. Rodchenko's linocuts of 1918 illustrate this space well with flexible frameworks of lines suspended among the shifting planes and spheres of space. Despite

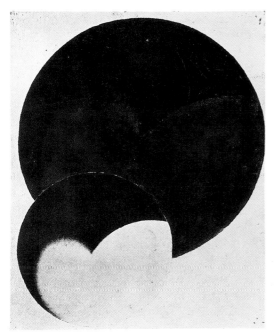

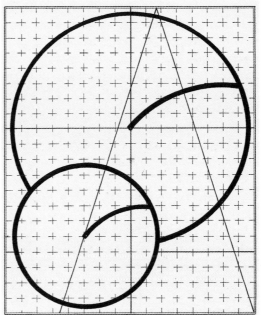

268, far left. Aleksandr Rodchenko *Non-Objective Composition 56 (76)*, 1917. Oil on canvas. 20 × 16 *vershok* (1 *arshin* wide). 88.9 × 71.12 cm (given as 88.5 × 70.5 cm). Tretyakov Gallery, Moscow.

269, left. Diagram showing the relation of the golden triangle to the height of the canvas and to the two circles in the compositional structure of Plate 268.

Rodchenko's determined independence he had clearly responded to Malevich's example: 'Follow me, comrade aviators! Swim into the abyss. I have set up the semaphors of Suprematism . . . Infinity is before you.'[14]

The 'Tenth State Exhibition: Non-Objective Creativity and Suprematism', held in Moscow in April 1919, revealed the strength of Malevich's innovation through the diversity of his own paintings and through the sheer number of painters now adopting geometric forms. As his early follower Ivan Klyun declared in the catalogue: 'The corpse of the Art of Painting, the art of nature with make-up added, has been placed in its coffin and marked with a black square. The casket is now on show to the public in art's new graveyard, the Museum of Pictorial Culture.'[15]

In this context the actual astronomical eclipse that occurred in May 1919 must have appealed to Russian Futurists as a Malevich or Rodchenko painting in the sky. As Malevich pointed out in the same exhibition catalogue: 'The system is constructed in time and space, independently of any aesthetic considerations of beauty, experience or mood, but rather as a philosophical colour system, the realisation of new trends in my thinking – as a matter of knowledge.'[16] This is almost a paraphrase of Khlebnikov's *Self-Statement* of 1919: 'Recently,' wrote Khlebnikov, 'I have begun writing with numbers, as Number-Artist of the eternal head of the Universe, how I see it and where I see it from.'[17]

In February 1919 Malevich attended a conference that recommended the establishment of museums of the practice of contemporary art. These were to be known as Museums of Pictorial Culture. Malevich also published an article 'O Muzee' (On the Museum) in *Iskusstvo Kommuny* (Art of the Commune) on 23 February 1919 in which he wrote that 'our wisdom hastens and strives towards the uncharted abysses of space, seeking a shelter for the night in its gulfs'.[18] Either to justify his position within the new art school system or simply to provide the theoretical basis for his increasingly influential art, Malevich began to write longer theoretical essays, which are, in themselves, thematic histories of Suprematism. *On New Systems in Art* was the first of these, completed in June 1919 and

published on 15 November 1919 in Vitebsk, where it was printed lithographically at the art school where he had been invited to teach. The theory and teaching of Suprematism became more or less inseparable. As a result his influence overwhelmed the art school at Vitebsk, to Chagall's regret, and gained him important new followers there including El Lissitzky. Malevich's retrospective in the Sixteenth State Exhibition was likewise a history of his development. The broader significance and history of Suprematism was promoted through his writings and in 1919 at least his work was receiving substantial recognition in a retrospective exhibition. At Vitebsk and in *On New Systems in Art* Malevich promoted 'economy' as 'the new fifth dimension',[19] which he believed controlled growth in nature and also refined and clarified mathematical truths. His own *Black Square* was a perfect and primary example of economy: 'Standing on the economic suprematist surface of the square as the absolute expression of modernity, I leave it to serve as the basis for the economic extension of life's action.'[20]

It is important to remember in this context how closely Khlebnikov involved himself with painters at this time. Malevich, who was one of Khlebnikov's 'Presidents of the Terrestrial Globe', declared in 1919: 'I have torn through the blue lampshade of colour limitation and come out into the white; after me comrade aviators sail into the chasm – I have set up the semaphores of suprematism.'[21] Khlebnikov's text *The Head of the Universe*, written in 1919, uses the same cosmic imagery, announcing that the 'number artist' can 'proclaim a free triangle with three points – the world, the artist and the number – he draws the ear or the mouth of the universe with the broad brush of numbers'.[22] It is almost as if Khlebnikov seems to describe early Suprematist drawings when he says: 'A single one of his lines provides an immediate lightning-like connection between a red corpuscle and Earth, a second precipitates into helium, a third shatters upon the unbending heavens and discovers the satelites of Jupiter.'[23] In the same text Khlebnikov alluded specifically to Malevich in whose 'shaded-in sketches, his encrustations of black planes and spheres, I have found that the ratio of the largest shaded area to the smallest black circle is 365. These collections of planes therefore contain a shade year and a shade day. Once more in the realm of painting I had observed time commanding space.'[24] In these words Khlebnikov united the Suprematism of Malevich with his own research into the rhythms of time and space, those vibrations of 365 years that he considered linked and separated the births of similar people and that led him to consider a sequence of thinkers as a 'Flying Dutchman with a single destiny who appears on the oceans of different peoples'.[25] He recommended that a man who rests from his daily labours should go to 'read the cuneiform of the stars',[26] just as Malevich described in his own vision 'the propeller' which 'with difficulty tears itself from the old earth's embraces'.[27]

Both Malevich and Khlebnikov saw mankind as a traveller in time and space, a traveller whose perceptions were developing into new dimensions. *Victory over the Sun* signified an escape from the time and space of planet earth subject to the sun in its regular orbits. It meant the freedom to conquer flight in the air and in the voids of space where perspectives of time, speed and distance were transformed by unprecedented viewpoints. Suprematism was a way of envisaging, forming and manipulating that space. It could be used analytically or constructively. At Vitebsk Malevich and his close team of followers in the collective Unovis began to develop its constructive potential.

Malevich, for all his individuality, frequently worked with collaborators in group endeavours. His involvement with the Donkey's Tail group was one example, followed by *Victory over the Sun* and the brief Supremus group. At Vitebsk Malevich was clearly the

focus of the Unovis (Affirmers of New Art) collective and Suprematism provided its means. The publication by Unovis of Malevich's *Suprematism: 34 Drawings* in 1920 is a sign of this: the book was at once a practical manual, a history and an appraisal of future possibilities – in all of which Malevich played the formative and all-embracing role.[28] Insofar as *Suprematism: 34 Drawings* was a history, it made of its author the sole progenitor and inventor of the movement. In this history Malevich has surveyed the development of Suprematism to select significant motifs retrospectively. In this way he may have given primacy, for example, to the black square, black circle and black cross because he thought they were important, whatever their position in the chronological sequence of events. He is imposing order upon a stream of inventiveness characterized by extraordinary diversity. As a result the categories that he devised overlap or become inconsistent. It is not possible to agree precisely, for instance, with his assertion that 'Suprematism falls into three stages, according to the number of squares of black, red and white: the black, the coloured and the white'.[29] Nor is it possible without reservation to accept the dates proposed by Malevich. If the black square signifies economy, the red square the 'signal of Revolution' and the white square 'pure action', it is surprising to find Malevich using the red square already in 1915. It is, however, possible to understand all of this as an assertion appropriate to his artistic and pedagogic position at Vitebsk in 1920.

In surveying the achievements of Suprematism, Malevich rehearsed several of its major forms in lithographic versions employing variations of earlier works. It is clear, however, that mathematical procedures remained a concern – indeed, Malevich now found himself working with a trained engineer in Lissitzky. Whilst Lissitzky's use of the circle and square is distinct from that of Malevich the debt is at once apparent. The Unovis sign (Plate 270), for example, sets the red square within the circle so that the lower corners form the base of a triangle (angle 36°), the sides of which meet at the apex which is central to the circle passing through the upper corners.

The Unovis collective was also made well aware of the importance of *Victory over the Sun*, which they restaged on 6 February 1920 at Vitebsk. Vera Ermolaeva produced stage

270, below left. El Lissitzky *Sign of Unovis*, as it was published in his *Story of Two Squares* in 1922.

271, below right. Vera Ermolaeva Set design for *Victory over the Sun*, 1920. Handcoloured woodcut on paper. 27.5 × 35 cm. Collection Mr and Mrs N.D. Lobanov-Rostovsky, London.

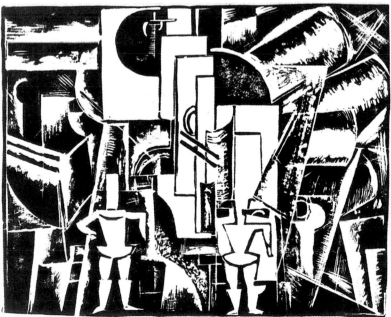

173

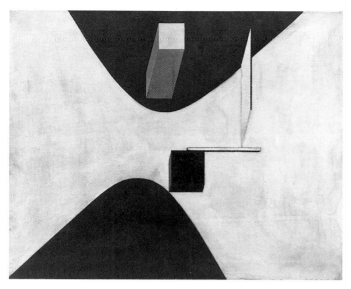 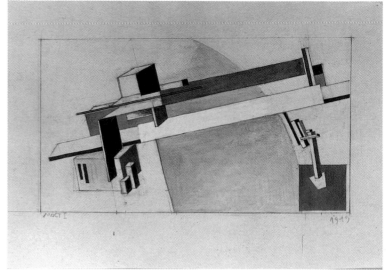

272, above left. El Lissitzky *Proun 23, No. 6*, 1919. Oil on canvas. 77 × 52 cm. Collection Dessau Family Trust.

273, above right. El Lissitzky *Proun 1A, Bridge I*, 1919. Watercolour. Inscribed 'most' (bridge) lower left. 15.2 × 19.4 cm. Collection Dessau Family Trust.

set and costume designs (Plate 271). In one design made by Malevich he recalled the playing card suits of his first studies for the opera, made some seven years earlier. Ermolaeva's hand-coloured woodcut of the set features future-dwellers standing before a large construction which even here retains a hint of its Cubist heritage. This represents, for Malevich, another reprise of his own recent history, in which the importance of Russian Futurism as a driving force for Suprematism is evident. Escape from fixed perspective, from a single light source and from gravity so as to be able to fly off into space and time, evidently remained Malevich's concern when *Suprematism: 34 Drawings* was completed on 15 December 1920. He wanted his forms to indicate 'a state of dynamism and, as it were, a distant pointer to the aeroplane's path in space − not by means of motors and not the conquerors of space by disruption . . . but the harmonious introduction of form into natural action'.[30] Malevich felt that a technical apparatus only embodied Suprematism in a crude form; his own imagined projects required no motors: 'One has only to find the interrelationship between two bodies speeding through space: the earth and the moon − perhaps a new Suprematist satellite can be built between them.'[31]

The impact of his vision of humanity's place in space can be seen at once in the work of El Lissitzky (Plates 272–3). In his essay *Suprematism in World Construction* in 1920, Lissitzky extolled the generative and disciplined power of the square as 'the very source of all creative expression'.[32] Suprematism, wrote Lissitzky, 'will liberate all those engaged in creative activity and make the world into a true model of perfection. This is the model we await from Kazimir Malevich. After the Old Testament came the New. After the New the Communist − after the Communist there follows *finally* the testament of Suprematism.'[33]

This idea of a last Testament embodies the extraordinary ambition of Suprematism. The Communist International encouraged theoretical speculation about a unified humanity living in harmony upon planet earth, but Suprematism, in the vision promoted by Malevich (Plate 274), had already passed beyond this to envisage life in newly revealed depths of space and time. His vision was cosmological, like that of Ouspensky and Khlebnikov. The idea of a new dispensation was already evident in Schuré's writings, but the temporal ideas of Ouspensky and Khlebnikov would have concerned any such great new movement with its echoes in time. This perhaps in part explains the grandiose tone

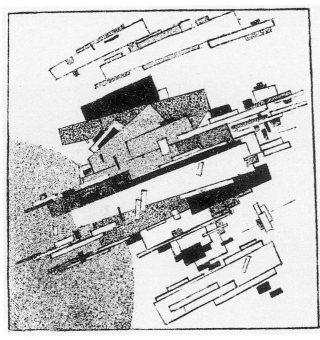

274. Kazimir Malevich *Suprematism*. Lithograph. Published in K. Malevich's *34 Drawings*, Vitebsk 1920. Inverted for comparison with Plate 289.

275, below left. Aleksandr Rodchenko *Two Figures*, 1919. Oil on panel. 34 × 22 *vershok*. 151.13 × 97.79 cm (given as 149.5 × 97 cm). Collection George Costakis.

276, below right. Albrecht Dürer *Adam and Eve*, 1504. Engraving. 25.2 × 19.5 cm. Germanisches Nationalmuseum, Nuremberg.

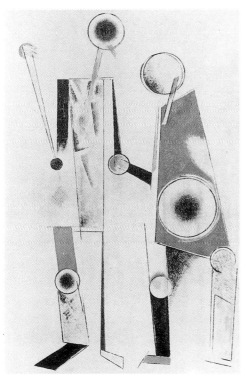

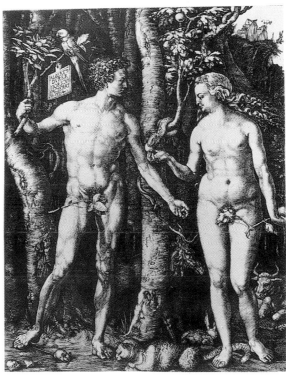

of Lissitzky's note. It may also explain his interest in ancient themes from Vitruvius, Alberti, Leonardo and Dürer. Chagall had set the joined images of Adam and Eve against a cosmic clock when he was still living in pre-war Paris. This was an opportunity to construct the perfectly proportioned human body. There is much evidence of this theme among the contemporaries of Malevich. Rodchenko's *Two Figures* of 1919 (Plate 275) may echo Dürer's *Adam and Eve* of 1504 (Plate 276). Rodchenko's linear structure is

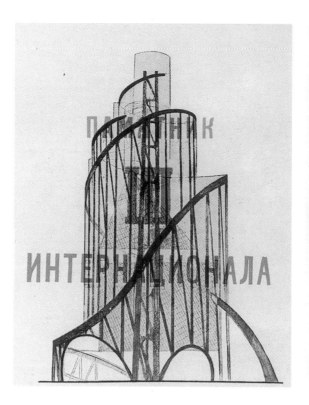

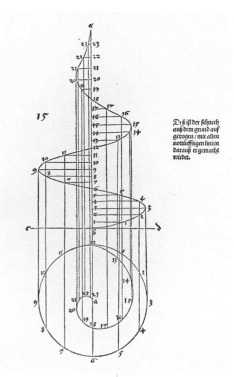

constructed entirely with the compass and ruler, as if to indicate that perfection lies in the mathematical relations of the square and circle.

Dürer may also be an element in the thinking behind Tatlin's *Monument to the Third International* (Plate 277). Dürer's mathematical studies published in his *Painter's Manual* in 1525 included the construction of three-dimensional conical spirals (Plate 278) and the mathematics of Tatlin's monument have been related to the themes of mathematics, melancholia and alchemy in Dürer's print *Melancolia I*. Tatlin's tower, without being Suprematist, was a geometric *tour de force* in which the entwined spirals embrace a spine of girders like the twin snakes of Hermes twined around his healing caduceus staff. Tatlin's monument was envisaged as the gigantic setting of world government, so that it also proposed an attitude to the planet as a whole. Pointing to the pole star it appeared in the guise of an orrery, sextant or clock measuring the history of humanity in the sun, stars and moon. As its rooms rotated in time with these rhythms, Tatlin's *Monument* represented a cosmological system of man's place in the universe and it was absolutely in tune with the mathematical-historical theories of Khlebnikov. It was revolutionary by virtue of the fact that it provided a model for social harmony in time and space organized with a mathematical, architectural clarity. This, as we have seen, is a function of perspective firmly in the tradition of Campanella and his Renaissance forebears who from a Russian Futurist viewpoint would have appeared to be forerunners, or echoes in time, of the same idea.

As far as Malevich was concerned the poet Khlebnikov was probably the common source for such global, interstellar and cosmological thinking. Khlebnikov and Malevich were both signatories in Spring 1917 of a text described by Khlebnikov: 'We alone rolled up your three years of war into a single spiral, a terrifying trumpet, and now we sing and shout . . . : the Government of Planet Earth already exists. We are it.'[34] In 1920 Khlebnikov was still promoting global harmony. In his 'Ladomir' (Goodworld), for

example, which is a world of future harmony, lies the country of *Lyudostan* (Peopleland) where a monument is erected upon the summit of Mont Blanc to symbolize the unity of human life. Mathematics was essential to such a vision as Khlebnikov above all realized: 'and may the space of Lobachevsky/Fly from the flags of night-time Nevsky.'[35]

Khlebnikov, Tatlin and Malevich could find sympathetic visions of Utopia in the novel *Vne Zemli* (Beyond Planet Earth), first published as a book in 1920.[36] Its author, Konstantin Tsiolkovsky, was a pioneer of Russian rocket design who had turned his attention to writing a fantasy of space flight. Like Khlebnikov and Malevich, he stretched the fabric of time in his writing. His utopian communities in space were established by scientists from France, England, Germany, America, Italy and Russia, yet these scientists came together from different centuries: they were Laplace, Newton, Helmholtz, Franklin, Galileo and perhaps Tsiolkovsky himself hiding behind the name Ivanov. These were all images of a perfect civilization in time and space. In the case of Khlebnikov, Malevich and Tatlin this Utopia was characterized by geometrical and arithmetical relationships. It was, in essence, the same image of harmony evident in Vitruvius, in the writings of Dürer and Leonardo and in the imagery of alchemy. Geometric harmony represented social harmony.

As images of social harmony they were potentially political. When such images occurred in Revolutionary Russia this had the inevitable consequence of urgently advancing a social model. The imagery of mathematics and the use of its harmonious relationships had evolved before the Revolution, but after 1917 it was inevitable that this iconography would gain political force and express an ideology. The Constructivists' exhibition 'October in the Cube' of 1919–20 is one example of the link between Communist ideology and this use of geometry. Standardization and impersonal organization were the threats that counterbalanced remarkable visions of new societies in space.

Tsiolkovsky's description of outer space reads like the space of a Malevich painting: 'When I saw the abyss underneath me, and that there was nothing to support me anywhere, I fainted, and did not recover my senses until the whole safety line had unwound and I was already a kilometre from the ship, which I could see at the end of the line, looking like a thin white rod.'[37] Yet Tsiolkovsky saw conformity, uniformity and standardization as essential adjuncts of the new life of mankind in space: 'The houses will be as standardised as the clothes; they will be built for millions of people! Newton replied "They too will be perfected. Moreover, the environment here will be so uniform that it will be just as easy to build perfect homes as to make perfect space-suits."'[38]

On the face of it, Suprematist theory proffered an inventiveness as diverse and flexible as that of a musical scale. As the revival of *Victory over the Sun* revealed, it did not finally necessitate a total ban on imagery – evidence of which can be found in the work of Rodchenko, Stepanova, Popova, Lissitzky and so on. Anonymity and uniformity within Communism were seen as a danger by some of its adherents, including the Futurist playwright and poet Vladimir Mayakovsky. He was not alone in this view as a novel unpublished in Russia reveals.

Evgeni Zamyatin wrote his novel *We* in 1920.[39] It describes a future Communist society wholly regulated by the state, a society in which everybody is identified by a number instead of a name. This state is about to launch the Integral, a machine designed to bring harmony to the whole universe. The novel's central character is the inventor: 'A thousand years ago your historic ancestors subdued the entire globe to the domination of the One State. Now a still more glorious deed lies before you: that of integrating, by means of the glazed, electrified, fire-breathing Integral, the endless equalization of all Creation.'[40] Other planets would have to conform: 'Should they fail to understand that

we are bringing them a mathematically infallible happiness, it will be our duty to compel them to be happy.'[41]

The city described by Zamyatin has much in common with the outward appearance of Suprematism: 'I saw the irrevocably straight streets, the ray-spurting glass of the roadways, the divine parallelipipedons of the transparent dwellings, the square harmony of our blue-grey ranks.'[42] At times Zamyatin is close to quoting Khlebnikov verbatim as in the Fifth Entry of this journal: this is headed 'The Square. Sovereigns of the Universe'.[43] Zamyatin's dystopian society is permeated by mathematics. In the Seventh Entry the central figure admits that 'With eyes closed, I dreamed in formulae: I once more calculated the initial velocity that would be needed to pluck the Integral loose from the earth'.[44] The Ninth Entry describes the focus of the city: 'The Plaza of the cube. Sixty-eight gigantic concentric circles: the rostra three. And sixty-six tiers of faces serene as lamps, of eyes reflecting the radiance of the heavens – or, it may be, the radiance of the One State.'[45]

Zamyatin called his protagonists 'humanised machines, machine-perfected humans'.[46] But in fact Zamyatin was desperate to ridicule such creatures and his novel is the story of the inventor's escape after a slow but irresistible disillusionment. What at first merely irked him was what eventually restored him: 'But R – had scarcely set foot in the room than he moved one chair, then another – the planes became displaced, everything departed from the accepted model, became non-Euclidean.'[47] He believed that 'Human history ascends in circles – like an aero. The circles vary in colour, some golden, some bloody, but all alike are divided into 360 degrees. Counting from zero we have 10 degrees , 20 degrees, 200 degrees, 360 degrees – and we are again at zero . . . this zero is a new, altogether different one.'[48] When he rediscovers the humanity of a fellow revolutionary in the Twenty-Second Entry, he sees that 'She was no longer a number: she was merely a human creature'.[49] Zamyatin was criticizing uniformity and conformity even when Rodchenko was quite unflinching in the severity of his painting and constructions – including suspended constructions of concentric geometric shapes that could be made up as kits for others to assemble. These constructions perhaps exemplify what worried Zamyatin: they are diagrammatic, geometric and impersonal: in essence they have no scale or material, just as a theorem in geometry has no size or material. Rodchenko's geometry was perhaps more like that of the alchemist whose dividers he shares with Tatlin and Lissitzky. In alchemy this implies a growing perceptiveness concerning the harmonies of mathematics and of the world in general, as well as the ability to build harmoniously with this knowledge. Malevich was, by his own admission, close to this position when he asserted that in man 'lie all the steps on an ever new metamorphosis of his being. Man, as a form, bears within him the eternal principle of being, and by economic movement along this endless path his form is also transformed.'[50]

Both Rodchenko and Lissitzky, as well as numerous other followers at Unovis and elsewhere, employed the systems of Malevich. The results were geometric but they were also widely diverse; they were not uniform, inflexible or wholly doctrinaire. Paintings executed by Lissitzky in 1920 make this evident. Lissitzky in *Proun 12E* of *c.*1920 (Plate 279) interslots his geometric planes at angles that suggest construction in space – a potential in Suprematism that Malevich had discovered by 1915 but which he was only now, with Lissitzky's collaboration, beginning to explore. Lissitzky has related his clusters of forms to the large triangle, the sides of which are echoed in the thin line that touches the circle. This point marks a 54° angle. Lissitzky's background space is deep and empty like that of Malevich and his clusters of forms fly weightless within it. The implied perspectival effects of rod- or box-like forms appear to twist and manipulate empty space.

Rodchenko and Lissitzky in 1920 were still close to the methods of Malevich although they were producing quite different results.

Numerous standard systems did emerge, not least in connection with teaching and the collective exploration of Suprematism and Constructivism. In both cases mathematics was a necessary ingredient. When Unovis moved to Moscow in 1920, contact with Moscow Inkhuk Constructivists was closer and easier. Unit constructions by Rodchenko and Stepanova were complemented by those of Ioganson, Popova and others. Work displayed at the First State Exhibition at Orenburg in 1920, for example, was dominated by Suprematist paintings but other proportional schemes were also in evidence. In many of these works the square and the cube continued to provide the basic means and proportions. Even in architectural theory and design the cube continued in its generative role. When the architect Ladovsky drew up a 'graphic demonstration of construction' in 1921 as a contribution to the contemporary debate on the difference between construction and composition, he used a square subdivided in a manner reminiscent of Malevich, employing the diagonal of a half of a square to give an angle of 63° and proportions for the Golden Section.

There was no doubting the practical potential of such systems and their visionary power. As Khlebnikov, Ouspensky, Miturich, Malevich and others saw perceptions changing around them, so their visions became more intelligible and their systems of perspective and proportion were more readily understood. Lissitzky produced a lithographic portfolio in 1921 including the lithograph *Proun 1E: The Town* (Plate 280) in which the black square of Malevich (Plate 281) appears as the core of a new city just beginning to grow along its axes, edges and diagonals. Suprematism, as Lissitzky shows, was widely applicable and capable of informing any aspect of design with its dynamic constructive rhythms. Lissitzky also began to teach after being called to the Moscow Vkhutemas in 1921. From there he took ideas and techniques to the West, to Berlin and

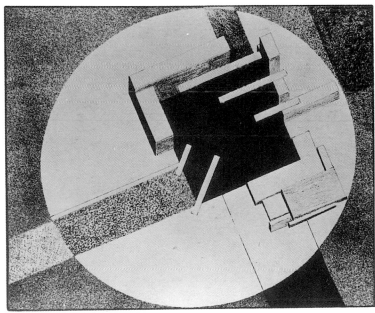

280, below. El Lissitzky *Proun 1E: The Town*, 1921. Lithograph from *The Proun Portfolio*, Moscow, 1921. 22.7 × 27.5 cm. Tretyakov Gallery, Moscow.

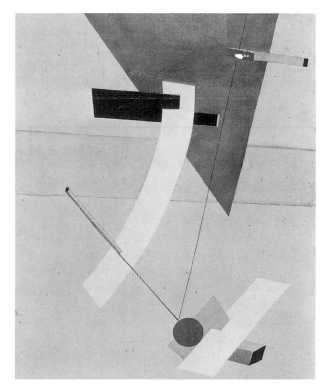

279, left. El Lissitzky *Proun 12E*, c.1920. Oil on canvas. 57.2 × 42.5 cm. Busch-Reisinger Museum (Alexander Dorner Trust Association Fund), Harvard University Art Museums, Cambridge, Mass.

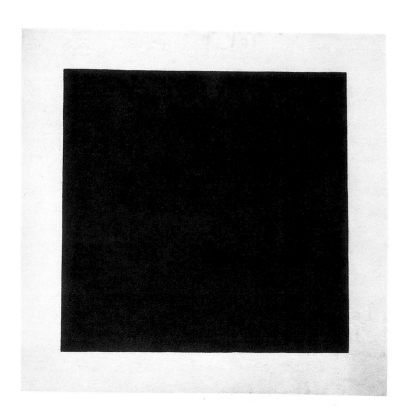

281. Kazimir Malevich
Black Square, 1920s. Oil on
canvas. 24 × 24 *vershok*.
106.68 × 106.68 cm (given
as 106 × 106 cm). Russian
Museum, St Petersburg.

elsewhere, travelling as a spokesman of Soviet art. Some of the proportional schemes were
already known in Western Europe, but the Russian Futurist concept of time and space
was unfamiliar. Khlebnikov expressed it well in a letter to Miturich on 14 March 1922:
'When the future becomes clear thanks to these computations, the feeling of time
disappears: it's as if you were standing motionless on the deck of foreknowledge of the
future. The feeling of time vanishes, and it begins to resemble a field in front of you and
a field behind; it becomes a kind of space.'[51]

By the time Lissitzky departed for Berlin, the restoration of diplomatic relations with
Russia under its Bolshevik Communist regime gave rise to a brief period of renewed
travel and exchanges of ideas. The isolation of Russian artists had been almost complete
since the outbreak of war in 1914. The whole Suprematist experiment, for example, had
happened in the enforced isolation caused by war and revolution. If Lissitzky provided a
bridge for Western European knowledge of Suprematism, Ivan Puni (who now adopted
the French spelling Jean Pougny) provided another. Puni's exhibition at the Galerie der
Sturm in Berlin in February 1921 was a mass of Suprematist forms, costumes, figures and
lettering (Plate 282). The mathematical side was not underplayed: Puni had costumes for
figures and letters to display in the street and enormous numerical figures pinned to the
wall of the exhibition gallery (Plates 283 and 284).

In Paris in 1921 a sense of proportion was again in the air. Post-war Purist tendencies
exemplified by Ozenfant and Le Corbusier were one important example, complemented
by Paul Sérusier's *ABC of Painting*, in which his mystical and mathematical theories were
at last published towards the end of a career that stretched from Gauguin in Brittany to
Cubists at the Académie Ranson in Paris until the war.[53] The international currency of
such mathematical theories by 1921 is further evidenced by the publication of Gino
Severini's *Du Cubisme au Classicisme: Esthétique du compas et du nombre* in Paris. The title-

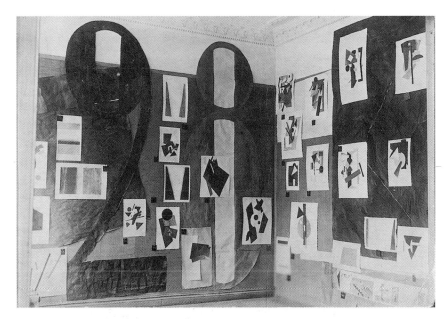

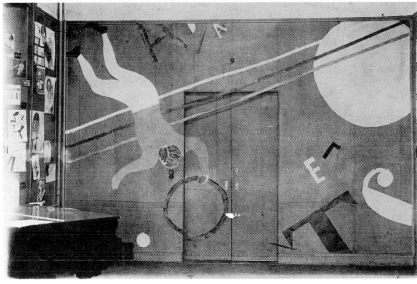

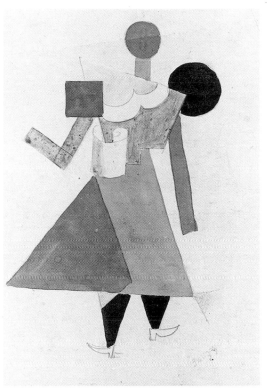

282, left. Installation of the exhibition of Ivan Puni's work at the Galerie der Sturm, Berlin, February 1921. Photograph © Puni-Archive, Herman Berninger, Zurich.

283, below left. Ivan Puni *Acrobat*. Part of the installation of Puni's work at the Galerie der Sturm, Berlin, February 1921. Photograph © Puni-Archive, Herman Berninger, Zurich.

page displays a pentangle like that used by Sérusier, and the preface by one Dr R. Allendy stresses the importance of 'the numerical arcana' whereby everything is in a mathematical proportion to everything else and therefore has a rhythm.[53] He mentions Paul Flambard's *Chaine des harmonies* and recommends 'Harmony which is a science of the relation of numbers'.[54] Severini then argues that art in his time is confused because 'artists in our epoch do not know how to use the compass, the ruler and numbers'.[55] He argues that 'Since the Italian Renaissance constructive laws have been gradually forgotten'.[56] Perspective, he says, has been replaced by a much vaguer reliance upon the senses.

Much of this seems relevant to a study of Malevich and much that follows in Severini's book echoes the story outlined in a different context within these pages. Severini discusses the proportions of the equilateral triangle, for example, which he says is found at Karnak, at the Parthenon and at Notre-Dame in Paris. Regretting the divorce of art and science Severini called for 'an art based on science and expressing the life of the Universe'.[57]

284, above. Ivan Puni *Costume Design for Figure 8 Woman*, 1920. Watercolour and pencil. 24 × 16.5cm. Collection Mr and Mrs N.D. Lobanov-Rostovsky, London.

Severini directly acknowledged the importance of Gauguin, Sérusier and Denis, as well as that of Seurat and Signac, for 'we are permitted to *recreate, re-construct* equivalents of balance of universal harmony'.[58] Severini's third chapter is devoted to a discussion of proportions including $\sqrt{2}$ as the diagonal of a square, the Golden Section defined as $\sqrt{5}$ minus 1 divided by 2, Fibonacci's series, the theorem of Pythagoras and the importance of the principles of Vitruvius. He also stresses the role of modular construction.[59] Furthermore, he greatly admires the achievements and attitude of Dürer in this respect: 'I include a "construction" of a nude by Albrecht Dürer, the rule and geometric spirit of which will be plain to the initiated.'[60] Severini proposes that the techniques of the engineer be applied to the proportions of the white canvas. He recommends a study of Vitruvius, Dürer and Leonardo on the subject of proportion. For him geometry is the means: the end is universal harmony.[61] Such a system, according to Severini, links man to the universe and because of this perspective it is a system of harmony and not a reproduction of optical vision.[62]

Malevich knew of such methods, which he applied in *vershok* and *arshin* units. When his works became available again in Western Europe in the 1920s he must have appeared their most extreme and brilliant exponent.

Since Malevich was working with the Unovis collective in Vitebsk in the early 1920s, he was in a position to explore the wide potential of Suprematism through the specialized abilities of his pupils and colleagues. This encouraged teaching, theoretical writing and the practice of Suprematism all operating in tandem. Malevich needed to explain his system and in the process he developed the first histories of Suprematism. This in turn required Malevich to reconsider and reassess aspects of his system, and it may also have demanded versions of basic works for teaching and display purposes. Malevich's paintings *Black Cross*

285, below left. El Lissitzky *The Story of Two Squares*, 1920. Lithographic book published 1922. Text: 'Here are two squares' and 'They fly to Earth from afar and . . .'

286, below right. Kazimir Malevich *Suprematism*. Lithograph. Published in K. Malevich's *34 Drawings*, Vitebsk 1920.

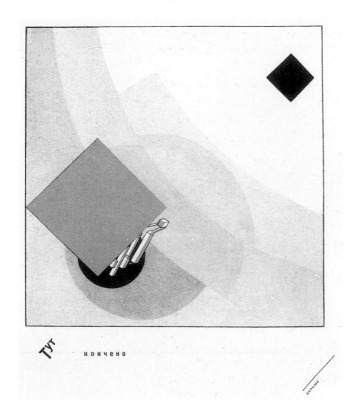

and *Black Circle*, works on canvas $1\frac{1}{2}$ *arshin* (24 *vershok* or 106.68 cm) square, are probably a reprise of this kind executed in the 1920s.[63] These forms, together with the *Black Square* painting are the three main protagonists of Suprematism. It is precisely this idea of square, circle and cross as protagonists of an action that informed El Lissitzky's politicized Suprematist narrative for children *The Story of Two Squares* (Plate 285), devised in 1920 and published in 1922. The story shows how the Red Square flying through space encounters a chaotic planet to which it brings order and harmony. The story is a primary example of the adaption of Suprematist form to a propaganda purpose, as it is clearly implied that Communism will bring harmony to the whole planet. Yet Lissitzky also succinctly refers to many of the preoccupations of Malevich, including economy of means. White space implies the infinity of outer space. Suprematism is seen to be a cosmological system in which space and scale are relative. The compositions rely immediately upon the proportional relationships of circle and square. Each print is bounded by a square (Plate 286). In at least two ways, however, Lissitzky extended Suprematism: first, he brought to it a new graphic precision for reproduction, publication and dissemination, and second, he stressed the architectural application of Suprematism, an aspect so far only adumbrated by Malevich. By 1920 other followers of Suprematism were developing this aspect too: Gustav Klucis's photomontage of *The Electrification of the Whole Country* of 1920 is one of many examples.

To a degree the work of Klucis reveals a synthesis of Suprematist and Constructivist tendencies. By 1920 Klucis, Rodchenko, Popova, Exter and others were establishing their own positions in relation to both tendencies. Both Suprematists and Construtivists displayed a mathematical aspect and there is even an interaction with engineering evident in the work of Tatlin, Gabo and Lissitzky. But the more extreme theorists of Constructivism were calling by 1921 for the total demise of art on ideological grounds. This threatened to marginalize Suprematist easel painting, however inspirational and even useful its proportional systems and visionary aspects might be. On the other hand, Suprematism was capable of anonymous and collective development. In this respect mathematical systems of proportion and geometric forms were particularly influential and adaptable: they appeared to be, and literally were, constructive.

When Popova, Rodchenko, Stepanova, Vesnin and Ekster put on the exhibition '5 × 5 = 25' in Moscow in 1921, Constructivists were on the point of renouncing art as a self-indulgent and outmoded speculation and turning instead to practical, politically motivated work. Nevertheless, the exhibition title testifies to the importance of mathematics at this transitional point. Five painters showed five works – a total of twenty-five paintings, but 5 × 5 = 25 is also a simple square of a Fibonacci number and a sign of the mathematics in the paintings displayed. Rodchenko's *Line*, 1920 (Plate 287) is one example of this, and its relationship to one of his bookcovers published in 1922 reveals how vigorously the geometry survived the shift of policy and ideology in favour of practical design and away from painting. The book *Zaumniki* (Plate 288) also shows the continuing importance of Russian Futurist poetic and linguistic ideas: the *Zaumniki* of the title are the poets of trans-sense (or beyond-sense) language known as *zaum*, namely Kruchenykh, Khlebnikov and Petnikov.[64] The line painting was in the familiar ratio of 5:4, which is half a golden rectangle. Rodchenko's three most radical canvases, which were painted in monochrome red, yellow and blue and exhibited as *The Last Painting* at the exhibition '5 × 5 = 25' in Moscow in 1921, may have utilized the same 5:4 proportion. On the one hand, the move out of painting was not simultaneously a move out of the proportional systems developed in painting; on the other hand, the mathematical systems were not specific to painting anyway and may have encouraged the move from easel painting to those

287, right. Aleksandr Rodchenko *Line*, 1920. Oil on canvas. Annely Juda Fine Art, London. Photograph © Rodchenko and Stepanova Archive, Moscow.

288, far right. Aleksandr Rodchenko Cover for the book *Zaumniki (Beyondsensers)* by A. Kruchenykh, G. Petnikov and V. Khlebnikov, 1922. British Library, London.

utilitarian design projects that the Constructivists' ideological position demanded from 1921. This phenomenon can be seen in transit, as it were, in the drawings for the catalogue of the '5 × 5 = 25' exhibition and in contemporary drawings by Rodchenko and Popova. These Constructivists in fact pursued practical design vigorously in graphics, theatre, clothing and numerous other fields. Yet they were not after all scientists or

289, right. El Lissitzky *Tatlin Working on his Monument to the Third International*, 1921–22. Photomontage, collage, pencil and ink. 25.5 × 32 cm. Dessau Family Trust.

290, far right. Varvara Stepanova *Rodchenko, Constructor*, 1922. Ink on paper. 20.2 × 14 cm. Inscribed 'Konstuktor, liniya, Rodchenko' (Constructor, line, Rodchenko). The dividers are set at 36 degrees. Museum of Private Collections, Moscow (Rodchenko and Stepanova Archive).

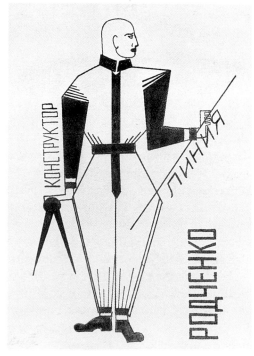

engineers, and their vision was probably as inspirational to their students as their work was. The image of the *constructor* with the dividers, with which Lissitzky also imbued Tatlin (Plate 289) and Stepanova equipped Rodchenko (Plate 290), is still that of the alchemist's vision. Lissitzky was soon to adopt the image himself. Rodchenko, emulating Leonardo, even made designs for perpetual motion machines by manipulating the circle, square and 3:4:5 triangle (Plate 291).

The mathematical theorist closest to the painters was Velimir Khlebnikov, who died on 28 June 1922. He had had the closest involvement with Larionov and Goncharova, David Burlyuk, Malevich, Tatlin, Filonov and, in his last days, with the painter Miturich, in whose presence he died. On 30 January 1922 he had attempted to transpose his work on historical waves to make them appropriate to the planets Jupiter, Saturn and Uranus; he published this in an *Edict of the Presidents of the Globe* which he signed 'Velimir I'. He was evolving a new theory of space and time for his Tables of Destiny (or Boards of Fate). He even seemed to consider himself no more than a number, or a ripple in time and space: 'Weary I beat my wings against man's window/Eternal numbers knock from outside/As a call to one's native land:/A number is called to return to the numbers.'[65] Tatlin was among those who paid homage to Khlebnikov by performing his *zaum* poem *Zangezi* in 1923 and attempting to make reliefs equivalent to Khlebnikov's verse. Another friend of Khlebnikov, the monk Pavel Florensky, perhaps reinforced the impact of mathematics on artists with his publication of *Imaginary Points in Geometry* in 1922, with a chapter on the wood-engraved illustration by Vladimir Favorsky.[66] Florensky was a committed priest and a sophisticated mathematician. The mysticism of Malevich in fact has points of similarity with that of Florensky, and Malevich was also discussing his concept of God in *God is Not Cast Down*, written in 1920 but published in Vitebsk in 1922.[67] This may be reflected in the resurgence of the cross motif in his paintings. The cross frequently appears painted in front of a circle or ellipse motif suggestive of a head and halo. To Malevich rhythm was 'the first and most important law of all that is manifested in life'.[68] He argued that 'Man too is a Cosmos or Hercules around which rotate suns and their systems', and that just as ideas and perceptions fly through the mind, so the universe, as in one of his paintings, may be the manifestation of a great mind: 'Is not the whole universe a strange skull in which meteors, suns, comets and planets rush endlessly? Are they not simply concepts of cosmic thoughts, and are not their entire movement and space and they themselves non-objective?'[69]

Drawings in the Stedelijk Museum which are dated 1922 reveal something of Malevich's organizational system for points in space and time. Malevich established a square within a square reminiscent of the 'frame' in use in *Victory over the Sun* in 1913, almost ten years earlier. The smaller square is half the width of the larger square. The diagonals create an effect of planes like the inside faces of a box at each side. The diagonals of these panels fix a centre point. The grid of lines is used by Malevich to fix points in space and plot the movement of points. It reveals how systematic his procedures can be. Furthermore, all of the angles in such a diagram are multiples of 9°. Malevich has annotated his diagrams to indicate the positioning of points in time and space by means of co-ordinates. In 'The Suprematist Mirror', published in 1923 after his move to Petrograd, Malevich wrote that 'the essence of nature is immutable in the midst of variable phenomena'.[70] The text is obscure and difficult to understand in its reduction of all human effort and belief to zero. But Malevich had described his *Black Square* as a 'zero of form' and it had proved the generative seed of a whole movement still spreading and diversifying in the mid-1920s. Zero, in the view of Malevich, could be fruitful: 'If religion knows God,' he wrote, 'it has known zero . . . If science knows nature, it has

known zero . . . If art knows harmony, rhythm and beauty, it has known zero . . . If someone knows the absolute, he has known zero.'[71] Zero for Malevich is perhaps like the point 0 on a graph or in a set of co-ordinates: it is the point of origin from which the framework of planes emerges to permit measurement in time and space.[72] In Lissitzky's words, Malevich 'wanted to reduce all forms, all painting to zero. For us, however, this zero was the turning point.' This zero, says Lissitzky, was a new beginning: 'We are saying that if on the one side the stone of the square has blocked the narrowing canal of painting, then on the other side it becomes the foundation stone for the new spatial construction of reality.'[73]

When Malevich was working with Matyushin and Filonov at the State Institute of Artistic Culture in Petrograd in 1923, a critic regarded them as mystics, referring to Malevich in particular as a 'mason'.[74] At the time Malevich's painting could be seen at the exhibition 'Petrograd Artists of All Tendencies'. Man as measurer of the universe is an image common to the symbolism of Freemasonry and to Renaissance concepts of cosmology, proportion and architecture. Le Corbusier's *Towards a New Architecture* of 1923, for example, expressed comparable ideas in words surprisingly close to those of Malevich.[75] For example, Le Corbusier asserted that 'The Engineer, inspired by the law of Economy and governed by mathematical calculation, puts us in accord with universal law. He achieves harmony.'[76] Le Corbusier argued that cubes, cones, spheres, cylinders and pyramids are 'the great primary forms', and so 'it is for this reason that these are beautiful forms, the most beautiful forms. Everybody is agreed to that, the child, the savage and the metaphysician.'[77] He concluded: 'These quantities provide a mass of material as a basis for work; brought into measure, introduced into the equation, they result in rhythms, they speak to us of numbers, of relationships, of mind.'[78]

Yet, as Le Corbusier and Lissitzky would agree, movement and transport changed perceptions. Le Corbusier compared a car to the Parthenon and in 'Wheel, Propeller and What Follows', for example, published in 1923, Lissitzky described the change of perception occasioned by the shift from striding in which 'movement is discontinuous, from point to point', to the wheel where it becomes 'continuous rolling', to the screw or propeller whereby 'continuous rolling changes into continuous gliding'. Lissitzky concluded with a Suprematist vision: 'The flying human being is at the frontier – at the frontier of the old conceptions. A new energy must be released, which provides us with a new system of movement, for example, a movement which is not based on friction, which offers the possibility of floating in space and remaining at rest.'[79]

This idea of an historical development of human movement and perception appears as part and parcel of Russian Futurist thinking. Individual inventions, such as the aeroplane, were only temporary embodiments of the human will to fly, an evolutionary development requiring enhanced perceptions of time and space. This was the theme of *Victory over the Sun* performed in St Petersburg in 1913, revived in Vitebsk in 1921, and reinterpreted by El Lissitzky yet again in 1923. For a whole decade these concerns remained in the forefront of Suprematist thinking. Simultaneously, the death of Khlebnikov in 1922 had brought his calculations of time, space and human history to attention just as *Zangezi* was performed in Petrograd. Malevich described Khlebnikov as 'quiet, silent as a shadow, he, the thinker of numbers, split the nucleus of destiny and fate by his dynamic silence in order to obtain for man the calculation board of events'. He clearly accepted Khlebnikov's view of time and space as his assertion indicates: 'For many years astronomers have calculated exactly the eclipse of planets, and this is simply what Khlebnikov has done with man.'[80]

The long poem *Zangezi*, which Tatlin performed, was written by Khlebnikov in 1920–

293, above. Leonardo da Vinci *Study in Human Proportions according to Vitruvius.* Accademia, Venice.

292, left. El Lissitzky *The New Man* from the Puppet Portfolio *Victory over the Sun,* c.1921. Lithograph. 53 × 45.5 cm. Tate Gallery, London.

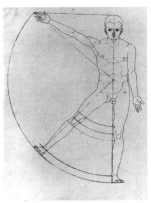

294. Albrecht Dürer *Man Inscribed in a Circle, Front View,* after 1521. Ink drawing from the Dresden Sketchbook. 29.3 × 20.7 cm. Sächsische Landesbibliothek, Dresden.

23. It employed 'Soundwriting' (*zvukopis'*), the language of the gods, the language of the stars, senseless language (*bezumnyy yazyk*), the decay of the word and 'trans-sense language – the surface of thought'.[81] The poem comprised many sections or 'surfaces' (*ploskosti*). It included a war of the letters R, K, L and G, as well as numerical figures and historical theories. Tatlin's installation and performance of *Zangezi* took place at the Museum of Pictorial Culture in Petrograd. The museum had five research departments under Malevich, who also directed the formal and theoretical section, Matyushin, who directed the section of organic culture, Tatlin the section of material culture, Pavel Mansurov in the experimental section and Filonov (and subsequently Nikolai Punin) in the section for general methodology.

Lissitzky's revival of *Victory over the Sun* (Plate 292) appeared as a portfolio of large lithographic prints in 1923. Lissitzky called it 'the plastic form of the electro-mechanical peepshow *Victory Over the Sun*' and designed it as a prototype of a puppet version of the opera. 'We are constructing the stage on a square', wrote Lissitzky in 1923, and the puppets are controlled by forces under the command of a central figure who 'directs the movements, the sound and the light'.[82] The cover design displays four figures within the framework, along with the title and a banner that declares in a multilingual 'translation' from the opera that *Alles ist bien was good nachinaetsya et hat no finita* (All's well that begins well and has no end). In addition, there are nine Suprematist costumes lithographed with an engineer's precision in contrast to the cruder, more forceful designs made by Malevich a decade earlier. As the Revolution has intervened, the Universal or New Man now inevitably displays the red square at his heart and the red star in his mind. Despite this, the *New Man* of Lissitzky's 1923 portfolio is the direct heir of all that Suprematism stood for in its mathematics and all that it recognized from the past. Lissitzky's *New Man* (Plate 292) has become his own measuring dividers. He is the heir to the circle and square whose forceful dynamism he demonstrates. He is the latest form of Vitruvian man and is a direct descendant of Leonardo's (Plate 293) and Dürer's (Plate

294) example. Both Malevich and Lissitzky would argue for the inclusion of time as the fourth dimension in any such diagram. To Malevich writing at about this time, 'the fourth dimension is a kinetic tape on which the object is unrolled in the fourth state, disclosing its whole in elements'[83] while Lissitzky (Plate 296) argued similarly that 'every form is the frozen instantaneous picture of a process. Thus a work is a stopping place on

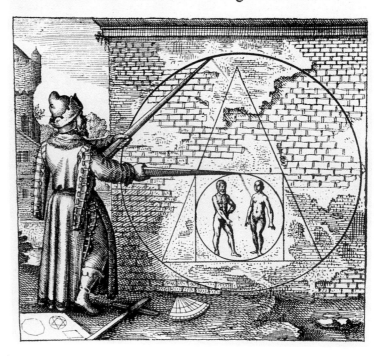

295, above left. El Lissitzky *Proun 99*, 1923. Oil on wood. 129.4 × 99 cm. Yale University Art Gallery, New Haven: Gift of the Société Anonyme.

296, above right. El Lissitzky *Self-Portrait: The Constuctor*, 1924. Photomontage / photogram. The dividers are set at 54 degrees. 11.3 × 12.5 cm. Stedelijk Van Abbemuseum, Eindhoven.

297. M. Merian *Here followeth the Figure . . .*, an alchemical illustration to Michael Maier's *Atalanta fugiens, emblema XXI*, Frankfort 1617.

the road of becoming and is not the fixed goal'.[84] Renaissance perspective fixed time and place for one viewpoint. Suprematism had broken through this horizon to a new weightless and relative space in which time too seemed malleable and unfixed. Lissitzky in *Proun 99* (Plate 295) actually included an older perspective system along with the corner view of the cube seen as the three diamond-shapes that make a hexagon. The space above the horizon is a square. According to Lissitzky: 'The geocentric Ptolemaic conception of the universe was replaced by the heliocentric system of Copernicus. The Euclidean conception of fixed space was destroyed by Lobachevsky, Gauss and Riemann.'[85] Lissitzky believed that 'Suprematism has advanced the ultimate tip of the visual pyramid into infinity'.[86]

Lissitzky's illusion of construction suggested architecture of a new kind. In the 1920s Malevich too began to pursue these implications which were already inherent in one of the paintings shown at the exhibition '0,10' in 1915. Like earlier thinkers (Plate 297), Malevich in the 1920s began to develop his system of proportion and perspective into an architectural form appropriate to his day. In 1923 at the Venice Biennale he exhibited six drawings of *planiti*, or flying architecture, together with a black square, a black circle and a black cross. In Lissitzky's words, 'the static architecture of the Egyptian pyramids has been superseded – our architecture revolves, swims, flies'.[87] Suprematism found a new expression in its architectural formulation in which Malevich played as central and as visionary a role as ever.

The Architecture of Flight

Malevich depicted space with no horizon, which meant that there was no sky and no earth, no up and no down. He changed and inverted the hanging of his canvases at different exhibitions. Gravity acted as a force of attraction operating through space in all directions. This concept of space he associated with the flight of aeroplanes and space-ships. His architectural projects developed in this space and were for this reason inevitably an architecture of flight, still only fleetingly and imperfectly represented by the new flying machines of his day. It was the will to fly that interested Malevich; the individual machine had little significance in itself, being no more than the cross-section of a process. If the forms painted by Malevich sometimes resemble aeroplanes it is because they are related: the aeroplane falteringly embodied Suprematism.

Lissitzky's narrative in the *Story of Two Squares* published in 1922 showed a space flight delivering order to a chaotic planet by establishing architectural structures there. The three-dimensional works by Malevich aspired to architectural forms, and a plaster *Black Square* (Plate 298) survives which is $\frac{1}{2} \times \frac{1}{2}$ *arshin* (8×8 *vershok*), and approximately $\frac{1}{8}$ *arshin* (2 *vershok*) thick. The plaster block is painted with a black square in oil paint.[1] Using wood and blocks of plaster Malevich began to develop constructions from the cube. These he called *arkhitektoniki* (architectons). They were not designs for specific buildings: Malevich was providing the means that Lissitzky, Chashnik, Suetin and numerous other assistants and followers would develop and use in specific projects. He exhibited *arkhitektoniki* in June 1926 even though he had been dismissed from the Directorship of the State Institute of Artistic Culture in February of that year.

The *planiti* projects of Malevich are essentially graphic equivalents to the models in wood and plaster. They are described as 'future dwellings for earthmen' and in at least one case the main drawing is accompanied by elevation drawings that make clear that it has a flat base, that it sits *on* the plane visible in the drawing and does not penetrate through it. It is, so to speak, constructed on the surface of a Suprematist plane that appears to fly in relation to the edge of the drawing (Plate 299). Having established this general structure, all other forms are rectangular and at right angles. These blocks are assembled symmetrically around a dominant axis across the 'ground' plane. The result resembles a Suprematist painting but is notably different from Lissitzky's works. Other *planiti* (see Plate 300) contain small elements of symmetry within a more irregular assemblage of blocks erected across a Suprematist plane. Each block then establishes axes around which assemblages of sometimes symmetrical smaller blocks are located. As in Suprematist paintings, scale is a question of proportion and not of size as such, so that the design may grow smaller clusters or develop into larger assemblies. One of these structures was sufficiently finalized for Malevich or a colleague to make an unusually traditional archi-tectural perspective drawing, although a photomontage by Malevich inverts an image of the same construction among the skyscrapers of New York. In the two-point perspective drawing it has the weight of a solid building; in the photomontage it appears to hover weightless and crystalline among the surrounding masonry like a visiting spaceship

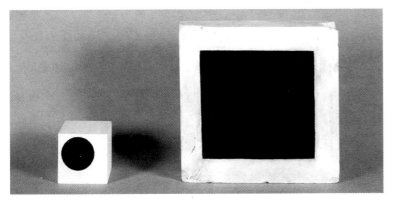

298. Kazimir Malevich *Black Square*, 1923–30. Oil on plaster. 8 × 8 × 2 *vershok* (½ × ½ × ⅛ *arshin*). 35.56 × 35.56 × 8.89cm (given as 36.7 × 36.7 × 9.2cm). Beaubourg Foundation, Paris: Anonymous gift. At left, a plaster fragment of the architectonic construction *Gota* is visible.

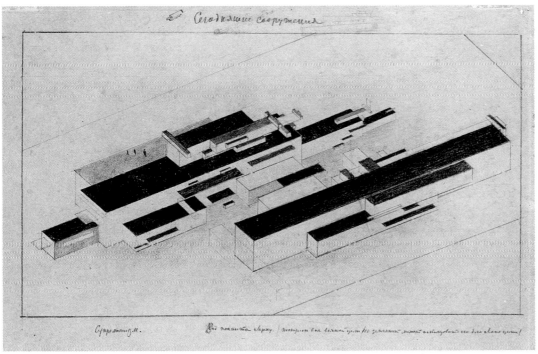

299. Kazimir Malevich *Modern Buildings*, 1923–24. Crayon on paper. 36 × 53.5cm. Stedelijk Museum, Amsterdam.

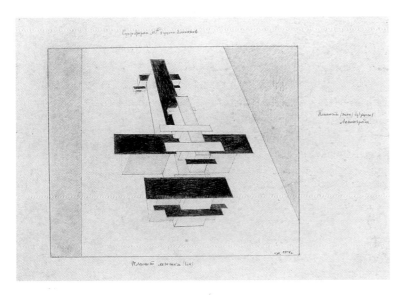

300. Kazimir Malevich *Future 'Planit' for Leningrad. Pilot's House*, 1924. Crayon on paper. 30.5 × 45 cm. Stedelijk Museum, Amsterdam.

191

unaffected by earthly conditions. Malevich has made the skyscrapers look dated and outmoded in comparison with his own visionary architecture.

The *arkhitektoniki* show at least four kinds of development visible in surviving pieces and in documentary photographs. First, a long, symmetrical 'basilica' format (Plates 301) with one main axis crossed by smaller subsidiary axes; second, the same long 'basilica' format but with a substantial vertical stack of blocks (Plate 303); third, long structures which include circular forms closely resembling practicable architecture, and fourth, vertical structures (Plate 302).

The basilica's long history as an architectural form culminated in the medieval church with its extended nave and wide crossing. Malevich may therefore have associated this form with religion, and specifically with the Catholicism of his Polish forebears, as the orthodox church has often preferred the Greek cross plan comprising a cross within a square, effectively dividing the square into nine compartments. But the cross is also a Suprematist motif. Its two axes are visible at many points in these constructions, both in the overall plan and in small-scale conjunctions of form (Plate 304). One of the *planiti* (Plate 300) drawings establishes a whole series of such crossings along the single long dominant axis of the piece, so that it resembles both church and aeroplane in a format appropriate perhaps to flying architecture.

The construction known as *Beta*, exhibited by Malevich in 1926, shares many of these features: there is a long axis with numerous crossings which in turn develop their own symmetries, and there is also a substantial height to the piece created by the stacking and crossing of blocks of intermediate scale. Malevich has here also introduced variations on the basic symmetry. This is visible in at least three places. The topmost elements occur on only one side, and a similar organization occurs at the other end of the long low body of the piece where a series of small blocks overhang one edge and not the other. This is balanced at the heart of the structure by other pieces, including a cube, placed off-centre.

The plaster assemblage known as *Alpha* shares so many of these features that it may be a different arrangement of the same pieces. Having established his proportional system, Malevich could have blocks that were all related to each other in their proportions, subdivisions and so on. This permitted an endless variety of designs to be explored. But another important quality also arises from this process. The scale of parts can be enlarged or reduced *ad infinitum*. Visually this means that a close-up of part of such a structure would resemble in essence the structure as a whole. Thus, Malevich is beginning to develop fractal structures unaffected by enlargement or reduction. In addition, each axis, when marked by one or more blocks, establishes subsidiary axes which can be developed in the same way. This process can be seen in *Alpha*, for example, at either side where cubic blocks and smaller forms begin to proliferate on a smaller and smaller scale.

The line and crossing lead to a proliferation of forms. All of this is inherent in the square, as the whole history of Suprematist painting revealed. The square and cube are fully evident in the *arkhitektoniki*, too, with the cross evident in every adjustment to the main axis. In at least one *arkhitekton* project the circle was made explicit in the structure. Malevich made a vast and monumental basilica with a crossing near one extremity, a cubic tower half-way along the main body of the building and culminating in a vast circular arena dominated by a low tower at the other extremity. This is a powerful, visionary architecture in which number and proportion are apparent in every detail. Each extension in space is subdivided and may be subdivided again, sustaining the largest and smallest rhythms within the same unifying system. This is most apparent on the upper surface of the long body of the building. Here a cube dominates the long axis, but beside this is a smaller cube. Nestling at these junctions of one surface and another are even

301, oppposite page, above left. Kazimir Malevich *Suprematist Arkhitekton*, *c.*1926. Whereabouts unknown. Documentary photograph.

303, opposite page, below left. Kazimir Malevich *Suprematist Arkhitekton*, *c.*1926–27. Plaster and wood. 6.5 × 2 × 3.5 cm. Collection Ludwig, Cologne.

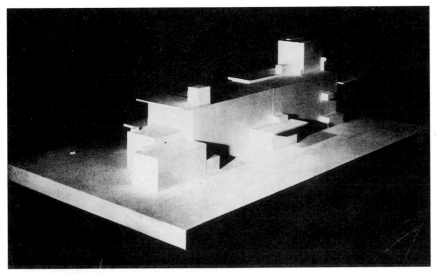

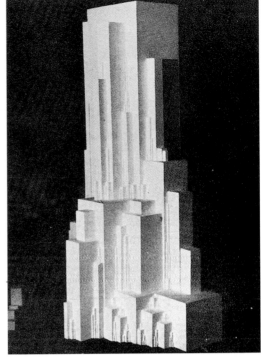

302, right. Kazimir Malevich
Arkhitekton: Gota, c.1923–27.
Plaster. 85.2 × 48 × 58 cm.
Musée national d'art moderne,
Centre Georges Pompidou, Paris.

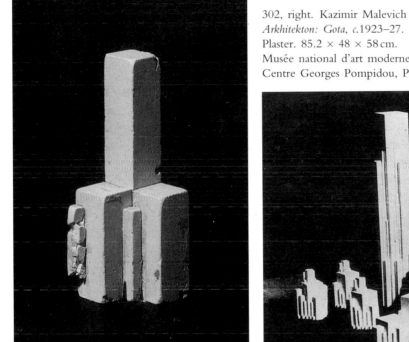

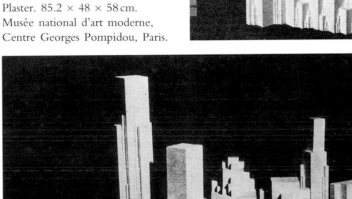

304, right. Kazimir Malevich *Suprematist
ornamentation*, 1927. Plaster. 18 pieces.
Documentary photograph.

smaller cubes. These forms evolve and multiply within an infinite series of rhythmic relations as in a geometric progression. Malevich's collaborators, students and followers, particularly Khidekel', Chashnik and Suetin, developed several different aspects of these new Suprematist structures. In the case of Khidekel' they became feasible building designs.[2]

The series of *arkhitektoniki* (Plates 302 and 303) in which the vertical element is

dominant illustrates the multiplicity of Suprematism. Like the alchemist seeking the cubic Philospher's Stone, Malevich has discovered a form capable of infinite multiplication along every axis, which then in turn reveals the same undiminished potential. These structures can replicate and multiply *ad infinitum* as more forms emerge from their points of conjunction as if from a different dimension. This system of generating forms through the internal relationships and proportions of the square has here become fractal.[3] This was his most economical expression of the fruitful potential of Suprematism since the installation of *The Black Square* at the exhibition '0,10' in 1915.

In the intervening decade, Malevich had made his prolific exploration public through exhibitions, writing and teaching. He had also made Suprematism a collective system by attracting an impressive number of collaborators, followers and students. Among these were Klyun, Puni, Bogoslavskaya, Rozanova, Popova, Exter, Vesnin, Rodchenko, Lissitzky, Kogan, Suetin, Chashnik, Khidekel' and many more. But now that Suprematism was in a position to make a direct contribution to architecture Malevich found his professional position less secure. He was dismissed from the Directorship of the State Institute of Artistic Culture in February 1926 and was severely criticized when he exhibited later in the year. Members of AKhRR, the Association of Artists of the Revolution, were particularly fierce in their criticism of Malevich. When he left Russia to visit Poland and Germany early in 1927 he was by no means confident of his future. Reaching the highpoint of Suprematism proved a precarious achievement.

But Malevich's philosophy, promoted now through painting, graphic works, lectures, articles and exhibitions, was not easily dismissed. Suprematism could be harnessed to politics and propaganda but this seems rarely to have been his purpose. His vision was perhaps more mystical: for example, he argued, in about 1927, that 'the aeroplane has appeared, not on account of the socio-economic conditions being an expedient cause, but only because the sensation of speed and movement looked for an outlet and in the end took the form of an aeroplane'.[4]

The influence of Malevich was also spreading internationally by the mid-1920s. His Suprematist paintings were first seen in Western Europe at the First Russian Art Exhibition (*Erste Russische Kunstaustellung*) held at the Van Diemen Gallery in Berlin in October–November 1922, before moving on to the Stedelijk Museum, Amsterdam, in April–May 1923. As well as the *The Knifegrinder: Principle of Scintillation* (Plate 79)[5] Malevich exhibited four Suprematist paintings including an all-white canvas, and in the summer of 1923 he exhibited six drawings of *planiti* with the black square, circle and cross paintings at the Venice Biennale. Lissitzky was also quick to acknowledge the importance of Malevich in his publications and in his own contacts in Western Europe. By 1923–4 the designs of Van Doesburg and Van Eesteren, and also the studio designed by Le Corbusier for the painter Ozenfant in Paris, were revealing similarities to architectural aspects of Malevich's work, because their work on unit construction and proportional systems meant that they had much in common with their Russian contemporary.[6]

In Russia the Unovis collective in Vitebsk had acknowledged the architectural potential of Suprematism immediately. Lissitzky's work was transformed by contact with Suprematism in this context and through him it became an ingredient also in the architecture of the Asnova (Association of New Architects) group. As Constructivism in turn fed its ideas and approaches into architecture, so the mathematics of Suprematism found further architectural expression. By 1925 the influence of the Suprematist idea of space was already evident in architecture.

At the Paris International Exhibition of Decorative and Industrial Arts in 1925 the Soviet Pavilion, designed by the architect Konstantin Melnikov, was built in wood and

decorated in red, grey and white by Rodchenko. Rodchenko's catalogue cover (Plate 305) in red and black is already a homage to the square breaking down into more complex diagonal symmetries. Melnikov's pavilion (Plates 306 and 307) on the other hand is a *tour de force* of mathematics. The rectangular plan is divided from corner to corner by a staircase that progresses diagonally up to first floor and down again. Beneath this the space flows continuously from one half of the pavilion to the other. The design is determined by modular elements, which in the plan form a grid at 72° to the rectangle

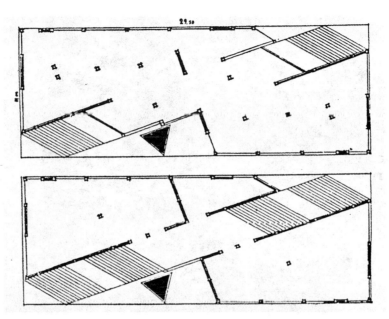

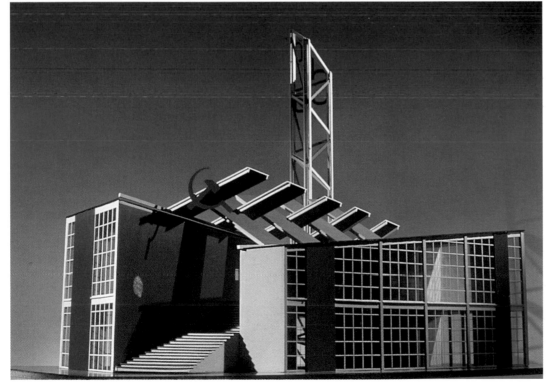

305, above left. Aleksandr Rodchenko Cover for the catalogue of the Soviet Pavilion at the Paris International Exhibition, 1925.

306, above right. Konstantin Melnikov *Soviet Pavilion, Paris: Ground and First Floor Plans*, 1925.

307, left. Konstantin Melnikov Soviet Pavilion at the Paris International Exhibition, 1925. Reconstruction by Henry Milner, 1994. Photograph © Henry Milner 1994.

308. Kazimir Malevich *Suprematist Drawing: Aerial View*, 1928. Pencil on paper. 22 × 10.5 cm. Collection Ludwig, Cologne.

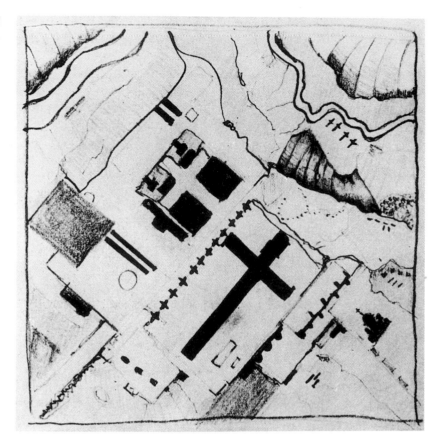

309, below. Ivan Leonidov *Palace of Culture Project*, 1929–30. *Elevation*. Published in SA, no. 5, 1930.

310, bottom. Ivan Leonidov *Palace of Culture Project*, 1929–30. *Plan*. Published in SA, no. 5, 1930.

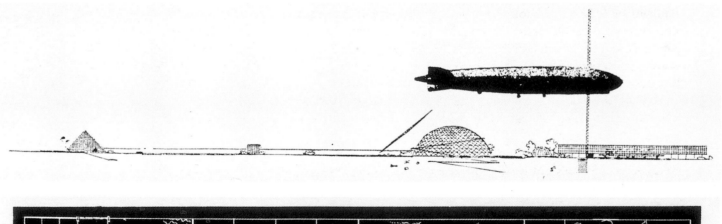

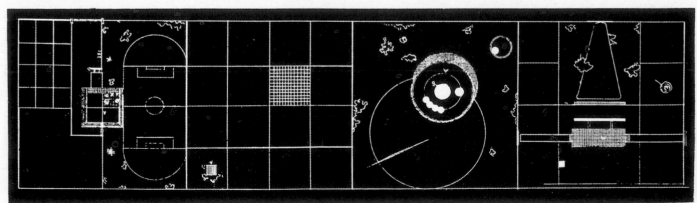

of the plan – just as Malevich used a grid in his paintings. This permits a division across the centre of the plan at right angles to the line of the staircase. In elevation the module is again evident throughout in the roofs of the pavilion's two halves. These rise, back to back and separated by the staircase. Above them rhomboid roofing elements cross like medieval vaulting although here they are set upon slanting edges so that the elements of one side descend whilst those opposite rise higher: their cross-over points, however, remain horizontal. These geometrical complexities were unthinkable without an awareness of Suprematism. Melnikov's tower confirms his preoccupation with proportion and perspective as its struts rise by increasing intervals, different on each of its three sides, as if to splay out from a particular viewpoint on the ground. Such spectacular structures defied tradition. But they were not simply fantasies. Melnikov's pavilion does not have an ill-considered angle or proportion anywhere in it. The same may be said of the paintings and *arkhitektoniki* of Malevich.

When Malevich travelled west in 1927 he visited artists and architects primed to receive him, figures who were responsive to his achievements; he travelled to places where geometric art and geometric architecture were well established. In Poland, for example, between 8 and 28 March 1927 he was in contact with Strzeminski, Stażewski and Kobro, members of the Blok group who had a close knowledge of Malevich's work. In Berlin from 29 March to 5 June Malevich was busy organizing his own room of paintings for the Great Berlin Art Exhibition (*Grosse Berliner Kunstaustellung*), open from 7 May to 30 September 1927, and he also visited the Bauhaus in its new building erected by Gropius at Dessau. The building must have recalled his own *arkhitektoniki* in its bare surfaces, strips of window and its bridge across the road. Kandinsky was tutor at the Bauhaus and Lissitzky had been a visitor. Malevich was in fact consolidating a considerable interest in Russian art for Gropius, Moholy-Nagy and others. The publication by the Bauhaus of Malevich's book *The Non-Objective World*[7] in German and his Berlin exhibition were remarkable signs of recognition in Germany. The book in particular brought Suprematism to a wider international readership.[8] In it Malevich retells the history of Suprematism, illustrating its elemental development and diversification in a new sequence of drawings. This sequence of images was determined more by theme than chronology and Malevich appended unconvincingly early dates to the early stages. He concluded with a schematic drawing of four forms useable in *arkhitektoniki* which he called *Suprematist Elements in Space 1915*.

Although Malevich could develop architectural projects he went no further than the drawings and models of his *planiti* and *arkhitektoniki*. He did, however, make a number of drawings that have the appearance of aerial views looking down onto architectonic structures in a landscape (Plate 308). These in turn suggest new kinds of painting never pursued by Malevich. These aerial views show Malevich considering site and architectural planning, just as Lissitzky had. Malevich came no closer to an architectural realization of Suprematism. This is perhaps a result of his lack of sympathetic supporters in Russia, but his imagery in any case was associated with an uncompromising vision of buildings suspended in orbit between the earth and moon. It was for others to resolve their mundane problems; Malevich was not, after all, a trained architect.

There was, however, an architect of remarkable vision who came much closer to the resolution of Suprematist architecture. Ivan Leonidov is usually considered a Constructivist but his Palace of Culture project (Plate 309), published in 1930, is absolutely rooted in the square and its ratios. He envisaged a space of four squares by one square in length, each of which was subdivided into a grid of four by four squares. These units, like the *vershok* squares of Malevich, determined the spaces, buildings and propor-

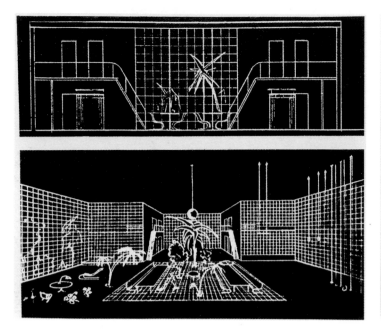

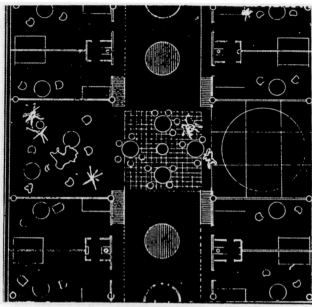

311, above left. Ivan Leonidov *Magnitogorsk Industrial Combine Project*, 1930. *Dwelling elements*.

312, above right. Ivan Leonidov *Magnitogorsk Industrial Combine Project*, 1930. *Plan*.

tions of the whole design. In one square there is a pyramid beside a sportsfield. In the next stands a glazed cubic building and beyond this a large hemispherical dome beside an airship mast and anchor cable until finally a long auditorium block is reached. Each section is a Suprematist composition in its plan for it organizes not only the harmonious relations of the parts but also the intervals of spaces between the geometric forms (Plate 310). The plan is extendable on a larger or smaller scale. In his designs for the Magnitogorsk Industrial Combine Project (Plate 311) Leonidov again built up his designs from the square. The dwellings were designed in units three squares wide, the centre one of which was a glazed wall of 12 × 12 window panes, divided into thirds by thicker glazing bars to resemble Malevich's cross, a motif that also dominates the planned layout of dwellings (Plate 312).[9]

Leonidov would perhaps have agreed with Malevich when he wrote in the Ukrainian periodical *New Generation* in 1928–30 that 'In reality, "non-objective" arts cannot be abstract, as they are the most concrete of all'.[10] He wrote also of the importance of the painters Cézanne, Picasso, Braque, Metzinger, Gris, Léger and Boccioni. He mentioned Tatlin, Gabo and Archipenko, as well as Van Doesburg and Le Corbusier. In elaborating his theories to include an art historical dimension he sought his own place in the history of art. The exhibitions 'Cézanne and Van Gogh' and also 'Gauguin', held in Moscow in 1926,[11] perhaps encouraged Malevich to indulge in a retrospective analysis of their seminal importance to his own development: they were now a part of his theory and subjects in his teaching. It is possible that they also became part of his painting once more, for at the retrospective exhibition of Malevich's work held in Moscow in 1929 he suddenly reverted to earlier themes.

Late Malevich shows an unexpected, prolific and still problematic change of direction which has only recently gained the attention and scholarship that it deserves. It is precisely as if the Suprematist Malevich returned to repaint the themes that dominated his art in 1913 when ikons and Cubism fought for his attention. The *Head of a Peasant* 1927–30 (Plate 313), is essentially the head of the *Head of a Peasant* (Plate 52) painted years before, even to the raising of one shoulder and to the curve of hair at the left. Here Malevich

even includes the distant church. Yet the colours and lines have the flat decisiveness of Suprematism, and the motif of the cross is clearly established at either side of the head and above it, like the cross in the halo of Christ. Malevich had in numerous texts rehearsed the development of his work. Here he appears to re-examine the seminal themes in paint. Other protagonists reappear, including the woodcutter and the man with the spade. Malevich himself is seen in a photograph as the man with the scythe.

The late paintings have a stridency and a magnificent vigour of their own but they mark perhaps a conclusion in the purely geometric art of Malevich. The late canvases are peopled by visionary creatures of another kind. Among the late works is a painting that depicts Malevich in the costume of another era (Plate 314), as if he were a latter day Dürer or Holbein; yet he remained a Suprematist in some sense and to show this he signed the self-portrait with a small black square which is visible lower right.[12]

The *Self-Portrait* hung near his deathbed in 1935. Many other later figurative canvases covered the walls. But directly behind his head hung *The Black Square*, the motif so often described by Malevich as the end and the beginning, the zero to which all is reduced and from which all evolves. These are fitting concepts to associate with his own death. There can be no doubt that he was determined to die a Suprematist. The poet Khlebnikov had a coffin inscribed 'President of the Globe', but the coffin of Malevich in its shape combined the square and the cross and was inscribed with a black square and black circle. A painting of the black square was in place as he lay in state in Leningrad with an *arkhitekton* at his feet. A Black Square was also mounted on the lorry that carried the dead painter to the railway on his final journey to the tomb near Moscow which had been

313, below left. Kazimir Malevich *Head of a Peasant*, c.1927–30. Oil on plywood. 16 × 12 *vershok* (1 × ¾ *arshin*). 71.12 × 53.34 cm (given as 69 × 55 cm). Russian Museum, St Petersburg

314, below right. Kazimir Malevich *Self-Portrait*, 1933. Oil on canvas. 16 × 15 *vershok* (1 *arshin* high). 71.12 × 66.68 cm (given as 73 × 66 cm). Russian Museum, St Petersburg.

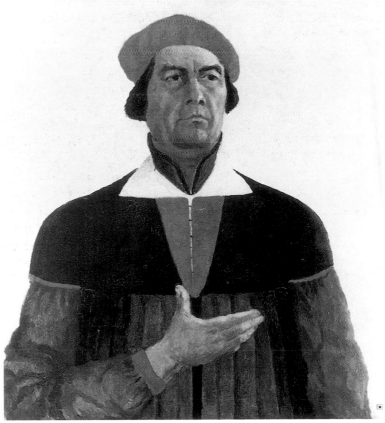

marked by his follower Suetin with a white cube and a black square. It was a suitable monument to his belief in the square. Its bleak façade was always for him a mass of rhythms which, like the Philosopher's Stone of the alchemists, represented eternal renewal, or, in Suprematist terms, it simply marked the end of one cycle of sensations and the beginning of the next.

Mathematics, for Malevich, revealed rhythm and the means to control it. That rhythm was universally manifest and available, as mathematicians from Pythagoras to Lobachevsky had shown. Malevich considered himself part of that universal rhythm. That was the harmony that he discussed so often and that he sought in his art. Mathematics was essential in its discovery, its description and its use.

Appendix 1

Utopian Geometry: Fibonacci and Campanella

Geometry and mathematics have long been associated with images of Utopia, that unattainable world of perfect social organization. To call a scheme 'Utopian' may be taken to mean that it represents an impossibly idealistic and impractical view: the word itself means literally 'no place'. On the other hand, Utopian ideas do have a practical aspect: by referring to another version of this world they can embody an ideal which will act as a goal or focus of thought for those seeking a particular model of organization in society. In this way they are more than fantasies, for they carry an implicit criticism of the deficiences of their own time. Harmony itself, however, has frequently been expressed by geometric forms, and equally the history of mathematics has a direct bearing upon the concepts of measure and control which are part of the organization of society from its city planning to the proportions of its doorways and the movements of its people.

An example of this is provided by the career of Leonardo Fibonacci who was born about 1170 and who died at some time after 1240. His father sent him to study in North Africa where he learned calculation under an Arab master. He became enormously influential in the introduction of Arabic and Indian mathematical concepts and techniques into Europe through his *Liber Abaci* of 1202 and his *Liber Quadraturum*, or 'Book of Squares', which followed in 1225. He is best known in modern times, however, for the numerical series named after him: the Fibonacci series is formed simply by adding the two adjacent numbers to provide the next, as follows: 0, 1, 1, 2, 3, 5, 8, 13, 21, 34, 55, 89, 144 . . . and so on. This series has many remarkable properties. As the numbers grow larger, for example, any adjacent pair approximates with increasing precision to the ratio known as the Golden Section, which is itself an ancient symbol of harmony. Also known as the Divine Proportion or Golden Ratio, it is an irrational number in that it is a non-recurrent decimal which begins 1.618 . . . It is associated with divinity and harmony because it divides a line so that the smaller part relates to the larger part in the same proportion as the larger part relates to the whole line. In other words, each of the parts is within the same set of proportions: any set of proportions constructed using this system will have a harmony of proportions in every part of it, however complex it may be. So the architect, designer or artist can build structures in which every part relates to every other part in the same proportional system. This is in itself an ancient system known to Pythagoras and incorporated by Vitruvius into his treatise on architecture. Fibonacci had discovered a new formulation of an ancient mathematical system of harmonic proportions: they represented a practical tool and not a fantasy. They were essential, as Pythagoras taught, in both geometry and music. As a result, they were also essential in the architectural schemes elaborated by Utopian writers and painters. The design of actual buildings and the construction of pictorial spaces were interlinked in this way and, insofar as the relation of the circle and the square were involved, this could provide a basis for both theory and practice. A system of proportion could be used either to depict a building or to construct it. The proportion, say, of 8:13 could be found in nature or employed in building. In fact, it is related to all of the geometric polygons and the regular geometric solids as well as to certain spirals and other forms. So in geometry lay harmony

and a means of construction handed down from Pythagoras to Vitruvius and, via the Renaissance, to the present day. This ultimately connected construction to cosmology.

Thomas More's *Utopia* of 1515–16 described a society housed in a city that was 'almost square'; More described how the inhabitants 'measure their months by the course of the moon and their years by the course of the sun'.[1] More's purpose, however, was largely that of satirical social criticism which did not require extensive architectural description. But a Utopian text of the next century, which drew upon More's example, is much more explicit in its description of architecture and town planning because its purpose balanced criticism of its own time with a forcefully developed design for an ideal society. Tommaso Campanella wrote his *City of the Sun* (*La Città del Sole*) in 1602, during a period of imprisonment under the Spanish Inquisition. It presents an explicit model of an ideal society in which communal ownership and centralized authority prevail. In the twentieth century these features were to attract the attention of Lenin and other Communists to Campanella's ideas.[2]

From time to time Campanella cited More's own words, but he went far beyond More in his detailed design of the 'City of the Sun'. He provided almost enough information to build it. Its citadel looked out upon a city in which geometry, number, architecture and social organization were seen to be ingeniously interwoven and interdependent. Campanella had linked astronomy and the planning of human society: fourteen years after *The City of the Sun* he was openly defending Galileo.

The City of the Sun is, according to the subtitle, 'A Poetical Dialogue between a Grandmaster of the Knights Hospitallers and a Genoese Sea Captain, his Guest'. It describes a city built on a hill situated 'on a large plain immediately below the equator'; the city plan comprises a series of seven concentric circles and has an overall diameter of two miles. The rings were named after the seven known planets and they were cut through by two streets at right angles, passing through the central point of the plan and running out towards the four cardinal points of the compass. The Sea Captain recounts that he saw 'a level space seventy paces wide between the first and second walls'.[3] Large palaces were joined to the wall of the second circuit 'in such a manner as to appear all one palace. Arches run on a level with the middle height of the palaces and are continued round the whole ring.'[4] There are promenades and colonnades on walls of three and eight spans' thickness. At the centre of all of this stands the hill upon which the central citadel acts like a sun to the concentric walls with their planetary names: here there stands 'a temple built with wondrous art'.[5]

Campanella supplies almost every detail of this temple. It is circular and has thick columns 'beautifully grouped'[6] which support a large dome from the crown of which emerges a smaller dome culminating in a spiral form. Beneath all of this the central altar is constructed. The temple occupies a space of 350 paces and has walkways above its outer columns. Over the altar hangs a large globe upon which the names of the heavenly bodies are inscribed, with a second globe representing planet earth. In the great dome all of the stars from first to sixth magnitude are depicted with their proper names and their power to influence earthly events. Seven lamps around the altar represent the planets and these are kept continuously burning. In forty-nine cells above the great dome live 'religious doctors' who include 'Astrologus, Cosmographus, Arithmeticus, Geometra, Historiographus'.[7]

Campanella's *City of the Sun* is a model of humanity's relation to the universe. The first circular wall around the temple is inscribed with 'all the mathematical figures . . . figures more in number than Archimedes or Euclid discovered'.[8] Next is a wall inscribed with minerals, a wall of rivers and liquids, then trees, herbs, fish and birds, as far as the sixth

wall which illustrates 'all mechanical arts and their instruments and their inventors named'[9] together with 'inventors in science, in warfare and in law'. The Captain says that he 'saw Moses, Osiris, Jupiter, Mercury . . . Pythagoras . . . and many more'.[10] Jesus dominated this section although Mohammed also appeared.

What was later to attract the attention of twentieth-century Communist revolutionaries was the fact that private ownership was not tolerated in Campanella's Utopian society: 'all things are common with them . . . no-one can appropriate anything to himself.'[11] The 'ruler must know necessity, fate, and the harmonies of the universe . . . He must also be well read in the Prophets and in astrology.'[12] According to their achievements the citizens occupy inner or outer rings of the city, for 'They have dwellings in common and dormitories . . . But at the end of every six months they are separated by the masters. Some shall sleep in this ring, some in another.'[13] There are no slaves and, as Campanella succinctly expressed it: 'They are rich because they want nothing, poor because they possess nothing.'[14] The sun's progress through the zodiac determined agricultural and social activities. The sun was considered to be the father of this world and the earth was considered its mother.

Despite its recognition of the divine authority of Jesus, Campanella's *City of the Sun* was already attracting the attention of Communist interpreters in the 1870s.[15] His vision of Utopia centred upon a seven-sided temple. It used architectural geometry to symbolize a spiritual order and to organize a social order. It was a cosmological scheme involving a particular relationship of geometry, architecture and social structure. In the early twentieth century some Russian Futurists had comparable cosmological visions and developed comparable means of exploring them.

Since Campanella's death in 1639 cosmology itself has undergone many upheavals. Once it was accepted that the earth moved around the sun a profound shift occurred in perception. As the Cubist painter Albert Gleizes pointed out, the Ptolemaic system with its central earth, and the Copernican system with its central sun, were more than simply right or wrong because they differed in their aims and purposes. The Ptolemaic system was a diagram of the central significance of humanity; the Copernican system shifted humanity from this position of importance. It is not surprising that the church resisted the philosophical and theological implications of this.

Mystical Geometry: French Art and Theosophy

In the late nineteenth century scientific discoveries in diverse fields demanded adjustments to conventional conceptions of space. It was in this context, for example, that the idea of a 'fourth dimension' became a topic of both popular and serious speculation in America, Europe and Russia. Two years before the birth of Malevich the American Charles Howard Hinton was already discussing the fourth dimension, in terms which would still be of interest by the time Malevich was active as an experimental painter. Hinton's two-volume *Scientific Romances* was published in 1884 and was followed by his book *A New Era of Thought* in 1888. The importance of such popular scientific speculation is that it sought to explain new ways of envisaging the world by means of new perspectives. The older conventions of depicting three-dimensional space by using one or two vanishing points were of course familiar, but the means to depict four-dimensional space were unknown. Some speculators proposed Time as the fourth dimension: H.G. Wells in his story *The Time Machine*, published in 1895, made his time-traveller say: 'The geometry, for instance, that they taught you at school is founded upon a misconception . . . a mathematical line, a line of thickness *nil*, has no real existence . . . Neither has a mathematical plane . . . Nor, having only length, breadth and thickness, can a cube have any real existence.'[1]

The time-traveller also pointed out that, 'Any real body must have extension in *four* directions: it must have Length, Breadth, Thickness and Duration'.[2] Wells failed to explain why four dimensions are adequate to conclude his argument, but he did make his time-traveller describe the fourth dimension as 'only another way of looking at Time. There is no difference between Time and any of the three dimensions of Space except that our consciousness moves along it.'[3] Wells's story had the time-traveller visit the year '802,000 odd' where he expected to 'discover a society . . . erected on a strictly communistic basis'.[4] His time-traveller was dismissive of Professor Simon Newcomb of the New York Mathematical Society who sought a fourth dimension perpendicular to the other three. Wells perhaps knew of Hinton's argument that we are aware of only three dimensions although there are many, and that as humanity develops perception will adjust to a four-dimensional framework. Hinton repeatedly argued that time is only an image of four-dimensional space. His argument followed a sequence of steps, soon made familiar by the writings of Kandinsky and others. Hinton progressed from point and line to plane, moving then into solid and thence into what he called 'hyperspace' dimensions. It was the movement of a point that made a line, the movement of a line that made a plane, the movement of a plane that made a solid and the movement of a solid that marked the step into hyperspace. Each step into a new dimension appeared at first to be movement in time but it became a dimension in space. Hinton also believed that the ability to perceive higher dimensions could be learned. The implications for older kinds of perspective were shattering. Since the Renaissance perspective had expressed a unity of space in which everything found its place in the same moment of time. A four-dimensional system of time and space was a subject which fascinated some Cubists in Paris as well as Futurists in Italy and Russia.

Coincidentally, Hinton's *Recognition of the Fourth Dimension* finally appeared in the same year that the great Russian collector Pavel Tretyakov opened his art collection to the public. This collection included Russian ikons of great importance, recognizing the achievements of ikon painting as part of the foundation of Russian art. The reforms of Peter the Great had introduced the Westernization of Russian culture and even in the nineteenth century academic art, in particular, was almost wholly foreign in its techniques. Yet in terms of perspective this meant that the study of Russian ikons threw Western academic systems into doubt. The ikon opened onto a spiritual world where time and place had little relevance. Russian artists were therefore effectively offered a choice of systems and frequently their paintings swung from one to another seeking a synthesis or confronting one system with the other.

In fact it was the late nineteenth century with its great international art and trade exhibitions, like those in Paris in 1889 and 1900, that brought widely differing cultures together. The colonialism of that time ensured that visitors witnessed an encyclopaedic assemblage of artifacts and cultures from almost every area of the globe. As the French painter Robert Delaunay sensed, the Eiffel Tower, built for the Exposition Universelle of 1889 in Paris, addressed itself to the universe, for at its feet lay the produce, culture and the people of almost the entire world. At the Exposition Debussy discovered Indonesian Gamelan music and there Gauguin collected images of carvings from Borobudur and from ancient Egypt, images that he took with him to Tahiti to create his own blending of cultures. In such a context it is not surprising that this period saw the growth of all kinds of comparative studies – in ethnography, anthropology, linguistics and religion as well as art and architecture.

In 1875 Helena Petrovna Blavatsky and Colonel Olcott founded the Theosophical Society which promoted the study of a wide range of world religions. This society was to have a far-reaching impact upon the visual arts in the period up to 1914. Although Blavatsky moved to India in 1878, establishing an ashram at Bombay and subsequently at Adya, her prolific writings on mysticism were thoroughly international in their content and range. Theosophists sought to compare religions, however widely spread across time and space, in order to seek their common roots and meaning. This could provide the basis of a future religion which would incorporate elements from many systems of religious thought. Theosophists argued that the spiritual leaders of Hinduism, Judaism, Christianity, Islam and other religions were the manifestations of a continuing revelation. By 1914 the Theosophical Society was a widely international phenomenon aspiring to link the mystical beliefs of many centuries and countries. Occultism, geometry and the fourth dimension all found consideration in Theosophy.

Blavatsky considered Pythagoras the prophet of an occult revelation, and she outlined in her writings her understanding of his concept of numbers as reflections of a divine harmony. This kind of mysticism became popular among Symbolist writers and painters from the mid-1880s onwards. Gauguin, for example, wrote to his friend Emile Schuffenecker on 14 January 1885: 'The straight line indicates the infinite, the curve limits creation, without taking into account the fatality of numbers. Have the numbers 3 and 7 been sufficiently studied?'[5] According to the painter Paul Signac, in 1886 or thereabouts, Gauguin copied out a relevant text by the late eighteenth-century Turkish poet Zumbul Zadé.[6] This text, *Ainsi parla Mani, le peintre donneur de préceptes* (Thus Spake Mani, the Painter and Giver of Precepts) was probably translated by an Orientalist friend, but Signac says that Seurat also knew it and Gauguin published it posthumously in *Avant et après*.[7]

Both Seurat and Gauguin used proportional systems in new ways: their geometry had

a significance. The Belgian writer Emile Verhaeren considered Seurat to be scientific and not 'an alchemist' as some commentators evidently thought.[8] The frozen stillness of Seurat's *Baignade à Asnières* (Bathing at Asnières) of 1883–84 is an image of harmony on more than one level. Seurat's workers have the grandeur of Renaissance figures and the youth at the right lacks only the conch shell that he would carry in a painting by Raphael to shatter the otherworldly silence of the scene. Beyond this, however, a geometric harmony keeps everything in its place around the circle of the straw hat. The proportions of the canvas are those of the Golden Section. In Seurat's *Grande Jatte* parasols make circular curves, and the monkey's tail describes a perfect spiral. Seurat's parade of contemporary Parisians uses strictly frontal or profile poses to provide the appearance of a hieratic relief, although its tunnel-like perspective denies this reading of the picture space. Here is a perspective system applied to a theme of contemporary life. Every figure and every detail finds a pre-allotted space within the interwoven light and shade sections of the format of the painting. Proportion, scale and perspective fit everything into place so that even the large profile figures at the right adopt a pose at right angles to the viewer, their heads framed by the circular curve of the parasol. Remarkably, the man's cane and the woman's parasol together describe the image of a pair of dividers placed at 27°, an instrument that would have been indispensable for the construction of such a painting. Seurat had adapted an ancient system of proportion to a new and particular use. In this he went beyond the Impressionists' incidental reflection of momentary effects because he was deliberately and meticulously *constructive* in his use of proportion: Seurat built his painting.

Gauguin's decorative and solemn canvases expressed emotions and temperaments within the seasonal cycles of the agricultural year and the church calendar cycle of Breton Pardons, in which local peasants appear as part of the harvest landscape.[9] Gauguin painted their psychology in terms of the four ancient 'humours', depicting melancholia, for example, in *Grape Gathering: Human Misery* and an impressive religious belief in the granite Calvaries and wood carvings of the area. In passing on these attitudes to other painters in Brittany Gauguin made a decisive impact upon Symbolist and mystically inclined painting. His acquaintance, the painter Verkade, for example, described his own personality in terms of the four humours in balance: 'It would be wrong . . . to presume that I possess a purely sanguine temperament even if many things might seem to indicate it. My temperament had at that time already a tendency to melancholy, and I have also something phlegmatic and choleric in my disposition.'[10]

In his friend and admirer Paul Sérusier Gauguin found an intellectual and mystical painter who was to prove instrumental in spreading his ideas. Sérusier visited Brittany in 1888 and received his celebrated painting lesson from Gauguin near Pont-Aven, producing the small *Talisman* which Sérusier subsequently gave to the painter and writer Maurice Denis.

Even before his departure for Tahiti, Gauguin had established in Brittany a school of mystical and decorative artists for whom the concept of harmony had a special importance. Sérusier frequently sent news of this back to Paris, so that in 1889, for example, he wrote from the coast at Le Pouldu where he was painting with Gauguin, describing how Wagner's Credo was inscribed on the wall there declaring: 'I believe that . . . the faithful disciples of great art will be glorified, and that, enveloped in a celestial tissue of rays, perfumes, melodious chords, they will return to be lost for eternity to the breast of the divine source of all harmony.'[11]

Sérusier came to believe that 'there exist primary principles in art'.[12] Writing of the art of the early Renaissance he asserted: 'It is enough, to be sure of this, to see the impeccable

harmony of lines and colours that one meets in their work.'[13] Again writing from Le Pouldu in 1889 he warned Denis that he should 'avoid too much mathematical regularity so as never to suggest the compass and ruler',[14] although he was certainly using them and it was largely through Sérusier that artists of Gauguin's circle adopted mathematical systems of proportion which they associated with mystical and religious subjects. The painter Charles Filiger, for example, was making what Denis called 'little archaic and hieratic compositions' based upon the circle, the octagon and square.[15] It was there too that Verkade studied under Sérusier, developing, in the words of Denis, 'from Synthetism to Divine Proportions'.[16]

Gauguin's friend, the Symbolist poet and critic Charles Morice, recalled: 'We were searching for Truth in the harmonious laws of Beauty, deducing all our metaphysics from that – for the harmony of nuances and tones symbolises the harmony of souls and of worlds and of all morals.'[17] Morice was all but paraphrasing Seurat's assertion that 'Art is harmony. Harmony is the analogy of opposites, the analogy of counterpoints of tone and colour and line',[18] concepts and practices implemented in Seurat's latest, and final, pictorial constructions *Le Chahut* of 1889–90, and the unfinished *Cirque* of 1890–91. These dynamic constructions are motivated throughout by an imbalance described in the ratio 8:5 or 13:8. The essential point is that this harmony is not to be understood as soporific or static.[19] In these works mathematics generates the composition. Harmony for Seurat was generative, producing a wealth of harmonious relationships in myriad growth. It was, in other words, a means of generating growth and movement whilst determining the relation of every point. Robert Rey has commented of Seurat that 'in effect what is dominant in his work is the idea that at the root of every sensation of harmony . . . are numbers, the relations between which are not accidental'.[20] A critic and poet, Théodore de Wyzewa, noted that 'from the first evening that I met him [Seurat], I discovered that his soul was also one of times past . . . Yes, I very clearly felt Seurat's kinship with Leonardo, Dürer, Poussin.'[21]

Gauguin, surprisingly, made a similar impression on some that knew him. Verkade, for example, recalled Gauguin describing number as 'the most perfect of the prototypes in the mind of the Creator' and 'the noblest trace discoverable in the creation which leads to wisdom'.[22] Verkade had more contact with Sérusier than with Gauguin but he was quite clear about Gauguin's interest in number, which was a topic of special interest to himself. 'Gauguin,' he wrote, 'sought conformity to law in the art of all periods'.[23] This has something of the tenor of Theosophical thinking. 'Sérusier,' recalled Verkade, 'spoke frequently also of the mysteries of numbers. "Numbers," he said, "represent the eternal Word, the rhythm and the instrument of Divinity".'[24] In fact, both Sérusier and Verkade had been deeply affected by Theosophy. Their vision of that 'rolling country . . . so sacredly still and full of God, that it reminded me of a nun, who in her bridal costume goes to the altar to become the bride of Christ', as Verkade wrote, a vision mediated by Gauguin, Sérusier and Theosophy.[25] As Sérusier put it, in terms which Malevich would later echo: 'Man is a little world in himself; he is the divine instrument which unites within itself all the elements and forces of nature.'[26]

What particularly impressed Sérusier and Verkade in Theosophy, as it impressed so many others, was the book *Les Grands Initiés* (The Great Initiates) by Edouard Schuré, which was published in Paris in 1889 and which, with the Exposition Universelle of the same year, transformed the perspective of many. Verkade was later to describe Theosophy as 'a halfway station for the better class of pagans, a temporary dwelling for the spiritually homeless', but he recognized that in Schuré's book 'There echo through its pages the plaintive longings of thousands of years'.[27] Russian interest in Theosophy blossomed at the

same moment, and in 1892 V.S. Solovev published *E.P. Blavatskaya: Iz peshcher i debrey Indiy* (E.P. Blavatsky: From the Caves and Jungles of India).[28] Theosophy became a potent ingredient of the Russian Symbolist movement.

Schuré's book proposed that there are two histories of religion, one being overt and official, comprising the teaching of the dogmas and myths.[29] The other history, which is precisely Schuré's subject, is occult (Schuré's word), because it is the hidden history of the mystical experiences of the great initiates of his book's title.[30] Schuré then tried to indicate the nature of the initiations of the ancient Aryans, Egyptians, Greeks, Persians, Jews and Christians.[31] He viewed Rama, Krishna, Hermes, Moses, Orpheus, Pythagoras, Plato and Jesus as all part of one revelation of God. This process of enlightenment Schuré saw as the spiritual evolution of humanity through history. According to Schuré, Jesus rebuilt the temple as an invisible spiritual temple within three days. The social realization of this temple, he claimed, was underway but far from complete. Europe, he concluded, could carry the new phase of enlightment to Russia and thence to Asia and to the New World.[32]

Schuré defined a series of related studies which he listed as: Theogony – absolute principles, the science of numbers and sacred mathematics, Cosmogony – the realization of eternal principles in time and space, Psychology – used to signify the evolution of the Psyche or soul through chains of existence, or reincarnation, and Physics – including alchemy, magic, divination and astrology.[33]

According to Schuré, it was Pythagoras who revived and transformed the traditions of Orpheus.[34] Number was at the core of his system: the Cosmos comprised three worlds, those of Nature, Man and Heaven and the key to the Universe lay in the rhythm and harmony of numbers. Schuré said that Pythagoras studied number in Egypt and visited Babylon where he was imprisoned for twelve years and saw the Tower of Babel before its destruction.[35] In describing the initiation of followers at the school of Pythagoras in Greece, Schuré explains how they were asked 'What means the triangle in the circle?' and 'Why is the dodecahedron in the sphere the figure of the Universe?'[36] God was defined as universal harmony and the seven modes of music corresponded to the 'seven colours of light, seven planets and seven spheres of life'.[37] Pythagoras called his disciples mathematicians and considered numbers as living forces acting within an overall unity.[38] The nine Muses in their temple were to give harmony to the soul. They included three major muses: Uranie for astrology, Polyhymnia for divination, and Melpomene for the science of death, transformation and rebirth.[39] In the Pythagorean system 1 was the monad, unity and harmony, the great unity in movement, a divine fire; 2 was the diad, division of male and female, the generative faculty displaying 'indivisible essence and divisible substance';[40] 3, the triad, was the trinity of nature, mankind and divine world, of 'body, soul and cosmic fluid'.[41] According to Schuré, 1, 2 and 3 together comprised Theogony, aspects of God, after which came Cosmology, a description of the world of matter in which 4 comprised the elements of fire, air, water and earth, from the rarest to the densest and from which everything is made. 5 completed the series. All other numbers contained these elements, so that 10 comprised a return again to unity of a greater complexity or power.[42]

Schuré then discussed Plato as a mystic and elaborated the Mysteries of Eleusis.[43] Finally, he turned his attention to Jesus whom he describes as a Nabi,[44] a prophet, who becomes the seventh Messiah and offers initiation to all mankind.[45] Schuré's descriptions of the agony of Jesus in the garden of Gethsemane and of the Crucifixion on Golgotha are images closely followed in paintings by Gauguin and Sérusier in Brittany.[46] They were perhaps affected by both Schuré's book and by the mysterious atmosphere of devotion in

Brittany which even contemporary guide books noted and which led Verkade to describe its landscape as the bride of Christ. Only the previous year, 1888, Sérusier had painted with Gauguin at Pont-Aven. By 1889 he was wholly converted both to Gauguin's ideas and to Schuré's Theosophy. In Paris he gathered about him his own group of Nabis, or prophets, including Séguin, Verkade, Vuillard, Bonnard and the painter-Theosophizer Ranson, whose apartment in Montparnasse became known as 'The Temple'.

Jan Verkade read *Les Grands Initiés* in 1890 and made Sérusier study it too. 'It was a revelation to him,' said Maurice Denis, 'his materialism was destroyed by it.'[47] Gauguin, mysticism and mathematics were inextricably linked in the minds of all of this circle. Verkade recalled how Sérusier spoke frequently also of the mysteries of numbers. 'Numbers,' he said, 'represent the eternal Word, the rhythm and the instrument of divinity'[48] and he spoke of reincarnation as 'recollecting yourself'.[49]

By this time a Catholic, Verkade sought, like Denis and Emile Bernard, a revival of religious art. For him mathematical proportions were an essential part of this, and for this purpose he travelled to the Abbey of Beuron in the German Tyrol in order to visit the painter and sculptor monk Desiderius, also known as Peter Lenz.[50] Verkade recalled that 'Little by little he gave me an insight into the mysterious power of the simplest numbers and geometric proportions in their application to art'.[51] According to Lenz, Egypt and Greece developed 'the principles of measuring and dividing', a view upheld by Schuré. By studying the art of the past Lenz evolved what he called 'the law of symmetry and the harmony of dimensions.' He wrote:

> This idea, the harmony of dimension, brought me to the domain of music. And now suddenly it became clear to me that, as music in melody and harmony is based upon the relation of numbers, so also the mysterious force of simple numerical proportions (arithmetically, 2:3, 3:4, 4:5, and geometrically $\sqrt{1:2}$, $\sqrt{2:3}$, $\sqrt{3:4}$) is met with in the classical temples and sculptures of antiquity. That is in fact the secret of their beauty.[52]

According to Lenz, 'the whole is achieved by use of the compass and rule'.[53] At Beuron, Lenz and his school had constructed a chapel in the form of a classical temple. The interior was square with an open portico reached by a flight of steps. The entrance was decorated with a square panel painted in 1868–69 showing the Madonna and flanked either side with panels of St Benedict, St Scholastica and a frieze of nuns. Inspired by Verkade's example, Sérusier also visited Beuron and subsequently translated Lenz's book on proportion. Indeed, it formed the basis of Sérusier's own study of proportion which he outlined in his book *ABC de la peinture*, which was not published until 1921.

In *ABC de la peinture* Sérusier argued that reproducing sight is a merely mechanical process and not intelligent.[54] For Sérusier perspective and proportion were wrongly used when employed to suggest a mirror to nature. He asserted clearly that the flat painted surface is the means of a construction reflecting not only position in space, form and weight but also emotional responses. These elements must be assembled to produce harmony, which Sérusier defined as 'the arrangement of sensations such that we desire nothing else. It satisfies both the senses and the spirit.'[55] According to Sérusier, to decorate a surface is to manipulate good proportions: 'I call good proportions those proportions upon which the external world is constructed, including our bodies; they are those which lie within the first and simplest numbers, their products, their squares and square-roots.'[56] He explains in terms very close to Schuré's image of Pythagoras that: 1 is not a number but it contains and engenders all numbers; 2 expresses the struggle between two principles; and 3 is the smallest number to delimit a surface (i.e. the equilateral triangle) – it signifies God the Creator. 4, writes Sérusier, gives the simplest solid (atetrahedron), is not

a prime (2 squared), is sacred and, according to the Golden Verse of Pythagoras, it is the source of nature.[57] In a square it gives the new measure $\sqrt{2}$ as its diagonal, which is called, says Sérusier, 'The Gate of Harmony'. Connected to four equilateral triangles it gives the Egyptian pyramids. He calls 5 'the Golden Number of Pythagoras from the pentagonal star which contains the Divine Proportion or Golden Section'.[58] Beyond this, numbers are composite, so that 6, for example, links the qualities of 2 and 3. Sérusier notes that the hexagon provides no new numbers as its sides are equal to its radii. The hexagonal star, however, made from two equilateral triangles, constructed Solomon's Seal. 7 is 3 and 4, signifying the union of Creator with what is created. 8 is 2 cubed and has the qualities of 2 and 4. 9 is 3 squared and has the virtues of 3. After 9, says Sérusier, numbers are no longer discernible or spiritually significant but simply the innumerable combinations of the first few numbers.[59]

In art, Sérusier notes, the diagonal of the square ($\sqrt{2}$) produced the landscape format of canvas sizes, whilst the Golden Section dominated the marine format, and doubled gave the portrait format.[60] Sérusier was convinced of the generative power of these ratios to order everything in his work, and says the artist need only use the angles of the simplest polygons, particularly the square and equilateral triangle. He also speaks of 'colour harmony' and forbids the mixing of cool and warm colours, even proposing the use of two palettes.[61] 'Art,' he writes, 'is a universal language expressed in symbols.'[62]

Sérusier visited Verkade at Beuron in 1897 and had an 'aesthetic revelation' of theories of art based on mathematics, number and geometry, theories professed in the great and flourishing monastic school of the Benedictines there. He wrote to Verkade in the same year: 'There is then an absolute beauty, it is a victory',[63] going on to say that Ranson and Denis were interested in the sacred measurements. 'I have come back to sacred measurements . . . and I swear to you that I am not alone and that I am slightly losing my head in it.'[64] Sérusier in fact concluded his later book of theories, *ABC de la peinture*, with a geometric diagram explaining how to preserve colour harmony.

The debate on this subject continued among the painters of Pont-Aven, among Symbolists and among followers of both Gauguin and Seurat throughout the 1890s. Reviewing an exhibition of work by the painter and printmaker Armand Séguin, again of the Pont-Aven school, Maurice Denis stressed 'the parallel influence of mystical affirmations like the theories of Bernard, and scientific researches like those of Seurat'.[65] Séguin had settled at Châteauneuf-du-Faou in south Finistère in Brittany, where Sérusier lived, and painted the local chapel.[66] He also filled a corridor of his own house with murals and the zodiacal signs with which he also introduced his letters. As Denis wrote of Jan Verkade in 1896: 'The perfection of decoration [at Beuron] corresponds to invincible spiritual beauty; admirable responses signify truth from on high; proportions express ideas; there is an equivalence between the harmony of form and the logic of Dogma.'[67]

Whilst Georges Seurat had avoided religious themes, he nevertheless made use of the same mathematical proportions, his more scientific outlook perhaps assisting his development of an art that revealed more objectively the interaction of forms, lines or colours within a proportional system. Seurat's follower and contemporary Paul Signac stressed these views at the turn of the century. In his book *D'Eugène Delacroix au Néo-Impressionisme*,[68] for example, he referred to 'these painters respectful of what is permanent in art: rhythm, measurement, contrast'.[69] Signac recalled how Seurat wrote little but spoke in esoteric terms of harmony and rhythm and explained that 'divisionism' meant more than the use of points or spots of colour, for imitators used it as 'only a process employed, but without the *divina proportione*'.[70]

All of these texts refer to a system of proportions based upon simple relationships between the smallest numbers. For Seurat and Signac this led to a system of mathematical harmonies which could be used constructively in painting. For Sérusier, Verkade and Denis, all of whom were followers of Gauguin and visitors to Brittany, this was also a sacred and mystical system which they could relate to the imagery of Hermes Trismegistus, Orpheus and Pythagoras as Schuré had described it in his book in 1889. For these artists, number in particular had an elemental force: it was a key to the structure of the universe, a god-given revelation to mankind. It appealed to their wish to define a new spiritual view and role for art. Such tendencies were reinforced by the Rosicrucian Salons of the 1890s and by their organizer Le Sâr Josephin Mérodack Péladan, whose *Introduction aux sciences occultes*, for example, sought, like Schuré's book, to establish mystical links with ancient times.[71] Péladan attributed to the Chaldees the discovery of 'the eternal continent, the Beyond'; he talked about the astral body, or double, of the Egyptians and discussed 'Astrology as the chief of occult sciences; Ziggurats . . . like the Tower of Babel, were at once both temples and observatories.'[72] A poster produced around 1893 shows Péladan as a magus, beneath a halo inscribed with the hexagon and pentagonal stars within a circle. The popularity of mysticism, from magic to the Catholic church, was at its fashionable height.

Mathematics was a persistent feature of this mysticism, as Denis described on visiting the Beuron monastery in 1903: Lenz 'uses Egyptian mathematical formulae: Golden Section, the Square and its diagonal, the equilateral triangle and its perpendicular, the regular hexagon and all the combinations engendered by the two triangles which comprise it'.[73] These studies of proportion and picture space were embedded in mysticism, for the systems of proportion seemed, like Schuré's Theosophy, to go back to ancient Egypt and beyond: they seemed god-given, generative, inexhaustible and exemplary of a great harmony. Small wonder that in the midst of all of this there were artists studying other cosmologies and, like the Theosophists, endeavouring to relate them together in a more generalized picture. Not least among these was Paul Gauguin working in Tahiti, the Gauguin who, according to Denis, 'claimed to read the book wherein the eternal laws of Beauty are written'.[74] Gauguin's own cosmological studies are evident, for example, in *L'Ancien culte mahorie*, his handwritten study of Tahitian legend which he describes as 'The Dialogue between Tefatou and Hina' (the spirits of the earth and moon): 'He was: Taaroa was his name: he stood in the void. No earth, no sky, no men. Taaroa calls, but nothing answers him; and existing alone he changes himself into the Universe.'[75]

Gauguin comments that 'Taaroa is the light, the germ; he is the base; he is the incorruptible, the strong, who created the Universe, the great and sacred Universe which is only the seashell of Taaroa. It is he who put it in movement and made harmony out of it'.[76] Gauguin was recounting a Tahitian equivalent of the book of Genesis: 'Then with his right hand he throws the seven skies to form the first base and light is created; Darkness no longer exists; Everything is seen; the interior of the Universe shines. The God remains stunned in ecstasy at the sight of the immensity. Immobility has ceased; movement exists.'[77] It is as if Gauguin were seeking to extend the examples discussed by Schuré, to find other revelations in other cultures to reveal the mystery that perhaps lay behind them all, for as Gauguin commented: 'there is a singular correspondence between this system of Astronomy and those of several other nations.'[78]

All of these themes, from Theosophy and occultism to mathematical enquiry, were finding interested followers in Russia. Blavatsky, one of the founders of the Theosophical Society, was herself Russian. In 1893 V.S. Solovev published his book *A Modern Priestess*

of Isis: My Acquaintance with E.P. Blavatsky.[79] And in Peter Ouspensky she was to find a persuasive Russian follower who gained an international reputation, whose impact upon Russian artists was acknowledged, and one who also endeavoured to link together ideas of a fourth dimension with the concepts of Theosophy. As in France, so in Russia Theosophy and higher dimensional space were both well-known and stimulating topics of discussion.

The painting and ideas of Gauguin, together with those of his mystical followers in Brittany and Paris, were also rapidly to gain currency in Russia. Indeed, Moscow was soon to house the biggest single collection of Gauguin's paintings. Seurat was far less well known until the Russian edition of Signac's book *D'Eugène Delacroix au Néo-Impressionisme* was published in 1912, but of the links with the thought and paintings of Gauguin, Sérusier, Denis and the Nabis there is no doubt whatsoever. It is in fact against this background that the formative work of Larionov, Goncharova and Malevich was developed and should be considered.

Appendix 3

Proportion and the Square

The systems employed by Malevich and certain collaborators were derived from the square. The square generates proportions that can be explored using only a compass and ruler. Malevich appears to have consistently used the old Russian measures of *arshin* and *vershok*, most frequently using canvases measuring 16 × 16 *vershok*, 18 × 18 *vershok* and 20 × 20 *vershok*. A scale translating *arshin* and *vershok* into centimeters appears at the end of this book. Subdivisions of the square will permit the construction of the Golden Section, golden triangle and the pentagon. It can also provide the simplest Pythagorean right-angled triangle, the sides of which are 3, 4 and 5 units long. Effectively, Malevich developed a system dependent upon angles measured in 9° intervals, forty of which make a complete circle. This proportional system was known in antiquity.

315. The central square in this diagram contains a star, formed by drawing a line from the centre of each side to the opposite corners. It is constructed from the diagonal of half of a square (see centre left), or √5, a proportion historically associated with alchemical diagrams (plate 317) and with the study of the Golden Section (plate 318). The intersections of the star permit the square to be subdivided along its sides into 2, 3, 4, or 5 units and their multiples, producing grids of 4, 9, 16 and 25 squares. The numbers 1, 2, 3, 4, 5 were considered by Pythagoras and his followers to be fundamental expressions of the structure of the universe. In the late nineteenth century these beliefs were revived by the Theosophists' study of Pythagoras. These diagrams show how the square may be used to generate grids and rhythmic relationships. The diagonal of half a square may also be used to construct diagonal grids (centre left). All of the angles produced in these diagrams are multiples of 9°. The triangle formed with one side of the square as its base (centre left) has angles of 63° and 54°. As a complete circle contains 360°, this suggests a compass divided into 40 sections of 9°.

316. The diagram left of centre shows the star motif (plate 315) repeated nine times. It may be seen to contain diagonal and vertical grids of squares all interrelated. Such grids could be used for compositional structures in painting, architecture and design. The diagram right of centre shows the structure of a design made by the Russian architect Nikolai Ladovsky in 1921, to demonstrate techniques of architectural composition. Other structures derived from the square include the square diagonally placed within a square (top left), forming a motif traditionally used in the recording of horoscopes. A frame-like motif is also contained in this format (top centre left), a structure employed by Malevich (top centre right). Related to this is a grid (top right) recorded by Dürer. Equal squares placed diagonally within a circle produce the octagon (lower centre) which to Pythagoreans signified completion of the octave and hence rebirth (the next octave). The hexagon (lower right), was presented by Theosophists as an image of interlaced equilateral triangles signifying the union of heaven and earth, of divine force descending and earthly force aspiring. Its proportional relationships were used by several twentieth-century Russian artists. For example the hexagon drawn to resemble a cube (lower left) was a motif adopted by El Lissitzky.

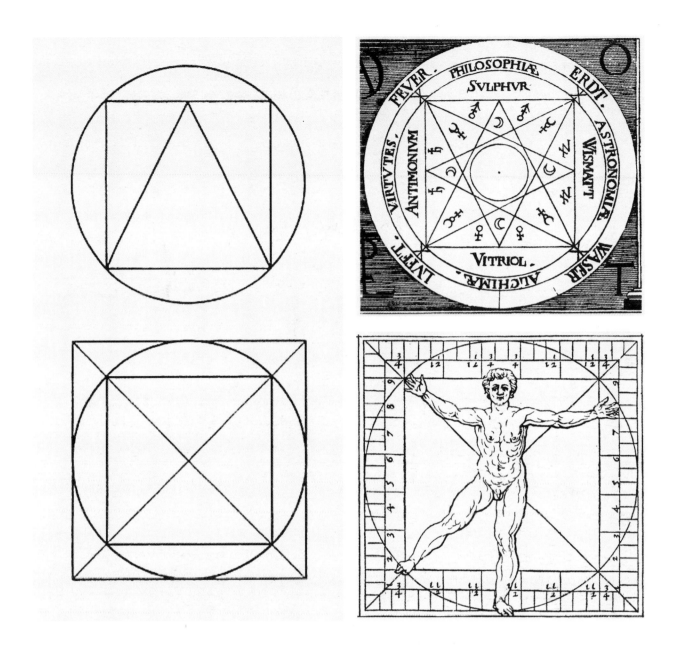

317. The diagrams in plates 315 and 316 provide for a particular relationship of the circle, square and triangle (top left), a sign used in alchemy to signify the philosopher's stone. The circle may be taken to signify heavenly perfection, the square to signify the four worldly elements of earth, air, fire, and water. The triangle may signify human aspiration towards perfection. The whole diagram read in this way then states a cosmic relationship. But as the proportional relationships of this geometry can be used for practical and constructional purposes, there is an implication that divine perfection may be realised on earth. This is one description of the alchemists' aim, and as such is relevant to the search for harmony in painting, design, architecture and music. The progression of the square (lower left) is the process of circumscribing a square with a circle, tangential to which a further square is drawn. The process may be repeated to produce a sequence of smaller or larger squares and circles. This relationship of circle and square appears in images of the human form related to geometry as in the example here by Scamozzi (lower right).

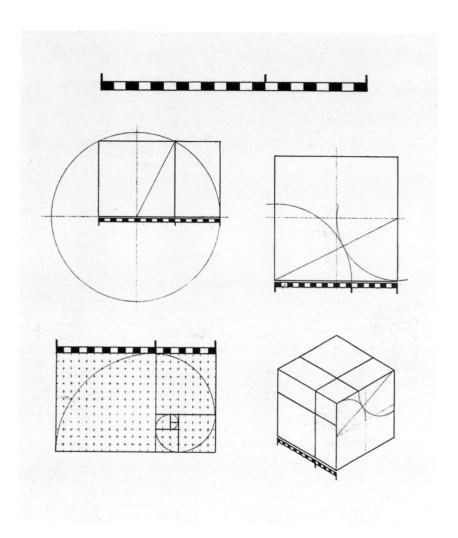

318. These diagrams illustrate the Golden Section, the most celebrated of ancient proprotional systems. The Golden Section cuts a line so that the ratio of the smaller part to the larger equals the ratio of the larger part to the whole line. All of the parts are in the same proportional relationship. Arithmetically this related to the Fibonacci series of numbers which begins with 0, 1 and proceeds by adding the last two terms to make the next: 0, 1, 1, 2, 3, 5, 8, 13, 21 . . . As the numbers increase in scale they approach the Golden Section ratio with greater accuracy. Here (top) is a rule divided in the ratio 13:8, already close to the Golden Section. Geometrically the Golden Section may be constructed by taking a line from the central point on the side of a square (upper left illustration) to one of its opposite corners, and with this as the radius drawing an arc to cut the base line extended. This 'base line' is divided at the Golden Section and the rectangle constructed upon it is the Golden Section rectangle. A second system provides for the internal division of the side of a square (upper right illustration) at the Golden Section. The Fibonacci Series may also be used to construct rectangles that approximate closely to the Golden Section (lower left): here the sides of the squares correspond to the series, commencing with the smallest: 1, 1, 2, 3, 5, 8, 13 . . . Circular arcs drawn within these squares construct a Golden Section spiral. This ratio generates a vast variety of interrelated forms with which painting, design and architecture may be constructed so that all the proportional relationships are harmonious. It was also known as the Divine Proportion. The diagonal of half a square, $\sqrt{5}$, evident in the motifs in plate 315 is here instrumental in constructing the Golden Section.

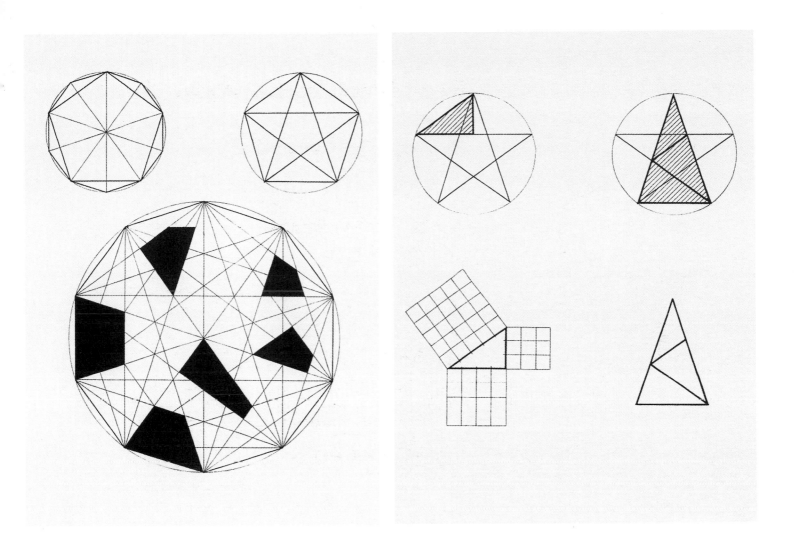

319, above left. The Golden Section is perfectly illustrated in the regular five-sided figure, the pentagon and in the pentagon star formed by connecting all of its corners (upper right). All straight lines here are cut in the Golden Section ratio. This completely harmonious quality gave the pentagon and decagon (upper left) special significance to Pythagorean mystics. The pentagon star was a secret sign used by the followers of Pythagoras and revived by the Theosophical study of Pythagoras. In Soviet Russia it was incidentally adopted as the format of the Red Star. All angles are again multiples of 9°. The decagon star (lower centre) contains a whole series of quadrilaterals used by Malevich.

320, above right. The golden triangle (lower right) is part of the pentagon (upper right). Its long sides are divided at the Golden Section. This bisects the lower part of the triangle into two smaller golden triangles. Rotation around the 72° angle of the base produces a pentagon. Rotation around the 36° angle of the apex produces a decagon. The pentagon star also contains the simplest expression of the Theorem of Pythagoras which states that the square on the hypoteneuse is equal to the sum of the squares on the other two sides (lower left). Here the sides are 3, 4, and 5 units in length and 9 + 16 = 25. This triangle is sufficient to construct all of the proportional systems illustrated here.

Conversion Scale

16 *vershok* = 1 *arshin* = 71.12 cm

vershok	arshin	cm	vershok	arshin	cm
1		4.45	12	$\frac{3}{4}$	53.34
2	$\frac{1}{8}$	8.89	13		57.79
3		13.34	14	$\frac{7}{8}$	62.23
4	$\frac{1}{4}$	17.78	15		66.68
5		22.23	16	1	71.12
6	$\frac{3}{8}$	26.68	20	$1\frac{1}{4}$	88.90
7		31.13	24	$1\frac{1}{2}$	106.68
8	$\frac{1}{2}$	35.56	28	$1\frac{3}{4}$	124.46
9		40.01	32	2	142.24
10	$\frac{5}{8}$	44.45	40	$2\frac{1}{2}$	177.80
11		48.90	48	3	213.36

1 The Symbolist

1. A clear sign of this is the fact that the Russian Museum in St Petersburg was only founded in 1895. It opened in 1898. See G.-W. Költzch *Morozov and Shchukin*, 1993, p.25.
2. Ivan Shchukin (1869–1908). See G.-W. Költzch *Morozov and Shchukin*, 1993, p.24.
3. Ivan Shchukin owned El Greco's *Opening of the Fifth Seal*, now in the Metropolitan Museum, New York. This is discussed in G.-W. Költzch *Morozov and Shchukin*, 1993, pp.46–8.
4. Ibid., p.25.
5. This was a copy of the tapestry that Sergei Shchukin had seen at Exeter College, Oxford. It depicts the Adoration of the Magi. See G.-W. Költzch *Morozov and Shchukin*, 1993, pp.49–53.
6. Claude Monet *Haystacks at Giverny*, painted 1886.
7. Painted 1879, acquired 1900.
8. Gaston La Touche *The Transfer of the Holy Relic*, 1899, Hermitage Museum, St Petersburg.
9. Aleksandr Benua 'Moris Deni' in *Mir iskusstva*, no. 7, 1901, p.53. This article is discussed in P. Stupples *Pavel Kuznetsov*, 1990, pp.55 and 59, in which he argues that Maurice Denis laid the basis for so-called primitivist art in Russia, including that of Kuznetsov.
10. Maurice Denis 'Le Salon de la Société nationale des Beaux-Arts' in *La Dépêche de Toulouse*, 22 avril, 28 avril, 6 mai 1901, reprinted in Maurice Denis *Théories 1890–1910*, Paris, 1913 (third edition), p.61.
11. Both published in Paris. Flambard was the pseudonym of Paul Choisnard. The Italian Futurist painter Gino Severini was among his admirers.
12. Charles Howard Hinton published, for example, *Stella, an Unfinished Communication, Studies of the Unseen*, London, 1895. *Recognition of the Fourth Dimension* was written in 1874 and published in 1902. D.C. Hinton also published *The Fourth Dimension*, New York, 1904 and 1921, which is discussed in V. and J-C. Marcadé *La Victoire sur le soleil*, Lausanne, 1976, and in Anthony Parton *Larionov*, Princeton, 1993, p.131. Hinton's books are discussed at length in L. Henderson *Fourth Dimension*, 1983.
13. Maurice Denis *Paul Sérusier, sa vie et son oeuvre*, Paris, 1947, p.86.
14. Maurice Denis gives the story of this visit in his *Journal*, volume 1 (1903), Paris, 1957, p.193ff.
15. *Vesy* is often translated as 'The Scales' but it is also the word for the zodiacal sign of Libra, which has scales as its sign.
16. Valeriy Bryusov 'Klyuchi tain' in *Vesy*, no. 1, 1904, p.20, cited in P. Stupples *Kuznetsov*, p.42, from the translation by Ronald E. Peterson in *The Russian Symbolists*, Ann Arbor, 1986, pp.52–64. This is also discussed in G.-W. Költzch *Morozov and Shchukin*, 1993, p.331. Bryusov's view was similar to that expressed by the Czech painter and mystic František Kupka: 'It is by sounding the microcosm of our own being that we will find ways to extend the means of unveiling the most subtle states of the human soul: by "we" I mean the collective self.' (Cited in Virginia Spate *Orphism: The Evolution of Non-Figurative Painting in Paris 1910–1914*, Oxford, 1979, p.104.)
17. Avreliy (an anagrammatical pseudonym of Valeriy Bryusov) 'Odilon Redon' in *Vesy*, no. 5, 1904, pp.41–4, cited in P. Stupples, *Kuznetsov*, 1990, p.42 n.22, who also refers to the article by Emile Bernard, 'Odilon Redon' in *L'Occident*, May 1904, pp.223–4.
18. Maurice Denis 'Introduction: Pierre Lenz *L'Esthéthique de Beuron*, translated by Paul Sérusier, Paris, 1905' reprinted in Maurice Denis *Théories 1890–1910*, Paris, 1913 (third edition), p.178.
19. Discussed in Anthony Parton *Larionov*, Princeton, 1993, p.10.
20. Benois and Denis were the subject of a comparison in the new periodical *Zolotoe runo* (The Golden Fleece): Aleksandr Shervashidze 'Individualizm i traditsiya – Aleksandru Benua i Morisu Denisi' (Individualism and Tradition – to Alexandre Benois and Maurice Denis) in *Zolotoe runo*, no. 6, pp.64–72, cited in P. Stupples *Kuznetsov*, 1990, p.69 n.17.
21. This is discussed in Kean *All the Empty Palaces*, 1983, p.160.
22. Maurice Denis discusses this in his *Journal*, vol. 3, Paris, 1959, p.214. The commission is illustrated and discussed in detail in G.-W. Költzch *Morozov and Shchukin*, 1993, pp.107–8ff.
23. This issue is discussed by Charlotte Douglas in E. Petrova *Malevich*, 1990.
24. Discussed in Anthony Parton *Larionov*, p.8.
25. These were from Ambroise Vollard. See Kean *All the Empty Palaces*, 1983, p.43.
26. See V.M. Lobanov *Khudozhestvennie gruppirovki za poslednie 25 let* (Art Groups of the Last 25 Years), Moscow, 1930, p.43.
27. Discussed in Anthony Parton *Larionov*, pp.12–13, P. Stupples *Kuznetsov*, 1990, p.349, and G.-W. Költzch *Morozov and Shchukin*, 1993, p.315.
28. Golden Fleece Salon, April–May 1907.
29. P. Stupples *Pavel Kuznetsov*, 1990, p.117, and G.-W. Költzch *Morozov and Shchukin*, 1993, p.30.
30. Maurice Denis *Synthetism*, excerpt from 'Cézanne' in *L'Occident* (Paris), September 1907, translated in H.B. Chipp *Theories of Modern Art: A Source Book by Artists and Critics*, Los Angeles, 1968, p.105ff.
31. These works to which E. Petrova *Malevich*, 1990, plate 12ff, gives the date 1907 may be part of the group of paintings exhibited by Malevich in 1911 as *The Yellow Series*.
32. Compare the word *Malerei* in German.
33. Shchukin owned one of Gauguin's self-portraits by 1906. See G.-W. Költzch *Morozov and Shchukin*, 1993 pp.390–91. Malevich clearly knew Gauguin's *Yellow Christ* as he referred to its composition and theme in his drawing *Golgotha*, made around 1911.
34. The exhibition shows Larionov and Kuznetsov capitalizing on the knowledge gained in Paris in 1906 in order to update Russian awareness of French art to include Fauve painting. The exhibition is discussed in Kean *All the Empty Palaces*, 1983, p.98; P. Stupples *Kuznetsov*, 1990, p.105; G.-W. Költzch *Morozov and Shchukin*, 1993, p.316; Anthony Parton *Larionov*, p.13, V.M. Lobanov *Khudozhestvennie gruppirovki za poslednie 25 let* (Art Groups of the Last 25 years), p.49.
35. P. Stupples *Kuznetsov*, 1990, p.105, and Anthony Parton *Larionov*, p.13.
36. Kean *All the Empty Palaces*, 1983, p.166; G.-W. Költzch *Morozov and Shchukin*, 1993, pp.73, 337.
37. Alexandre Mercereau 'Matiss i sovremennaya zhivopis' (Matisse and Contemporary Painting) in *Zolotoe runo*, no. 6, 1909, discussed in P. Stupples *Kuznetsov*, 1990, p.146. See also note 59 below. L. Henderson *Fourth Dimension*, 1983, p.260ff, discusses Mercereau's involvement with the Golden Fleece.
38. The 1909 *Zolotoe runo* exhibition is discussed in Kean *All the Empty Palaces*, 1983, p.99; G.-W. Költzch *Morozov and Shchukin*, 1993, pp.31, 316; and V.M. Lobanov *Khudozhestvennie gruppirovki za poslednie 25 let* (Art Groups of the Last 25 Years), p.54.
39. E. Petrova *Malevich*, 1990, proposes 1908 or 1910–11 as alternative possible dates.
40. Maurice Denis 'De Gauguin et de Van Gogh au Classicisme' in *L'Occident*, May 1909, reprinted in Maurice Denis *Théories 1890–1910*, Paris, 1913, (third edition), p.35ff.
41. Ibid., p.42
42. Maurice Denis *Journal*, vol. 2, Paris, 1957, p.99.
43. Ibid., p.100.
44. Ibid., p.102.
45. Ibid., p.105.

46. Ibid., p.108.

47. Sergei Shchukin opened his house in 1909. This is discussed in Kean *All the Empty Palaces*, 1983, p.211; and P. Stupples *Kuznetsov*, 1990, p.146.

48. Moris Deni 'Ot Gogena i Van-Goga k klassitsismu' in *Zolotoe runo*, no. 5, 1909, pp.63–8, and no. 6, 1909, pp.64–7. This was a translation of Maurice Denis 'De Gauguin et de Van Gogh au Classicisme' in *L'Occident*, May 1909. Larionov's interest is discussed in Anthony Parton *Larionov*, p.23.

49. Charles Morice 'Gogen kak skul'ptor' in *Zolotoe runo*, no. 1, 1909, pp.9–12, in no. 7–9, 1909, pp.132–5, and in no. 10, pp.47–51. See Anthony Parton *Larionov* p.28.

50. This is revealed and illustrated in Anthony Parton *Larionov*, fig. 19. The print may be a reference to Dürer's *Witches*.

51. The inscription is to be found on R. Delaunay *Tower (First Study)*, 1909, 46.2 × 58.2 cm, formerly in the collection of Mme Delaunay. It reads 'Exposition Universelle 1889, La Tour à l'univers s'adresse . . . Mouvement profondeur, 1909. France-Russie'.

52. See Vladimir Markov *Russian Futurism*, 1968, p.12.

53. According to Virginia Spate *Orphism: The Evolution of Non-Figurative Painting in Paris 1910–1914*, p.27.

54. Discussed in ibid., p.95.

55. The nature and experience of time was a recurrent theme in the philosophy of Henri Bergson.

56. R. Maurice Bucke *Cosmic Consciousness: A Study in the Evolution of the Human Mind*, Philadelphia, 1905.

57. Cited in Virginia Spate *Orphism: The Evolution of Non-Figurative Painting in Paris 1910–1914*, p.18. See also Daniel Robbins 'From Symbolism to Cubism: the Abbaye de Creteil' in *Art Journal*, Winter 1963–64, pp.111–16. Alexandre Mercereau was discussing the mathematics of Lobachevsky, Bolyaï and Riemann by 3 September 1912. See L. Henderson *Fourth Dimension*, 1983, p.60.

58. Virginia Spate *Orphism: The Evolution of Non-Figurative Painting in Paris 1910–1914*, p.21.

59. Ibid., p.64.

60. Exter met Picasso, Braque, Apollinaire and Max Jacob in 1908. See Anthony Parton *Larionov*, p.113. Robert Delaunay and Sonia Terk married in 1910. See Virginia Spate *Orphism: The Evolution of Non-Figurative Painting in Paris 1910–1914*, p.17. Robert Delaunay and Fernand Léger contributed to the second Knave of Diamonds exhibition in Moscow in January 1912.

61. Maurice Denis *Paul Sérusier, sa vie et son oeuvre*, p.39 and pp.94–7. L. Henderson *Fourth Dimension*, 1983, p.60, cites a letter of 29 November 1911 from Roger de La Fresnaye, applauding the lecture that he had attended a few days earlier when he heard Apollinaire discussing the fourth dimension.

62. A large memorial exhibition comprising 158 works by the Lithuanian composer-painter M.K. Čiurlionis was incorporated into the World of Art exhibition which opened on 28 November 1911 in Moscow and travelled to St Petersburg in January 1912.

2 Bathers and Peasants

1. Picasso made measured proportional studies for *Les Demoiselles d'Avignon*. See *Picasso: Les Demoiselles d'Avignon*, exhibition catalogue, Musée Picasso, Paris, 1988.

2. To a degree the Maillol Sculptures *Pomona* and *Flora* made in 1910 for Ivan Morozov fit this role of idealization which can suggest fecundity and even the fruitfulness of a landscape. Late Renoir bathers have this connotation. Le Fauconnier's *Abondance* illustrates the idea in a Cubist context. Denis also presented ideally proportioned figures. The image of Adam and Eve can incorporate the theme of perfect proportions and its is significant that this theme occurs in Parisian Cubist circles in the work of, for example, Chagall, Duchamp, La Fresnaye, Picabia and others.

3. Matisse's visit to Moscow is discussed in P. Stupples *Kuznetsov*, 1990, pp.144–8; and in G.-W. Költzch *Morozov and Shchukin*, 1993, pp.32, 66.

4. Anthony Parton *Larionov*, p.37.

5. Kandinsky had studied the book in German in 1910. Note also the article by A. Shervashidze 'Zhorzh Sera (Georges Seurat): 1859–1891' in *Apollon*, no. 7, 1911, pp.26–29.

6. As did the writer Jacques Nayral and the publisher Eugéne Figuière. This is discussed in Virginia Spate *Orphism: The Evolution of Non-Figurative Painting in Paris 1910–1914*, p.27.

7. Péladan's version of this, which Delaunay and Kupka also studied. See Virginia Spate *Orphism: The Evolution of Non-Figurative Painting in Paris 1910–1914*, pp.87, 188–9.

8. Duchamp seems to have introduced his friends to the mathematician Maurice Princet. See Virginia Spate *Orphism: The Evolution of Non-Figurative Painting in Paris 1910–1914*, p.36. For an authoritative and extensive examination of the mathematical interests of Duchamp and his contemporaries in Paris, see L. Henderson *Fourth Dimension*, 1983, p.60ff.

9. The Section d'Or group exhibited at the Galerie de la Boëtie, Paris, in October 1912. Two hundred works were exhibited by thirty-nine artists.

10. Cited in *Apollinaire on Art: Essays and Reviews 1902–18*, edited by Leroy C. Breunig, translated by Susan Suleiman, London, 1972, p.254.

11. Cited in Virginia Spate *Orphism: The Evolution of Non-Figurative Painting in Paris 1910–1914*, p.87, without a source reference.

12. Robert Delaunay *Lumière*, Summer 1912, reprinted in Robert Delaunay *Du Cubisme à l'Art Abstrait*, Paris, 1957, p.148.

13. André Salmon *La Jeune Peinture Française*, Paris, 1912, translated as the 'Anecdotal History of Cubism' in H.B. Chipp *Theories of Modern Art: A Source Book by Artists and Critics*, p.199.

14. André Salmon 'Anecdotal History of Cubism', p.203.

15. Ibid., p.205.

16. Discussed by Adrian Hicken in his doctoral thesis 'Simultanisme and Surnaturalisme', unpublished doctoral thesis, Birmingham Polytechnic (University of Central England), 1987, p.300.

17. All discussed in P.D. Ouspensky *The Symbolism of the Tarot*, writings dated 1911–29, reprinted in P.D. Ouspensky *A New Model of the Universe*, London, 1931. This quotation is from the edition published in London in 1948, p.208ff.

18. P.D. Uspenskiy *Tertium Organum. Klyuch k zagadkam mira* (P.D. Ouspensky *Tertium Organum: A Key to the Mysteries of the Universe*), St Petersburg, 1911.

19. There was also close contact between Kandinsky and Robert Delaunay who exhibited in the first Blaue Reiter exhibition in Munich in December 1911. This is discussed in Jelena Hahl-Koch *Kandinsky*, London, 1993, and in G.-W. Költzch *Morozov and Shchukin*, 1993, p.32.

20. Letters 30 and 31 in V. Khlebnikov *Collected Works*, 1989, p.15. He was in St Petersburg in June 1911 where he met Mayakovsky through the writers David Burlyuk and Aleksei Kruchenykh.

21. These have a startling human appearance. Several figures of this kind are preserved in the Russian Museum in St Petersburg. For a discussion of the biological interests in particular, see Charlotte Douglas 'The Evolution of the Biological Metaphor in Modern Russian Art' in *Art Journal*, Summer 1984, pp.153–61.

22. It remains difficult to effect precise identification. Malevich used these titles again for slightly later works. See, for example, Plate 68.

23. H. Berninger *Pougny*, Tübingen, 1972, p.143. See catalogue nos. 15, 18 and 19.

24. Vladimir Markov notes that the poet Elena Guro and her husband the composer Mikhail Matyushin suffered the death of a son. She wrote about this is a play *Osennyy son* (Autumn Dream) published in 1912. There may be a connection as Malevich and Matyushin were to work closely together and were also exhibiting together by December 1911. Chagall also depicted scenes of birth and death in his early paintings.

25. Matyushin was a major driving force behind the Union of Youth.

26. Tatlin, like Malevich, used the works by Picasso that were visible in Moscow as a model of how to proceed. Picasso's 1907 *Bust of a Woman*, Sergei Shchukin Collection, presents an analysis of the lines of the face comparable with that of Tatlin's curvilinear analysis of the face of his *Sailor*.

27. Vladimir Markov *Russian Futurism*, 1968, p.39, provides an account of this incident.

28. Discussed in G.-W. Költzch *Morozov and Shchukin*, 1993, p.339.

29. Ibid., p.327.

30. S. Makovsky 'French Artists in the Collection of I.A. Morozov' in *Apollon*, nos. 3–4, 1912, pp.5–24.

31. G.-W. Költzch *Morozov and Shchukin*, 1993, p.323.

32. See V.M. Lobanov *Khudozhestvennie gruppirovki za poslednie 25 let* (Art Groups of the Last 25 years), pp.64–6, who also lists Le-Dantyu, Rogovin, Skuye, Fon-Vizin (Von Wiesen) and Yastrzhembsky. See also the discussion in Vladimir Markov *Russian Futurism*, 1968, pp.38–9.

33. P. Sinyak *Ot Delakrua k neo-Impressionizmu. S prilozheniem stati o zakonakh tsveta iz 'Grammaire des Arts du Dessin' Sharlya Blonka* (P. Signac From Delacroix to Neo-Impressionism: With Introductory Texts on the Laws of Colour from Charles Blanc's 'Grammaire des Arts du Dessin'), translated by Ivan Dudin, Moscow, 1912.

34. G.-W. Költzch *Morozov and Shchukin*, 1993, p.32.

35. See Jelena Hahl-Koch *Kandinsky*, pp.199, 242.

36. Robert Delaunay *Du Cubisme à l'Art Abstrait*, p.179.

37. Wassily Kandinsky 'Über die Formfrage' in *Der Blaue Reiter*, Munich, 1912, pp.74–100. This passage is translated in H.B. Chipp *Theories of Modern Art: A Source Book by Artists and Critics*, p.166. Robert Delaunay's *Ville de Paris No. 2* was exhibited at the *Blaue Reiter* in Munich in December 1911 to January 1912.

38. V. Khlebnikov *Collected Works*, 1989, vol. 1, pp.281–2.

39. These paintings are discussed at length in Anthony Parton *Larionov*, p.51.

40. Larionov's half-length portrait known as the *Portrait of Vladimir Tatlin*, Musée national d'art moderne, Paris, is inscribed with the Cyrillic equivalent of the verbal fragments *ba* and *lda*. There is a likeness to Tatlin so that this identification has some credibility. It may depict a fool as this is a meaning of the word *balda*. Larionov did exhibit a *Portrait of an Idiot* (not using the word *balda*) at the Donkey's Tail exhibition. But in view of the figure's nakedness it probably depicts a soldier at the bathhouse and the lettering probably derives from the Russian for this 'soldat v bani' which contains the fragments *ba* and *lda*. The canvas size, given as 90 × 72cm, corresponds to 20 × 16 *vershok* (88.9 × 71.12cm) giving a ratio of 5:4 and perhaps an underlying grid based on the *vershok* units.

41. A. Kruchenykh, V. Khlebnikov *Igra v Adu. Poema* (A Game in Hell. Poem), 1912, discussed in Vladimir Markov *Russian Futurism*, 1968, p.41.

42. *Mirskontsa* (Worldbackwards), 1912. See S. Compton *World Backwards*, 1978.

43. Goncharova's cover resembles Gauguin's horned bust of *Le Père paillard*, 1892, and Valentine Marcadé has discovered a further French reference in the title of the book which derives from Arthur Rimbaud's *Saison en enfer*. See Valentine Marcadé 'Le Chef d'oeuvre des éditions aveniristes' in V. and J.-C. Marcadé *Le Victoire sur le soleil*, Lausanne, 1976, p.221.

3 Rural Futurist

1. Albert Gleizes and Jean Metzinger *Du Cubisme*, Paris, 1912. These quotations are from the partial translation in H.B. Chipp *Theories of Modern Art: A Source Book by Artists and Critics*, pp.212, 215. They referred to Bernhard Riemann (1826–66), the German mathematician who worked on non-Euclidean geometry.

2. *Apollinaire on Art: Essays and Reviews 1902–18*, edited by Leroy C. Breunig, p.286. Ouspensky's *Tertium Organum* also discussed non-Euclidean geometry and was referred to by Roberto Bonola *Non-Euclidean Geometry, a Critical and Historical Study of its Development*, Chicago, 1912.

3. *Apollinaire on Art: Essays and Reviews 1902–18*, edited by Leroy C. Breunig, p.93.

4. Ibid., pp.284–85. Marcel Duchamp had been exploring the theme of Adam and Eve since 1910–11 when he painted *Paradise* (Philadelphia Museum of Art, Arensberg Collection).

5. *Mishen'* (Target) exhibition, Moscow, 24 March–7 April 1913.

6. V.M. Lobanov *Khudozhestvennie gruppirovki za poslednie 25 let* (Art Groups of the Last 25 years), pp.66–7.

7. Orphism was also discussed in the periodical *Rech'*, 11 March 1913. See Parton *Larionov*, p.231 n.15. The painter Giorgio de Chirico was also associated with Orphism.

8. Robert Delaunay *Du Cubisme à l'Art Abstrait* p.150. He wrote to Franz Marc on 11 January 1913 asserting that 'Painting is properly a language of light' (Robert Delaunay *Du Cubisme à l'Art Abstrait*, p.181).

9. Delaunay says 'membres simultanés dans un action', ibid., p.181.

10. Delaunay *Du Cubisme à l'Art Abstrait* p.160, which reprints his essay 'Note sur la construction de la réalité de la peinture pure', op. cit., p.158ff

11. Stravinsky too was perhaps alert to this in his *Rite of Spring* of 1913. See also Parton *Larionov*, Princeton, 1993, p.96.

12. This is approximately 45 *vershok* wide.

13. Much of this is discussed by Blavatsky and Ouspensky. The hermaphrodite was also discussed by Péladan. It may appear in Brancusi's *King and Queen*.

14. There is some difficulty over the date of the painting. It is often given as 1911–12 but it seems unlikely that it should predate Delaunay's *Disk* of c.1912. Chagall's canvas was first exhibited at the Galerie der Sturm, Berlin, in June 1914.

15. See A. Kamensky *Chagall: The Russian and Soviet Period 1907–22*, London, 1989, p.125.

16. Peter Ouspensky *Tertium Organum: The Third Canon of Thought. A Key to the Enigmas of the World*, Harmondsworth, 1990, p.169. This book was first published in Russian in 1912. References here are to the Penguin edition of 1990. Ouspensky's reference to Blavatsky is from *The Secret Doctrine*, 1897, vol. 3, p.146. To these Theosophical writings must be added the mathematical speculations of Claude Bragdon, who was the co-publisher of *Tertium Organum* and the translator of its American edition. With reference to Adam it is perhaps significant that Sérusier, as well as Chagall, Duchamp and others, painted Adam and Eve. Delaunay's theme of Lovers and Brancusi's *Kiss* may be developments of the theme.

17. Donald Gordon *Art Exhibitions, 1900–1916*, Munich, 1974, gives the dates as 6–20 April, and Marcadé gives them according to the old-style calendar thirteen days earlier: 24 March–7 April.

18. Goncharova included at least two studies of *Sunflowers*. Mylius's illustrations featured alchemical sun-trees. The imagery of the sunflower as Van Gogh and Gauguin employed it is largely compatible with the use of the image in alchemical literature.

19. *Ogonyok*, no. 1, 1913, pp.20–8. This is discussed and illustrated in T. Andersen *Malevich*, Amsterdam, 1970, p.77, where it is recorded as *Lost in Berlin*.

20. L. Zhadova *Suprematism*, 1982, plate 17.

21. At the Union of Youth exhibition, November 1913, no. 63 was listed as *Peasants in the Street (Trans-Sense Realism)*. Alternatively the painting under discussion may be *Village Street* exhibited as no. 91 at the Target exhibition in March–April 1913. It is possible that both titles refer to the same work.

22. Chagall's painting combines Delaunay's Orphism with village life. Chagall's inverted figures recall Burlyuk's paintings from four points of view. Here they make an interesting comparison with Malevich's vivid reflections.

23. Emile Mâle discussed this kind of imagery in the context of medieval architecture and sculpture. Its most lavish example is perhaps the *Très Riches Heures* of the Duc de Berry.

24. When Van Gogh drew a peasant cutting wood with an axe he achieved a quality of reportage rather than a symbolic image. Julius Meier-Graefe's book *Impressionists*, which included chapters on Van Gogh as well as Guys, Manet, Pissarro and Cézanne, was published in Russian in 1913: Yulius Meyer-Grefe *Impressionisty* (*Gys, Mane, Van-Gog, Pissaro, Sezann*), Moscow, 1913.

25. Juan Gris discussed his work in terms of strategy. Charlotte Douglas *Malevich*, London 1994, p.66, discusses this theme and also reproduces well *The Carpenters* of *c*.1912.

26. J.F. Millet *The Reaper*, 1866–68, pastel and black crayon, 96 × 68 cm, Museum of Fine Arts, Boston.

27. Compare Emile Bernard's *Blé noir*, 1888, 72 × 92 cm (Plate 70).

28. In Russian *Vesy*, the title of the Symbolist periodical. Other zodiacal titles include the almanach *Strelets* (archer, Sagittarius).

29. Compare Goncharova's almost square *Moscow Winter*, Regional Art Museum, Simbirsk.

30. The Roman god of thresholds was the two-faced Janus who looked both backwards and forwards and is commemorated in the name of the month January for this reason. It is perhaps Janus who appears in Chagall's painting *Paris through the Window* of 1913 where he is associated with the threshold of the open window.

31. These were: Al'bert Glez and Zhak Metsenzhe *O Kubizme*, translated by 'M.V.', Moscow, 1913; and Al'bert Glez and Zhak Metsenzhe *O Kubizme*, translated by E. Nizen and edited by M. Matyushin, St Petersburg, 1913. The French edition was originally published on 27 December 1912. See L. Henderson *Fourth Dimension*, 1983, p.26.

32. G. Apollinaire *Les Peintres Cubistes*, Paris, 1913. This quotation is from the partial translation in H.B. Chipp, *Theories of Modern Art: A Source Book by Artists and Critics* p.237.

33. H.B. Chipp *Theories of Modern Art: A Source Book by Artists and Critics*, p.223.

34. No. 66 *Tochilshchik (zaumnyy realizm) 1912g.* See Berninger *Pougny*, Tübingen, 1972, p.291, which illustrates the whole catalogue.

35. Robert Delaunay *Du Cubisme à l'Art Abstrait*, p.63. See also Virginia Spate *Orphism: The Evolution of Non-Figurative Painting in Paris 1910–1914*, p.205.

36. Patricia Railing *On Suprematism: 34 Drawings*, Forest Row, 1990, p.26.

37. Duchamp's interest in mechanical devices such as the *Chocolate Grinder* is matched by Picabia's use of mechanical imagery. Duchamp's *Nude Descending the Staircase No. 2* is inscribed 'Neuilly 1912'. Duchamp withdrew it from the Salon des Indépendants of 1912 but exhibited it at the Salon de la Section d'Or in 1912 in Paris. Aleksandra Exter was a fellow exhibitor.

38. Troels Andersen ed. *Malevich: Essays*, vol.4, p.203, translated from the letter dated 9 May 1913 in the Tretyakov Gallery, Manuscript Section 25/9, 1.2.

39. Cited in Virginia Spate *Orphism: The Evolution of Non-Figurative Painting in Paris 1910–1914*, p.211.

40. Sillart 'Vystavka futuristskoy skul'ptury Bochchioni' in *Apollon*, no. 7, September 1913, pp.61–63. This quotation occurs on p.61. However, Susan Compton has discussed Charles Blanc's *Grammaire des Arts du Dessin* as a source of repeated motifs as adopted by David Burlyuk in Russia. Blanc's text was included in the Russian edition of Paul Signac's *D'Eugène Delacroix au Néo-Impressionisme* (see Chapter 2, note 33).

41. Sillart, p.63.

42. Ibid., p.62.

43. Moving wheels also occur in Goncharova's contemporary painting *The Cyclist* of 1912–13, Russian Museum, St Petersburg. This is illustrated in M.N. Yablonskaya *Women Artists*, 1990, plate 43.

44. *Head of a Peasant Girl* is presumably the *Face of a Peasant Girl* exhibited at the Union of Youth exhibition in St Petersbury in November 1913, listed as entry no. 62 in the catalogue.

45. This point is well made and illustrated in Rainer Crone *Kazimir Malevich*, plate 34.

46. *Woman with Buckets* was exhibited at the 1913 Target exhibition in Moscow and listed as no. 3 in the catalogue. It was also exhibited at the Union of Youth exhibition in Petrograd in November 1913, listed as entry no. 61 in the catalogue in the group of paintings described there as *zaumnyy realizm* (trans-sense realism).

47. *Ogonyok*, no. 47, 1913, p.7. This is illustrated in Andersen *Malevich*, 1970, p.76.

48. Troels Andersen *Malevich: Essays*, vol. 4, p.204, where the source of the letter is given as the Tretyakov Gallery, Moscow, Manuscript Department, 25/9, 1.11–12.

49. V. Khlebnikov, A. Kruchenykh, E. Guro *Troe*, St Petersburg, 1913. *Troe* means a group of three, a trio. According to Vladimir Markov *Russian Futurism*, 1968, p.125, this book was published in September 1913.

50. A religious reference was maintained in the title of the publication V. Khlebnikov, V. Mayakovsky, D. and N. Burlyuk *Trebnik Troikh* (The Service Book of the Three), Moscow, 1913.

51. P. Ouspensky *Tertium Organum*, 1990, p.87.

52. This print is discussed in the context of mathematical theories in R. Crone 'Malevich and Khlebnikov' in *Artforum*, December 1978, pp.38–47, particularly p.39ff.

53. Quoted in Vladimir Markov *Russian Futurism*, 1968, p.52.

54. Quoted ibid., p.125.

55. P. Ouspensky *Tertium Organum*, 1990, pp.26–32.

56. A. Kruchenykh, V. Khlebnikov *Slovo kak takovoe*, Moscow, 1913. There are several Babylonian references in *Troe*. Babel first diversified languages. The Phoenician letter was based on the eye image.

57. P. Ouspensky *Tertium Organum*, 1990, pp.100–2. Ouspensky is citing the Professor's lecture on time and higher dimensions. N.A. Oumoff discussed Minkowski's mathematics and he published on Minkowski in 1910 and 1912. See L. Henderson *Fourth Dimension*, 1983, p.242ff. Ouspensky is discussed on p.244ff.

58. Cited in P. Ouspensky *Tertium Organum*, 1990, p.18, from H.P. Blavatsky *The Secret Doctrine*, London, 1893 (third edition), vol.1, p.271.

59. P. Ouspensky *Tertium Organum*, 1990, p.20.

60. Ibid., p.79.

61. Ibid., p.97, citing H.P. Blavatsky *Isis Unveiled*, vol.1, New York, 1884.

62. H.P. Blavatsky cited in P. Ouspensky *Tertium Organum*, 1990, pp.97–8.

63. P. Ouspensky *Tertium Organum*, 1990, p.65, Ouspensky's italics.

64. The infinitives of the verb are *Klevat'* and *klyunut'*. A whole series of images may have been developed from the roots of words and names. I am especially grateful to Professor Robin Milner-Gulland at the University of Sussex for the spark of inspiration which made me realize this possibilty. *Malevich* suggests *malyar*, a signpainter or decorator, and *malevat'* to daub or paint in a rough way. *Matyushin* suggests the *mat* syllable in *matematika*/mathematics and *matros*/ sailor. As *Khlebnikov* suggests *khleb*/bread (with connotations of harvest) and *khleborod* is ploughman, husbandman or peasant, there does seem to be some correspondence. There is at least one Chagall that features footprints perhaps derived from *shag*/step. More evidence is needed if this is to be made conclusive, however. Compare *Lot* which was the name with which Tatlin signed some of his later works. *Lot* means a plumbline of the kind used by sailors to gauge depth. Tatlin was an experienced sailor.

65. See S. Compton *World Backwards*, plate 22, R. Crone *Kazimir Malevich*, plate 55, E. Petrova *Malevich*, 1990, plate 67, and V. Khlebnikov *Complete Works*, 1989, vol. 1, p.257.

66. This is as difficult as Duchamp's puns. *Par* means 'steam', which is here associated with the hair. *Parikmakher* is a 'hairdresser' or 'barber'.

67. For example, *The Word as Such* describes language as a saw.

68. Burlyuk's title again recalls Duchamp's titles but Duchamp's closest title dates from 1918: *À regarder (l'autre côté du verre) d'un oeil de près pendant presque une heure*, Museum of Modern Art, New York (Katherine S. Dreier Bequest 1953).

69. P. Ouspensky *Tertium Organum*, p.62.

70. Ibid., p.102.

71. Compare the painter Nikolai Kulbin in his article 'Svobodnoe iskusstvo kak osnova zhizni' (Free Art as the Basis of Life) in which he discusses the symmetry of the crystal. This was reprinted in

V. Markov *Manifesty i programmy russkikh futuristov*, Munich, 1967, p.15ff.

72. P. Ouspensky *Tertium Organum*, 1990, p.131.
73. Ibid., p.133.
74. Ibid.
75. This curtain is derived from a photographer's backdrop and it appears in Russian Futurist photographs taken in 1913.
76. The resemblance is enhanced by the numbers. In Boccioni's painting the train number 6943 is painted across part of the canvas.
77. The painting is sometimes called *The Accounting Lectern* (R. Crone *Kazimir Malevich*, plate 70) or *Desk and Room* (E. Petrova *Malevich*, 1990, plate 56). It is inscribed on the back of the canvas *Portrait of a Lady. Landowner/Desk and Room*. The themes are present in a painting by Venetsianov but no apparent resemblance exists.
78. The painting is also known as *Through Station, Kuntsevo*. It is inscribed on the reverse *Stantsiya bez ostanovki* (Station without Stops). Klyun's *Swift Landscape* may illustrate a similar theme.
79. If Malevich is deliberately seeking to make enigma the subject of his painting, it may indicate an awareness of the work of De Chirico or a response to enigmatic themes in Chagall's work. De Chirico used the term 'enigma' in his titles for paintings executed from 1910 onwards. His debut at the Salon d'Automne, Paris, was in 1912. He exhibited *The Enigma of the Hour* at the Salon des Indépendants, Paris, in 1913. His assemblages of images might have been considered alogist by Russian artists.
80. This is translated from R. Crone *Kazimir Malevich*, p.100. A further discussion of 'alogism' and language may be found in L. Henderson *Fourth Dimension*, 1983, p.271ff.
81. Numerous cows occur in Chagall's paintings and in 1914 the Russian Futurist Kamensky published *Tango s korovami* (Tango with Cows). This painting is dated 1911 on the reverse. The apparently irrational juxtaposition of images is related to Ouspensky's theories in W. Sherwin Simmons 'Kazimir Malevich's "Black Square": The Transformed Self. Part One: Cubism and the Illusionistic Portrait' in *Arts Magazine*, October 1971, pp.116–25, specifically p.120.
82. Other words with this sound include *skotovodstvo*/cattle-rearing, *skryvat'*/to conceal, *skladyvat'*/to put together, *skleivat'*/to paste together. *Skryabin*/Scriabin the composer also comes to mind. The irrational or enigmatic juxtaposition of objects was fully developed in De Chirico's work also by this time, as in his *Melancholia* of 1912–13, his *Conquest of Philosophy* of 1913–14, and his *Portrait of Apollinaire* of 1914 which features a jelly mould in the shape of a fish.
83. P. Ouspensky *Tertium Organum*, p.226.
84. Ibid., p.227.

4 Victory over the Sun

1. A print by David Burlyuk was also incorporated in the poster.
2. Stepanova and Rodchenko produced a comparable photograph ten years later, complete with inverted furniture.
3. A. Parton *Larionov*, p.133. It has been argued that *Victory over the Sun*, though an opera, was well within the Russian *Balagan* tradition of fairground entertainments. See John Bowlt 'When Life Was a Cabaret' in *Art News*, December 1984, pp.122–7. See also Charlotte Douglas 'Birth of a Royal Infant: Malevich and Victory over the Sun' in *Art in America*, March 1974, pp.45–51.
4. V. Khlebnikov *Collected Works*, 1989, vol.1, p.288.
5. Raymond Cooke *Velimir Khlebnikov: A Critical Study*, Cambridge, 1987, p.14 n.45. Khlebnikov's tutor in mathematics was A.V. Vasiliev who published an anthology *Novye idei v matematike* (New Ideas in Mathematics), 2 vols., St Petersburg, 1913. This is discussed in L. Henderson *Fourth Dimension*, 1983, p.242ff.
6. This is discussed in G.-W. Költzch *Morozov and Shchukin*, 1993, p. 342. There have been several attempts to re-create the opera. See *Art in America*, April 1984, p.184, and H. Günther 'Der

Erstaufführung der futuristichen Oper "Sieg über die Sonne"' in the *Wallraf-Richartz Jahrbuch*, vol. 53, 1992, pp.189–207.
7. For an extended discussion of Malevich and the fourth dimension, see L. Henderson *Fourth Dimension*, 1983, p.274ff.
8. Playing cards occur, of course, in Cubist works by Picasso, Braque and others. In Russia, the Ace of Clubs occurs far more frequently than other cards and it is also common in Parisian paintings. Clubs are indicative of worldly power but their appearance in paintings awaits explanation. Card games appear also in the Russian Futurist book *Igra v Adu* (A Game in Hell) which Goncharova and Malevich both illustrated. The Knave of Diamonds exhibition society adopted the name of a card and Rozanova was to execute a whole series of paintings on the theme of playing cards. In Russia there were also the significant literary precedents of Pushkin's story 'The Queen of Spades' and Gogol's 'Gamblers'.
9. A. Mgrebov *Zhizn' v teatre* (Life in the Theatre), Moscow-Astrakhan, 1935, pp.282–3, cited in L. Zhadova, *Suprematism*, 1982, p.26.
10. This is the translation given in the article 'Victory over the Sun', translated by Ewa Bartos and Victoria New Kirby in the *Tulane Drama Review* (*The Drama Review*), Fall, 1979, vol. 15, no. 4, p. 108, but really this passage is untranslatable.
11. Ibid., p.103, which asserts that Malevich made twenty large pieces of decor in four days.
12. Ibid., p.109.
13. Ibid. Apollo of course was god of the Sun and of the Arts, as in the name of the art periodical *Apollon*.
14. Ibid., p.110. They utter the syllables 'Klyun sur der' which may suggest the painter Klyun, so wise (*surovyy*) with wood (*derevo*) or in the village (*derevnya*), themes that Malevich associated with the image of Klyun.
15. Ibid., p.112.
16. Ibid.
17. Goncharova illustrated precisely this theme in 1913 in her canvas *Aeroplane over Train*, Kazan Art Museum.
18. '*Zel. do pokh*', abbreviated from the words meaning 'green until the funeral'.
19. Benedikt Livshits *Polutoroglaznyy Strelets* (One-and-a-Half-Eyed Archer), Leningrad, 1933, pp.187–8, cited in L. Zhadova *Suprematism*, 1982, pp.27, 120 n.36.
20. 'Victory over the Sun', p.114. There may be references here to the sportsmen depicted by Robert Delaunay and Gleizes and to Larionov's paintings of the *Seasons*.
21. Ibid., p.115.
22. Malevich refers to act one, scene three and so on. This has caused confusion as the libretto is divided only into scenes and not into acts. The present text follows the libretto in this.
23. 'Victory over the Sun', p.116.
24. Ibid., p.119.
25. Ibid., p.120.
26. Ibid.
27. Ibid., p.121.
28. Ibid. L. Henderson *Fourth Dimension*, 1983, p.277, discusses the cross-section of the hypercube which may be referred to here by Malevich in his set (Plate 150) and in his painting *Musical Instruments* (Plate 153).
29. Ibid., pp.123–4. Compare this with the Fatman who declares 'the tower, the sky, the streets are upside down'. Kamensky crashed his plane. He also lectured on 'Airplanes and Futurist Poetry' at the Polytechnic Museum, Moscow, 11 November 1913. See V. Markov *Russian Futurism*, 1968, p.135. See also Kamensky cited in W. Woroszylski *Life of Mayakovsky*, London, 1972, p.35.
30. See Evgeniy Kovtun 'K.S. Malevich. Pis'ma k M.V. Matyushinu' in *Ezhegodnik rukopi'nogo otdela Pushkinskogo doma*, Leningrad, 1976, pp.177–84, cited in *Malévitch*, Paris, 1978, p.12.
31. A precedent of a sort was set by Benois in his design for *Petrushka* in 1911 which features a bedroom with the starry night sky upon its walls as if it were open to the sky. For a more nihilistic interpretation, see V. Gnedov *Smert' iskusstva* (The Death of Art), also of 1913.

32. P. Ouspensky *Tertium Organum*, 1990, p.106.

33. Benedikt Livshits *Son of Wolves*, cited by V. Markov *Russian Futurism*, 1969, p.189. This process of naming is one of the activities attributed to Adam.

34. The canvas is inscribed '*1914 g Awiator*' (Year 1914 Aviator) on the reverse.

35. Khlebnikov's poem *Ka* apparently dates from 1916, however.

36. It contains the words and fragments *Klyun* in scene one, *KM* (K. Malevich) in scene six, *KR* (Kruchenykh) four times in scene six, and so on. These points are supported in part in W. Sherwin Simmons 'Kazimir Malevich's "Black Square": The Transformed Self. Part Two' in *Arts Magazine*, November 1971, p.130ff.

37. This may indicate also a kind of half-rhyme of *apteka* (apothecary) with *optika* (optician). *Apteka* has also been discussed in connection with Mayakovsky. See W. Sherwin Simmons 'Kazimir Malevich's "Black Square"' pp.131–5.

38. This canvas is inscribed on the reverse '*K. Malevich 1914. Mlody Anglik*', the first part in Russian, the second in Polish. See E. Petrova *Malevich*, 1990, catalogue no. 58.

39. '*Londonskiy malenkiy prizrak*'. Perhaps he was elluding to his 'English' dress-sense, as well as to his thinness. Raymond Cooke made this point in a letter to the author on September 28, 1986.

40. For example, the Second Balkan War, 1913. See G.-W. Költzch *Morozov and Shchukin*, 1993, p.30.

41. This effect is also evident in Seurat's *Grande Jatte*.

42. For example, it appears that the bayonets once extended lower and an outline of lettering is just visible in the top left fan-shaped quadrant of the painting. The image of a fish appears in contemporary paintings by De Chirico, most similarly in De Chirico's *Portrait of Guillau me Apollinaire*, 1914.

43. 'Victory over the Sun', p.115.

44. Ibid.: '*skrylos' solntse*'.

45. This must remain speculation at present. Other avenues of inquiry into the subject do exist. For example, the 'one-eyed' effect in *The Aviator* and in the *Englishman in Moscow* could concern David Burlyuk who had only one good eye. The 'one-eyed' effect in the *Portrait of Ivan Klyun* argues against this connection, however. It is also possible that a whole network of images at this time is derived from words having the same root or similar fragments to link them. For example, with reference to the *Englishman in Moscow*, many of the images seem to relate to words beginning with the letters *lo*. *London* is one of these which obviously fits in with the painting's title. Others include *lozhka*/spoon, *lobzik*/fretsaw, *lozha*/gunstock, *lozung*/slogan, *lom*/scraps, *lopast'*/blade, *lord*/lord, *lososina*/salmon, *loshadnyy*/equine. Drawings at this time also feature a spade (*lopata*) and a small boat (*lodka*).

46. Her painting *Workbox*, 1915, Tretyakov Gallery, Moscow, has scissors like those in the *Englishman in Moscow*. This is reproduced in M.N. Yablonskaya *Women Artists*, 1990, plate 52, p.89. The clock motif appears in much the same way in De Chirico's painting *The Philosopher's Conquest* of 1914.

47. The *Mona Lisa* was stolen on 21 August 1911 and Apollinaire was questioned. See W. Sherwin Simmons 'Kazimir Malevich's "Black Square"' pp.116–25. The collage inscription 'apartment changing hands' or 'apartment to let' was the title of a painting *Appartement à louer* by the French academic and genre painter François-Auguste Biard (1798–1882). It was exhibited at the Salon of 1844 in Paris where it was a popular success. Charles Baudelaire discussed the painting in his 'Salon of 1856' (*sic*). Marcel Duchamp's moustachioed reproduction of the *Mona Lisa* was like a Russian Futurist work in its word games and image but dated from 1919, five years after this work by Malevich.

48. The scissors in the *Englishman in Moscow* are also like those in Severini's *Dynamic Hieroglypghic of the Bal Tabarin*, 1912, Museum of Modern Art, New York (Lillie P. Bliss Bequest).

49. The spoon appears in the *Englishman in Moscow* but it was also worn as an absurd buttonhole decoration by Russian Futurists in 1914. On 8 February Malevich and Morgunov each wore a red wooden spoon while demonstrating on Kuznetsky Most' in Moscow, and again on 18 February Malevich wore a red wooden spoon while

protesting at the Knave of Diamonds discussion. See *Malevich*, Amsterdam, 1988–9. Several of these drawings are linked by musical motifs of one kind or another. It is possible that Malevich was considering another project with the composer Matyushin – perhaps the illustration of a libretto, which might explain the references to professions as roles (merchant is one example) as well as the S-curve from the violin. If they are related to a narrative they may also shed light on such paintings as *The Guardsman*. They may, however, be designs for a burlesque or other entertainment.

50. Cited in L. Zhadova *Suprematism*, 1982, p.122 n.4. Other Russians exhibiting at the Salon des Indépendants in 1914 included Archipenko, Baranoff-Rossiné, David and Vladimir Burlyuk, Chagall, Charchoune and Exter.

51. *Vystavka kartin: futuristy, luchisty, primitivy*, no. 4, Moscow, 1914.

52. Kamensky's exhibits included: *MA + 4, Street of Carousels, Constantinople, Newspaper 12763914, Fall from an Aeroplane* and so on. See V. Markov *Russian Futurism*, 1969, pp.198–9.

53. This was published in V. and D. Burlyuk *Tango s korovami* (Tango with Cows), Moscow, 1914.

54. Professor Robin Milner-Gulland, in a letter to the author on 23 March 1988, notes that each large letter points to several references – a poet, a direction in space, a geometry of the universe, and it organizes words semantically into different fields.

55. Cited in L. Zhadova *Suprematism*, 1982, p.122 n.2.

56. This article is reprinted in *Apollinaire on Art: Essays and Reviews 1902–18*, edited by Leroy C. Breunig, pp.412–13. This quotation is from p.413.

57. Ibid., p.400.

58. V.D. Barooshian *Russian Cubo-Futurism*, The Hague, 1974, p.148. There may be many more French Symbolist links. Kruchenykh's book *Pustynniki* (Hermits), illustrated by Goncharova and published in 1913, was partly modelled on Flaubert's *Tentation de St Antoine* and the lithographs made by Redon under Flaubert's inspiration. Rimbaud's *Saison en enfer* of 1873 declared a love of naive paintings, signboards and popular illustrations, just as Russian Futurists did.

59. Benedikt Livshits *Polutoroglaznyy Strelets*, Leningrad, 1933, pp.222–8, cited in V.D. Barooshian *Russian Cubo-Futurism*, The Hague, 1974, p.150.

60. Maurice Denis *Paul Sérusier*, p.98.

61. Pavel Florenskiy *Stolp i utverzhdenie istiny*, Moscow, 1914, republished in French as *Père Paul Florensky La Colonne et le fondement de la vérité*, translated by Constantin Andronikof, Lausanne, 1975. An extended and useful discussion on the impact of Poincaré, Ernst Mach and other mathematicians and scientists occurs in the unpublished doctoral thesis by John G. Hatch 'Natural Laws and the Changing Image of Reality in Art and Physics', University of Essex, 1995.

62. P. Florensky *La Colonne et le fondement de la vérité*, p.321ff. The mathematician Georg Cantor (1845–1918) was born in St Petersburg but worked in Germany. His theories concerned transfinite numbers and infinity.

63. P. Florensky *La Colonne et le Fondement de la Vérité*, Lausanne, 1975, p.337.

64. Ibid.

65. Ibid., p.338.

66. Ibid., p.491 n.877.

67. N. Goncharova *Misticheskie obrazy voyny. 14 litografiy*, Moscow, 1914.

68. Translated in V. Khlebnikov *Snake Train*, edited by Gary Kern, Ann Arbor, 1976, p.175.

69. Ibid., p.174.

70. Ibid.

71. Ibid.

72. V. Khlebnikov *Collected Works*, Harvard University Press, 1989, vol. 2, p.56.

73. Ibid., p.63.

74. Ibid., p.73. In December 1914 Khlebnikov was writing to Matyushin about the mathematician Poincaré. See L. Henderson *Fourth Dimension*, 1983, p.242.

75. Khlebnikov's *Ka* included a cardgame played against universal will. See V. Markov *Russian Futurism*, 1968, p.291.

76. *Levye Techeniya. Byuro N.E. Dobychina*, Petrograd, 1915. Rozanova's playing card paintings included various Kings, Queens and Knaves. She also pasted a collage heart onto the cover of A. Kruchenykh and Alyagrov (pseudonym of Roman Jakobson) *Zaumnaya Gniga*, Moscow, 1916. See also the Ace of Hearts which features in Chagall's *Homage to Apollinaire*.

77. Particulary the lost *Central Relief* with palette and set square reproduced in C. Lodder *Russian Constructivism*, London and New Haven, 1983, p.13, plate 1.3.

78. Illustrated in H. Berninger *Pougny*, p.39.

79. Listed as a title in the catalogue *21–25 Soderzhanie kartin avtoru neizvestno* in H. Berninger *Pougny*, Tübingen, 1972, p.39.

80. What L. Zhadova *Suprematism*, 1982, p.122 n.4, called 'Februarism'.

81. Ibid., p.120 n.34.

82. Ibid., p.120 n.34.

83. Ibid., p.123 n.4, gives the letter dated 24 September 1915. Malevich discussed '*Fevralism* (Februarism) in a letter of 28 November 1914. This was pointed out by E.F. Kovtun and discussed in W. Sherwin Simmons 'Kazimir Malevich's "Black Square"', p.130ff.

84. Catalogue entries 54 and 55 are both entitled *Marinetti*. The impact of Italian Futurism in Russia has been discussed in Charlotte Douglas 'New Russian Art and Italian Futurism' in *Art Journal*, September 1975, pp.299–337.

85. Peter Stupples discusses this in *Kuznetsov*, 1990, p.146. Tairov was studying the Indian epic *Shakuntala*, designed by Kuznetsov for the first production at Tairov's Kamerny (Chamber) Theatre in Moscow.

86. The article is discussed in V. Markov *Russian Futurism*, 1968, p.280.

5 Zero

1. V. Khlebnikov *Collected Works*, vol. 2, 1989, p.24.

2. Ibid., p.357.

3. Ibid.

4. Ibid., p.359.

5. Cited in L. Zhadova *Suprematism*, 1982, p.123 n.4. Matyushin was discussing the fourth dimension in May 1915. This is considered in L. Henderson *Fourth Dimension*, 1983, p.285.

6. In Ouspensky's system this could imply a shift into a new dimension as any line in one plane is at right angles to the plane of a new dimension. On the other hand E.F. Kovtun has credibly indicated that '0,10' signified ten artists passing 'beyond zero', which was how Malevich decribed their aim. See E.F. Kovtun 'Kazimir Malevich' in *Art Journal*, Fall 1981, p.234ff. A discussion of the growing interest shown in Lobachevsky as a result, at least in part, of the activities of Khlebnikov's tutor Aleksandr V. Vasiliev may be found in L. Henderson *Fourth Dimension*, 1983, p.238ff.

7. Discussed in L. Zhadova *Tatlin*, 1988, p.160. Here Syrkina says that Tatlin's set was designed to be constructed from several materials including wood, ropes and wires.

8. An impressively coherent proposal was put forward by Patricia Railing in her essay *On Suprematism: 34 Drawings*. She suggests that the terms are part of a systematic categorization of paintings.

9. This view is again close to that in Patricia Railing *On Suprematism: 34 Drawings*.

10. 'Deadart': here Malevich has invented the word *mertvopis'* from *mertvyy* (dead) and *zhivopis'* (painting). *Zhivopis'* is made from *zhivo-* (alive) and *pis'* (writing), the Russian word for painting means 'live-writing', which Malevich here changes into 'dead-writing' to refer to the traditions of the Academy.

11. The lecture poster is reproduced in H. Berninger *Pougny* p.68.

12. A. Kruchenykh and V. Khlebnikov *Slovo kak takovoe (The Word as Such)*, illustrated by K. Malevich and O. Rozanova, Moscow, 1913. *Bukva kak takovaya (The Letter as Such)*, also by A. Kruchenykh and V. Khlebnikov, remained unpublished until later. This is discussed in Vladimir Markov *Russian Futurism*, 1969, p.398 n.24.

13. 'Kor re rezh . . .', manuscript, *c*.1915, Stedelijk Museum, Amsterdam, published and translated in T. Andersen *K. Malevich: Unpublished Writings*, vol. 6 of *Malevich: Essays*, 1978, p.30.

14. Ibid.

15. K. Malevich 'I Am the Beginning', published and translated in ibid., p.12.

16. Ibid., p.12, from a manuscript in the Stedelijk Museum, Amsterdam, dated *c*.1915 by Andersen.

17. Ibid., p.13.

18. Ibid., p.15.

19. Hinton's *A New Era of Thought* and *The Fourth Dimension* were published in Russian together with an introduction by Ouspensky in 1915.

20. T. Andersen *K. Malevich: Unpublished Writings*, p.10.

21. This is from the third edition published in Moscow in 1916, translated in T. Andersen *Malevich: Essays*, vol. 1, p.38. A possible Egyptian source of reference for Ka and related images which was published in Russia is discussed in W. Sherwin Simmons 'Kazimir Malevich's "Black Square"', pp.116–25.

22. T. Andersen *Malevich: Essays*, vol. 1, p.19.

23. Ibid., p.35.

24. Ibid., p.33. See also John Golding 'Kazimir Malevich's "Black Square"' in *Studio*, April 1974, pp.190–95, and July 1974, pp.7–8.

25. T. Andersen *Malevich: Essays*, vol. 1, p.38.

26. L. Zhadova *Suprematism*, 1982, p.120 n.34.

27. This is also the view expressed in L. Zhadova *Suprematism*, 1982, p.43.

28. Fibonacci's series also begins with 0 followed by 1. These figures are given and everything else follows from them, rather as Malevich began, in principle, with zero (white or empty space) within which the first form was established (black, square).

29. This may also apply to *Victory over the Sun* where no single design of a balck square appears to survive.

30. L. Zhadova *Suprematism*, 1982, p.46, indicates that this was discussed in Viktor Shklovsky's article 'Prostranstvo zhivopisi i suprematisty' (The Space of Painting and the Suprematists) in *Iskusstvo*, Moscow, no. 8, 1919, where the diagrams published by Wilhelm Wundt in his *Ocherki psikhologiy* (Outline of Psychology), Moscow, 1912, p.118, were considered in this context.

31. The exhibition is an early example of the display of paintings unframed.

32. Discussed in Patricia Railing *On Suprematism: 34 Drawings*, p.35.

33. Railing *On Suprematism: 34 Drawings*, p.35, credibly suggests that this canvas is one of the series listed in the catalogue as nos. 60–77: *Colour Masses in Two Dimensions in a State of Rest*.

34. Published in T. Andersen *Malevich: Essays*, vol. 4, plate 5, where it is dated 1915.

35. The black cross also had wartime connotations insofar as it was used on German aeroplanes. Given Malevich's involvement with wartime propaganda he would have been perfectly aware of this.

36. Railing *On Suprematism: 34 Drawings*, also considers this a separate, dynamic phase. Subsequently Malevich characterized phases of the development of Suprematism as dominated by the black, red and white squares respectively.

37. Hinton illustrated a variation applied to sheering forms.

38. This was photographed on exhibition in Moscow in 1919 but hung the other way up.

39. Railing *On Suprematism* has argued against this as she considers this canvas to be one of the series listed in the catalogue as nos. 48–59 *Painterly Masses in Movement*.

40. K. Malevich *Secret Vices of Academicians*, Moscow, 1916, translated and published in T. Andersen *Malevich: Essays*, vol. 1, pp.17–18.

41. Railing *On Suprematism*, p.35, considers this to be one of the series of works listed in the catalogue as nos. 48–59 *Painterly Masses in Motion*.

42. Railing *On Suprematism*, p.35, considers this to be no. 46: *Lady – Colour Masses in Two and Four Dimensions* on the basis that it is dynamic and monochrome, categories she attributes to particlular

descriptions employed by Malevich. This view may gain support from the painting's resemblance to Wyndham Lewis's *Portrait of an English Woman*, painted in 1914 and recently published in the Russian almanac *Strelets*. The mathematics of the painting *Eight Red Rectangles* is discussed in L. Henderson *Fourth Dimension*, p.285ff.

43. Railing *On Suprematism*, p.35, considers this to be catalogue no. 45 *Automobile and Woman – Colour Masses in Four Dimensions*.

44. The sequential effect is potentially like a film, a possibility that interested Malevich later. This is discussed in A. Shatskikh 'Malevich and Film' in the *Burlington Magazine*, vol. 135, July 1993, pp.470–77.

45. An impressive survey of the impact of flight on art is Robert Wohl *A Passion for Wings*, New Haven and London, 1994.

46. According to V. Markov *Russian Futurism*, p.303, the Society of 317 was founded by Khlebnikov and Petnikov in Moscow in February 1916.

47. V. Khlebnikov *Snake Train*, edited by Gary Kern, Ann Arbor, 1976.

48. I am indebted to Robin Milner-Gulland for drawing my attention to Khlebnikov's *Dream* and for translating it.

49. V. Khlebnikov *Dream*, translation by Robin Milner-Gulland, unpublished.

50. This canvas is inscribed on the reverse in Polish 'K. Malewicz/ Supremus/No. 50/Moskwa'.

51. Malevich is known to have been painting *Supremus No. 51* in April 1916 according to L. Zhadova *Suprematism*, p.123 n.5.

52. *Rez'ba O. Rozanovoy, Slova A. Kruchenykh: Voyna*, 1916. *(Cut-outs by O. Rozanova*, Words by A. Kruchenykh *War)*.

53. A. Kruchenykh and O. Rozanova *Vselennaya voyna* (Universal War), Petrograd, 1916.

54. The painting was photographed on exhibition in 1919 where comparisons provide an estimated size of 11 *vershok* square. Malevich produced a closely related drawing for his book *The Non-Objective World*, 1927, where he gave this title and the date 1914–15.

55. *Ocharovannyy Strannik*, Petrograd, 1916, cited in L. Zhadova *Suprematism*, p.32 n.47.

56. Ouspensky continued to publish during this period including: P.D. Uspensky *Razgovory s d'yavolom. Okul'tnye raskazy* (Conversations with the Devil: Occult Tales), Petrograd, 1916.

57. V. Khlebnikov *Collected Works*, 1989, vol. 2, p.90.

58. Ibid., p.92.

59. Ibid., p.82. Compare this with *Dream*, which refers to an exhibition called '$\sqrt{-2}$'.

60. V. Khlebnikov *Vremya mera mira*, Petrograd, 1916, reprinted in *Collected Works*, vol. 2, p.460. The following five quotations form Khlebnikov are from the same source.

61. In such a climate of thought someone probably noticed that Khlebnikov and Tatlin were born 365 years after Raphael (and 366 years after Leonardo), but there is no obvious match for Malevich.

62. The letter is given in L. Zhadova *Suprematism*, 1982, p.123 n.28.

63. The letter is cited in T. Andersen *Malevich: Essays*, vol. 1, p.48.

64. It may relate to topic no. 4, 'the route from space to time,' as listed on the poster.

65. L. Zhadova *Tatlin*, 1988, p.89, reproduces the poster. Other topics include 'The days of Icarus. Cast iron Wings. Contemporaneity as a smelting furnace. The use of word creation. The laws of language.'

66. V. Khlebnikov *Truba Marsyan* in *Collected Works*, vol. 2, 1989, p.323.

67. L. Zhadova *Suprematism*, 1982, p.125 n.66.

68. Listed in the catalogue as nos. 202–7.

69. Listed in the catalogue as nos. 45, 46 and 48.

70. Letter cited in V. Khlebnikov *Collected Works*, vol. 1, p.119.

71. Malevich had written of 'drop-shaped time' and Khlebnikov had written of time melting. See Chapter Four, note 73.

72. Russian Futurists often responded to French precedents. *Yellow Quadrilateral* may be comparable with *Madness*, lithograph no. 6 from Odilon Redon's print cycle *A. Edgar Poe*, 1882.

73. K. Malevich 'K Novomu Liku' (To the New Image) in *Anarkhiya*, no. 28, 27 March 1918, Moscow, translated in T. Andersen ed. *Malevich: Essays*, vol. 1, p.51.

1. K. Malevich 'Otvet' (Reply) in *Anarkhiya*, no. 29, 28 March 1918, Moscow, translated in T. Andersen *Malevich: Essays*, vol. 1, p.54.

2. K. Malevich 'Arkhitektura kak poshcheshchina betona zhelezu' (Architecture as a Slap in the Face of ferro-concrete) in *Anarkhiya*, no. 37, 6 April 1918, Moscow, translated in T. Andersen *Malevich: Essays*, vol. 1, p.64.

3. Discussed in L. Zhadova *Suprematism*, 1982, pp.56, 124 n.57.

4. See G.-W. Költzch *Morozov and Shchukin*, 1993, pp.116–17.

5. Ya. Tugendkhol'd *Zhizn' i tvorchestva Polya Gogena, Pol' Gogen Noa-Noa, Puteshestvie na Taiti* (J. Tugendhold *Life and Works of Paul Gauguing* Paul Gauguin *Noa-Noa, Journey to* Tahiti), second edition, Moscow, 1918.

6. Maurice Denis *Journal*, vol. 2, p.206.

7. These stages bear some comparison with the stages of *nigredo* (black), *rubedo* (red) and *albedo* (white) in alchemy. Another useful discussion of the white paintings is A.C. Birnholz 'On the Meaning of Malevich's "White on White" series' in *Art International*, January 1977, p.9ff.

8. This was explained by Khlebnikov in *Khudozhniki Mira* (Artists of the World) in 1919.

9. See the periodical *Izobrazitel' noe iskusstvo*, no. 1, 1919, which included the following essays by Malevich: 'Nashi zadachi' (Our Aims), p.27; 'O tsveta i ob'ema' (On Colour and Volume), p.27; and O poezii (On Poetry), p.27. The books listed here are from p.67. This also included Jean-Baptiste Rondolet's *Traité théorique et practique de l'art de bâtir*, originally published in seven volumes in 1802–17 in Paris where Rondolet (1743–1829) worked with the architect Soufflot building the Panthéon.

10. *Izobrazitel'noe iskusstvo*, no. 1, 1919, p.67.

11. The ikon of the *Virgin of Vladimir* came to Russia from Constantinople and had even been attributed to St Luke.

12. The Tate Gallery, London, has an enlarged version of this, executed in steel in 1964.

13. These may also be Redon lithographs. See Redon's *And in the very Disk of the Sun*, no. 10 in the print cycle *La Tentation de St Antoine*, 1888.

14. Malevich's statement in the catalogue of the 'Tenth State Exhibition: Non-Objective Creation and Suprematism', 1919–20 is cited in L. Zhadova *Suprematism*, p.238.

15. Cited in ibid., pp.42, 123n.9.

16. Cited in ibid., p.282.

17. V. Khlebnikov *Collected Works. Volume Two: Prose. Plays and Supersagas*, translated by Ronald Vroom, Harvard University Press, 1989, p.8.

18. K. Malevich 'O muzee' (On Museums) in *Iskusstvo komuny*, no. 12, 23 February 1919, cited in T. Andersen *Malevich: Essays*, vol. 1, p.69.

19. K. Malevich *O novykh sistemakh v iskusstve* (On New Systems in Art), Vitebsk, 1919, translated in T. Andersen *Malevich: Essays*, vol. 1, p.83ff.

20. Ibid., p.83.

21. Malevich in the catalogue of the 'Tenth State Exhibition: Non-Objective Creation and Suprematism, 1919–20'.

22. V. Khlebnikov *The Head of the Universe: Time in Space* in *Collected Works*, vol. 2, 1989, p.362.

23. Ibid.

24. Ibid., p.363.

25. V. Khlebnikov *Collected Works*, vol. 1, 1989, p.389.

26. Ibid., p.390.

27. K. Malevich 'O muzee' p.69.

28. L. Zhadova *Suprematism*, p.59, called this 'a type of permutation system . . . a laboratory method for processing Suprematist shapes'.

29. K. Malevich *Suprematizm: 34 Risunka* (Suprematism: 34 Drawings), Vitebsk, 1920.

30. K. Malevich *Suprematizm: 34 Risunka* (Suprematism: 34 Drawings), Vitebsk, 1920, reprinted and analysed in Patricia Railing *On Suprematism: 34 Drawings*, p.123.

31. K. Malevich *Suprematizm: 34 Risunka* (Suprematism: 34 Drawings) reprinted and analysed in Railing *On Suprematism,* p.124.

32. El Lissitzky *Suprematism in World Construction,* 1920, translated and published in S. Lissitzky-Küppers *El Lissitzky,* London, 1968, p.327.

33. Ibid., pp.329–30. For a further discussion of Lissitzky, mathematics and Suprematism, see Henderson *Fourth Dimension,* p.294ff.

34. V. Khlebnikov 'October on the Neva', 1918, in *Collected Works,* vol. 2, 1989, p.116.

35. *Nevsky* is of course Nevsky Prospekt, the great thoroughfare in St Petersburg. *Ladomir* was published in the *Lef* periodical, no. 2–3, April–May 1923.

36. Konstantin Tsiolkovsky *Vne Zemli,* Kaluga, 1920, translated by Kenneth Spears and published as *Beyond Planet Earth,* Oxford, 1960. All references are to this translation.

37. *Beyond Planet Earth,* p.81.

38. Ibid., p.94.

39. References are to the Penguin edition: Evgeni Zamyatin *We,* Harmondsworth, 1980, which derives from the 1924 Russian language edition.

40. *We,* p.19.

41. Ibid.

42. Ibid., p.23.

43. Ibid., p.36.

44. Ibid., p.47.

45. Ibid., p.58.

46. Ibid., p.90.

47. Ibid., p.54.

48. Ibid., p.120.

49. Ibid., p.128. The dystopian aspect of this book accords well with the view of geometry in relation to morals and ethics expressed in S.H. Madoff 'Vestiges and Ruins' in *Arts Magazine,* December 1986, pp.32–40.

50. K. Malevich 'The Question of Imitative Art', Smolensk, 1920, translated in T. Andersen ed. *Malevich: Essays,* vol. 1, p.165.

51. V. Khlebnikov, letter to Miturich, 14 March 1922, in *Collected Works,* vol. 1, p.137.

52. Paul Sérusier *ABC de la peinture,* Paris, 1921.

53. Gino Severini *Du Cubisme au Classicisme: Esthétique du compas et du nombre,* Paris, 1921, p.7.

54. Ibid., p.9.

55. Ibid., p.13.

56. Ibid.

57. Ibid., p.17. He is quoting an article of his own published in the *Mercure de France,* 1 February and 1 June 1917

58. Ibid., p.24.

59. Ibid., pp.28–32.

60. Ibid., p.35.

61. Ibid., pp.60–70.

62. Ibid., pp.123, 79. Severini also discusses many specific issues including the ratios 3:2, 4:3, 3:5, 5:4 and so on (p.48), the Egyptian triangle (p.53ff), the hexagon (p.54), the circle divided into twelve parts (p.58) and the control and balance of colour (p.91ff).

63. E. Petrova *Malevich,* dates these works 'early 1920s' as in her plate 130.

64. A. Kruchenykh, G. Petnikov and V. Khlebnikov *Zaumniki,* Moscow, 1922.

65. Vladimir Markov *The Longer Poems of Velimir Khlebnikov,* Berkeley, 1962, note 97.

66. Pavel Florenskiy *Mnimosti v geometriy,* Moscow, 1922. Florensky also discussed mystical connotations of number as well as perspective. See K. Sokolov and A. Pyman 'Father Pavel Florensky and Vladimir Favorsky' in *Leonardo,* vol. 22, no. 2, p.237ff. See also P. Florensky *Analiz prostranstvennosti i vremeni v khudozhestvenno-izobrazitel'nykh proizvedeniyakh* (Analysis of Space and Time in the Products of the Plastic Arts), Moscow, 1993.

67. K. Malevich 'Bog ne skinut. Iskusstvo, tserkov, fabrika' (God is Not Cast Down: Art, Church, Factory), Vitebsk, 1922, translated in T. Andersen ed. *Malevich: Essays,* vol. 1, p.188ff.

68. Ibid., p.189.

69. Ibid., p.196.

70. K. Malevich 'Suprematicheskoe zerkalo' (The Suprematist Mirror) in *Zhizn' iskusstva,* Petrograd, 22 May 1923, cited in A.B. Nakov *Malévitch: Ecrits,* Paris, 1975, pp.227–8.

71. Ibid.

72. This is also a technical theme in the constructions of Naum Gabo and Antoine Pevsner.

73. Cited in S. Lissitzky-Küppers *El Lissitzky,* pp.333–4.

74. 'Mason' here means Freemason. This is discussed in Nicoletta Misler *Pavel Filonov, Painter of Metamorphosis,* citing an article in *Zhizn' iskusstva,* Petrograd, no. 24, 1923, pp.26–7. Other relevant material includes Pavel Florensky *Chislo kak forma* (Number as Form), Moscow, 1923, and the contemporary publication of Claude Bragdon *Primer of Higher Space: The Fourth Dimension,* New York, 1923 (second edition), and his *Four-Dimensional Vistas,* London, 1923 (second edition).

75. Le Corbusier *Vers une architecture,* Paris, 1923. Quotations are from the 1970 edition of the English translation *Towards a New Architecture,* London, 1927.

76. Ibid., p.7.

77. Ibid., p.31.

78. Ibid., p.151.

79. El Lissitzky 'Wheel, Propeller and What Follows' in *G,* no. 2, September 1923, Berlin, translated in S. Küppers-Lissitzky *El Lissitzky,* p.345.

80. K. Malevich 'About Zangezi', 1922–3, translated in T. Andersen ed. *Malevich: Essays,* vol. 4, p.95.

81. *Zaumnyy yazyk – ploskost' mysli* (trans-sense language is the surface of thought).

82. S. Küppers-Lissitzky *El Lissitzky,* p.348.

83. K. Malevich *The World as Non-Objectivity,* 1922–25, translated in T. Andersen ed. *Malevich: Essays,* vol. 3, p.55. The comparison between Leonardo da Vinci and Lissitzky is also pursued in A.C. Birnholz 'Forms, Angles, Corners: On Meaning in Russian Avant-Garde Art' in *Arts Magazine,* February 1977, pp.101–9.

84. El Lissitzky 'Nasci', first published in *Merz,* nos. 8–9, April–July 1924, Hanover, translated in S. Küppers-Lissitzky *El Lissitzky,* p.345.

85. El Lissitzky 'A. and Pangeometry', 1925, translated in S. Küppers-Lissitzky *El Lissitzky,* p.348. A vigorous and convincing analysis of Lissitzky's debt to Minkowski in particular is made in John G. Hatch 'Nature's Laws and the Changing Image of Reality in Art and Science', unpublished doctoral thesis, University of Essex, 1995.

86. El Lissitzky 'A. and Pangeometry', p.350.

87. Cited in S. Küppers-Lissitzky *El Lissitzky,* p.326.

7 *The Architecture of Flight*

1. It may be relevant that the New Jerusalem is described in the Revelation of St John, chap. 21, as square with twelve gates.

2. Discussed and illustrated in Selim Khan-Magomedov *Pioneers of Soviet Architecture,* London, 1987, plates 607–9 and plates 49–50.

3. Malevich used *vershok* and *arshin* for convenience. His geometry never relied upon specific size, only relative size, that is to say proportion. Many of his projects were potentially fractal, if this is taken to mean that enlargement does not substantially affect the form. This is the case with the Fibonacci series, the spiral and so on.

4. K. Malevich 'Oshchushchenie' (Sensation), *c.*1927, manuscript, Stedlijk Museum, Amsterdam, translated in T. Andersen ed. *Malevich: Essays,* vol. 4, p.144.

5. Katherine Dreier bought this for the Société Anonyme collection, now at Yale University Art Gallery.

6. For example, Le Corbusier and Pierre Jeanneret in 1924 designed prototype mass-production dwellings for artisans. These dwellings were square in plan with a diagonal internal balcony the length of which was therefore √2. See Le Corbusier *Towards a New Architec-*

ture, p.237. Ultimately Le Corbusier's Modulor system can be compared with the systems of Malevich.

7. K. Malewitsch *Die gegendstandslose Welt*, Munich, 1927. The text was heavily edited. Gropius apparently required substantial cuts according to G. Schwartz and J. Bowlt 'Malevich's Artistic Political Testament' in *Art News*, May 1976, p.20ff.

8. In June 1927 before his departure from Germany, Malevich left his writings with Von Riesen and his paintings with the architect Hugo Häring.

9. These were unbuilt. The square was also much employed by the architect Moizei Ginzburg. See Selim Khan-Magomedov *Pioneers of Soviet Architecture*, p.386.

10. K. Malevich 'Nove iskusstvo' (New Art), in *Nova generatsiya* (New Generation), 1928–30, Kharkov, translated in T. Andersen ed. *Malevich: Essays*, vol. 2, p.9.

11. Both exhibitions were held at the State Museum of Modern Western Art, Moscow, in 1926.

12. This also applies to the companion portraits of his wife and a portrait that may show the critic Nikolai Punin. See E. Petrova *Malevich*, 1990, plates 197, 203.

Appendix 1 Fibonacci and Campanella

1. Sir Thomas More *Utopia*, 1515–16, reprinted in H. Morley *Ideal Commonwealths*, London, 1899, p.238.

2. Paul Lafargue 'Campanella. Etude critique sur la vie et sur la Cité du Soleil' in *Le Devenir social*, vol. 1, 1895, pp.305–20, 465–80, 561–78. These texts are discussed in Bernardino M. Bonansea *Tommaso Campanella: Renaissance Pioneer of Modern Thought*, Washington, 1969. East European translations and commentaries have included the Polish edition of B. Limanowski *Dwaj znakomici komunisci, Tomasz Morus i Tomasz Campanella, i ich systematy*, 1873, as well as the Bulgarian publications of Ivan A. Georgov whose inaugural lecture on Campanella was published in 1905: *Toma Kampanela. Rektorska Rech*', Sofia, 1905.

3. Tommaso Campanella *The City of the Sun* (written 1602), translated in H. Morley *Ideal Commonwealths*, London, 1899, pp.217–18.

4. Ibid., p.218.
5. Ibid., p.218.
6. Ibid., p.219.
7. Ibid., p.221.
8. Ibid., p.221.
9. Ibid., p.222.
10. Ibid., p.224.
11. Ibid., p.225.
12. Ibid., p.229.
13. Ibid., p.231.
14. Ibid., p.238.
15. More recent East European publications include T. Kampanella *Gorod solntsa* (City of the Sun), translated from the Latin by F.A. Petrovsky with an introduction by V.P. Volgin, Moscow-Leningrad, 1947; T. Kampanela *Civitas Solis (Panstwo slonca)*, Warsaw, 1954; and Lev V. Vorob'ev *Utopicheskiy roman XVI–XVII vekov*, Moscow, 1971, pp.143–89.

Appendix 2 Mystical Geometry: French Art and Theosophy

1. H.G. Wells *The Time Machine*, London, 1981, p.19.
2. Ibid., p.19.
3. Ibid., p.20.
4. Ibid., p.21.
5. H.B. Chipp *Theories of Modern Art*, p.59.
6. Paul Signac *D'Eugène Delacroix au Néo-Impressionisme*, p.96 n.7.

7. Paul Gauguin *Avant et après*, Paris, 1923.

8. Emile Verhaeren 'Les Salons des Vingt à Bruxelles' in *La Vie Moderne*, 26 février 1887, p.138, cited in William Innes Homer *Seurat and the Science of Painting*, 1964, p.145.

9. This is perhaps comparable to Gauguin's comment in a letter to Schuffenecker written in Pont-Aven, Brittany, 14 August 1888, 'Creating like our Divine Master is the only way of rising towards God', although Gauguin was willing to employ religious imagery in a way that Seurat rejected. The quotation of Gauguin's letter is cited in H.B. Chipp *Theories of Modern Art*, p.60.

10. Jan Verkade *Yesterdays of an Artist-Monk*, London, 1930, p.175.

11. See Maurice Denis *Paul Sérusier*, Paris, 1947, pp.41–5.

12. See ibid., pp.48–9.

13. See ibid., pp.50–51.

14. See ibid., pp.55.

15. 'De petits compositions archaïques et hieratiques' in Maurice Denis *Paul Sérusier*, p.51.

16. Maurice Denis *L'Influence de Paul Gauguin* in H.B. Chipp *Theories of Modern Art*, p.101.

17. Cited in H.R. Rookmaaker *Synthetist Art Theories*, Amsterdam, 1959, pp.195–6.

18. Cited in Lionello Venturi *Piero della Francesca, Seurat, Gris*, 1953, reprinted in N. Broude ed. *Seurat in Perspective*, Englewood Cliffs, New Jersey, 1978, p.108ff.

19. Matisse may have used the term in this specific sense in his 'Notes of a Painter' in 1908: 'A work of art must be harmonious in its entirety', Henri Matisse *Notes of a Painter* in A.H. Barr *Matisse: His Art and His Public*, New York, 1951, p.119ff., orignially published as Notes d'un peintre *La Grande Revue*, Paris, 25 December 1908.

20. Robert Rey *The Renaissance of Classical Sensibility in French Painting at the End of the Nineteenth Century*, 1931, cited in N. Broude, ed. *Seurat in Perspective*, p.65.

21. T. de Wyzewa 'Georges Seurat' in *L'Art dans les deux mondes*, 18 avril 1891. p.263, cited in ibid., p.48.

22. Jan Verkade *Yesterdays of an Artist Monk*, p.68.

23. Ibid., p.69.
24. Ibid., p.79.
25. Ibid., p.93.
26. Ibid., pp.78–9.
27. Ibid., p.133.

28. V.S. Solov'ev *E.P. Blavatskaya: Iz peshcher i debrey Indiy*, 1892. An English edition was published as *From Caves and Jungles of Hindoostan*, London, 1892.

29. Edouard Schuré *Les Grands Initiés*, Paris, 1889 (first edition). Quotations used here are from the French edition published in Paris in 1931.

30. Ibid., p.xiv.
31. ibid., pp.xv–xvii.
32. Ibid., p.553.
33. Ibid., p.xviii.
34. Ibid., pp.269–73, 280.
35. Ibid., p.283.
36. Ibid., pp.319, 320.
37. Ibid., p.324.
38. Ibid., p.326.
39. Ibid., p.330.
40. Ibid., p.332.
41. Ibid.
42. Ibid., p.341.
43. Ibid., pp.428–41. This theme was depicted by Sérusier.
44. Ibid., pp.454–5.
45. Ibid., p.516.
46. Ibid., p.530.

47. Maurice Denis *Paul Sérusier*, p.61. This is also discussed in Jan Verkade *Yesterdays of an Artist Monk*, pp.69–72.

48. Jan Verkada *Yesterdays of an Artist Monk*, p.79.

49. Ibid.

50. Peter Lenz, or Didier, known as Desiderius in the religious context, was born at Haigerloch, Hohenzollern, Germany, in 1832.

He studied at the Munich Academy before becoming a monk and leader of the so-called School of Beuron at the Benedictine Abbey of Beuron. He designed buildings there as well as sculpture and paintings. He also worked at San Alfonso dei Liguori in Rome, at the Monastery of Emaus in Prague, at the church of Notre-Dame in Stuttgart, and at Monte Cassino in Italy which was his major work. He died at Beuron in 1928.

51. Jan Verkade *Yesterdays of an Artist Monk*, p.269.
52. Verkade is paraphrasing the words of Desiderius, in ibid., p.249.
53. Ibid., p.269.
54. Paul Sérusier *ABC de la peinture*. Quotations here are from the 1942 edition published in Paris.
55. Ibid., p.10.
56. Ibid., p.15.
57. Ibid., p.16.
58. $\sqrt{5} + 1$, all divided by 2, or 1.6180339887. It is, for example, the ratio of the side of a pentagon to the side of a pentagon star. It occurs in many relationships in the pentagon.
59. Sérusier *ABC de la peinture*, p.18.
60. Ibid., p.19. Seurat was clearly aware of this as his canvas proportions show.
61. Ibid., p.27.
62. Ibid., p.33.
63. Maurice Denis *Paul Sérusier*, pp.74–5.
64. Ibid., pp.75–6.
65. Maurice Denis 'A propos de l'exposition d'A. Séguin' in *La Plume*, 1 March 1895, reprinted in Maurice Denis *Théories 1890–1910*, p.22.
66. Séguin died there on 30 December 1903.
67. Maurice Denis 'Notes sur la peinture religieuse (pour Jan Verkade)' in *L'Art et al vie*, October, 1896, reprinted in Maurice Denis *Théories 1890–1910*, p.31ff.
68. Paul Signac *D'Eugène Delacroix au Néo-Impressionisme*, Paris, 1899. Quotations here are from the edition of 1964 published in Paris. This quotation p.35.
69. Paul Signac *D'Eugène Delacroix au Néo-Impressionisme*, Paris, 1899, p.15.
70. Ibid., p.107.
71. Josephin Péladan *Introduction aux sciences occultes*, Paris, n.d. This edition was republished and retitled *Introduction aux sciences ésotériques*, Hérouville-St-Clair, 1898, p.2.
72. Ibid., p.28.
73. Maurice Denis *Journal*, vol. 1 (1903), Paris, 1957, p.192.
74. Maurice Denis 'L'Influence de Paul Gauguin' in *L'Occident*, October 1903, reprinted in Maurice Denis *Théories 1890–1910*, p.163.
75. Paul Gauguin *Ancien culte mahorie*, Paris, 1951, pp.9–13.
76. Ibid.
77. Ibid.
78. Ibid., p.41.
79. V.S. Solov'ev *Sovremennaya zhritsa Izizy. Moe znakomstvo s E.P. Blavatskoy*, St Petersburg 1893.

Troels Andersen *K.S. Malevich: Essays on Art*, 4 volumes, Copenhagen, 1968–78.

Troels Andersen *Malevich: A Catalogue Raisonné of the Berlin Exhibition of 1927*, Stedelijk Museum, Amsterdam, 1970.

Susan Compton *The World Backwards: Russian Futurist Books 1912–16*, London, 1978.

Rainer Crone *Kazimir Malevich: The Climax of Disclosure*, London, 1991.

Charlotte Douglas *Swans of Other Worlds: Kazimir Malevich and the Origins of Abstraction in Russia*, Ann Arbor, 1980.

Charlotte Douglas *Malevich*, London, 1994.

Linda Dalrymple Henderson *The Fourth Dimension and Non-Euclidean Geometry in Modern Art*, Princeton, 1983.

German Karginov *Rodchenko*, London, 1979.

Donald Karshan *Malevich: The Graphic Work 1913–30. A Print Catalogue Raisonné*, Jerusalem, 1975 (London 1976).

B.W. Kean *All the Empty Palaces: The Merchant Patrons of Modern Art in Pre-Revolutionary Russia*, New York, 1983.

Velimir Khlebnikov *Collected Works*, 2 volumes, translated by Ronald Vroom, Harvard University Press, 1989.

G.W. Költzch *Morozov and Shchukin: The Russian Collectors: Monet to Picasso*, Folkwang Museum, Essen, Pushkin Museum, Moscow, Hermitage, St Petersburg, 1993–4.

Christina Lodder *Russian Constructivism*, London and New Haven, 1983.

Kazimir Malevich, exhibition catalogue, Moscow, Leningrad and Amsterdam, 1988–9.

Kazimir Malevich, exhibition catalogue, Washington, Los Angeles, New York, 1990–91.

Malévitch, Musée national de l'art moderne, exhibition catalogue, Paris, 1978.

Kazimir Malevich, exhibition catalogue, Moscow, Leningrad, Amsterdam, 1988–9.

Jean-Claude Marcadé *Le Futurisme russe 1907–1917*, Paris, 1989.

Jean-Claude Marcadé *Malévitch*, Paris, 1990.

Valentine Marcadé *Le Renouveau de l'art picturale russe 1863–1914*, Lausanne, 1971.

Vladimir Markov *Russian Futurism: A History*, Berkeley, 1968.

Jean-Hubert Martin and Poul Pedersen *Malévitch: Oeuvres de Casimir Severinovich Malévitch*, Centre Georges Pompidou, Paris, 1980.

Emmanuel Martineau *Malévitch et la Philosophie*, Lausanne, 1977.

A.B. Nakov *Malévitch: Ecrits*, Paris, 1975.

Evgeniya Petrova, Charlotte Douglas and others *Malevich: Artist and Theoretician*, Paris and Moscow, 1990.

A.Z. Rudenstine *Russian Avant-Garde Art: The George Costakis Collection*, New York, 1981.

W. Sherwin Simmons *Kasimir Malevich's 'Black Square' and the Genesis of Suprematism 1907–1915*, New York, 1981.

Peter Stupples *Pavel Kuznetsov: His Life and Work*, Cambridge, 1990.

Bettina-Martine Wolter and Bernhart Schenk *Die Grosse Utopie. Russische Avantgardekunst 1915–32*, exhibition catalogue, Frankfurt and Amsterdam 1992.

M.N. Yablonskaya *Women Artists of Russia's New Age 1900–1935*, London, 1990.

L. Zhadova *Malevich: Suprematism and Revolution in Russian Art 1910–1930*, London, 1982.

L. Zhadova *Tatlin*, London, 1988.

Index